6-17-94 P8

American Unitarianism, 1805–1865

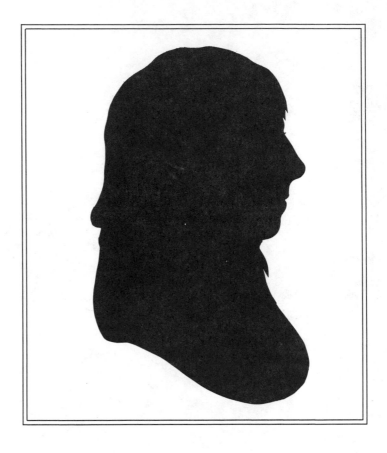

Rev. William Ellery Channing (1780–1842). Hollow-cut silhouette by an unidentified artist, n.d. Gift of Miss Frances R. Morse, 1915. Collection of the Massachusetts Historical Society.

American Unitarianism

1805–1865

Edited by

Conrad Edick Wright

Published Jointly by
The Massachusetts Historical Society and
Northeastern University Press
Boston

Massachusetts Historical Society Studies in
American History and Culture, No. 1

Library of Congress Cataloging in Publication Data
American unitarianism, 1805–1865.
(Massachusetts Historical Society studies in American
history and culture ; no. 1)
Papers presented at a conference on the history of
American unitarianism.
Bibliography: p.
Includes index.
1. Unitarianism—United States—History—19th
century—Congresses. 2. United States—Church history—
19th century—Congresses. I. Wright, Conrad Edick.
II. Series.
BX9833.A273 1989 288'.73 88-13445
ISBN 1-55553-047-8 (alk. paper)

Designed by Daniel Earl Thaxton

Composed in Bembo by Graphic Composition,
Athens, Georgia. Printed and bound by Edwards Brothers, Inc.,
Ann Arbor, Michigan. The paper is
Glatfelter Offset, an acid-free sheet.

MANUFACTURED IN THE UNITED STATES OF AMERICA
93 92 91 90 89 5 4 3 2 1

Contents

Appendices

Preface

✿

CONRAD EDICK WRIGHT

Three decades ago, in 1958, David B. Parke, then the editor of the *Proceedings of the Unitarian Historical Society*, set about to survey the condition of Unitarian historical scholarship. "There are evidences," Parke determined, "that Unitarianism has entered a new era in historiography." The death in 1956 of Earl Morse Wilbur, the author of the two-volume *History of Unitarianism*, had ended one age, a period marked by "the collection and collation of source materials from two continents." The publication of several new books and articles by younger historians and the promise of more works to come raised hopes that a new age was dawning. "There can be no doubt that the best of the new writing is more penetrating than much of what preceded it," Parke declared. The "new history" was characterized by a "depth, scope and competence" that the old history could not muster.[1]

The generation of younger historians that inspired Parke to proclaim a new historiographical era has long since matured, and the most senior of them have begun to reach retirement. Convinced that these scholars should not pass from the scene without comment, the Massachusetts Historical Society organized a conference, held on May 15 and 16, 1987, to assess their achievement and to consider examples of the latest work

Conrad Edick Wright is Editor of Publications, Massachusetts Historical Society.

on American Unitarianism. The essays in this collection are drawn from the papers presented at that conference.

American Unitarianism's "new history" has at least three salient characteristics. There is, first of all, more of it now than there ever has been before. Professor Conrad Wright of Harvard Divinity School has compiled an unpublished guide to historical writing on liberal Christianity, both its development as Arminianism in the second third of the eighteenth century and its subsequent maturation as Unitarianism, and his research demonstrates a remarkable growth of interest in the field since World War II. Wright's survey of books, articles, and dissertations issued in 1946 dealing either entirely or in significant part with the history of liberal Christianity revealed only four works. For the first five years of the postwar period he discovered only forty-five. Activity within the field began to accelerate by the mid-1950s, however, and in all but two years during the 1970s the literature grew by at least thirty new titles. Approximately 1,000 items of various descriptions have enriched the historiography of American Arminianism and Unitarianism since World War II.[2]

Second, the new scholarship on the history of American Unitarianism has placed the denomination squarely within the tradition of American Puritanism. Wilbur's *History of Unitarianism* concentrated on theological considerations and traced the course of Unitarian doctrines from Arius (d. 336) and Faustus Socinus (1539–1604) through sixteenth-century Poland and Transylvania to the New World.[3] The earliest important accomplishment of the new scholarship was to show that American Unitarianism was indigenous to New England, an outgrowth of seventeenth-century preparationist teachings and the rise of the Arminian wing within the Standing Order of Massachusetts. If American Unitarians and their Arminian forebears shared some teachings with Arius, Socinus, and certain European theologians of the sixteenth century, their agreement was not the consequence of influences or theological inheritances. As Wright commented in 1955 in his study of New England Arminianism:

> The New England liberals were called Arminians, not because they were directly influenced by Jacobus Arminius (1560–1609), the Dutch Remonstrant, but because their reaction against Calvinism was similar to his. They were descended spiritually as well as biologically from the settlers of the Bay Colony, and to a very great extent, their Arminianism was a development out of Puritanism under the pressure of social as well as intellectual forces.[4]

Third, recent writing on the history of American Unitarianism has been frankly, even stridently, revisionist in replotting the boundaries dividing nineteenth-century liberal Christians from their contemporaries, both orthodox Congregationalist and Transcendentalist. In each case, traditional lines have blurred. It now seems that the more we know about mainstream Unitarianism, the more we find it had in common with its harshest critics.

The discovery by Timothy L. Smith and Daniel Walker Howe of a pietistic, evangelical strain within classical Unitarianism has forced many scholars to reconsider the nature of the controversy in the early nineteenth century that divided liberal Christian from orthodox.[5] Jedidiah Morse, Jeremiah Evarts, Lyman Beecher, and their orthodox allies often stigmatized Unitarianism for its spiritual coldness, its icy rationalism, and generations of scholars have accepted this judgment without challenge. One of the principal achievements of the new historiography of American Unitarianism, however, has been to show this assessment to have been a partisan caricature. Leading Unitarian thinkers undoubtedly deplored the emotional excesses of their era's religious revivals, but liberal intellectuals believed no less than their Calvinist counterparts that "what America needed was a spiritual reawakening."[6]

If "a strain of Neoplatonic pietism is one of the distinguishing characteristics of all the religious heirs of the New England Puritans, whether Hopkinsian, Bushnellian, Unitarian, or Transcendentalist, right through the nineteenth century," as Howe suggests in his contribution to this volume, then new definitions both of orthodoxy and of liberal Christianity are needed. One of the major concerns of the new historiography of American Unitarianism has been to reappraise the religious controversy of the early nineteenth century and find new ways to describe the competing parties.

The research of William R. Hutchison, Lawrence Buell, David Robinson, and others has resulted meanwhile in a similar reappraisal of the Transcendentalist controversy of the 1830s and 1840s.[7] Indeed, the new historiography's quarrel with traditional definitions of mainstream Unitarians and Transcendentalists has gone even farther than its challenge to customary distinctions between liberal Christians and the orthodox. Scholars now realize the importance of the fact that most of the leading Transcendentalists remained within the Unitarian fold rather than separating themselves from it.[8] Classical Unitarians and Transcendentalists disagreed over the reliability of Christian revelation, to be sure, but in

"self-culture," the careful nurturing of the soul, both groups shared their most cherished spiritual aspiration. Most members of the "New School" of religious liberalism considered their movement a reform of conventional Unitarianism, not a revolt against it. In this respect, Emerson, so often used to epitomize his movement, was not a typical Transcendentalist but an anomaly.

The essays in this collection extend the work of the past generation of scholarship and point the way toward new issues for investigation. The first three contributions—by Conrad Wright, Joseph Conforti, and Lilian Handlin—refine our understanding of the Unitarian controversy, in each case by concentrating on its sociology and psychology rather than on its theology. The early nineteenth century was not a time of theological innovation in eastern Massachusetts. Instead, as Wright, Conforti, and Handlin indicate, the controversy disrupted existing social networks that spanned the doctrinal divisions which had grown out of the First Great Awakening of the 1740s. After 1810 the challenge for each faction within the Standing Order was organizational, as Unitarians and orthodox Congregationalists each attempted to coalesce as a religious party.

The orthodox and liberal Christians of eastern Massachusetts shared a common theological and ecclesiastical inheritance, but as Wright shows in his essay in this volume, the divisions of the early nineteenth century encouraged the two parties to draw on different portions of this legacy. Orthodox Congregationalists, who sought to excise what they considered to be the Unitarian heresy, and liberal Christians, who urged a spirit of charity and compromise within the Standing Order, each claimed with equal justification to be the spiritual heirs of New England's founding generation. As the Unitarians and the orthodox Congregationalists confronted each other, Conforti adds, each explained its positions in historical terms. Selective reading of the past allowed each party to create its own history, its own "social memory," to use Conforti's term. Many liberals never reconciled themselves to the development of competing denominations, but as Handlin demonstrates in her contribution, a circle of younger men, among whom Andrews Norton was especially insistent, struggled to force their allies to recognize the futility of compromise and concessions and to organize for battle.

The liberal Christians had scarcely coalesced around the American Unitarian Association, established in 1825, when in the 1830s their own internal differences threatened their unity. As the second three essays—

by Daniel Walker Howe, David M. Robinson, and Robert N. Hudspeth—reveal, however, conventional Unitarians and Transcendentalists continued to have much in common. Mainstream Unitarians correctly understood Transcendentalism to pose a strong challenge to the special place of scriptural revelation within their theology. Yet notwithstanding substantial disagreements over this important issue, for the most part the two groups remained on civil terms with each other.

By the late nineteenth century, as Howe notes in his contribution to this volume, "the Transcendentalists proved able to reestablish themselves within the Unitarian denomination." Howe, Robinson, and Hudspeth each help us to understand how the two groups effected their reconciliation. Howe, who addresses this issue the most directly, finds the key in the heritage of "Platonic idealism and pietism" that Transcendentalists and classical Unitarians shared. Robinson's discussion of the place of grace and works in the thought of Ralph Waldo Emerson serves in part to remind that even the most determined of Transcendentalist rebels could not escape important elements of the Puritan theological legacy that also continued to influence conventional Unitarian thought. And Hudspeth's investigation of the vocational crisis and literary career of Margaret Fuller, which finds her approach to criticism significantly different from the characteristic moralizing of Harvard Unitarianism, nevertheless recalls that her primary goal was the moral growth of her readers. Mainstream Unitarians seeking to nurture their souls, no less than Transcendentalists, could appreciate the importance of her critical aspirations.

The remaining three essays in this collection—by Lawrence Buell, William H. and Jane H. Pease, and Gary L. Collison—point the way to some interesting new issues for scholars of Unitarianism to study. Buell addresses literary scholars and asks them to reconsider the literary significance of the Unitarian movement. A sounder understanding of the relationship between Unitarianism and the American Renaissance of the years between the end of the War of 1812 and the start of the Civil War will result, Buell predicts, if scholars of American literature study not only the leading lights of this era, but also certain "frames of reference," for instance, the theological and ecclesiastical controversies of the day and the work of lesser writers who are often excluded from the literary canon. William and Jane Pease remind us that historians of Unitarianism have not yet effectively exploited the analytical tools that social historians have developed over the past two decades. Social and economic interests

help to explain the reluctance of many Unitarians to involve their churches in antebellum reform movements, the Peases maintain. Collison's contribution rehabilitates the reputation of the Harvard Divinity School, often dismissed as intellectually arid during much of the nineteenth century. Scholars who follow his lead may find that other Unitarian institutions—including the American Unitarian Association, itself—will equally repay careful study.

Of course, these suggestions are only a few of the items on the agenda for the next generation of historians of American Unitarianism. Scholars are already working on the visual aesthetics of antebellum Unitarianism, the influence of American Unitarianism on nineteenth-century European thought, and Unitarianism as a missionary faith, to name only three of many projects now underway. Peter Drummey and Alan Seaburg survey research materials for these and many other topics in the appendices, which describe the two principal collections for the study of Unitarian history—at the Massachusetts Historical Society and at Harvard Divinity School's Andover-Harvard Theological Library.

The publication of this collection of essays marks the culmination of a four-year project. It is a pleasure to acknowledge the assistance of the many institutions and individuals that made it possible. A generous grant from the North Shore Unitarian Universalist Veatch Program underwrote the conference at which the articles in this volume were first presented. We owe a special word of thanks to Eleanor H. Vendig of the program's staff. In addition to the authors of these contributions, the following also participated in the conference: Daniel Aaron, Philip Gura, David D. Hall, Patricia Hill, William R. Hutchison, Elizabeth McKinsey, Joel Myerson, Elizabeth C. Nordbeck, Norman Pettit, Ronald Story, and Harry S. Stout. Neither the conference nor the resultant volume would have been possible without the aid of the staff of the Massachusetts Historical Society, especially Louis L. Tucker, Peter Drummey, Edward W. Hanson, Donelle Meyer, Heidi Mosburg, Mimi Steinberg, and Ross Urquhart. This volume also marks the start of a new venture, a joint publication program involving the Massachusetts Historical Society and Northeastern University Press. I am pleased to express the appreciation of the Society to the staff of Northeastern University Press, especially William A. Frohlich, Deborah Kops, Susan M. Kuc, and Ann Twombly for their willingness to enter into this new partnership.

Notes

1. David B. Parke, "Editor's Note," *Proceedings of the Unitarian Historical Society* 12:vii (1958). On Unitarian historiography from Wilbur to the "new history," see David Robinson, "Unitarian Historiography and the American Renaissance," *ESQ* 23:130–137 (1977), and George Huntston Williams, "Wilbur's Vision: Freedom, Reason, and Tolerance Reglimpsed," *Unitarian Universalist Christian* 42:43–62 (1987).

2. This guide, to which Professor Wright continues to add, is available for consultation at the Massachusetts Historical Society and the Andover-Harvard Theological Library.

3. Earl Morse Wilbur, *A History of Unitarianism* (Cambridge, Mass., 1945–1952).

4. Conrad Wright, *The Beginnings of Unitarianism in America* (Boston, 1955), 6.

5. Timothy L. Smith, *Revivalism and Social Reform in Mid-Nineteenth-Century America* (New York, 1957), 95–102; Daniel Walker Howe, *The Unitarian Conscience: Harvard Moral Philosophy, 1805–1861* (Cambridge, Mass., 1970), 151–173.

6. Howe, *Unitarian Conscience*, 151.

7. William R. Hutchison, *The Transcendentalist Ministers: Church Reform in the New England Renaissance* (New Haven, 1959); Lawrence Buell, *Literary Transcendentalism: Style and Vision in the American Renaissance* (Ithaca and London, 1973), and *New England Literary Culture: From Revolution through Renaissance* (Cambridge, 1986); and David Robinson, *Apostle of Culture: Emerson as Preacher and Lecturer* (Philadelphia, 1982).

8. Hutchison, *Transcendentalist Ministers*, viii.

American Unitarianism, 1805–1865

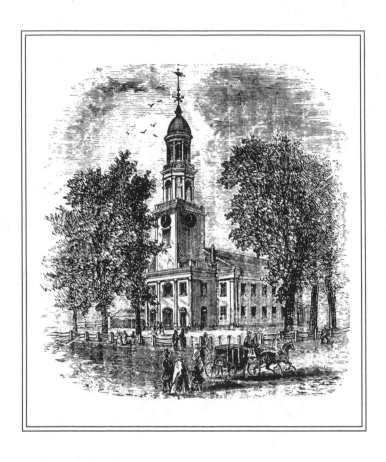

Second Church in Dorchester. Wood engraving, *Manual of the Second Church, Dorchester* (Boston, 1883), cover. Collection of the Massachusetts Historical Society.

Institutional Reconstruction in the Unitarian Controversy

CONRAD WRIGHT

The Unitarian controversy began in 1805 with the election of Henry Ware as Hollis Professor of Divinity at Harvard. It lasted for about thirty years, until in 1835 the younger Henry Ware regretfully acknowledged that the Unitarians were a community by themselves.

These thirty years divide neatly into three phases, each a decade in length, each with a characteristic prevailing concern. From 1805 to 1815, while Jedidiah Morse was the dominating figure, the dispute centered on what Channing was later to call "the system of exclusion and denunciation in religion." This phase ended with Morse's publication of the pamphlet *American Unitarianism*, Jeremiah Evarts's review of it in the *Panoplist*, and the interchange between Channing and Samuel Worcester that followed. The middle decade, from 1815 to 1825, was dominated by theological discussion, the most important single event being Channing's Baltimore sermon in 1819. Pamphlet debates followed between Andrews Norton and Moses Stuart over the doctrine of the Trinity, and between Leonard Woods and Henry Ware over the doctrine of human nature. The final phase began in 1825 with the organization of the American Unitar-

Conrad Wright is Professor of American Church History, Emeritus, Harvard Divinity School.

ian Association. This was a crucial step in the development of Unitarianism as a separate denomination, sponsoring its own institutions for missionary activity, the publication of tracts and periodicals, Sunday school work, and organized charity.

The attention of historians has been especially drawn to the middle decade, with its high drama of the conflict of ideas. The critical reviews, sermons, and pamphlets of this period have provided rich material for intellectual historians and historians of doctrine. But the very abundance of this material and its relative accessibility tend to distort our understanding of the larger controversy by overemphasizing the doctrinal aspect of it. Despite the vigor of the theological debate, this was not a time of theological innovation or fresh religious insights. It was rather the final stage of a confrontation between Arminian and Calvinist, Arian and Trinitarian, that had been developing for two generations.[1]

The Unitarian controversy added nothing significant to familiar theological arguments except for the introduction of new methods of biblical interpretation, which the liberals assumed would bolster their long-held position.[2] The liberals were groping for a more appropriate vocabulary in which to express their unevangelical doctrine and were developing a more literary preaching style, innovations that have been of interest to literary scholars.[3] But the doctrine itself, even in Channing's Baltimore sermon, did not represent a break with the tradition of Chauncy, Mayhew, Gay, Belknap, and Bancroft. Two generations of Arminians had achieved a creative theological adjustment to Enlightenment currents of thought and had amassed the intellectual capital on which the liberal Christians drew in the time of controversy.

If thirty years of conflict produced little in the way of fresh theological insights—at least until transcendental stirrings began to be felt at the very end of the period—nevertheless they radically transformed the ecclesiastical institutions of New England. Yet this is the part of the story that historians have treated least adequately. They have generally been content with a simple narrative of events, with minimal analysis of the process by which a rapid reshaping of institutional structures was taking place. The Standing Order was abolished, its demise hastened in Massachusetts by the split between liberals and orthodox. The territorial parish disappeared, and new ways of financing public worship had to be devised. The long-established practice of pulpit exchanges was subverted. Ecclesiastical councils as instruments to moderate conflict lost credibility and soon became vestigial. Theological seminaries replaced

Conrad Wright

apprenticeship training for the ministry. Religious journals and magazines emerged as important instruments for the shaping of opinion; they depended on business organization for their success. Voluntary societies were created for the promotion of missionary activity and the publication of tracts; they introduced bureaucratic methods and values into ecclesiastical affairs. These are aspects of an institutional restructuring far more radical than anything taking place in the realm of doctrine.

The conflict between liberals and orthodox within the churches of the Standing Order was not the only reason for such changes. Forces widely operative in the larger society had much to do with them, and other groups and other parts of the country were likewise affected. Religious pluralism was rendering the Standing Order obsolete. The territorial parish, appropriate for a rural society, could not accommodate the mill village. Improved transportation had its effect on ministerial exchanges and ecclesiastical councils. Technological change in the printing trades had a bearing on the increased output of books, tracts, and magazines. Population growth and migration westward gave impetus to the development of voluntary associations for benevolent causes. But the disruption of the Standing Order meant that such social forces operated with special intensity in Massachusetts and produced change the more rapidly.

Many of these changes had their inception in the first decade of the Unitarian controversy, from 1805 to 1815, and so that period is deserving of more attention than it has received. Jedidiah Morse founded the *Panoplist* in 1805. The Andover Theological Seminary was established in 1808, and the first steps leading to the establishment of the Harvard Divinity School were taken three years later. The Park Street Church was gathered in 1809. The American Board of Commissioners for Foreign Missions was organized in 1810. A General Association of Ministers on an evangelical basis, formed in 1802, finally began to attract wide support from the orthodox after 1810. The *Christian Disciple*, forerunner of the *Christian Examiner*, dates from 1811.

In short, the institutionalization of the split between the two parties was well advanced before the period of liveliest theological debate. This process went on for a generation, producing the *Christian Register* and the Berry Street Conference in 1820 and the American Unitarian Association in 1825. Some divisions in local parishes occurred even after that date. But by 1835, it was clear that no more major victories for either side were possible. Some sniping continued, but other issues were emerging. The liberals now had to decide what to make of Transcenden-

talism within their midst, while the orthodox became concerned about the way the Plan of Union seemed to be operating to their disadvantage.

The institutionalization of the division between the liberals and the orthodox proceeded mainly by small events and local actions, no one of which by itself seems of great consequence. But there was one dramatic episode that deserves recognition—more recognition than it has received—as a major representative event of the entire period of controversy. It was the dispute in the Second Parish in Dorchester from 1810 to 1812, which resulted in the withdrawal of the liberal faction to organize the Third Religious Society.[4] The Dorchester controversy produced no memorable theological statements for later historians to analyze. But what happened in Dorchester was widely noted elsewhere and became an object lesson to other parishes, which soon found themselves grappling with the same social forces and disputing over the same issues. Pulpit exchanges, the limits of Christian fellowship, the role of ecclesiastical councils in moderating conflict, the relationship of church to parish—all these problems, which surfaced in Dorchester, had ramifications in the larger society which call for exploration.

But first, the story of some parochial events of the years 1810 to 1812 must be told. There at the parish level—which is, after all, where congregationalism insists the church exists—Dorchester is the Unitarian controversy in miniature.

The Second Church in Dorchester was gathered on January 1, 1808, by twenty-seven men and thirty-seven women recently dismissed from the First Church. No doctrinal dispute occasioned the separation; rather, the growth of population made a division of the town for ecclesiastical purposes unavoidable. But unlike many such towns, Dorchester was not divided geographically. Instead the Second Parish was a poll parish, made up of those persons who found the location of the new meeting house more convenient and chose to be assessed for the support of public worship there. First a meeting house was constructed, in 1805–1806; next the Second Parish was incorporated by the General Court, in 1807; and finally the Second Church was gathered within it.[5]

The new parish, like the old First Parish, included both liberals and orthodox. They had been accustomed to the preaching of Thaddeus Mason Harris, which was mildly liberal without being notably offensive to the orthodox. Harris deplored sectarianism and shunned party labels. But prior to his ordination in 1793 he had served briefly as librarian of

Harvard College, and he was a member of the Historical Society and a Fellow of the American Academy. He was, in short, one of those ministers whose cultivated urban ways and liberal associations, quite as much as their half-acknowledged Arminianism or Arianism, seemed to the more doctrinally minded of the orthodox to be subversive of the gospel.[6]

Harris had been reluctant to see his flock divided, but he participated in the service when the church was gathered in the new Second Parish. The other ministers who participated on that occasion were likewise liberals. Dr. Eliphalet Porter of Roxbury, who gave the Right Hand of Fellowship, spoke of the "harmony and friendly intercourse" that had long prevailed among the churches and ministers of the neighborhood, and expressed confidence that with the new church peace and friendship would "continue and abound."[7]

In September of that year, the Church voted unanimously to invite John Codman to be its minister; and the Parish, with only four dissenting voices, agreed to his settlement and voted him an annual salary of a thousand dollars.[8] Codman, the son of a prosperous Boston merchant, had graduated from Harvard College in 1802. He began to read law under his kinsman John Lowell; but the untimely death of his father seems to have turned him toward the ministry. For a while he studied theology under Henry Ware, then minister in Hingham, who had earlier prepared him for college. After about a year, he moved to Cambridge, where Joseph Stevens Buckminster and William Ellery Channing were close friends. Like them, Codman was moved by an intense, essentially evangelical piety; unlike them, his theological views were developing in an orthodox direction. His biographers attribute much to his reading of William Cooper's *Doctrine of Predestination Unto Life*, then just reprinted, which he was asked to review for the *Monthly Anthology*. The result was too orthodox for the editors of that magazine, and the review appeared in the *Panoplist* instead.[9] His orthodox tendencies were strongly reinforced thereafter when he traveled abroad for almost three years, spending a considerable part of that time reading theology in Edinburgh.

Codman had only recently returned, and he had actually preached in Dorchester only twice when he was invited to settle there. He was aware of the mixed character of the parish, and before he accepted he took pains to avoid all misunderstanding as to his doctrinal position. Lest there be doubt in the mind of anyone, he wrote to the parish committee, "I think it my duty in the presence of a heart searching God, and of this Church, to declare my firm, unshaken faith in those doctrines, that are sometimes

Institutional Reconstruction

7

called the doctrines of the reformation, the doctrines of the cross, the peculiar doctrines of the Gospel." He went on to reject specifically "*Arian* and *Socinian* errors." He also affirmed his adherence to the congregationalism of the Cambridge Platform, thereby dissociating himself from Jedidiah Morse's attempts to presbyterianize congregational polity.[10]

Both church and parish responded promptly and favorably to Codman's letter. The reply of the parish committee made no issue of his orthodoxy but expressed confidence that all would be well, given "a spirit of condescension, patience, and toleration." "We have no doubt," the committee stated, "but you will use your endeavors to promote peace and friendship among the people of your charge, and to continue and confirm it among our sister churches and their pastors, and the university, of which you will be an overseer." To this Codman replied that it would be his earnest endeavor "*as far as consistent with the faithful discharge of ministerial duty*" so to promote peace and friendship. An ecclesiastical council was assembled, made up of both liberals and orthodox; Codman presented to it an unambiguously orthodox confession of faith; and he was ordained on December 7, 1808. He received the Right Hand of Fellowship, symbolic of the communion of the churches, from Thaddeus M. Harris. The sermon, by William Ellery Channing, was warmly applauded by both liberals and orthodox. Its success perhaps lay in the skillful way it communicated an evangelical spirit at the same time that it avoided what the orthodox termed "the peculiar doctrines of the Gospel."[11]

Though the seeds of dissension had already been sown, Codman's first year in Dorchester went smoothly enough. He had been frank about his Calvinism and there was no criticism on that score. But he had not made it clear that he favored the exclusive policy of non-intercourse between liberals and orthodox that men like Jedidiah Morse were beginning to advocate with increasing urgency. Indeed, at least three members of the parish had conversed with him on the matter previous to his settlement and had received what they thought were assurances that he expected to join the Boston Association, with which he meant to be "upon the most intimate terms of friendship," and that "he did not see any difficulty respecting exchanges."[12] The liberals, knowing of Codman's early associations and family connections, took it for granted that under him the Second Parish, like the First from which it had sprung, would encompass diverse opinions. In this they were disappointed, and they came to feel that he had misled them.[13]

Conrad Wright

8

In November 1809, forty members of the parish addressed a respectful letter to Codman expressing concern over rising uneasiness in the congregation. They took pains to make it clear that they had no desire "to prescribe what doctrines would be most congenial" to hear from him, but they indicated disappointment over his failure to exchange generally with the other members of the Boston Association—many of whom, after all, had joined in the occasion of his settlement. "This we did expect," they wrote, "and this we think we have a just claim to expect from your own observations, previous to your being settled as our Minister." But Codman replied: "you must give me leave to say, that I never can nor never shall PLEDGE myself to exchange pulpits with any man or body of men whatever; and that I never did, from any observations previous to my being settled as your minister, give you any just claim to expect it."[14]

Relationships between Codman and the disaffected members of his parish deteriorated steadily in the months following. At a parish meeting on April 19, 1810, a motion requesting Codman to alter his policy with respect to exchanges was defeated; but on October 22, a similar vote went the other way, 40 to 35. Unless Codman altered his position, the parish declared, his connection with it ought to "become extinct." A committee was instructed to write to the orthodox ministers with whom Codman had been exchanging, asking them not to do so for the time being lest they further "convulse a parish already shaken to its centre." Joshua Bates of Dedham and Jedidiah Morse of Charlestown responded with letters of righteous indignation at the suggestion. Codman's supporters rallied behind him; one statement commending him was signed by 73 gentlemen, and another by 181 ladies. Attempts were evidently made to alter the balance within the parish meeting by recruiting new members from the First Parish and from Roxbury. In August, some 38 pews in the meeting house had been offered for sale; and again in December, an advertisement appeared in the *Centinel* offering 69 pews for sale "together with all the right, title, and interest the proprietors of the above pews have in the Rev. Mr. Codman." Friends of the minister seized upon this demeaning reference to him as illustrating the indecent level to which his opponents had stooped.[15]

Various extraneous issues readily crept into the dispute. It was recalled that on the evening of Codman's ordination, some of his parishioners planned an "ordination ball" and courteously invited him to join them for "innocent amusement." He declined in an abrupt note, which gave

great offence; but his friend Joshua Bates was convinced that the ball had been planned "to try and perplex" him, in view of the evangelical attitude toward "polite amusements." Again, while the tenor of Codman's preaching was never made a matter of formal complaint, there is no doubt that it was pungent and plainspoken. It was the firm conviction of Codman's supporters that the issue of exchanges was a manufactured subterfuge on the part of the opponents, who, as might have been expected, were artfully concealing their real objection, which was to the truths of the Gospel that Codman was so faithful in maintaining. Next, Codman was accused of trying to persuade members of his congregation not to attend the funeral of the son of one of his opponents because he had not been asked to officiate. His explanation was that all he had said was that he hoped the funeral would not interfere with the attendance at his lectures. Finally, he was accused of trying to arouse opposition to Dr. Harris of the First Parish by circulating a card warning against the adoption there of Watts's catechism in place of the Assembly's. Some, at least, of these complaints were trivial, and there were those among the liberals who protested as much. But they were symptomatic of a situation in the parish that was unhealthy and growing worse.[16]

In June 1811, the Parish voted to recommend to Codman that he resign; but should he decline, he was requested to join in calling an ecclesiastical council "to hear and determine on all matters of controversy between him and said society." Should he refuse to join in a mutual council, the Parish was prepared to call an *ex parte* council to advise it as to a proper course of action. Prolonged negotiation followed, with many letters back and forth, until the parties finally agreed on a definition of the scope of the articles of complaint and the makeup of the council. Finally, on October 4, 1811, letters missive went out to twelve churches, inviting each to send the minister and a lay delegate. Half were nominated by each party. Meanwhile, seven of the aggrieved persons had preferred similar charges against Codman in church meeting but found themselves very much in the minority there.[17]

The council assembled on Wednesday, October 30, 1811. Advocates for the parish were Benjamin Parsons, Esq., and the Honorable Samuel Dexter. Dexter had been United States senator, secretary of war, and secretary of the treasury; he had the reputation of being an especially accomplished advocate. Representing the interests of the church, even though it was not directly a party to the dispute, was Daniel Davis, Esq., solicitor-general of the Commonwealth; and representing Codman was

his neighbor, the Reverend Joshua Bates of Dedham. It is a measure of the importance of the dispute that such distinguished advocates were enlisted; it is a measure of the seriousness with which the issues were regarded that the council was in session for eight days. The presentation of evidence and the arguments of counsel occupied the time from Wednesday through Saturday; Dexter's three-hour speech on Saturday was long remembered, even by the orthodox, as dazzling in its eloquence. From Monday until the following Thursday, the members of the council debated among themselves. They easily dismissed the trivial extraneous charges. But on the central issue, whether the aggrieved brethren had "just cause of complaint" against Codman for his practice with respect to exchanges, the council split down the middle. The six ministers with their lay delegates nominated by Codman voted to vindicate him; the six ministers and their lay delegates nominated by the parish voted to condemn. The most that could be achieved was a recommendation to the pastor, church, and congregation to preserve "a condescending, mild, peaceable, and charitable disposition." [18]

Matters had clearly gone too far for mild admonitions to have any effect. On November 28, 1811, the Parish voted, 57 to 36, to request an ecclesiastical council to consider whether Codman should be dismissed, or at least asked to resign. The first council had been requested to pass judgment on Codman's behavior with respect to exchanges; the new council would be asked to pass judgment on the troubled state of the parish and advise whether Codman's withdrawal would be in the interests of peace and reconciliation. His supporters took the position that he had been sufficiently vindicated by the failure of the first council to condemn him and argued that his dismissal would simply open the way to more dissension. The church nevertheless agreed to join Codman in accepting the proposal of the parish for a second mutual council. [19]

Once again the selection of members of the council was a long, drawn-out process. This time, each party chose four churches, each to be represented by its minister and a lay delegate; and by mutual agreement, the Reverend Joseph Lathrop of West Springfield was prevailed upon, despite some reluctance, to be the impartial moderator. The council met on May 12, 1812, this time for three days only. As before, the ministers and delegates split along party lines, and so the burden of casting the deciding vote fell on Lathrop. [20] He then voted against dismissal, but he appended to the Result of the council the notation that his vote had been taken "on a full belief and strong persuasion" that Codman would now "open a

Institutional Reconstruction

more free and liberal intercourse with his ministerial brethren." Should he fail to do so, and should the question come before him again, Lathrop declared, he would "have no hesitancy" in voting for Codman's dismissal.[21]

Two months later, Codman received a letter from the parish committee, sounding him out as to his intentions with respect to the more free and liberal intercourse enjoined by Lathrop. Perhaps injudiciously they included a list of twelve ministers of the Boston Association, to which Codman belonged, and asked specifically whether he intended to exchange with them. Codman seized on this as an invitation to repeat that he would not pledge to exchange with any particular individual, though he would attempt to consult the feelings and wishes of his people in general. Two more months passed, and Codman had exchanged with only two of the twelve. The discontented members of the parish became impatient and addressed to him two long letters of complaint. Finally, on November 24, 1812, the parish voted fifty-five to forty-five to dismiss him. This vote, to be sure, was directed to his relationship to the parish, as its "public teacher of piety, religion, and morality"—to use the language of the constitution of the Commonwealth. His salary, paid by the parish, would be discontinued; and the meetinghouse, title to which vested in the parish, not the church, would be denied him. Strictly speaking, he could be dismissed as minister of the church only by vote of the church, following an ecclesiastical council. But so closely related were these two distinct bodies that it inevitably seemed to the majority of the church that a majority of the parish was wrongfully depriving their minister of his proper standing.[22]

Codman had been planning an exchange for the following Sunday, but the other minister withdrew on representation by a delegation from the parish that his presence might create difficulties. The parish committee arranged for a substitute preacher, the Reverend Warren Pierce, formerly minister in New Salem, but not then regularly settled, who lived nearby in Milton. Rather earlier than usual on the Sabbath, Codman and his friends went to the meetinghouse, only to find that eight men were posted on the pulpit stairs to deny him access. He therefore began to conduct the service from the floor, in front of the pulpit. During the first prayer, Pierce arrived and was admitted to the pulpit, where he remained quietly until Codman and his faction had concluded their worship; then he in turn conducted worship for the rival faction. During the noon hour Pierce prudently remained in the pulpit, where refreshment was brought

to him, and then he conducted the afternoon service. Finally, Codman returned with his supporters and conducted their second service. The orthodox party remarked triumphantly that there had been 220 worshipers on the lower floor of the meetinghouse at their afternoon service, but only 48 at the service of the liberal party.[23]

Some weeks earlier, the suggestion had been made that the friends of Mr. Codman should purchase the pews of the disaffected members of the parish at the same price that had been paid for them. Now at last a solution of the dispute along such lines was seriously explored. The opposers sold their pews, resigned their parish offices, received exemption from future parish taxes, received a proportionate share of the ministerial fund, and were set off as a separate religious society. They were incorporated as the Third Religious Society and gathered the Third Church; with the blessing of the Boston Association they dedicated the "New South Meeting House in Dorchester" on October 6, 1813; and in due course they installed Edward Richmond as their minister.[24]

Codman could be unyielding when it seemed to him necessary, as in the matter of exchanges, to take a stand for principle; but he was not, like Jedidiah Morse, of a contentious or conspiratorial disposition. For their part, the liberals were ready to acknowledge that in such disputes "many things would be said and done, by individuals, on both sides, which they, in their more cool and tranquil moments, would condemn, and which the deliberate judgment of no one could approve." Hence both parties welcomed the settlement as permitting the return of civility and harmony to the town.[25]

But there were to be lasting consequences for the larger community. The issues had been made known by the publication by the church of a pamphlet of more than a hundred pages, containing the proceedings of church and parish, and much of the correspondence between Codman and his critics. The liberals stated their position in an appeal to public opinion published as they were preparing to dedicate their new meetinghouse. But at the same time that Codman was contending with his critics in Dorchester, Jedidiah Morse was engaging his enemies on many sides, and in his view the Dorchester controversy was another skirmish in the larger struggle. Morse himself was a member of the first ecclesiastical council, as was his parishioner Jeremiah Evarts; and Samuel Dexter, counsel for the parish, had been one of the referees whose decision, in the dispute between Morse and Hannah Adams, Morse was doing his best to evade. Little wonder, then, that the *Panoplist* printed a long re-

Institutional Reconstruction

view by Evarts of the pamphlets in the case in which Codman's troubles were laid at the door of the liberal party in Boston, "a party always vigilant to extend its influence, and active to bear down those who stand in its way,—a party, which, under the guise of charity and candor, is aiming to establish a strong and lasting domination,"—a party, in short of the most illiberal sort, which all the time proclaims its own "strength, and wisdom, and learning, and liberality." [26] If the people of Dorchester were ready to accept some tolerable accommodation that could be honorably adopted, the Jedidiah Morses were eager to use the episode to multiply antagonisms and widen the breach in the churches of the Standing Order. Increasingly thereafter, a refusal to exchange with any but evangelical ministers became the fixed practice of the orthodox.

In the Dorchester controversy, several of the recurrent issues of the larger Unitarian controversy were already vigorously disputed. Most immediate was the question of pulpit exchanges: was this a matter for the minister alone to determine, or were there legitimate expectations of the congregation to be respected? This question was part of a larger issue, namely, the limits of Christian fellowship: how much diversity were the churches willing to encompass? Who is to be excluded and on what basis? The problem of the adequacy of ecclesiastical councils for the resolution of disputes was also posed, as was the appropriateness of the traditional relationship of church and parish within the Massachusetts Standing Order. These several aspects of the controversy invite particular examination.

Pulpit Exchanges. Of the various forms of intercommunion among the churches of the Standing Order, the most important in the latter part of the eighteenth century were ecclesiastical councils and pulpit exchanges. While councils may be regarded as in keeping with the second way of communion authorized by the Cambridge Platform (1648), ministerial exchanges were essentially an eighteenth-century development. By the end of the century, both councils and exchanges were familiar and accepted institutional practices, a part of the custom of the country.

How regularly and frequently ministers were accustomed to exchange no doubt depended on a variety of circumstances: their personal preferences, their reputations as preachers, the degree of collegiality among members of a given ministerial association, the accessibility or inaccessibility of their locations, the time of the year. Hence there was doubtless considerable variation in the practice. In Salem, from March 1785

through the end of 1786, William Bentley exchanged twenty-seven times, on many occasions for half a day with Thomas Barnard of the North Church. In Northborough, Joseph Allen was in his own pulpit about half the time in the early years of his ministry, 1816–1817. In the six months following his ordination at Charlestown in March 1817, Thomas Prentiss preached fifty times, exactly half of them away from home. From October 1822 through April 1823, John Brazer of the North Church in Salem preached to his own congregation twenty-eight times out of fifty-three; eleven different ministers preached for him when he was away. It is clear that at this time exchanges were an important part of the life of the churches.[27]

From the point of view of the minister, the great advantage was that he was relieved of the burden of preparing two sermons every Sunday for his own congregation. That burden had undoubtedly increased as sermons became less exegetical and more literary in character. The minister could carry with him on exchange the manuscript of one of his more successful sermons; and this was the more readily possible since most preaching was on moral or doctrinal themes, with no necessary reference to topics of the day of immediate and transient concern that would require fresh preparation.

From the point of view of the congregation, the advantage was that over a period of time it might hear different voices expressing a variety of points of view. At a time when long pastorates were common and lifetime pastorates not unusual, and when transportation was difficult, people in rural communities could not easily escape if they found it hard to tolerate the preaching of their own minister. So long as the system of exchanges prevailed, their misery was alleviated to the extent that they could hear a different accent of the spirit from time to time. A liberal in West Cambridge might hear Dr. Stearns of Lincoln once in a while; a Calvinist in Lincoln might get a chance to listen to Dr. Osgood of Medford. In a time of increasing doctrinal diversity within churches of the Standing Order, pulpit exchanges served as a necessary safety valve. To restrict them, as the orthodox ministers increasingly sought to do, was inevitably to produce an explosion.

The disputes that resulted were the more rancorous because each party could claim to be adhering to long-standing tradition. The orthodox could plausibly argue that it had always been assumed that it was for the minister to determine when and with whom he would exchange, and that it had never been supposed that he was subject to instruction by the

congregation in the matter. So Codman regarded it as axiomatic that he should not pledge to exchange with any man or body of men. The liberals acknowledged that the detailed arrangements necessarily were the responsibility of the minister but insisted that a party line had never been invoked, as though certain regularly ordained ministers of congregational churches, in good standing, were unworthy of Christian fellowship. Accordingly, in a given ministerial association, all members would exchange freely as occasion offered. It was within this accepted framework that the ministers themselves would make particular arrangements for a given Sunday.

The logic of the orthodox position was simple enough. Dr. Samuel Miller of New York stated it with exemplary clarity in a letter to Codman. If it is wrong to preach heterodoxy ourselves, he argued, it is wrong to be accessories to the same sin committed by others. To admit a liberal to the pulpit on exchange is to suggest that his heresies are of small consequence after all. Even if liberals avoid an explicit assertion of unsound doctrine, the effect will be to undermine evangelical truth. "They are not only betrayed by their omissions, but also, at every turn, by their phraseology and by their theological language; so that, in fact, they seldom enter our pulpits without holding out to our people false grounds of hope." Even worse, the preaching of the orthodox themselves will be corrupted. Their duty is to preach "the peculiar doctrines of the Gospel in a plain, pointed and pungent manner." If they preach to liberals on exchange, they will be tempted to temper their language—if not absolutely to omit important truths, "at least in a considerable degree to soften and polish it down, that it may be received with as little irritation as possible." But if they exchange frequently, such laxity will seem acceptable and become habitual. Twenty years of such preaching, Miller thought, would banish religion from the Church.[28]

Instances may be cited earlier than the Dorchester case where ministers adopted the exclusive policy. Park Street in Boston was founded on that basis from the beginning in 1809. But the events of 1810 to 1812 forced the issue for many and resulted in increasing pressure on orthodox ministers to join the "strict party." These pressures became well-nigh irresistible in the 1820s. In Northampton in 1824, Mark Tucker was installed as minister of the First Church after the liberals had sought, and thought they had received, assurances that his policy "would satisfy the expectations of all." Once installed, Tucker made it clear that he felt no obligation to exchange, and rebuffed the overtures of the liberal Reverend Wil-

liam B. O. Peabody of Springfield.[29] In Bedford the same year, the Reverend Samuel Stearns reversed a policy of long standing and ceased to exchange with any but evangelical preachers; the ultimate outcome was the formation of a separate Trinitarian Congregational Society.[30] In the Second Church in Waltham the first minister was the Reverend Sewall Harding, whose exclusive policy produced dissension in the parish. He was dismissed in 1825 and departed, together with a group of followers calling themselves the Trinitarian Congregational Church.[31] In Lincoln, where Charles Stearns had been minister for forty-five years, his successor in 1826 was the orthodox Elijah Demond. His exclusive practice resulted in massive desertions and the town voted to dismiss him in 1830; his supporters then organized an independent parish.[32] In Cambridge the Reverend Abiel Holmes adopted the exclusive policy in 1826, after more than thirty years of friendly intercourse with the liberals and harmony in the parish. Two years of controversy ended in his dismissal by the parish in 1829 and his departure with a majority of the members of the church.[33]

Christian Fellowship. The system of exclusion was soon extended to other acts of fellowship. When Codman was ordained in December 1808, none of the orthodox protested that both liberals and orthodox were participating in the ordaining council and the service that followed. Even Jedidiah Morse had no qualms, despite the presence, among other liberals, of Joseph Stevens Buckminster, and the choice of William Ellery Channing to preach the sermon. But such comity could not last, and soon the line would be drawn on such occasions also. An early instance was the ordination in May 1809 of Ichabod Nichols as colleague of Dr. Samuel Deane at the First Church in Portland, Maine. There had been some coolness over the years between the First Church, where Deane was an Arminian, and the Second Church under Dr. Elijah Kellogg. Deacon Freeman of the First Church approached Edward Payson, Kellogg's staunchly orthodox young colleague, representing it as the wish both of the church and of Nichols that he give the Right Hand of Fellowship, "that there might be harmony between the churches." Payson replied that he could not say whether he would participate until the council had examined the candidate and it was clear "what were the sentiments he intended to inculcate." Payson, alone among the members of the council, not only refused to take part in the ordination, but publicly protested against it.[34]

Payson at least participated in the deliberations of the council, even if

he refused to join in the ordination ceremony itself and to exchange with Nichols thereafter. Soon, however, some of the orthodox began to argue that merely to act in an ordaining council with a liberal is an act of fellowship, and so impermissible. This question arose in November 1813, when the church in Greenfield, seeking to ordain an orthodox minister, included the Deerfield church among those to which letters missive were sent convening an ecclesiastical council. The Deerfield church responded favorably, sending its minister, Samuel Willard, and a lay delegate.

A large minority of the council then declined to participate as long as Willard was to be one of their number. They recalled that when he had been settled in Deerfield six years earlier, the council had refused to ordain on the grounds that his views were insufficiently orthodox. Resort had then been made to a second council made up largely of liberals from the eastern part of the state. By convening a second council drawn from distant parts, the argument went, the Deerfield church had separated itself from the local body of churches, and Willard was not in regular standing with the other ministers. Is it not "subversive of the order and hazardous to the faith and purity of the Churches," the orthodox asked, to expect that such a minister "should enjoy the fellowship of those Pastors and Churches who had regularly, according to long usage and scriptural authority, determined that such candidate ought not to be ordained in a Church of their connexion?" [35]

The climax of this first phase of the Unitarian controversy came in 1815. That was when Jedidiah Morse published the pamphlet entitled *American Unitarianism*, a reprint of one chapter of Thomas Belsham's *Life of Theophilus Lindsey*, describing the spread of liberal theology in New England. Morse's purpose was to make it appear that the New England liberals were Unitarians after the manner of Belsham, who was Socinian in Christology, and that they were dishonestly concealing their true opinions. Lest anyone miss the point, the pamphlet was reviewed in the *Panoplist* by Jeremiah Evarts, who called upon the orthodox party to come out and be separate. "It is the reproach and sin of Massachusetts," he wrote, "that while all the orthodox, from Connecticut to Georgia, are unanimous in withholding communion from Unitarians, she is lagging behind, and dallying with this awful and responsible subject. It is high time for decisive action on this point." [36]

To these publications William Ellery Channing responded in his *Letter to the Rev. Samuel C. Thacher*. Samuel Worcester of the Tabernacle

Church in Salem replied, and the interchange continued until 500 pages of polemics had accumulated. From these pamphlets it appears that the most basic disagreement between the two parties was the question what the debate should be about. For the liberals it was the limits of Christian fellowship; for the orthodox it was evangelical truths as authoritatively stated in the creeds and confessions of the Church, most particularly the Westminster Confession.

From the liberal point of view, the real issue was not doctrine. The theological differences, they acknowledged, were real but of small consequence compared to the truths on which all agreed. Both liberals and orthodox believed in the unity of God, even while they differed over the doctrine of the Trinity; both regarded human beings as accountable under God's moral government, even if there was disagreement as to their natural state and their power to do the will of God; there was agreement that our hopes rest in the divine mercy, even if all were not of one mind as to the terms of salvation; all acknowledged that Jesus Christ came to deliver us from sin and its consequences, even if there was disagreement as to how this could be accomplished. The position of the liberals was that it is Christian character that makes a Christian, not subscription to creeds expressing doctrinal subtleties remote from practical living. The honor of religion, Channing declared, "can never suffer by admitting to christian fellowship men of irreproachable lives, whilst it has suffered most severely from that narrow and uncharitable spirit, which has excluded such men for imagined errours."[37]

To the orthodox, the theological differences separating the parties were not trivial. "The God whom you worship is different from ours," Samuel Worcester declared; "the Saviour whom you acknowledge is infinitely inferiour to ours; the salvation which you preach is immensely diverse from that which we preach." These differences are not merely speculative, but are "most vitally and essentially practical."[38] From this perspective, the reluctance of the liberals to preach on controverted points of doctrine, lest Christian fellowship be endangered, could only be interpreted as hypocrisy and concealment.

In the Dorchester case, when the liberals protested Codman's policy with respect to exchanges they emphasized that they had no wish "to prescribe what doctrine would be most congenial to [their] feelings to hear" but were willing to let him exercise his own opinion. But the orthodox responded: "We believe that the complaint against Mr. Codman

with respect to exchanges, has been with many only *ostensible*, and, *that opposition to his religious doctrines is the radical cause of complaint and dissatisfaction.*" [39]

The first phase of the Unitarian controversy was clearly a defeat for the liberals. The hope was frustrated that—as Channing put it—the controversy would "terminate in what is infinitely more desirable than doctrinal concord, in the diffusion of a mild, candid, and charitable temper." [40] The liberals were quickly drawn into the kind of theological debate that would sharpen differences and encourage provocative language. Soon John Lowell was publishing a pamphlet entitled *Are You a Christian or a Calvinist?* In due course Channing himself would liken the orthodox view of the crucifixion to a gallows in the center of the universe, and assert that the spirit of a government "whose very acts of pardon were written in such blood, was terror, not paternal love." [41] From Dorchester to Morse's publication of *American Unitarianism* was a short step. Though some of the liberals were unwilling to admit it to their dying day, the cause of catholicity was lost and Jedidiah Morse had won.

Ecclesiastical Councils. The Cambridge Platform does not use the term *councils,* but it does contemplate a consultation of churches "if a Church be rent with divisions amongst themselves." [42] In 1695, Massachusetts law made provision for a council in case of disagreement between a church and the inhabitants of a town over the calling and settlement of a minister. In 1705, a series of proposals was submitted to the Massachusetts Ministers' Convention, recommending among other things that the "Associated Pastors, with a proper Number of Delegates from their several Churches, be formed into a standing or stated Council." [43] The proposal was never implemented in Massachusetts, though it bore fruit in Connecticut in the Saybrook Platform (1708). In Massachusetts a much less structured institution for moderating disputes developed, until by the time of the Dorchester controversy there were generally understood procedures for sending letters missive, for the appointment of delegates, for organization by the choice of a moderator and a scribe, for the presentation of testimony and the consideration of evidence, for deliberation in private, and for the preparation of the written decision, or Result. The first council meeting in Dorchester, with all its formal procedure, was the fully elaborated outcome of a long process of institutional development.

Yet both mutual councils in Dorchester failed. They neither restored

Conrad Wright

harmony to a divided parish nor pointed the way to an alternative settlement that both parties would feel under obligation to accept. The final solution, by which the liberals withdrew and were compensated for their pews, was achieved by direct negotiation, not by mediation or arbitration by council.

Ecclesiastical councils could be effective only if their members were genuinely disinterested. In the beginning that could ordinarily be assured. If a minister came into conflict with his parishioners, the ministers and delegates composing the council would be concerned to restore harmony but would not have some special interest of their own to promote. As long as New England was not divided into theological factions or parties, an issue that would come before a council would be peculiar to a local situation, not a local version of a larger divisive issue.

Down to the time of the First Great Awakening, therefore, ecclesiastical councils were a plausible device for moderating conflict. As soon as New England divided into Calvinist and Arminian, it became very difficult to assemble a disinterested council in any case involving doctrinal differences. Given the improvement in transportation, it then became easy to pack a council by reaching out to secure the participation of churches likely to render a favorable verdict. The Mathers had sought to avoid such a distortion of the system by establishing stated councils, and Connecticut did so by its established system of county consociations and ministerial associations. But Massachusetts, adhering to the Cambridge Platform, was vulnerable.

As early as 1747, when the West Church in Boston sought to ordain Jonathan Mayhew, a council of representatives of nearby churches was unable to proceed when two of the local ministers boycotted the event, at least in part because of Mayhew's reputation for doctrinal irregularity. A month later, a second attempt was made. This time the Boston churches were ignored and more distant churches, carefully selected, were invited.[44] In 1785, when Aaron Bancroft was ordained in Worcester, five of the nine churches invited were from Boston, Cambridge, and Salem, and only four from Worcester County; all were predisposed in his favor.[45] In 1807, as we have seen, it took a second council to ordain Samuel Willard in Deerfield; the successful council, which endorsed him unanimously, included well-known liberals from Lancaster, Concord, Lincoln, Weston, Salem, Bridgewater, and Beverly.[46]

The resort to ecclesiastical councils to resolve disagreements was reduced to absurdity in Dorchester. When every member of both councils

lined up in accordance with the expectations of those who had chosen them, the Result could hardly be accepted as disinterested advice. One consequence was that in later disputes, the failure of a mutual council was promptly followed by the convening of an *ex parte* council. Protocol prescribed that an *ex parte* council might be summoned if one of the parties unreasonably refused to join in a mutual council. Thus in Cambridge in 1829, a committee sought to arrange a mutual council to consider the grievance of the parish with respect to Dr. Holmes's exclusive policy on exchanges. The effort came to naught when the church insisted that it had to be a party to the calling of a council, while the parish responded that its dispute was only with Dr. Holmes, not with the church, hence the church had no standing in the matter. Eventually the parish summoned an *ex parte* council, which supported its position in every particular.[47] In Groton in 1826, where the question at issue was the right of the parish to provide for preaching when the minister had become incapacitated through infirmities of age, the orthodox convened a council on their own without even suggesting that the matter be referred to a mutual council.[48]

By this time, councils served only to validate actions the parties concerned were prepared to take in any event. For this limited purpose, they continued to be used both by the liberals and by the orthodox as a public recognition of ordinations. On the liberal side, one last attempt to use a council for the reconciliation of differences came in 1840, when the Proprietors of the Hollis Street Church sought to dismiss the Reverend John Pierpont. A mutual council struggled conscientiously to sort out the issues and reached the conclusion that adequate grounds to require his dismissal had not been offered. But the Proprietors voted not to accept the Result and urged Pierpont "to acquiesce in the dissolution of the connexion between himself and this Society."[49] The whole proceedings were then subjected to the bitter sarcasm of Theodore Parker. After that experience, no one was tempted to go that route again.

Church and Parish. In Dorchester, a majority of the church consistently supported Codman. Almost as consistently, his opponents were in the majority at parish meetings. A comparable divergence between church and parish appeared in controversies elsewhere, the most widely discussed cases being Princeton in 1817, Dedham in 1818–1820, Cambridge in 1827–1829, and Brookfield in 1829–1831. This recurrent discord between churches and parishes is a clear indication of a failure of long-established institutions and suggests that the Standing Order of the

churches was no longer functional. Originally, in the seventeenth century, when the franchise was restricted to members in full communion of one of the particular churches, no such discord would be likely to arise. By the end of the century, the franchise had been broadened, so that Baptists or Quakers or members of the Church of England, as well as the religiously apathetic, might be voting in town meeting on ecclesiastical affairs.

In 1692, the General Court passed a law requiring the inhabitants of each town to provide "an able, learned orthodox minister or ministers, of good conversation, to dispense the Word of God to them; which minister or ministers shall be suitably encouraged and sufficiently supported and maintained by the inhabitants of the town." The minister entitled to public support was to be chosen "by the major part of the inhabitants . . . at a town meeting duly warned for that purpose," and he was to be regarded as "the minister of such town." Similar provisions were made in the same law for the employment of schoolmasters.[50]

It may seem anomalous that a law for the settlement of ministers should make no reference to churches. The implication is that ministers, like schoolmasters, were performing a public function, distinct from their ecclesiastical role, and that it was as the minister of the town, not as the minister of the church, that he was to be supported by taxes. Within the church, he administered the ordinance of baptism and communion and participated in the discipline of church members. In the community at large, he was concerned to transmit, clarify, refine, and advance the values on which civilized existence in this life was deemed possible. All the inhabitants of a town benefited from this service—hence the appropriateness of taxing all for the support of public worship and of providing that those who were taxed should be the ones to choose the town minister.

It was taken for granted that the minister of the gathered church in the town would also be the "minister of such town." Yet congregational polity as stated in the Cambridge Platform made it clear that a gathered church chooses its own minister. So a clarifying amendment was made the following year to specify that the initiative in the choice of a minister would rest with the church, which would then refer its choice to the town for concurrence and legal settlement. But if there was no gathered church, as in a new town just settled, the town meeting would nevertheless have full authority to "choose and call an orthodox, learned and pious person to dispense the word of God unto them."[51]

Institutional Reconstruction

These arrangements presupposed a religiously homogeneous population in which the ministers could perform acceptably two different roles, one ecclesiastical, the other civic. Adjustments had to be made when minority religious groups became large enough to protest that they were being unfairly assessed for the support of a town minister of a different persuasion. In 1727, exemption was granted to the Episcopalians, and the following year to the Quakers and Baptists. The Great Awakening complicated the situation further, as "separate" congregational churches made their appearance and conflict arose between Calvinist and Arminian within the Standing Order. It became increasingly difficult to state the binding consensus uniting the social order in traditional theological language. The Calvinists believed firmly that the social order would collapse unless evangelical religion prevailed; the liberals insisted otherwise. An increasingly pluralistic society meant that the Standing Order, which existed to promote the binding ties of cohesive sentiment, was obsolescent.

The Massachusetts Constitution of 1780 met this problem by distinguishing the civic role of the minister from the ecclesiastical role and making "civic religion" the common responsibility of the ministers of all religious groups. The importance of public worship to promote "the happiness of a people, and the good order and preservation of civil government" was restated. No mention was made of "ministers"; they were identified rather as "public teachers of piety, religion and morality," who might be of any sect or denomination. The constitution acknowledged that the support of public teachers would continue to be by towns or territorial parishes, as well as by dissenting religious societies. It followed appropriately that those who were assessed for public worship should "have the exclusive right of electing their public teachers, and of contracting with them for their support and maintenance." [52]

By logical extension, it could be argued that the town that chooses a minister to be its public teacher also has the right to dismiss him. This issue arose in 1803 in the Berkshire town of Tyringham. Joseph Avery had been settled there in 1788. In May 1803, the town meeting voted to consider him no longer the minister of Tyringham. Avery sued for his salary on the grounds that his settlement was for life; the town replied that the settlement was for no certain time and should therefore be interpreted according to the law governing civil contracts. That would mean that when no fixed period is agreed upon, "the law construes it to be a

contract determinable at the will of either party, or, at the most, hiring for a year."

Chief Justice Theophilus Parsons's decision acknowledged that the settlement of ministers had always been understood to be for life. It followed that he might not be removed at the pleasure of the town, but only for cause. A minister guilty of immoral conduct or negligence in performing parochial duties would forfeit his position. The town would be justified in dismissing him; if he did not acquiesce, his recourse would be to sue for his salary, whereupon "the charges made by the town, as creating a forfeiture, are questions of fact properly to be submitted to the jury." Judgment in Avery's case was entered for him, since the town had voted to dismiss as a naked act of will, not on the basis of charges preferred. But the decision in *Avery* v. *Tyringham* indicated that the relationship between a public teacher of religion and the town was independent of the relationship between a minister and his church. If a town disapproved the choice of a church as the minister, and the church refused to propose another candidate,

> or the town, for any cause, shall abandon the ancient usages of the country in settling a minister, it may, without or against the consent of the church, elect a public teacher, and contract to support him. And such teacher will have a legal right to the benefit of the contract, although he cannot be considered as the settled minister of the gospel, agreeably to the usages and practice of the Congregational churches in the state.[53]

When the Second Parish in Dorchester voted to dismiss Codman and to deny him the use of the meetinghouse, which belonged to the parish and not to the church, the decision in *Avery* v. *Tyringham* was cited as the legal basis for the action. A list of twelve charges was prepared, and the parish was ready to defend its position on that basis if Codman brought suit against it. Instead the compromise settlement was reached, by which Codman's friends bought the pews of his opponents and they withdrew.

Although a legal basis existed for a recognition of the separate and independent existence of church and parish, each with its own rights and privileges, it was hard for many people to understand what was happening. Both liberals and orthodox within the Standing Order had been so accustomed to a connection between church and parish that they assumed it was necessary and indissoluble, and that the minister of the

church must necessarily be the public teacher also. The liberals thought the way out was for the minister to be more inclusive in his preaching, avoiding divisive doctrinal issues, seeking consensus at a more basic level of agreement. The orthodox likewise sought agreement but thought to achieve it by exscinding those who held Arminian, Socinian, or deistic views, so that evangelical Christianity might prevail universally.

Neither tactic worked. Eventually it was recognized that the kind of religious unity that had once prevailed was no longer possible. *Avery* v. *Tyringham* was pointing the way out; unfortunately that path was not followed. Instead the court stumbled into *Baker* v. *Fales*, which was not only bad law based on a misreading of history, but an unrealistic solution to the problem of conflict between orthodox majorities in churches and liberal majorities in parishes. It made a difficult situation much worse. In Dorchester, at least, the contending parties were finally persuaded to compromise.

The decision of any one evangelical minister not to exchange with a liberal neighbor on a given Sunday was a trivial matter; the decision of many such ministers not to exchange at all drastically changed a familiar institution. The failure of two ecclesiastical councils to restore harmony in Dorchester did not discredit the institution in any formally recognized way; but its credibility was undercut nonetheless. The "public teacher of piety, morality and religion" found his influence in the whole community shrinking to the boundaries of his own church; the Standing Order was slowly disintegrating long before its remnants were abandoned in 1833. New enterprises were begun, such as magazines and newspapers, tract and missionary societies, theological seminaries; but it was only by a gradual process that the rival groups developed a full range of denominational organizations to take the place of the Standing Order with its lost dream of a united community serving God through an ordered society. The separation of the two denominations was a process, not an event. It was nonetheless a radical dissolution and reconstruction of social institutions, which took place over a relatively brief span of years.

Notes

1. Conrad Wright, *The Beginnings of Unitarianism in America* (Boston, 1955).
2. George H. Williams, ed., *The Harvard Divinity School: Its Place in Harvard University and in American Culture* (Boston, 1954), 44–53; Jerry Wayne Brown, *The Rise of Biblical Criticism in America, 1800–1870* (Middletown, Conn., 1969).

Conrad Wright

3. Lawrence Buell, "The Unitarian Movement and the Art of Preaching in 19th Century America," *American Quarterly* 24: 166–190 (1972).

4. The primary printed sources are: *Proceedings of the Second Church and Parish in Dorchester* (Boston, 1812); *The Memorial of the Proprietors of the New South Meeting-House in Dorchester, to the Ministers of the Boston Association* (Boston, 1813); and [Jeremiah Evarts], "Review of the Dorchester Controversy," *Panoplist and Missionary Magazine* 10:256–281, 289–307 (1814), afterwards published as a pamphlet. See also William Allen, *Memoir of John Codman, D.D.* (Boston, 1853).

5. John Pierce, *A Sermon, Delivered at the Gathering of the Second Congregational Church, in Dorchester . . . with an Appendix* (Boston, 1808), 31–38.

6. W. B. Sprague, *Annals of the American Pulpit* (New York, 1865), 8:215–222.

7. Eliphalet Porter, "The Right Hand of Fellowship" in Pierce, *Sermon at the Gathering*, 25.

8. *Proceedings*, 9–10.

9. Allen, *Memoir*, 22–25; [John Codman], "Review of Cooper's Sermons on Predestination Unto Life," *Panoplist* 1:23–25 (1805).

10. *Proceedings*, 11–13.

11. Ibid., 14–21; William Ellery Channing, *A Sermon Delivered at the Ordination of the Rev. John Codman* (Boston, 1809).

12. *Memorial of the Proprietors*, 42–44.

13. Ibid., 6 ff.

14. *Proceedings*, 22–24.

15. Ibid., 25–44.

16. Allen, *Memoir*, 188–189, 190–191; *Proceedings*, 82–83, 76–78.

17. *Proceedings*, 44–103.

18. Ibid., 105–109; Allen, *Memoir*, 87–91, 202–214. The ministers who, with their delegates, supported Codman were: Thomas Prentiss of Medfield, Joseph Lyman of Hatfield, William Greenough of Newton, Samuel Austin of Worcester, Jedidiah Morse of Charlestown (the delegate being Jeremiah Evarts), and Samuel Worcester of Salem. Those who voted against him were: John Reed of Bridgewater, Richard R. Eliot of Watertown, Thomas Thacher of Dedham, Aaron Bancroft of Worcester, Samuel Kendall of Weston, and Nathaniel Thayer of Lancaster. Of these only Morse was a member of the Boston Association.

19. *Proceedings*, 110–124; Allen, *Memoir*, 91–92, 220–225.

20. The ministers who, with their delegates, supported Codman at this time were: Thomas Prentiss of Medfield, Daniel Dana of Newburyport, Samuel Stearns of Bedford, and Samuel Worcester of Salem. Those who voted to dismiss him were: Thomas Barnard of Salem, John Reed of Bridgewater, John Allyne of Duxbury, and Nathaniel Thayer of Lancaster. By agreement, each party was allowed to select no more than two of the churches represented in the first council to participate in the second. Allen, *Memoir*, 93; Evarts, "Review," 10:294.

21. *Proceedings*, 124; Allen, *Memoir*, 93–94, 225–227; Evarts, "Review," 10:295–297.

22. Evarts, "Review," 10:298–300.

23. Ibid., 10:300–302.

24. Ibid., 10:302–305; *Memorial*, passim.

Institutional Reconstruction

25. *Memorial*, 4.

26. Evarts, "Review," 10:257.

27. For Bentley, see a memorandum in the Bentley Papers, Vol. 4, American Antiquarian Society, Worcester; for Allen, the source is his Journal, privately owned; for Prentiss, *History of the Harvard Church in Charlestown, 1815–1879* (Boston, 1879); for Brazer, Abigail Phippea West, Record of Preaching at North Church, Salem, Massachusetts, 1822–1826, Andover-Harvard Library.

28. Allen, *Memoir*, 102–103.

29. *A Statement of Facts, in Relation to the Call and Installation of the Rev. Mark Tucker, over the Society in Northampton* (Northampton, 1824), 5, 13.

30. Richard Holmes, *Communities in Transition: Bedford and Lincoln, Massachusetts, 1729–1880* (Ann Arbor, 1980), 136.

31. Richard Sykes, "Massachusetts Unitarianism and Social Change: A Religious Social System in Transition, 1780–1870" (Ph.D. diss., Univ. of Minnesota, 1966), 101–102.

32. Holmes, *Communities in Transition*, 139.

33. [First Church in Cambridge], *An Account of the Controversy in the First Parish in Cambridge* (Boston, 1829); [First Parish in Cambridge], *Controversy Between the First Parish in Cambridge and the Rev. Dr. Holmes, Their Late Pastor* (Cambridge, Mass., 1829).

34. Asa Cummings, *Memoir of the Rev. Edward Payson, D.D.* (Portland, 1830), 186–189.

35. *An Address to the Christian Public* (Greenfield, Mass., 1813), 13.

36. [Jeremiah Evarts], "Review of American Unitarianism," *Panoplist* 11:265 (1815).

37. William E. Channing, *Remarks on the Rev. Dr. Worcester's Second Letter to Mr. Channing, on American Unitarianism* (Boston, 1815), 26–27.

38. Samuel Worcester, *A Letter to the Rev. William E. Channing* (Boston, 1815), 28.

39. *Proceedings*, 22, 119.

40. Channing, *Dr. Worcester's Second Letter*, 42.

41. *The Works of William E. Channing, D.D.* (Boston, 1841), 3:197.

42. Williston Walker, *The Creeds and Platforms of Congregationalism* (New York, 1893), 230.

43. Ibid., 488.

44. Charles W. Akers, *Called Unto Liberty: A Life of Jonathan Mayhew, 1720–1766* (Cambridge, Mass., 1964), 48–53.

45. Walter D. Kring, *The Fruits of Our Labors* (Worcester, Mass., 1985), 26.

46. *The Results of Two Ecclesiastical Councils* (Greenfield, Mass., 1813), 9–10.

47. See note 33.

48. [Lyman Beecher], *The Rights of the Congregational Churches of Massachusetts* (Boston, 1827).

49. *Report of the Committee of the Proprietors of the Meeting House in Hollis Street, Upon the "Result" of the Late Mutual Ecclesiastical Council* (n.p., n.d.), 20.

Conrad Wright

50. Province Laws, Ch. 26, Session of 1692–1693, in *Acts and Resolves, Public and Private, of the Province of the Massachusetts Bay* (Boston, 1869), 1:62–63.

51. Province Laws, Ch. 46, Session of 1692–1693, ibid., 1:103.

52. Conrad Wright, "Piety, Morality, and the Commonwealth," *Crane Review* 9:90–106 (1967); Charles Lippy, "The 1780 Massachusetts Constitution: Religious Establishment or Civil Religion?" *Journal of Church and State* 20:533–549 (1978).

53. *Avery* v. *Tyringham*, 3 Mass. 180–181.

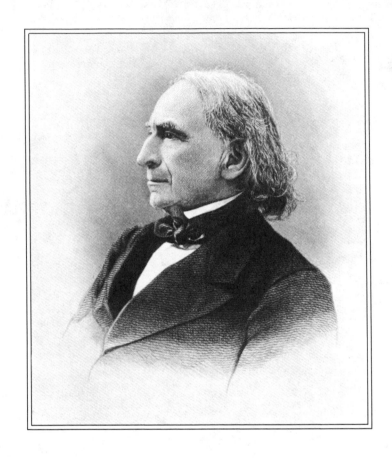

James Walker (1794–1874). Engraving by J. A. J. Wilcox, n.d. Collection of the Massachusetts Historical Society.

Edwardsians, Unitarians, and the Memory of the Great Awakening, 1800–1840

Ⓥ

JOSEPH CONFORTI

In September of 1775 a New England army rendezvousing at Newburyport, Massachusetts, paused to attend Sunday worship in the church that contained the remains of the acclaimed revivalist of the First Great Awakening, George Whitefield. With the service completed Samuel Spring, the Edwardsian chaplain, and a group of officers, entered the tomb, opened Whitefield's coffin, cut up and distributed remnants of his burial clothes, and set off to battle the British, cherishing the sacred relics that connected them to the era of the Great Awakening.[1] Though more than a generation removed from the end of the Awakening in New England and from Whitefield's impressive triumphs, the New Englanders readily summoned recollections of the famous evangelist and of the great revival.

Memories of the man and of the event persisted far beyond the Revolutionary era as well. In an article on Whitefield published in the *North American Review* in 1839, the centennial of the start of the revivalist's

Joseph Conforti is Director of New England Studies, University of Southern Maine.

grand preaching tour of America, Edward T. Channing acknowledged
the survival of the Awakening in memory and myth:

> We remember hearing two of our public men describe Whitefield many years
> ago. They were then aged, and disposed to value the solid more than the
> showy. . . . And the imagination of the one was filled with his preaching a
> farewell sermon on Boston Common at sunrise, and investing the new-born
> day with a glory the eye had never seen; it became a religious memorial. The
> other dwelt upon the flight of the dove towards heaven, and gave Whitefield's
> action as his soul seemed to follow the waving of its wings. They had prob-
> ably forgotten much of the doctrine, but the image was fixed for ever.[2]

Personal recollections of the Great Awakening comprised such images,
which were frequently preserved in oral tradition and passed down to
descendants of those who had participated in or witnessed the colonial
religious upheaval. Both personal and second-hand recollections of the
mid-eighteenth-century Awakening were revivified by the new out-
bursts of evangelical piety that began in the 1790s, that extended into the
1830s, and that have been called by historians the Second Great Awak-
ening. Indeed, this Second Awakening transmuted individual recollec-
tions of the First into social memory—group pictures of the past that
wielded interpretative power over the present. In short, the Second
Awakening revived and transformed the memory of the First; and in turn
the social memory of the First Awakening instructed the participants and
disputants in the Second.[3]

In New England both Edwardsian supporters and Unitarian critics of
revivalism viewed the Second Great Awakening from the perspective of
the images, personalities, issues, and conflicts—the social memory—
of the First. They drew on the social memory of the colonial revival to
defend and to discredit, to justify and to repudiate—to establish the
meaning of—the events of the Second Great Awakening. They turned to
the past for help with the conflicts of the present and for reassurance
about the course of the future. In the midst of the Second Great Awak-
ening Edwardsians and Unitarians rediscovered their origins in the era of
the First. For both groups social memory transformed the colonial re-
vival into the formative event—the primary historical referent—in the
development of religion in New England.

The commencement of the Second Great Awakening may be dated to
the local revivals that swept through Connecticut in the 1790s. These

Joseph Conforti

local revivals were led, in the main, by New Divinity disciples of Jonathan Edwards who were tied either directly or through their theological teachers to the era of the First Great Awakening. New Divinity preachers employed historical, theological, and geographical ties to Edwards to appropriate an Edwardsian revivalistic legacy, which they defined as a tradition of sober, clerical-directed local revivals.[4] The Southern frontier camp meetings at the turn of the century revivified New Divinity memory of the intemperance that had sullied the colonial revival. Camp-meeting revivalism summoned recollections of the social disorder and emotional excesses that had eroded public confidence in the authenticity of the colonial Awakening and that had promoted the growth of rational, proto-Unitarian religion in New England. The opening phase of the Second Great Awakening appeared to Edwardsians as potentially a historical recapitulation of the developments that had aborted the eighteenth-century revival.[5]

Both the past and the present encouraged New Divinity leaders of the Second Great Awakening to use organs like the *Connecticut Evangelical Magazine* to delineate and take possession of an Edwardsian tradition of socially respectable, moderate revivalism that would discredit camp-meeting practices and disarm Unitarian critics. At the same time the social memory of the behavioral excesses that accompanied the colonial Awakening and the contemporary reality of camp meetings impelled New England leaders of the Second Great Awakening to channel and institutionalize the religious fervor that local revivals stimulated. The formation of missionary and moral societies became part of the revival impulse in New England. As a result, the local, orderly, institutionally based revivals of the first phase of the Second Great Awakening in New England were remarkably free of the religious enthusiasm that had undermined the colonial revival and that characterized the "methodistic" camp meetings in the South. Indeed, the Edwardsians' success at promoting sober revivalism drew them to the conclusion that religious immoderation had been a dissonant but only minor chord in the spiritual harmony of the colonial revival. Opponents of evangelical religion, most notably Charles Chauncy, the Edwardsians believed, responding only to the Awakening's discordant notes, had helped destroy public confidence in revivalism and given proto-Unitarian rational religion a foothold in New England. Edwardsian leaders of the Second Great Awakening were determined to ensure that liberal Christianity not profit once again from the emotional indulgence of evangelical Protestants.[6]

Edwardsians, Unitarians, and the Great Awakening

Through the second decade of the nineteenth century, local revivals in New England were not disfigured by the kind of unbridled behavior that filled accounts of frontier camp meetings and that the New Englanders' memories associated with James Davenport during the colonial Awakening. Thus, because of the relative moderation of the local "harvests" of souls in New England, revivalism did not emerge as a major issue of contention between Edwardsians and Unitarians before the 1820s. Moreover, there was a pietistic side to New England Unitarians that recognized the importance of religious affections and that accepted aspects of the heart religion of the Second Great Awakening. "Harvard professors in the early nineteenth century," Daniel Walker Howe has pointed out, "were not immune to the contagious evangelical mood of their times. The Harvard moral philosophers, like other evangelists, looked forward to infusing a warm Christian piety throughout the land." Evangelical or pietistic Unitarians repudiated enthusiasm, not revivalism. They sought a balance between pietism and rationalism; they espoused a religious psychology that recognized the "symmetry" of human nature; they endeavored to reconcile the higher and the lower faculties, natural and supernatural affections, the devotional and the ethical.[7]

While Unitarians did not endorse the comparatively staid local revivals that marked the opening phase of the Second Great Awakening in New England, their disquietude and revulsion focused on Southern camp meetings, where the spiritual descendants of the enthusiasts of the colonial Awakening appeared to be in command. New England Edwardsians shared the Unitarian loathing for camp-meeting revivals.[8] Both groups deplored unlettered enthusiasts whose dirty fingernails proved that they had simply exchanged the plow for the pulpit. Through the early 1820s theological issues—the doctrinal defection of Harvard, the closet liberalism of the eastern Massachusetts clergy, the orthodox counter-reformation spearheaded by Andover Seminary—rather than revivalism furnished the basis for contention between Edwardsians and Unitarians in New England. The leaders of the Second Great Awakening in Connecticut and Massachusetts entered the decade of the 1820s with a clear vision of their historical descent from the era of the colonial Awakening and confident in their ability to use consecrated, judicious revival practices to redeem the young republic and to subdue Unitarians and enthusiasts. But then a new James Davenport appeared.

* * *

Joseph Conforti

The story of the rise of Charles Grandison Finney and "New Measures" revivalism is well known. After a transforming conversion experience in Adams, New York, in 1821, Finney abandoned a legal career, was ordained as a Presbyterian home missionary, and began traveling by horseback among the towns that would soon constitute a "burned over district." By the mid 1820s Finney's remarkably successful preaching signaled that the Second Great Awakening had entered a new phase. Finney, like triumphant revivalists before and after him, inspired emulation. Other revivalists assisted him in popularizing controversial revival practices that evangelical antagonists derisively labeled "new measures": protracted meetings, identifying sinners by name, using an "anxious seat" for awakened individuals, denouncing ministerial opponents, and permitting women to pray and exhort in the presence of men. Such practices encouraged groaning, shouting, fainting, and other indecorous behavior that threatened the socially respectable tradition of revivalism that New England Congregationalists had been forging since the start of the Second Great Awakening. More important, the New Englanders feared that the practices of Finney and his new measures followers—like the emotional excesses of Davenport, Gilbert Tennent, and the enthusiasts of the colonial Awakening—would benefit the liberal, anti-revival cause.

At New Lebanon, New York, in the summer of 1827, Lyman Beecher, Asahel Nettleton, and other moderate revivalists from New England and New York appealed to Finney and his "western" supporters to temper their revival practices and to restrain the "disorderly" social behavior that new measures encouraged. Finney and his supporters, emboldened by success, remained resolutely committed to their brand of revivalism. In the aftermath of the New Lebanon conference, Beecher and Nettleton published their sharply critical *Letters . . . on the "New Measures" in Conducting Revivals of Religion* (1828).[9]

Again, most of the foregoing is well known, as is the fact that Finney represented the birth of "modern" revivalism—a recognition of the human role in "getting up" a revival. What has not received adequate attention is the way in which Finney's new measures inaugurated a major cultural debate over and a creative historical search for an *American* revival *tradition*.[10] The memory of the colonial Awakening provided a major historical arena for this debate over religious tradition. The revivalistic conflicts, personalities, and images of the 1820s and 1830s renewed the social memory of the First Great Awakening. Evangelicals and Uni-

tarians turned to the past to understand and resolve the religious controversies of the present. This appeal to the authority of the past, however, only produced competing social memories of the Awakening that mirrored and reinforced the conflicts of the present.

Finney and his evangelical opponents contended for the right to don the historical mantle of Jonathan Edwards and colonial revivalism. To combat Finney, the New Englanders invoked the memory and the authority of an Edwards who embodied temperate, judicious revivalism. Unitarians also summoned Edwards but usually in conjunction with an appeal to the authority of his major eighteenth-century rationalist foe, Charles Chauncy. In fact, New England Unitarians saw the rise of Finney, new measures, and evangelical contention over revivalism as a recurrence of the enthusiasm and divisiveness that Davenport, Tennent, and others had provoked in 1741 and 1742 and that had fostered the growth of rational, proto-Unitarian religion in New England. Following a historical script that they saw originating with Chauncy, Unitarians worked to publicize evangelical emotional incontinence and disputation to the benefit of rational religion.

A month after the New Lebanon conference in the summer of 1827, the Unitarian *Christian Examiner and Theological Review* published the complete minutes of the gathering with sarcastic comments. The motions introduced at the conference "were only concealed attacks of the two parties upon each other," the *Examiner* observed. "And all this was mixed up with 'seasons of prayer,' 'interspersed with singing,' and preceded by a VOTE!" From the late 1820s through the decade of the 1830s, the *Examiner* and other Unitarian journals sustained a running critical commentary on both specific evangelical excesses and the "revival system" in general.[11]

James Walker, minister in Charlestown, editor of the *Christian Examiner* between 1831 and 1839, and subsequently professor of moral philosophy at Harvard as well as president of the university, emerged as the most intelligent and combative Unitarian antagonist of the evangelicals. If Edwards, Whitefield, and Davenport cast historical shadows over the evangelical parties, a recollection of Charles Chauncy informed Walker's aggressive response to moderate and new measures revivalists and to the issues raised by the Second Great Awakening. As evangelicals quoted chapter and verse from Edwards and republished the great revivalist's writings with commentaries designed either to legitimate or repudiate new measures, so, too, Walker appealed to Chauncy and endeavored to

undermine the evangelicals' invocation of historical authority. Thus reconstructions of the past reproduced and gave intellectual shape to the religious conflicts of the present. Clearly, Unitarians as well as evangelicals viewed the controversies of the Second Great Awakening through the lens of social memory—in terms of the images, personalities, and conflicts of the colonial Awakening that pervaded nineteenth-century religious discourse about American revivalism.

In a lengthy article published in the *Christian Examiner* in 1827, entitled "The Revival under Whitefield," Walker not only quoted extensively from Chauncy's famous response to Edwards at the height of the colonial Awakening; he assumed Chauncy's persona as the public defender of rational religion against new historical incarnations of the spirit of Davenport, Whitefield, and Tennent. The history of the colonial Awakening provided a forum for a rational, "less prejudice[d]" examination of the emotionally charged, divisive issues that the revivalism of the 1820s aroused, Walker claimed. Yet contemporary conflicts over revivalism and the competing social memories of the colonial Awakening to which they became attached only produced divergent reconstructions of the past.[12]

Walker's analysis, for example, suggested that the Second Great Awakening was in the process of unfolding as a historical rerun of the First, with the same contrived origins, the same failed promise, and the same opportunities for proponents of rational religion on the one hand and for "nothingarians" on the other. Walker's retrospection made no distinction between the modern revivalism and democratized Calvinism of the Second Great Awakening and the Edwardsian revivalism and hyper-Calvinism of the First. The colonial Awakening, like the contemporary revival, originated in orthodox alarm over the growth of rational religion, the proto-Unitarian Arminianism and Arianism of mid-eighteenth-century New England. Unable to "Meet the supposed errors in discussion and by fair argument" because their experience "taught them that Calvinism seldom throve by such means," the orthodox resorted to "popular enthusiasm" to shore up a doctrinal system whose intellectual authority had eroded all around them.[13]

Such revivalistic enthusiasm, far from being "naturally inspired by the circumstances or the subject," was aroused "by artificial means, and so directed and controlled, by its contrivers and managers, that it might answer their purposes."[14] Thus, rather than movements that evinced spiritual renewal and religious vitality, both the colonial Awakening and its nineteenth-century successor were symptoms of intellectual infirmity, of

Edwardsians, Unitarians, and the Great Awakening

an orthodoxy entering its dotage. For Walker, then, revivalism was little more than the periodic outburst of contrived popular enthusiasm that not only would fail to stop the progress of enlightened rational religion but would contribute to its growth. Walker's memory of the colonial Awakening supported his confidence.

For what the rise of Davenport in the eighteenth century and Finney in the nineteenth disclosed to Walker was that, once passions became "excited inordinately," it was as difficult to manage them "as to control the storms when they are wildest."[15] In Walker's view, the appearance of Davenport and Finney marked an identical historical movement: the point at which revivalistic religion inevitably degenerated into "animal passions," into popular enthusiasm unleavened by the understanding. Walker recalled the fate of the distinguished Jonathan Edwards to show the destructive consequences of religious enthusiasm, even to those who had "gotten up" a revival and labored to control it.

Walker's recollection of the great man of the colonial Awakening appeared in the midst of a cultural revival of Edwards's authority in America. On a theological level, the Second Great Awakening produced a shift away from Edwardsian Calvinism toward an arminianized doctrinal system more compatible with nineteenth-century democratic intellectual currents.[16] But the popular piety of the Second Great Awakening led to the recovery of another, more important side of Edwards's legacy. The brilliant theologian came to be recognized as a man of remarkable, even saintly piety; his private writings were exhumed and became sacred public property that furnished a model of genuine evangelical spirituality for participants in the Second Great Awakening. Moreover, as the "father" of the colonial Awakening, Edwards was resurrected as the American authority on individual conversion and mass revivalism. Nineteenth-century evangelicals enshrined Edwards as the most distinguished eighteenth-century founding father of America's righteous empire, and they inundated the young republic with redactions of his works on popular piety: *Some Thoughts Concerning the Revival of Religion in New England*; *Religious Affections*; the *Personal Narrative*; "Resolutions for Moral and Spiritual Development"; and the *Life of David Brainerd*. Thus, the Second Great Awakening produced a new Edwardsian structure of authority that the competing evangelical parties in the dispute over new measures revivalism appealed to for historical legitimation of their positions.[17]

Walker introduced the Unitarians into this historical debate, summoned Charles Chauncy to his side, and attempted to subvert Edwards's

new cultural authority in evangelical America. Walker conceded that Edwards was an impressive historical figure—a man of "great piety" who displayed a "strong natural turn for metaphysical investigation" and who "was as remarkable for his abilities in managing a revival, as in getting it up in the first instance." Perhaps no other minister, Walker concluded, "ever possessed so much influence over his people in time of a revival, and . . . none on the whole, ever exerted it with more judgment and discretion" than Edwards.[18] And yet the revivalistic message, even in the hands of such a saintly, skilled preacher as Edwards, was based on a psychology that violated the symmetry of human nature. The appeal to the lower, natural, affective side of worshippers excited enthusiasm and false expressions of piety that even the great Edwards could not control.

Consider, Walker stressed, how the history of Northampton after the Awakening established the wisdom of Chauncy's courageous dissent from the popular enthusiasm of the colonial Awakening. More than any other community in eighteenth-century America Northampton had supposedly been purified repeatedly by the fires of revivalism kindled by the "most reknowned" preacher of the era. One might expect, then, that the town "long continued the abode of peace and virtue, so that in all after time, if any one durst lisp a syllable against revivals, men might say, 'Look at Northampton.'" Instead, within months of the decline of the revival the town was embarrassed by an obscene book episode involving children of some of the most prominent families in the First Church. Edwards's handling of the incident became the first in a series of divisive issues that pitted the membership against the distinguished revivalist and "that were a scandal to the whole country."[19] The church that had witnessed the birth of the Great Awakening in New England dismissed the "father" of American revivalism in 1750. The historical lesson for the moderate evangelicals of the Second Great Awakening was clear: if such a distinguished revivalist and student of the religious affections as Edwards could not prevent false piety and religious enthusiasm from corrupting his own church, could lesser men a century later contain the destructive consequences of the new generation of Davenports who had invaded America's churches?

Walker's account of the colonial Awakening suggested another historical lesson for contemporaries. Popular religious enthusiasm not only produced the kind of false piety that victimized Edwards; it also promoted the growth of Arminianism and Arianism, the proto-Unitarian heresies that revivalistic religion was supposed to arrest.[20] Indeed, if an-

tebellum evangelicals looked back to the era of the colonial Awakening for the historical roots—the cultural authority comprising myths, symbols, images, sacred texts, and heroic pioneers—of America's righteous empire of the spirit, so too nineteenth-century Unitarians fashioned a competing memory, even mythology of their own past which located the formative events and personalities of their movement in the era of the First Great Awakening. Walker encouraged fellow Unitarians to look to the past for an understanding of the present and for confidence about the future.

Unitarian commentary on revivalism down to 1840, the centennial of the start of the colonial Awakening in New England, testifies to the way Walker's early and forceful response to new measures framed the Unitarians' interpretation of contemporary and past religious developments. In the pages of the *Christian Examiner* and the *Unitarian Advocate* as well as in works devoted to revivalism, Unitarians invoked the memory of the colonial Awakening as part of their zealous critique of religious zeal.[21] Extending Walker's analysis, Unitarian commentary focused on three historical points concerning American revivalism. First, Unitarians argued that new measures were, in fact, not new and that moderate revivalists were historically misinformed if they believed that they could control and contain the "brooding *incubus* of a Revival" which would inevitably lead to an orgy of enthusiasm.[22] Second, pursuing Walker's analysis, Unitarians recalled the era of the Great Awakening as the turning point in the growth of rational religion in New England. After all, Unitarians recollected, the father of the colonial Awakening offered eloquent testimony to the shattered promise of revivalism and its stimulus to rational religion. In his *Farewell Address* delivered in 1750, Edwards warned his Northampton congregation of the spread of Arminianism and proto-Unitarianism since revival ardor had waned in 1743: "These doctrines at this day are much more prevalent than they were then; the progress they have made in the land, within this seven years, seems to have been vastly greater than at any time in like space before."[23]

Finally, Unitarians followed Walker in stressing the continuity between the First and Second Great Awakenings while at the same time singling out Edwards for modest praise that separated him from the "uncouth" horde of itinerants who dominated American revivalism. In particular, Unitarians recalled that Edwardsian revivalism was erected on an admirable if too radically self-denying ethic of disinterested benevolence. The liberals did not uncritically endorse the Edwardsian doctrine of disinter-

ested benevolence because it rejected the idea of "laudable self-love." Yet they saw much that was praiseworthy in Edwardsianism when they contrasted it with "methodistical" revivalism of Whitefield, Davenport, and the Second Great Awakeners who displayed "excessive vanity" and who appealed to the "selfishness" (the "inordinate self-love") of their converts. Far more than Edwards, Unitarians reflected, Whitefield bore the responsibility for the likes of James Davenport and for the birth in America of the "methodistical" revivalism that prevailed in the Second Great Awakening. Like Finney and his unlettered disciples, Whitefield's heart religion was not tempered by "learning" and adequate "preparation for the ministry"; consequently, his preaching "often grossly violated providence and decorum." Moreover, the protracted camp meetings of the nineteenth century descended from Whitefield's "field preaching," which encouraged the now familiar "promiscuous assembling" of people and a "violent, rudely passionate style of oratory."[24]

By contrasting the disinterested benevolence of Edwards with the "selfish character" of the repentance Whitefield encouraged, Unitarians fashioned a memory of the colonial Awakening that linked it to Finney and the methodistical revivalism of the 1820s and 1830s. At the same time the Unitarians' memory of the colonial revival and their interpretation of contemporary evangelical religion relegated Edwards's moderate brand of revivalism to a subordinate historical position. Edwardsian revivalism rested on a challenging ethic of disinterested benevolence which was antithetical to the self-centered popular enthusiasm that reigned in America from the First to the Second Great Awakening. Whitefield was responsible, William Henry Channing complained in the *Christian Examiner*, for directing American piety toward "a selfish pursuit of salvation . . . , instead of the love of absolute goodness and the utter surrender of private interests to universal well-being, in which the higher views of Edwards, when followed out to their just consequences, would have terminated."[25]

Similarly, the distinguished Unitarians William Ellery Channing and George Bancroft recalled with admiration the Edwardsian commitment to disinterested benevolence, if not the revivalistic means of attaining that ethical goal. Channing, for example, expressed his esteem for Samuel Hopkins, Edwards's closest friend and devoted disciple, who formulated the most radical interpretation of disinterested benevolence. While Channing could not accept aspects of Edwardsian and neo-Edwardsian ethical thought, he was "not . . . ashamed to confess the

Edwardsians, Unitarians, and the Great Awakening

deep impression, which this [Hopkinsian] system [of benevolence] made on my youthful mind." Channing credited Hopkins with "turning my thoughts and heart to the claims and majesty of impartial, universal benevolence."[26] Yet, Unitarians reflected, Edwardsian ethics failed to restrain the self-indulgent popular enthusiasms of American revivalism.

Unitarian recollection of the history of American revivalism complicated the efforts of moderate evangelicals such as Lyman Beecher to invoke the authority of Edwards and the legacy of the colonial Awakening to counteract new-measures revivalism. By tracing a line of methodistical enthusiasm that connected the First and Second Great Awakenings, by recalling Edwards's failure to curb the intemperance of the colonial revival, and by lamenting the demise of disinterested benevolence, Walker and his fellow Unitarians attempted to dismantle the new structure of Edwardsian authority which was one of the most important cultural creations of the Second Great Awakening. New England's moderate Edwardsians were forced to confront not only the ghost of James Davenport in Charles Grandison Finney, but also a historical reincarnation of Charles Chauncy in the intellectually combative James Walker.

At the height of the Second Great Awakening, during the late 1820s and early 1830s, Walker and the *Christian Examiner* aroused a new pugnaciousness in Lyman Beecher and his orthodox supporters in New England, who established a Unitarian-baiting organ in Boston—*The Spirit of the Pilgrims*. For several years, New England Edwardsians had been discussing the need for a monthly publication in Boston that would challenge Unitarian "misrepresentation" of orthodox doctrine. The dispute over new measures and the rise of a Unitarian critique of orthodox revivalism pressured Beecher and the New Englanders into action. Within months of the publication in the *Christian Examiner* of the minutes of the New Lebanon conference and of Walker's lengthy analysis of the colonial Awakening, Lyman Beecher was positioned to wage his paper war against the Unitarians of eastern Massachusetts. *The Spirit of the Pilgrims* began publication in 1828, committed to exposing how "a large portion of the community has been totally deceived [by the Unitarians] in regard to the doctrines and preaching of the orthodox."[27]

Starting with its inaugural issue, *The Spirit of the Pilgrims* returned to the mid-eighteenth century to rescue the history of religion, and particularly of revivalism, in New England from Unitarian "deceptions." While the *Christian Examiner* impeached Edwards's authority on reviv-

alism, *The Spirit of the Pilgrims* hammered away at the Unitarians' invocation of their historical authorities from the era of the colonial Awakening. "The names of Chauncy and Elliot, of Mayhew, Howard, and Thatcher, and of many of their contemporaries," *The Spirit of the Pilgrims* protested, "are highly honored as belonging to those who it is said were *liberal*, in the modern sense of the term, and cherished almost the identical faith of those who now minister to the same congregations." But the anonymous writer took pains to point out that mid-eighteenth-century liberals, some of whom initially supported the Awakening, "taught and enforced many of the essential doctrines of the Gospel," and were thus far more theologically orthodox than the nineteenth-century liberals.[28]

Moreover, the eighteenth-century religious liberals were closer to the New England "spirit of the pilgrims" than to their nineteenth-century rationalist descendants in other ways, the orthodox writer suggested. When the Unitarians ridiculed nineteenth-century revivalists as "judges of religious purity and decorum [who] seem not to have learnt the morality of washing their faces,"[29] *The Spirit of the Pilgrims* responded caustically with its own caricature of a modern liberal minister who inhabited a different social world from Chauncy, Mayhew, and the other "fathers" of rational religion in New England:

> A young man of popular talents, pleasing address, and Chesterfieldian politeness, becoming a candidate for the Gospel ministry, has, in many places, *no need of piety, no need of particular respect for religion. Piety would rather injure than assist him. He must write, speak, converse, and bow handsomely, make himself agreeable, tell of his charity, rail at Orthodoxy, dine with Herod, praise his wine, admire his situation. . . . He will soon be settled handsomely.*[30]

Similar, populist rhetoric, which echoed the danger of an unconverted ministry theme that was so central to the colonial Awakening, was often used by new measures revivalists against their orthodox opponents. *The Spirit of the Pilgrims* attempted to redirect such a populist critique of the ministry toward the Unitarians as part of a larger campaign to use the threat of a common enemy to encourage evangelicals to close ranks.

For what haunted Beecher's memory of the colonial Awakening was the recollection of how the enthusiasm of the early 1740s produced a liberal-moderate coalition against the revival that helped devitalize the New Light cause and prepare the way for the propagation of proto-Unitarian rational religion in New England. With the founding of *The*

Spirit of the Pilgrims Beecher sought to avoid a repetition of history—to prevent the rationalists from exploiting a new strain of enthusiasm to discredit evangelical religion. Consider Beecher's response to *Letters of an English Traveller to his Friend in England, on the "Revivals of Religion," in America*, the first in a series of anti-revival Unitarian tracts published in New England in the late 1820s and early 1830s.[31]

Orville Dewey, Unitarian minister in New Bedford, Massachusetts, and author of the *Letters*, assumed the anonymous but familiar guise of an urbane foreign traveler-observer of the American scene and produced an anti-revival volume that the *Christian Examiner* compared favorably to Charles Chauncy's captious commentaries on the colonial Awakening.[32] The "English traveller" characterized American revivalism as a "colloquial exhibition," an expression of the young nation's provincialism. Only in America, "the English traveller" observed, were revivals "brought into a system and plan, as much as the religion itself—a system of operations as much as its theology is [brought] into a system of speculations." Such a system encouraged a state of religious affairs in which "those who exhort and pray publicly among the laity, far outnumber those who *are considered* as regularly ordained." Far from embodying universal spirituality, American revivalism was a provincial religious system that worked "to fasten the yoke of religious timidity and subservience on the mass of the people."[33]

In a lengthy review in *The Spirit of the Pilgrims*, Beecher assailed the fictitious English traveler and his Unitarian supporters for their campaign of distortion and deceit. Both the *Letters* and James Walker's earlier essay on the colonial Awakening reminded Beecher of how "Dr. Chauncy and his coadjutors" had attacked Edwardsian revivalism with "sneers, reproaches, malicious insinuations, and slanderous reports."[34] Beecher responded with letters of his own. In 1829 *The Spirit of the Pilgrims* launched a new series, *Letters on the Introduction and Progress of Unitarianism in New England*, which offered an orthodox reading of the region's religious history, and particularly of its revivalistic tradition, to counter the rationalists' version.[35]

While Beecher returned to the mid-seventeenth century to locate the origins of New England's "declension" from the religion of its pilgrim founders, he focused on the era of the Great Awakening as the critical period in the religious evolution of the region. Thus he added a new dimension to New England's familiar filiopietism, linking the spiritual pioneers of the eighteenth-century revival to the founding fathers of the

Joseph Conforti

city on a hill. On the eve of the Awakening, New England had not yet witnessed a "general and open dissent" from the founders' orthodoxy. But the preconditions for such a defection were well established. "The clergy were, for the most part," Beecher argued, "grave men reputedly, speculatively, moderately Orthodox, and regularly maintained the forms of religion; but who, in some instances, had well nigh lost the spirit of religion, and in others, it may be feared, had never felt it."[36]

The Great Awakening amounted to nothing less than a powerful re-vitalization of the spirit of the pilgrims after decades of religious declension. Like other evangelicals Beecher offered a "great man theory" of the colonial Awakening that reflected the nineteenth-century confidence in the role of human agency in revivalism. In fact, at no time before or after the late 1820s and 1830s did Jonathan Edwards, the "great" revivalist of the colonial Awakening, bulk so large in evangelical memory and histor-ical imagination. For Beecher and other nineteenth-century evangelicals, Edwards ignited the colonial revival single-handedly, fanned its flames with the assistance of the likes of George Whitefield and Gilbert Tennent, and labored—though not always successfully—to prevent it from raging out of control. Beecher spoke for many other Second Great Awakeners in assessing the accomplishments of a heroic Edwardsian generation: "most that is at present desirable in the religious aspect of things among us may be directly traced to the influence of men who were trained and instructed in the revival of 1740."[37]

Yet the colonial Awakening also aroused proto-Unitarians: and even the great Edwards, Beecher admitted, was unable to subdue intractable Arminian opposition to the revival. The "grave men" of the cloth knew "that if this was religion, they had none of it." Consequently, many of them chose "to condemn and oppose the revival, as mere frenzy and delusion."[38]

Furthermore, some friends of the revival were guilty of excesses that invited proto-Unitarian opposition to the Awakening but that did not invalidate its spiritual authenticity. In responding to Walker and the *Christian Examiner*, *The Spirit of the Pilgrims* increasingly resonated with the century-old Edwards–Chauncy debate over the colonial Awakening. Beecher adopted the historical judgment of the "judicious Edwards." Drawing on Edwards's *Some Thoughts Concerning the Present Revival of Religion in New England*, Beecher asserted that the colonial Awakening— like the revival currently surging around him—"was undoubtedly a great and glorious work of God's Holy Spirit, commenced in the midst

of deep declension, and prevailing for a season with much power, and with best effects." Yet, as a result of the "unreasonable opposition of unholy men, and the delusions of Satan, and the errors of those who were thinking to promote it," the revival became "corrupted and defaced, and liable in many points to objection and censure."[39]

Charles Chauncy, the founding father of rational religion in New England to nineteenth-century Unitarians, became for Beecher the *bête noire* of the colonial Awakening. "Perhaps no individual," Beecher fumed, "did so much to transform and deface the religious character of Boston and the surrounding region, as this man." Through "cunning" and "artful methods," which Beecher saw Walker, Dewey, and other Unitarian contemporaries duplicating, Chauncy and his assistants aroused prejudice against New Light religion of the heart and prepared the way for the Arminian, Pelagian, and ultimately Unitarian defection of the eastern Massachusetts religious establishment.[40]

While Beecher joined the Unitarians in returning to the eighteenth century for ammunition to fight the religious paper war of the nineteenth, he also invoked Edwards and the historical and cultural authority of the colonial Awakening against Finney. Beecher and the moderates who had argued with Finney in New Lebanon sought to use the Unitarian menace and the memory of the First Great Awakening as the basis for reestablishing an evangelical consensus on revivalism. One moderate, the Reverend Silas Aiken of Utica, New York, reported to Beecher in 1827 that the controversial Finney had begun to modify his practices. "I apprehend that reading those very quotations which you make from Edwards on Revivals was the means of his reformation," Aiken observed. "Until he came to my house (at Utica) he had never read the book, and here it was frequently in his hands during the revival; also other volumes of the great writer; and he often spoke of them with rapture."[41]

In 1831 Beecher invited Finney to Boston to contend with the Unitarians, claiming that the revivalist had moderated his controversial practices. The extent to which Finney actually did so is debatable. Yet it seems clear that the memory of the colonial Awakening helped shape the pronouncements and behavior of Finney, Beecher, and other prominent participants in the nineteenth-century revival. And the same might be said for the Unitarian critics of the Second Great Awakening. Walker, Dewey, and other Unitarians recalled the colonial Awakening as the formative period for rational religion in New England. They observed

Joseph Conforti

the new eruption of evangelical enthusiasm with the expectation (perhaps an over-confident expectation) that, in the words of William Henry Channing, "zealous brethren served at least the end of a prairie-fire of burning up dry grass and fertilizing the ground with ashes for a fresher growth."[42]

But it was precisely because Unitarians and Edwardsians cultivated vivid memories of the colonial revival's effects that the Second Great Awakening would not follow the script of the First, would not unfold as a historical rerun. Well before Joseph Tracy published the first comprehensive history of the Great Awakening in 1842, the liberals and the orthodox had come to recognize the revival as a seminal event and had invested it with enormous historical and cultural authority.[43] Nineteenth-century religious controversialists transformed the Great Awakening's place in American historical consciousness from individual memory to social memory to full-fledged, if partisan, interpretation of a heroic past. In the process they allowed the Awakening's interpretive authority to influence the present.

Perhaps the Unitarian's preoccupation with the "enthusiasm" that American heart religion from Edwards to Finney stimulated led them to violate their balanced religious psychology and recognition of the symmetry of human nature. By the 1850s, when a new revival appeared on the American landscape, some Unitarians had followed the pietistic strain in their movement into the evangelical camp.[44] Other disaffected Unitarians had already found an outlet in Emersonian Transcendentalism. One Unitarian claimed at mid-century that, after the liberals had created "a Gospel without a Holy Ghost," it was almost inevitable that an Emerson would appear in New England.[45]

In his famous essay, "From Edwards to Emerson," Perry Miller argued for a direct connection between the two great New Englanders. He quickly and wisely repudiated his line of interpretation.[46] Yet an analysis of the memory of the Great Awakening and of its interpretive authority in the nineteenth century suggests possibilities for a reassessment of direct and indirect links between Edwards and the *age* of Emerson.

Notes

1. Alan Heimert, *Religion and the American Mind: From the Great Awakening to the Revolution* (Cambridge, Mass., 1966), 483.
2. Edward T. Channing, "Philip's *Life and Times of George Whitefield*," *North American Review*, 48:479 (1839).

3. For a good analysis of the role of social memory in the reconstruction of New England's religious past, see David M. Scobey, "Revising the Errand: New England's Ways and the Puritan Sense of the Past," *William and Mary Quarterly* 41:3–31 (1984).

4. Joseph A. Conforti, *Samuel Hopkins and the New Divinity Movement* (Grand Rapids, 1981), ch. 11; Conforti, "Joseph Bellamy and the New Divinity Movement," *New England Historical and Genealogical Register* 137:126–138 (1983); Charles Roy Keller, *The Second Great Awakening in Connecticut* (New Haven, 1942); and Richard D. Shiels, "The Second Great Awakening in Connecticut: Critique of an Interpretation," *Church History* 49:401–415 (1980).

5. My use of the term Edwardsian does not refer simply to New Divinity men. Rather, the label also embraces Congregationalists and Presbyterians who rejected key elements of Edwards's high Calvinism but who admired the pietistic and revivalistic side of Edwards and who reprinted his evangelical writings and invoked his authority on popular piety. See Joseph Conforti, "Jonathan Edwards' Most Popular Work: *The Life of David Brainerd* and Nineteenth-Century Evangelical Culture," *Church History* 54:188–201 (1985); and Conforti, "Nineteenth-Century Evangelicals and the Cultural Revival of Jonathan Edwards," *Journal of Presbyterian History* 64:227–241 (1986).

6. See, for example, "Life and Character of Jonathan Edwards," *Connecticut Evangelical Magazine and Religious Intelligencer* 2nd ser. 1:165–166 (1808); Benjamin Trumbull, *A Complete History of Connecticut . . .* (1817–1818; rpt. New London, Conn., 1898), 2:103, 123–125, 193, 201, 219.

7. Daniel Walker Howe, *The Unitarian Conscience: Harvard Moral Philosophy, 1805–1861* (Cambridge, Mass., 1970), 160–161. See also William Henry Channing, "Edwards and the Revivalists," *Christian Examiner* 43:387 (1847).

8. Howe, *Unitarian Conscience*, 163–164; Perry Miller, *The Life of the Mind in America: From the Revolution to the Civil War* (New York, 1965), 10–20.

9. The best account of the rise of Finney and the moderate evangelicals' response remains William G. McLoughlin, *Modern Revivalism* (New York, 1959), ch. 1.

10. For a helpful work that does pay some attention to this cultural debate, see Donald Weber, "The Image of Jonathan Edwards in American Culture" (Ph.D. diss., Columbia Univ., 1978), ch. 3.

11. "Revivals," *Christian Examiner* 4:357–358 (1827). See also, for example, [James Walker], "The Oneida and Troy Revivals," ibid., 242–265; [Walker], "Dissentions Among the Revivalists," ibid., 6:101–130 (1829); John Brazier, "Essay on the Doctrine of Divine Influences," ibid. 18:50–84 (1835); ". . . Means of Grace," *The Unitarian Advocate* 3:241–254 (1831); and "Fatal Consequences of Recent Measures," ibid., 5:114–120 (1832).

12. [James Walker], "The Revival under Whitefield," *Christian Examiner* 4:465 (1827).

13. Ibid., 480.

14. Ibid., 480–481.

15. Ibid., 471.

16. See William G. McLoughlin, *Revivals, Awakenings, and Reform* (Chicago, 1978), ch. 3.

17. Conforti, "Antebellum Evangelicals," 235–237. See also Thomas H. Johnson, *The Printed Writings of Jonathan Edwards, 1703–1758: A Bibliography* (Prince-

Joseph Conforti

ton, 1940); and Mark A. Noll, "Jonathan Edwards and Nineteenth-Century Theology," paper presented at the conference "Jonathan Edwards and the American Experience," Wheaton College, October 24–26, 1984.

18. Walker, "The Revival under Whitefield," 468–469.

19. Ibid., 490–491.

20. Ibid., 495.

21. See, for example, Ezra S. Gannett, *A Comparison of the Good and Evil of Revivals* (Boston, 1831); Bernard Whitman, *A Letter to an Orthodox Minister on Revivals of Religion* (Boston, 1831); "A Glance at the Past and Present State of Ecclesiastical Affairs in Massachusetts . . . ," *Unitarian Advocate* 3:27–34 (1831); "Recollections and Remarks of an Aged Clergyman . . . , ibid. (March 1831), 128–132; and also see n. 11 above.

22. [Orville Dewey], *Letters of an English Traveller to his Friend in England, on the "Revivals of Religion," in America* (Boston, 1828), 120.

23. Edwards, "Farewell Address," *Works*, (New York, 1843), 3:79–80; "A Glance at the Past and Present State of Affairs in Massachusetts . . . ," 29–30; "Recollections and Remarks of an Aged Clergyman . . . ," 129–131.

24. Walker, "The Revival under Whitefield," 472–483; Channing, "George Whitefield," 485, 493; [Channing], "Edwards and the Revivalists," 387–389.

25. [Channing], "Edwards and the Revivalists," 388.

26. William Ellery Channing, quoted in Edwards A. Park, *Memoir of the Life and Character of the Reverend Samuel Hopkins* (Boston, 1852) 211–212; see also [Channing], "Remarks on National Literature," *Christian Examiner* 7:269–295 (1830). For Bancroft's views of Edwards, see his *History of the United States* (Boston, 1838), 4:155–158; and Bancroft, "Jonathan Edwards," in *The New American Cyclopaedia* (New York, 1859), 7:11–20.

27. *The Autobiography of Lyman Beecher*, ed. Barbara M. Cross, (Cambridge, Mass., 1961) 2:92. *Spirit of the Pilgrims* 1:1–20 (1828).

28. "Sentiments of Ministers Formerly Settled in and Around Boston," *Spirit of the Pilgrims* 3:652–664 (1830).

29. [Dewey], *Letters of an English Traveller*, 116.

30. Quoted in "Letter to the Editor," *Unitarian Advocate* 2:112 (1828). See also [Beecher], "Review of *Letters of an English Traveller*," *Spirit of the Pilgrims* 1:248–266 (1828).

31. In addition to Dewey's *Letters*, see Gannett, *A Comparison of the Good and Evil of Revivals*; Whitman, *A Letter to an Orthodox Minister*; Jonathan Farr, *On Revivals* (Boston, 1831); and Farr, *"These Four Days Meeting": What are they for? And what will be the Cost and Fruit of them?* (n.p., 1831).

32. *Christian Examiner* 5:88 (1828).

33. [Dewey], *Letters of an English Traveller*, 1–2, 120.

34. [Beecher], "Review of *Letters of an English Traveller*," 248–266; [Beecher], "Letters on the Introduction and Progress of Unitarianism in New England," *Spirit of the Pilgrims* 2:181 (1828).

35. The series began in 1829 and continued into 1831. Another series reinforced many of Beecher's historical arguments. See Ebenezer Porter, "Letters on Revivals," *Spirit of the Pilgrims* 5 and 6:(1832–1833).

36. [Beecher], "Letters," *Spirit of the Pilgrims* 2:122 (1829).

37. Ibid.; see also [Noah Porter], "President Edwards on Revivals," *Christian Spectator* 1:295–308 (1827); Porter, "Review of the Works of President Edwards," ibid., 3:337–357 (1831); and Conforti, "Antebellum Evangelicals," 235–237.

38. "Letters," *Spirit of the Pilgrims* 2:124–128. Beecher and other moderate evangelicals reprinted and invoked Edwards's *Some Thoughts* against both the Unitarians and Finney. See, for example, Charles Spaulding, *Edwards on Revivals* (New York, 1832); and Johnson, *Printed Writings of Jonathan Edwards*, 31.

39. "Letters," *Spirit of the Pilgrims* 2:127, 181 (1829).

40. Ibid.

41. Cross, ed., *Autobiography of Lyman Beecher*, 2:67–68. See also William B. Sprague, *Lectures on Revivals* (Albany, 1832).

42. Channing, "Edwards and the Revivalists," 391.

43. Joseph Tracy, *The Great Awakening: A History of the Revival of Religion in the Time of Edwards and Whitefield* (Boston, 1842).

44. See Timothy L. Smith's chapter "Evangelical Unitarianism," in *Revivalism and Social Reform: American Protestantism on the Eve of the Civil War* (1957; rpt. New York, 1965), 95–102.

45. Rufus Ellis, quoted in ibid., 98.

46. Perry Miller, "From Edwards to Emerson," in *Errand into the Wilderness* (Cambridge, Mass., 1956), 184–203.

Joseph Conforti

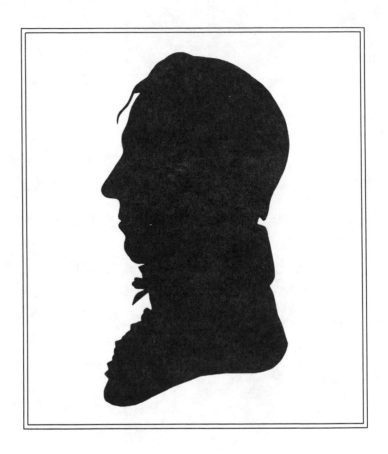

Andrews Norton (1786–1853). Hollow-cut silhouette by an
unidentified artist, n.d. Gift of Miss Elizabeth Norton, 1948.
Collection of the Massachusetts Historical Society.

Babylon est delenda—
the Young Andrews Norton

☙

LILIAN HANDLIN

In March 1819 militant Andrews Norton declared that "orthodoxy must be broken down. . . . Our motto must be Babylon est delenda."[1] The identification of orthodoxy with Babylon, mother of harlots, abominations, demons, and wantonness, captured the young man's mood. Thirty years later, a very different man assessed the results. In 1849 trinitarianism as an issue was dead, and Norton wanted to know why liberal Christianity, from his perspective, was, too. With the 20/20 vision that comes from hindsight, he blamed liberalism and orthodoxy for an outcome that benefited neither. In the clash between them a movement became first a sect, later a party, and by 1849 the repository of all the world's religious trash. It seemed that at a crucial time, monumental mistakes were made. That time lay between 1810 and 1823.[2]

This essay examines Norton's conception of liberalism in that period to understand his combative militancy, which, though occasionally mentioned, is rarely explained. The nature of that militancy and its unacceptability to leading coreligionists fleshes out additional facets of the battle with orthodoxy, and it provides the background for the ordeal of the young Andrews Norton.[3] The essay also attempts to correct the cari-

Lilian Handlin is the author of *George Bancroft: The Intellectual as Democrat.*

cature of Norton, the representative of a by now outdated tradition cast aside in the evolution of the American creed, its positive features identified with a liberal agenda traceable in part to William Ellery Channing. The young reformer emerges, in fact, as a most perceptive early critic of that agenda who exposed, in the course of a religious dispute, the shortcomings of a lemming mentality that forfeited the battle to orthodoxy.

Andrews Norton descended from ancestors who believed that "all of the Church were a royal Priesthood, all of them prophets and taught of God's spirit." By the year of his birth, 1786, Hingham, Massachusetts, was light years away from John Norton's dogmas, and Henry Ware, Sr., stood in the pulpit; but the sense of chosenness and duty, which meshed personal and public concerns, prophecy and mission, lingered. The boy's formative years passed in the shadow of the pious and caring shopkeeper Samuel Norton, whose relaxed faith spared his son the need to divest himself of Calvinism. Andrews's experience in this regard differed from that of his friends like Joseph Stevens Buckminster, Levi Frisbie, and John Farrar, whose liberalism paralleled inner personal conflicts. All three were less radical in their response to orthodoxy and more understanding of the difficulties the latter faced. To Norton, by contrast, Calvinism was an intellectual construct, demolishable by rational alternatives, a source of militancy the others lacked.[4]

Samuel Norton's rational faith meshed easily with Federalist politics and reserved total depravity only for Jeffersonian democrats. Andrews proposed to rewrite the Bill of Rights by replacing "all men are born free and equal" with the declaration that "the greater part of mankind have no other right but a right to be governed." The anti-Federalist minister Joseph Richardson was "a jacobin, a fanatic, a scoundrel and a fool," and thus a great favorite with the people. This attitude toward the masses would also affect the strategy of Norton's activism in ways he as yet did not know. He did know, however, that in a democratic society, aspiring youngsters like himself had to prepare for ostracism in constant warfare against talent and virtue.[5]

Andrews embarked on that warfare at Harvard, where the frail and sickly country boy, already troubled by poor eyesight and bad headaches, compiled a respectable if undistinguished record. Samuel Norton extended money and pious advice, which his son followed as he fretted over his clothes, studies, standing in class, and lack of polish. But in his junior year Andrews's horizons broadened when he joined a circle that

Lilian Handlin

54

included Samuel C. Thacher and Charles Eliot, sharing the taste for literature and the desire to make names for themselves. All three developed a cast of mind shaped by Harvard's moral philosophy, but whereas his friends aimed for the ministry or nurtured desires financeable by parental generosity and seemed untroubled adolescents in an era when the term did not yet exist, Norton was plagued by depressions, deep unhappiness, and great inner turmoil.[6]

He first vented his literary ambitions in the *Literary Miscellany*. The magazine emerged in 1803 against the wishes of the orthodox Professor Eliphalet Pearson, of the "big name, big frame, big voice and beetling brow," who feared an attack on what Jedidiah Morse could see as the product of a proto-illuminati secret society (the Phi Beta Kappa). Among its contributors were Norton's future friends, Levi Hedge, Buckminster, John Lovejoy Abbot, and Thaddeus Mason Harris. Harris encouraged Norton's literary proclivities and the study of oriental languages, arguing that cultural advancement demanded clashing opinions, that scholars needed the marketplace to validate their knowledge and usefulness by immediate action. Since Harris was a gentle minister, his religious liberalism was never transformed into a strident reformist mentality. But for Norton these influential ideas merged easily with his view of life as a struggle carried on by scholar-intellectuals, the new royal priesthood in an age of "peculiar freedom of thought and action," against forces of darkness and "catholicism."[7]

The death of David Tappan, a moderate Calvinist, in August 1803 resurrected stories about his initial appointment to the Hollis chair, a minor dress rehearsal for the struggle over the succession. Norton, however, was preoccupied with the death of President Joseph Willard, because Pearson, acting president until 1806, was less generous with financial aid. The bachelor's degree Norton received in 1804 was not followed by an expected scholarship, and the young man proposed to teach in Nova Scotia, proof to his father that American disrespect for learning and talent forced able young men abroad for a livelihood.

For the next four years Andrews was mired in the first crisis of his young life, the choice of a career, which, given his desires and situation, meant bleak alternatives, as Harris reminded him:

> If to the Church he bend his virtuous care,
> No earthly gains reward his labors there;
> A stinted salary may his needs supply,
> But he must seek his treasure in the sky.

The Young Andrews Norton

55

The rewards of a literary profession were equally meager:

> See HANNAH ADAMS, modest and resigned,
> With artless manners and replenished mind,
> Whose worth and industry should gains insure,
> By study blind, by publishing made poor![8]

Instead of moving to Nova Scotia, however, Norton shuttled between Hingham and Cambridge, preparing for the ministry with Henry Ware, Sr., reading English literature and Rousseau as well as Burton's *Anatomy of Melancholy* to match his mood. A clerical career would do, he thought, if its duties left time for Greek, Latin, French, and Italian, all "absolutely necessary to form a man of letters." Teaching school at Haverhill was fine, except that it was "going out of the way of notice." He knew that, in John Adams's words, "It is not novels or Poetry. It is neither Scott or Lord Byron who make useful men"; but how to be useful remained the question. His diary recorded sad moods: "the past without pleasure and the future without hope." "I sometimes look forward to life with much the same sensations as one rising in a gloomy morning of November looks forward to the day and wishes it were ended." His father reminded him that "our time is short, be up and doing," and that "God established a beautiful economy in nature and thereby taught us to practice in the same circumstances in which he has placed us," an old-fashioned attitude that did not solve Norton's dilemma.[9]

The friendship of Thacher gave Norton entrée to the *Monthly Anthology*, which furthered literary ambitions and journalistic skills and encouraged greater self-confidence. His pieces dealt with the tyranny of opinion and the danger of following beaten paths, perhaps to justify his irresolute drifting. "Example, in fine, makes men monkies, and opinion forms them images of monkies," implied admiration for individuals unhampered by custom. The familiar strictures on the "poisonous atmosphere" of democratic societies led to a blast at that "miserable love of popularity" prevalent in the United States, "which courts the rabble's smile, the rabble's nod, / And makes, like Egypt, every beast its God." An article on the poverty, ignorance, and overwork of the clergy expressed Norton's reservations about joining their ranks and called on those who did to improve their own sad state. But the club members at first rejected his anti-orthodox attack on Samuel Hartley, Joseph Priestley's antagonist. The gingerly made suggestion which questioned the sublimity of Jewish scriptures also encountered resistance from Kirk-

land, Ticknor, and Thacher, who recommended that a disclaimer accompany the passage if printed. The *Anthology* did publish an assault on those who clung to doctrines that were "the inventions of men, . . . not doctrines of Christianity," thus suggesting that the greatest threat to religion stemmed not from Deism but from overzealous Calvinism. By 1809 the young members of the society that sponsored the magazine were ready for bolder moves. But for every step forward, in a reversal of Lenin's dictum, the liberals marched two steps back. The experience was a salutary lesson on the limits of courage and free expression.[10]

In the summer of 1809 Norton received two employment offers, Ware's recommendation to the Augusta pulpit and Levi Hedge's suggestion of an instructorship at Bowdoin in Brunswick. Norton chose the pulpit, where illnesses, stingy parishioners, and local ignorance and bigotry added to his discontent, while quarrels over trinitarianism sharpened his contempt for the Athanasian creed. This violation of common sense forged "in the delirium of folly" led some, by defining preaching as "a plan to support men too lazy to work," to damn all religion. While the rest of the nation was verged on ruin due to Madisonian demagoguery, the backwoods of New England rebelled against Calvinist irrationalities only to find refuge in strange sects fostered by charismatic figures through strategies that mobilized ever-wider circles of people, not all of them the dregs of humanity. This important realization, which informed Norton's response to orthodoxy in a few short years, led him at first to ever more systematic readings in divinity, to outline the meaning of enlightened Christianity and trace its broader ramifications. A substructure was necessary on which the liberals could build, not only because the opposition *Panoplist* said they could have none, and Andover was founded to prove that they did not, but because "corruptions" of any sort (Calvinist, enthusiastic, Hopkinsian, or other kinds) produced "either distress or anxiety or indifference."[11]

For the time being Norton did not work out the wider significance of this conclusion. But the Augusta experience also revealed another unwelcome discovery—his own inadequacy as a clergyman. The enthusiasm for a ministerial career, never great to begin with, gave way to a self-defined vision of the religious reformer that demanded talents other than those that made good preachers. The pen rather than the spoken word would become his instrument of reform. The choice marked Norton as one of those transitional figures in the history of American congregationalism, an activist and organizer who forged new tools of communi-

The Young Andrews Norton

cation to mold public opinion, unhampered by pulpit restrictions. The pattern would prove more acceptable to the orthodox than to the liberals, whose distaste for public slugging matches was famous, another cause of Andrews Norton's ordeal.[12]

Those who could not preach, taught. Norton transferred to Bowdoin, where at least the salary came in on time. Though the life of tutors in the wilds of Maine was potentially more hazardous than at Harvard, relief from parish chores, the friendship of Benjamin Tappan, long conversations with Benjamin Vaughan (friend and defender of Priestley), and peaceful students made his stay agreeable. This further exile, however, only exacerbated longings for Cambridge, where Norton thought (the mistake has been common) "all the wit and good temper . . . all the learned disputes and critical acquisitions, all the pleasant parties" concentrated. By the spring of 1810 not even the rumor that Harvard was about to be saddled with a Democratic board of overseers squinting towards orthodoxy could keep him away. In July he was back, a more articulate, rational Christian. He was after "a literary life," whatever that was, leading the exasperated but ever-patient Samuel to commend his strange son to God and His holy keeping.[13]

A literary life combined a steady Harvard occupation with the editorship of a worthy publication, and fortunately Norton was offered both. The former materialized in a mathematics tutorship, though friends knew that Andrews having "breathed the air of Attica" would not be happy with it. Samuel Norton, tired of subsidies, urged acceptance and the need for an unspotted reputation. Perhaps he already suspected that his son was nursing controversial plans. At the same time Thacher offered Norton the *Anthology* editorship, but his terms proved unacceptable. The collapse of the *Anthology* in June 1811 left liberal New England literati without a publication and gave the new mathematics tutor his chance.[14]

The plan called for a new liberal journal to rally the troops by articulating an agenda of reform based largely on ideas in circulation for years. Sporadic pot shots in the *Anthology* continued the *Literary Miscellany*'s mission "in resisting every species of bigotry and intolerance, especially in religion where our highest interests are involved," paralleled by private feuds of individuals speaking only for themselves. Thacher and Buckminster cautiously legitimized the model of the religious and literary reformer under the slogan that arguments contrary to reason admitted of no belief. Yet the liberals remained a motley group expressing shades of

Lilian Handlin

58

opinion, united in public mainly in their hostility to controversy. Even Thacher emphasized that, appearance notwithstanding, the *Anthology* was not the tool of political or theological factions and apologized for occasional irritants. The flap about the constitution of the Andover Seminary, for example, was not generated by the fact that its supporters were "Hopkinsians . . . [or] Calvinists," but because their "conduct and principles" gratified "the unholy ambition of aspiring heresiarchs." The magazine, he said, had "the faults of youth and young men, we know, are always dogmatical and usually vain." [15]

The fate of the *Anthology* was one lesson Norton pondered—its demise proof that worthy goals sometimes generated no support. "Timid characters," as James Freeman called them, still held center stage, though he for one assumed that people were ready "for more bold and ardent successors." [16] Samuel Norton's stress on respectability and the all-pervasive dislike of open warfare were also factors to consider. The latter, a do-nothing attitude, was an outgrowth of the liberals' vision of the future, which belonged to them, no matter what they did. Given the progressive nature of knowledge and the rosy future of the republic (which even the trials and tribulations of Jeffersonian administrations left intact), the nation's predestined growth in culture and civilization augured well for liberal religion.

Norton's militancy in 1811 stemmed from the belief that this prophesy was fundamentally flawed. It may have been correct in the long run, but in the short haul it left the field to the orthodox, whose tactics made the price of delay, vacillations, and charity very high. Nothing less than a mental breakthrough would do, since what Norton was about to urge on his colleagues was that they divest themselves of long-cherished patterns of behavior in the name of a cause he assumed they all shared. Yet Andrews had neither sufficient income nor enough personal prestige to march where others feared to tread. In 1811 he had behind him an unspectacular preaching career, a few articles, proper opinions, and much self-acquired knowledge. But he was ambitious, and when private feelers encouraged broader vision Norton thought he could solve his own and other people's problems by meeting a need. His would not be the only instance where a born scholar and intellectual misread reality when engaged in activism.

In the next few months the shy and troubled young man acquired a new persona to match his inner needs, an antidote to depressions, self-doubts, and anxiety. "No one can really be happy without having suf-

fered, which teaches men to do their duty." That rare "man of sensibility and reflection" who raised popular consciousness refused to sink back "into the general quagmire of bigotry and superstition." A religious reformer and crusader was by definition a member of "that party of the few," in a world where "a few individuals govern the rest of the species." Since, as Buckminster said, "that learning . . . which lives with its possessor is more worthless than his wealth which descends to posterity," Norton felt obliged to be one of "the natural guides of society" and, by "great labor and self devotion and even self sacrifice," heave the mass forward. This sense of mission, already widespread, should be channeled, Norton thought, to the reform of New England congregationalism.[17]

Norton's challenge proposed a broader focus for religious liberalism, in line with ideas articulated in sermons and private communications. But where Thacher was only willing to expose the evil principles fostered by men who happened to be Calvinists or Hopkinsians, Norton intended to assault them on the ground that *they were* an evil in themselves, with their parties, exclusionary tactics, societies, and vast networks of influence to further nefarious causes. Furthermore, faith was too important to be left solely to divines, especially when the laity seemed in advance of the clergy in breaking through the shells of "abstract creeds and coming to the kernel of religion." The *Panoplist*, too, noted that Christians dwelled less upon the forms and more upon the substance of religion, which gave liberals their chance. Until 1811 they had confined themselves to appropriate remarks without making clear their own potential contribution to their society's crisis of confidence. The moderate Calvinists were on the right track when they argued that their precepts were comparable to waking up a sleeping family whose house was on fire. Their premises, however, were all wrong, and the time had come to expose the charade which made Calvinism, however modified, the only method to keep sinful man and sinful society in line. "The intellectual and moral improvement of our race," peace, prosperity, and happiness, depended on the "prevalence of rational Christianity and a catholic spirit." The dispute would be not only over scriptural interpretations, textual editions, dogmas, and doctrines, but also over the very basis of life in a reformed society, man's true character, and the nature of republican institutions. In effect, New England liberalism was the only faith suitable for the entire United States. The missing components of

this wider vision would be supplied as the magazine refined the tenets of rationalism and expanded their larger significance.[18]

Such an agenda had excellent chances in 1811, Norton assumed. Religious pluralism, to begin with, forestalled orthodox designs for dominion. Even the *Panoplist* admitted as much when bewailing the fact that "to the descendants of the Puritans there is a charm in the very name of liberty." To Jedidiah Morse the real danger was anarchy; for the liberals it was a golden opportunity. Since in the United States religious errors were not "in alliance with the distinction of ranks, the power of government, the establishment of religion," their extirpation called for a change of minds, not for the upheavals that traumatized less fortunate European countries. Politicians also knew, Norton thought, that "only catholic christianity" was the way to office, dooming efforts to bamboozle the citizenry by scaring them with a liberal bogey. The almost un-American, monarchic, and popish face of their opponents also encouraged liberals. The fate of Abiel Abbot of Coventry, Connecticut, the Ware, Sr., controversy at Harvard, and other disputes proved that more than dogma was at stake. Confrontational tactics could mobilize those who, while uninterested in strictly religious issues, recognized that only a combination of rationalism and piety formed proper citizens.[19]

Confrontational tactics were needed because, while liberals sat on their hands and declaimed against controversy, orthodoxy, a protean creature to begin with, was busy changing its colors. Already in 1808 Jedidiah Morse acknowledged that Calvinism needed to be "adapted to the present state of society and of the times." By 1810 the *Panoplist* was enumerating orthodox contributions to human happiness, propagating the argument that only orthodox psychology met man's needs, for religion involved questions not only of metaphysics, but also of utility. The pride of consistent Calvinists in their militancy, and orthodox attempts to achieve greater unity and uniformity, not only in doctrinal matters but in organization and power, also boded ill. Warnings against these efforts "to speak one language and by combining their influence render it effectual," would do no good without the liberal united front Norton counseled.[20]

A front united by an articulate agenda also required a learned foundation, the product of biblical criticism. The catholic camp, beneficiary of God's wonderful system of checks and balances and moral philosophy, needed proper "facts" to displace outdated orthodox "speculations," res-

The Young Andrews Norton

idue of a propensity "to theorize antecedently to examination and observation." Noah Worcester's *Bible News*, for example, was not good enough, since its correct conclusions, which aligned common sense with higher wisdom, lacked scholarly proof. Thacher was glad to "see that the great cause of the absolute and essential unity of God does not require the support of learned criticism to prove it from the scriptures," but Norton was unwilling to dispense with an insurmountable advantage. He knew, of course, how controversial it was, given the charge that for liberals "things that are necessary to our salvation depend on verbal criticism or the wrangling of scholars who are striving for literary fame." The liberals' stress on practical religion and piety aimed to destroy the canard that only irrelevant metaphysics was in dispute. The new magazine would prove that academic theology was relevant to devotion by explaining the metaphysics liberal preachers avoided in their discourses.[21]

Norton's conception of liberalism, the nature of the opposition he hoped to overcome, and the advanced agenda he outlined also affected his strategy and tactics. A mobilized elite would influence the lower orders, for, he argued, the future of the region and the nation depended on everyone's becoming a rational Christian, and it was easier to start at the top than at the bottom. Norton knew that the masses never read the *Anthology*, and he did not expect them to snatch up the *Repository*. But their betters, merchants, senior craftsmen, shopkeepers, men like his father would, and through them the benefits of rationalism would trickle down to others. In the Dorchester controversy, for example, Jedidiah Morse accused wealthy parishioners of threatening the lower orders should they support the embattled John Codman. Norton denounced such unseemly tactics (in the case of Abiel Abbot of Coventry), but welcomed the implication that influence could make itself felt. Levi Frisbie agreed, as he looked forward to the day when "the principles and ends of moral action" would descend from "the higher and more intellectual classes of society . . . [to] the great mass of mankind in the humblest walks of life" who, in becoming rational Christians, would also become amenable to the Federalist message, a consideration that gave a political dimension to Norton's missionary fervor.[22]

That political dimension was doubly urgent in 1811 as the evil effects of mistaken policies, courtesy of popularly elected presidents, affected the region. In days of economic distress, mortal dangers, and disastrous programs, even cautious clergy like Channing abandoned their usual reserve to preach on controversial topics, using their pulpits to rally the

people. An intimate connection existed between a proper religious out-look and correct behavior in the polling places. Those who wished to smite the Democratic Republicans should be eager to see rational religion spread its benign influence, which in turn would restore to the Federalists the power they had lost since 1800. To do this demanded a lay and clerical elite mobilized behind a proper agenda, willing to exercise its influence in ways that would count.[23]

The pattern by 1811 had already affected the environs of Boston where liberal divines, leading men of letters, and parishioners gradually prop-agated a faith to fill churches with enlightened Christians. Not everyone understood the finer points of the controversy, nor was it important that they should. Elsewhere also were Calvinists who kept the name, dis-carded the content, and practiced "a simple, . . . reasonable Christian-ity." Though the orthodox maintained that in the final analysis mystery was a vastly more powerful weapon than reason, Norton thought that given the choice, the people would prefer his own intelligibility over incomprehensible trinitarian doctrines. And the trickle-down theory would ensure that they did.[24]

This was to be the magazine's new strategy, a costly mistake, as Nor-ton admitted in the long run, but explicable in light of the fact that he, like his young friends, lacked an alternative model for mass mobilization, a problem shared by Federalist politicians. Norton's faction was a pris-oner of its own somber but also optimistic assessment of human nature, and also of the constraints imposed by the requirements of rational Christianity and of the congregational system, which lacked any central organization to be seized and made the source of directives about new doctrines. Nor was it willing to imitate the detested revivalists, charis-matic leaders, or other deviants who developed new methods of recruit-ment with appeals to the "weak in intellect, and inclined to superstition." Thacher blasted "that love of the marvellous, and passion for what is mysterious and obscure in religion" which swelled the ranks of Baptists and Methodists. The success of the latter should have given Norton pause; but he, like his supporters, misunderstood the Second Great Awakening and traced the success of enthusiastic preachers to popular revulsion from Calvinism, which he thought the liberals could exploit for their own benefit by channeling it in proper directions.[25]

Charles Eliot and Samuel C. Thacher agreed and in the summer of 1811 became the magazine's editorial board, patterned after the *Anthology*'s

The Young Andrews Norton

society. Unlike the latter, however, the Cambridge alliance would be no convivial dining club but a small cell of the like-minded. Edward and Alexander H. Everett and John Farrar were admitted, Nathaniel L. Frothingham and John T. Kirkland were not. Norton knew that Kirkland, though always on the side of the angels, acted "only with a great deal of circumspection and discretion and forethought." To Kirkland's favorite Congreve epithet—"a wise man and a conscientious one and one who does not commit an error"—Norton added, "nor do what is right either." Nor was there a place for William Ellery Channing, who in 1810 had disapproved of the process of party formation (whether by Morse or Norton). The entire set-up was therefore shrouded in secrecy, its conspiratorial atmosphere recognition of potential explosiveness. For the clash between the camps, labeled tradition versus renewal, orthodox versus liberal, conservative versus progressive, or more precisely as fratricidal encounters within the Standing Order, among Hopkinsians, moderate Calvinists, and Arminians, was really an implacable battle for the right to rule.[26]

To Norton's credit, he saw the issues at stake well before others did. He warned that the system of exclusion was already in place and that the controversy exceeded the boundaries of polite disagreement, given the fact that church issues, as many of the disputes showed, affected "the peace and edification of the society at large," revealing "that power of all kinds is liable to abuse," but especially the kind wielded by the party of the past. How else was one to interpret the efforts to establish consociations in Massachusetts (in 1808) and the tightening reigns of the orthodox Central Association of Hampshire County, to mention but two. This perception sharpened Norton's sense of urgency and deepened his militancy in the days when most fellow liberals mouthed pious phraseologies. His personal tragedy stemmed from the hope that this warning led troops from darkness to enlightenment. Instead the result was a movement from ignorance to confusion.[27]

The November 1811 backing of Samuel Eliot, Samuel Dexter, and others produced the *General Repository and Review* (January 1812), an expression of liberalism's stormy adolescence. A journal devoted to a cause on which the future "improvement in virtue and happiness of mankind" rested (Norton refused to think small) required an appropriate motto. The editor chose *Nec Temere, Nec Timide* as a challenge to Morse, Andover, moderate Calvinists, and Hopkinsians, and as a rallying call for the Lowells, Channings, and Kirklands. The day foreseen by Thacher

of a theological combat with fanaticism, ignorance, and credulity had arrived. That "intolerant ignorance, which pretends to dogmatize, and to make its own opinions the standard of belief" would be its victim. [28]

The first issue opened with Norton's defense of liberalism and "right reason," implying, as the *Panoplist* furiously charged, that catholic Christianity had a monopoly on both. The article traced the issues in dispute, took up orthodox charges one by one, attacked their propensity to "melancholy and madness" and their "barbarous jargon of technical theology," defending liberalism on the basis of scriptural, philosophic, and moral tendency arguments. The distinctions between the two parties that explained why support for one was vastly preferable expressed no "intemperate zeal for making proselytes" or desire to undermine "authority." But the orthodox demand for implicit faith and their appeal to passions were indefensible, no "authority" at all, merely the accidental product of sad times (the Reformation). Those who did not think Calvin and Hopkins inspired from heaven surely agreed and would not willingly shackle their reason, or define good works as buying the *Panoplist*. Other articles provided the intellectual substructure for Norton's Defense, while Farrar's essay on comets and Eliot's taste for moral literature showed the magazine's broader horizons. Concluding pages on the growth of theological instruction at Harvard implied that, in the future, fewer would confound speculations with Scriptures and behave like apostles. The two parties, sad to tell, were a fact of life, though imprecisely labeled orthodox and liberal. The real division was between supporters of "a scheme" and "a revelation," for a new definition of "personal holiness." Whoever determined this definition would control the future of the republic, for warfare waged between the party of the past and the party of the future had cosmic ramifications. [29]

The reaction to this package of old ideas in new wrappings was mixed. Judge Davis in Boston approved and Samuel Norton found nothing contradicting Henry Ware, Sr. Those who never read it were sure the magazine expressed "rank Socinianism." Others chided Norton for using difficult terms or slighted him by crediting Buckminster or Noah Worcester with the entire enterprise. The more discerning saw the publication as the groundwork for a new sect, dubbed by Benjamin Vaughan "the sect of imprudents." The only article to which no one objected was Farrar's on the comets. The *Panoplist* denied liberals a monopoly on candor, charity, and rationality, while wondering at the kind of liberality that fostered sectarianism, as the *Repository* was supposed to do. For Norton the luke-

warm response produced a new depression and further requests for paternal aid.[30]

Samuel sent money and described events in Hingham where Federalist–Republican battles provided further rationale for Norton's mission. The father, frightened "at the enemies of order . . . rallying their forces . . . to attack everything sacred," thundered that this was the hour for "every good man to enquire what may be done, to ask counsel of God and exert himself in every fit way to put a stop to the flood of evil." The "scheme" supporters, to his son, were one rivulet in that flood, and the *Repository* the only publication manning the dikes. A renewal of personal holiness was the answer to the pervasive sense of malaise and the fear that the American experiment was on its last legs. But personal holiness depended on rational Christianity, which taught, in Charles Eliot's words, that man was but part of a larger entity, his happiness to be sought only "in the welfare of the whole." The salvation of the American experiment required a renewed sense of the corporate community, attainable by liberalism, not by Calvinist mysteries. Everything that had happened in the past few years strengthened that perception.[31]

But though many shared Norton's sense of crisis, few agreed with his tactics, and moderate Calvinists as well as Hopkinsians snickered at the internecine fighting within the liberal camp. Channing made incautious pronouncements, and while in far-off England Belsham praised the *Repository* (which Norton did not welcome), at home the result was an effort to muzzle the combative editor. Joseph Stevens Buckminster, who viewed himself as "a gentle knight" opposed to "the fanaticism of literary crusaders associated to plant their standard on territory recovered from heathens or heretics," became the magazine's censor. Andover gossip, branding the *Repository* dangerous, vindicated Norton's strategy but not enough to overcome the sense that public debates generated dogmatism and speculations without advancing personal holiness. The journal, according to its potential supporters, served both the Nothingarians (by making religion odious) and the deviants, since the controversy "would render the multitude bigoted and persecuting Calvinists"—presumably the last thing the editor wanted. That mental breakthrough he urged, which challenged the liberals to hasten the future by action, did not happen. Instead, they preferred to deny reality.[32]

In the next issue of the magazine, therefore, Norton apologized for too much attention to theological matters, Buckminster buried his message under mountains of Greek terms, and Thacher's appreciation for

Lilian Handlin

Noah and Thomas Worcester's pamphlets vindicated untutored common sense. A tribute to the late Reverend William Emerson's *Historical Sketch of the First Church* showed that contemporary defenders of the faith once delivered to the saints had nothing in common with those saints and disposed of the slander that liberalism was a recent accommodation to infidelity. Eliot's review of Robert Southey's poetry deplored the fate of reformers branded heretics and sectarians. Potential subscribers could expect even greater literary diversity in the future. Buckminster's death, June 9, 1812, further damaged the magazine, whose editor mourned the fallen hero by toning down theological militancy in favor of a more secular orientation. The *Repository* listed the reasons why that entrenched habit of reliance "upon the arguments of authority," and the consequent "dread of innovation and departure from authority," retarded the growth of personal holiness and postponed the dawn of a new era. John Lowell's sneer at Madison pandered to the Federalists, while Thacher cautiously admitted that the bad effects of Calvinism did not extend to every Calvinist. Norton's eulogy implied that only rational Christianity produced such prodigies as Buckminster. Charles Eliot's blast at Morse and Jeremiah Evarts for being self-appointed "delegates of heaven to judge and censure and punish," "supported by authority and not by reason," led liberals like Henry Colman to believe that the writer exaggerated. Norton, fretting over his health and failing finances, advised Eliot to keep his authorship secret. The October 1812 issue closed with the threat of resignation and the obligatory promise to pay still less attention to theology. The January 1813 issue devoted three-fourths of its pages to literature, science, and poetry.[33]

A series of committees, all "of the first respectability," extended Norton's ordeal and prolonged the magazine's misery by deciding to pay the editor a salary. Gentlemanly promises, however, produced no cash. Instead, further restraints followed, whereupon Norton announced that the current volume would be the last. Though his private "barometer of reputation" remained high, the March 1813 appeal for subscriptions implied even more censorship. Its author, Alexander H. Everett (he of the changing colors), noted that, since disagreement on touchy points was inevitable, the magazine would open its pages to contrary opinions and exonerated Norton of any blame by suggesting conspiratorially that powerful forces were out to wreck the *Repository*. Norton would remain editor, subject to a committee's oversight.[34]

This half-hearted vote of confidence clouded Norton's writings that

spring, and he used the April issue for the boldest statement so far. The private battle with Abiel Holmes of Cambridge (over objections to the "Defence of Liberal Christianity") asserted his own definitions of liberality and civility. A review of Ezra Stiles Ely's *Contrast between Calvinism and Hopkinsianism* reprinted relevant correspondence, exposing the machinations of "the church militant." "Stale sophism," "the great principle of popery," "religious vasselage," "sectarian partizans," described moderate Calvinists, various shades of Presbyterianism, and Hopkinsians to prove the wonderful operation of "checks and balances" for the benefit of liberal Christianity and to expose the illusion that the leadership of the two parties had much in common. Potential allies among moderate Calvinists or Hopkinsians jealous of congregationalist independence existed only in the imagination of some liberals. The Westminster Assembly, occurring in "one of the most tumultuous, fanatical and disgraceful periods of English history," was an improper standard for faith at any time, and certainly in 1813. Calvinist ministers were jesuitical casuists, perverters, and narrow sectarians, their exclusionary terrorist tactics self-defeating since it was "the policy of laymen to be catholic and patronize catholic Christianity," even if its spokesman lacked their courage. The article closed with a final call for men to rise above "fear of reproach or personal inconvenience" for a gospel free of human corruption, in the name of personal holiness.[35]

The call was answered, but not in the manner he had hoped. While the new editors of the *Repository* humbly proclaimed that they were "no contemners of public opinion, though it is not always infallible" and promised anyone "a fair hearing, if his manner of [expression] . . . be decorous and manly," Channing assembled a task force untainted by *Repository* associations. The politics of exclusion applied to dissident liberals as well. The *Christian Disciple*, founded in 1813, would be evangelical and pronouncedly unsectarian, its editor the Reverend Noah Worcester, presumably more truly Christian in spirit and more controllable. Although Channing opined, "we could . . . render the name of Calvinist as much a word of reproach in our societies as that of unitarian is in some parts of the country," he did not say how. "Let us remember that our opposers cannot ultimately injure us unless we permit them to awaken bad passions and to impair our virtues." *Nec Temere, Nec Timide* gave way to "Speaking Truth in Love," and anything remotely offensive was diluted by suitable apologies. Norton never wrote for this version of the *Disciple*, in part because he was never asked.[36]

Lilian Handlin

Instead, in April 1813, he accepted the Dexter Lectureship, the appointment twice before denied him. Kirkland concurred in the hope that teaching, parietal duties, and incarceration in the Yard would keep the young man out of mischief. Norton was eager, for the college, within limits, would give him a free hand. The two-year appointment, though poorly paid, had possibilities. The *Repository* had failed. Perhaps a teaching platform would not. Where orthodoxy sniffed "sophistical subtilities of speculation," Norton saw the potential for erecting an orderly facade for catholic Christianity.[37]

Buckminster's frantic study of German Higher Criticism aimed to forge a weapon against orthodoxy. But Norton disagreed, and his contempt for "German speculation of any sort" never abated. He shared the misgivings of Stuart, Morse, and later Nathaniel Taylor and did not intend to justify their smears of catholic Christians with German infidelity. An explanation of the New Testament required correct notions; since the brave German critics lacked them, their conclusions were often as suspect as their methodology, an "impalpable inanity." Nor did he think foreign models tainted with "hereditary mischief . . . decrepit prejudices . . . and . . . the corruptions of age" appropriate for Americans. And he had been warned time and time again that "the contempt of old opinions may be as real and as slavish a prejudice as the fear of new ones." To the *Panoplist*, liberals were guilty of an "unnatural and far-fetched figurative explanation, suggested by ingenuity on the rack and supported by palpable sophistry." The new Dexter Lecturer would prove otherwise.[38]

The answer was an American version of higher criticism, a Nortonian construct, born of years of study, battles with Calvinists, in-house liberal warfare, and, most directly, Herbert Marsh. Since "the very life of man in a well regulated society [is] affected by the truths or falsehood of their opinions respecting God," the lectureship's scholarly terminology aimed to provide the intellectual foundation for personal holiness. That condition required a faith, and critical principles never exceeded Arian doctrinal commitments in order to disprove the slander that liberals left believers "in a state of endless vacillation and perplexity in regard to the character of their savior till they gradually sink into socinianism." The divine system of checks and balances required help, in those days of "passion, fear and delusion . . . termed awakenings." That help was a faith cleared from the evils of linguistic ambiguities, a vindication of instructed common sense, in short, the only barrier to the republic's degeneration into deluded barbarism. Though Norton did not know it, he

The Young Andrews Norton

had stumbled into to enterprise that would lead eventually to the publication of *The Genuineness of the Gospels*.[39]

Even this soft version of higher criticism was too much for the college authorities, who later carted in Norton's old enemy, Abiel Holmes, to counterbalance its impact with lectures on ecclesiastical polity and dispel the charge that Harvard was an exclusively liberal brain trust. A committee that evaluated teaching proposals told both to tolerate "unbiased inquiries" without inculcating "a particular system upon the controverted points of theology." Holmes conformed and Norton, badly paid and muzzled once again, set his eyes on the newly endowed Greek professorship, which went to Everett. Since 1813 he had published nothing and engaged in no controversy but watched to see whether the events of 1814–1815 would lead liberals to acknowledge that his earlier warnings had proved prophetic.[40]

They did not. Channing, amidst the flurry of published letters, continued to urge martyrdom. "Let us welcome suffering . . . [and] . . . secure to ourselves that peace of conscience which is infinitely better than the smiles of the world," which substantiated John Lowell's conviction that "the clergy would not do their duty upon the occasion." And Samuel C. Thacher, against his better judgment, mounted the pulpit trembling and distraught to answer the *Panoplist* with an apology. "I can hardly describe the pain and reluctance with which I have submitted to a duty which the times seemed to impose," he told his congregation. Though Norton had warned time and time again that such pusillanimity was grist for orthodox mills, since Calvinists fought for real while liberals guarded their precious souls, no one listened. The only ray of light in this gloomy period, from Norton's viewpoint, was the renewal of his lectureship in 1816, perhaps as a reward for having kept his mouth shut.[41]

By then the theological seminary which Norton envisioned as "the great defender of the true Protestant cause . . . the source of rational, catholic and evangelical Christianity . . . the glory of the age and the hope of posterity" was about to receive a more systematic form. The college authorities had decided to place ministerial training on a sounder basis and had begun an extensive fund drive. The appeal to the public expressed views Norton had long articulated. But once more he was slighted, allowed to participate neither in the drive nor in the planning. The *Panoplist* warned potential donors away from an institution that employed his likes, and Harvard responded by keeping him out of sight.[42]

Though by the spring of 1817 Norton's classroom at times included

members of the government and outside visitors, his sense of frustration and insecurity remained. The debacle that followed justified his fears, for the death of the Reverend Joseph McKean seemed to the college authorities a means to shunt him aside by giving him the Rhetoric chair. Yet given Norton's reputation, he knew his hands were tied. "I have left myself very little room to say anything about it," he noted, as he embarked on a convoluted campaign to get the Dexter Professorship. Instead of confronting the corporation directly, he engaged the services of John G. Palfrey, Levi Frisbie, Levi Hedge, and others to overcome the opposition of leading rational Christians who feared for the theological school's future should the most qualified man for the job receive one of its prize professorships.[43]

The behavior of Kirkland, Channing, and members of the corporation was further evidence of the self-defeating accommodationism that placed rational Christianity eternally on the defensive. The orthodox said as much. "Truly the liberal party must acquire more courage," the *Panoplist* crowed; "they must learn not to be ashamed of their own works the moment these works are laid to their charge." Nor should they be ashamed of one of their most prominent spokesmen as they were in searching for a less dogmatic individual, one more willing to see both sides of the issue, and though entitled to opinions in the country of free speech, also willing to suppress them. "He who wishes to convince others, ought at least to be convinced himself." How else could rational Christianity advance? Evenhandedness only generated "inextricable confusion and general skepticism." Yet this was what Channing advocated by suggesting that, at best, Norton be given the duties though not the title of the professorship.[44]

"If a young man set out in his life with high purpose," Norton wrote of himself, "he will find a great many who have no fellow feeling with him, who cannot comprehend his character . . . who refer everything to themselves and . . . are ready to believe that every wise man does the same." In a heartless world, full of "selfishness . . . neglect and unkindness," reform ideas were viewed as "merely the result of inexperience and such as every man of course gets rid of when he becomes a little acquainted with the world" by those who "in the catalogue pass for men." One example was Kirkland, who shied away when the going got rough under the slogan "I have a heavy pack of my own to carry," but Norton could extend the list.[45]

Luckily a reaction for the moment saved the movement from "de-

plorable somnolency." The orthodox "sowing [of] tares" generated a counter-offensive in 1819. The old *Disciple* collapsed to be replaced by a more confrontational publication, and even Channing, Joseph Tuckerman, Charles Lowell, and the Reverend Francis Parkman joined the fray. Norton rejoiced. "The main body of rational Christians are at last putting themselves in motion to support those of us who have been engaged as enfants perdus." The moment arrived, he noted, when those who had cried, "Peace, peace, when there is no peace," prepared for the war he hoped would make rational religion a national faith. The *Panoplist* compared its chances with the likelihood of "a vigorous and healthy vegetation [arising] among the snows of Greenland." Norton thought otherwise. The army was still small, but to Norton it resembled European imperialists (still good things in those days) who clobbered helpless natives with superior skills and weapons. "Orthodoxy in all its forms has seen its best days." [46]

Proof was everywhere. Sparks's *Letters on the Episcopalian Church* appealed to "the common reader" a healthy turn away from the liberals' penchant for obscure minutiae. The Unitarian *Miscellany* performed sterling service by showing that rational Christianity "was not new but . . . held by some of the wisest and most enlightened of men" in the past, while Maryland, Kentucky, Ohio, and New York Unitarianism separated liberalism from "accidental causes"—such as those prevailing around Boston. Though Norton was willing to leave "the manufactories of lexicons and editions of the classicks . . . at Halle and Gottingen," developments at Harvard and elsewhere proved that "never in all past ages did a prospect so glorious rise to the view of any nation as that which is disclosed to our own." [47]

With his eye on that future, Norton worked frantically to hasten the millennium. His inaugural discourse connected theology to devotion, in opposition to "the rubbish of technical theology" as well as "those metaphysical quibbles, which show how much morbid ingenuity may remain, while common sense is entirely prostrated." Lest this comment be misunderstood as a vote for ignorance, Norton listed the qualities necessary for acute theologians, which, not surprisingly, were those he possessed himself, including a poetic soul. *The Statement of Reasons* denied scriptural sanctions for trinitarianism, identifying Calvinism as "the most efficient cause of infidelity and indifference," a blow "at the foundation of public and private happiness, of the good order of a well regulated society." *The Genuineness of the Gospels*, conceived in December

1818 and planned to be finished in six months, aimed to refute the ortho-dox charge that Unitarianism was destructive deconstruction. The party of the past had Jonathan Edwards and Samuel Hopkins; the advanced party would have Andrews Norton, who always believed that intellectual modesty was for the intellectually modest. He called on reformers to support that definition of personal holiness that generated the "disinter-ested love of virtue which in the end will improve the human condition," while the attacks on "false religion" vindicated earlier judgments. Only "an honest and strong avowal of truth" would end the spread of "poi-son." Liberals "have trusted . . . too much to the gradual progress of knowledge and . . . improvement," their "indifference" encouraging the transformation of the populace "into fanatics and unprincipled sectari-ans." Those with a "philosophical or epicurean dislike to controversy, . . . fearful lest it . . . put [their] . . . dignity to hazard," should stand aside. "Unitarian Christianity," Channing's ordination sermon for Sparks marked, "a new era," an end to sermons on the evils of dogma-ticism and censoriousness, the duties of diffidence, modesty, meekness.[48]

What happened next? The press reported the "haloo balou about . . . calvinism and trinitarianism and unitarianism and every other ism . . . enough to give a man rheumatism and skepticism," while Channing and Norton became a hit in Universalist circles, another sign of the general muddle. To the orthodox Channing was the official founder of a new sect, while among the liberals self-congratulations mingled with the fa-miliar caution that liberalism was too refined to spread like wildfire among the multitudes. The vast popularity of "Unitarian Christianity" was never translated into numbers and the spirit of exclusion was in force. Elsewhere questions arose about the value of collegiate education and divinity schools—when had Harvard produced a Benjamin Frank-lin? As the euphoria generated by Channing's sermon evaporated, the show of liberal determination and unity disappeared as well.[49]

Behind this development was an old argument—an eye for an eye makes us both blind. Shows of unity and bold pronouncements were not "respectable," said Samuel A. Eliot. The parties were sufficiently known for truth to prevail. Better remain small and pure, since "there are more important circumstances than numbers to determine the respectability of a party or the truth of its tenets." When the question arose who should answer Moses Stuart, Norton, as usual, was not the first choice, and when picked, was told to reign his temper. The cry went up that "we retire from controversy and write as we used to." "I think we might as

The Young Andrews Norton

well, after having raised the frame of a building retire and leave the boards to be nailed on and the rooms to be finished by accident, sheltering ourselves meanwhile in the cellar," was Norton's sour response. The *Christian Disciple* once again traced low circulation figures to controversial articles, while in Salem, Edward Everett, attacked for suggesting that liberalism was the only faith for a man of sense, found few defenders. "I thought at last the Hebrews were coming out of their" shelters, said Palfrey, but they did not. Their unwillingness "to rise above the fear of men and the love of ease" produced in-house debates on whether the controversy "was not unfavorable to the spirit of ourselves and our opponents." Though Channing for a brief moment handled Calvinism "without mittens," Norton's argument that confrontational tactics accounted for the better treatment of liberals in the previous two years fell by the wayside.[50]

Norton's contempt for that delicate, guarded, qualifying, trimming, mincing mode of speaking truth lasted a lifetime. But subterfuge was again needed in the days when the Reverend Francis Parkman asserted that "the purest zeal is the fruit of opposition" and argued that "truth makes tolerable progress without it," while sermon after liberal sermon evinced hostility to militancy. "The numerical increase of . . . [the] party" was of no concern to William Ellery Channing. "The prejudices which are so current against our views are to be overcome not so much by ingenious reasoning as by holy living. . . ." When the "most judicious, reflecting . . . [and] richest Unitarians" concurred, Norton recanted. By now Norton was no longer the impecunious and insecure young missionary of 1811 but allied by marriage to the Eliots, one of Boston's richest families, from whom greater decorum was expected. But more important than that, he was also a defeated radical. "A religious controversy has almost always something unpleasant associated with it," he said. Liberals should concentrate on exhibiting "Christianity as it is." The brief reign of *Babylon est delenda* had ended. "We must not be in haste to raise the building before having laid the foundation." Were not twenty years of struggle foundation enough? Apparently not.[51]

This devastating admission expressed Norton's realization that the failure of his strategy and the liberals' inability to overcome the mistaken hope that the future would take care of itself extended orthodoxy an almost insurmountable advantage. The general unwillingness to follow his advice, "to separate and to distinguish most clearly . . . truths from error

Lilian Handlin

74

. . . to draw a broad and deep line of demarcation," allowed the opposition to set the terms of the debate and draw the boundary, while Channing complained that "the intellect is often exercised among us too exclusively," and a liberal ordination sermon asserted, "these are not the days in need of speculation and evidences." Furthermore, the amorphousness so dear to men like Charles Lowell, Channing, and others fostered an anti-authoritarian temper which, while not of their making, would claim them among its victims. At the same time, the meager ranks of the liberal camp swelled with unwelcome allies, blurring its message and raising the spectre of social anarchy. And to worsen matters, "shadowy orthodoxy" assumed new forms to employ liberal arguments for its own use.[52]

The signs included lessening attention to dogmatics, a cavalier attitude to theological concerns, and a populist spirit that skated around hard issues and substituted phraseology for scriptural argument. Jared Sparks was not the only one that year arguing that though "faith from authority *may* be of value," anything accepted on such a basis was of limited utility, suggesting the abolition of "all creeds and formularies." "For myself," Norton responded, "I do not agree . . . in supposing that *faith* in order to be of any value must be founded upon rational conviction. Most men must believe upon authority, simply because they have been so taught and belief resting upon this formulation may be of the highest value." In creedal matters especially, the masses had to "rely in some degree upon the authority of their teacher," whose rational religion was an alternative to Andoverian authority, but a combination of "German theology, Hopkinsian metaphysics and worldly passions," the "authority of . . . past ages."[53]

But the authority of the new age, already unacceptable to some, was further undermined by unwelcome additions to the ranks. By 1820 Norton was warning not only against the evil effects of Calvinism and revivalism, the chimeras of German theologians and an anti-authoritarian temper, but also against ultra-liberals, their infidel religion "of imagination and of temporary sentiment" a substitute for "the religion of understanding." These men "of light minds . . . ready to think that the further they remove from established opinions, the more they show themselves free from vulgar prejudices," agreed "with the defenders of true religion . . . only in attacking certain errors, and not in maintaining the great truths."[54]

Anti-authoritarianism and ultra-liberalism were grist for the muta-

tions of orthodoxy. Norton's sobering catalogue of Calvinist horrors, "the naked truth," was dismissed as an irrelevancy by Nathaniel Taylor's *Christian Spectator,* since the Calvin Norton thought he knew was not the one the *Spectator* acknowledged. How could anyone, the *Spectator* queried with good Nortonian logic, expect a sixteenth-century reformer to reason with the light of the nineteenth? Misrepresentation was the crux of the liberal assault, and the *Spectator* suggested a better title for Norton's effort would be "Calvinists charged with believing what calvinists do not believe." Norton's replies left Taylor unmoved but elicited liberal condemnation, focusing his anger more on those "delicate, guarded, qualifying, trimming, mincing gentlemen" than on the challenges heard from New Haven. "Nothing is more disgusting to me than the hypocritical cant of candor," since the question was not whether what he wrote was "severe" but "whether it was true." [55]

Warnings such as "beware, beware, remember you go into eternity not with . . . Norton's Statement of Reasons for not believing as you judge but with the Bible in your hands" showed the distance traveled since the days of "The Defence of Liberal Christianity." After 1823 Norton moved to the cellar and turned inward, to infightings about the college and the divinity school, and the ways to consolidate liberalism. By then, ironically, his allies were ready to act upon the earlier message, but Norton thought that strategy inapplicable because the orthodoxy he set out to combat no longer existed. [56]

In the end the very flexibility of congregationalism, and God's wonderful system of checks and balances, upon which Norton counted to further his cause, proved his undoing. They fostered a do-nothing attitude in the 1810s that allowed orthodox metamorphosis. Meanwhile, though the nation moved to ever-higher levels of civilization, scheme supporters, not catholic rationalism, benefited. It was no consolation to be reminded that the former had changed, in part as a result of his prodding, for the earlier clash about the definitions of personal holiness and the right to rule aimed to extirpate orthodoxy, not modify it. Hopkinsians, Taylorites, and Beecherites might compete for the prize of having dealt liberalism a death blow, but Norton in the end thought it was a self-made job. As younger and more energetic suitors for the minds of men emerged, liberals, a minority and not a national faith, behaved as embattled sects, according to Norton, usually did: badly. What he did not know was that his ordeal had just begun.

Lilian Handlin

Notes

1. Andrews Norton to John Gorham Palfrey, Mar. 19, 1819, Jan. 1, 1820 (Palfrey Papers., Houghton Library). Unless otherwise noted, all references to Andrews Norton's letters and writings refer to the Andrews Norton Papers, Houghton Library, Harvard University.

2. Andrews Norton to George Ticknor, in [George Ticknor], "Memoirs of the Buckminsters," *Christian Examiner* 47:196–203 (1849). Here Norton dated the separation of the two parties to the 1750s. Nathaniel Taylor in New Haven sensed that there was an almost parasitic relationship between liberalism and orthodoxy, and the *Christian Spectator* 3:205–206 (1821) warned prophetically, "If orthodoxy dies as its victim, unitarianism must die with it."

3. For the intellectual context of Norton's radicalism, examined so ably by today's historians, see Daniel Walker Howe, *The Unitarian Conscience: Harvard Moral Philosophy, 1805–1861* (Cambridge, Mass., 1970); Conrad Wright, *The Beginnings of Unitarianism in America* (Boston, 1955); George Williams, *Rethinking the Unitarian Relationship with Protestantism* (Boston, 1949). These and other works have led me to leave out almost entirely the intellectual and theological dimensions of Norton's mental universe.

4. Charles Eliot Norton, *Address at the Celebration of the Two Hundredth Anniversary of the Building of the Old Meeting House at Hingham* (Cambridge, Mass., 1882), 8. Norton's debt to his father is acknowledged in Andrews Norton to Samuel Norton, Apr. 26, 1817. On the background of Hingham religious liberalism, see Robert J. Wilson III, *The Benevolent Deity: Ebenezer Gay and the Rise of Rational Religion in New England, 1696–1787* (Philadelphia, 1984). Norton was present at Frisbie's deathbed, a frightful experience because Frisbie's father, a gloomy Calvinist, had been insane for a year before his own death. Frisbie, Jr., was haunted by his father's beliefs, which Norton tried to alleviate in prolonged deathbed conversations, leading the dying Frisbie to say, "If what we believe is true, I shall probably in a few weeks be far happier than you are," but the "if" remained. See Andrews Norton to Samuel A. Eliot, Aug. 3, 1822; D. A. White to Andrews Norton, Jan. 28, 1823. On Buckminster, see Eliza Buckminster Lee, *Memoirs of Rev. Joseph Buckminster, D.D., and of His Son* (Boston, 1849), 19, 325. Norton himself traced his ancestry to John Norton. See Andrews Norton to Samuel Norton, Nov. 17, 1818, in Norton Papers, Massachusetts Historical Society.

5. Samuel Norton to Andrews Norton, Apr. 26, 1810, Andrews Norton to Samuel C. Thacher, Oct. 14, 1805, to Samuel A. Storrow, Aug. 12, 1805, to Seth Newcomb, Oct. 14, Dec. 31, 1805. See also Andrews Norton, Diary, 1806.

6. For Norton's Harvard peccadillos, see Faculty Records, vol. 7, Harvard University Archives. Samuel Norton's numerous letters of advice are in the Norton Papers, Houghton Library. On moral philosophy's critical influence, see Howe, *Unitarian Conscience*. On one aspect of the intellectual context, see James Turner, *Without God, Without Creed: The Origins of Unbelief in America* (Baltimore, 1985).

7. William Bentinck-Smith, ed., *The Harvard Book: Selections from Three Centuries* (Cambridge, Mass., 1982), 119. On the history of the *Literary Miscellany*, see Sidney Willard, *Memories of Youth and Manhood* (Cambridge, Mass., 1855), 2:137–159. Thaddeus M. Harris, "Literary and Benevolent Associations," *Literary Miscellany* 1:5–8 (1804–1805); "Remarks on classical learning," ibid., 12; "Sketch of

the life, character and writings of Jonathan Mayhew," ibid., 65; Andrews Norton, "Review of Henry Ware," ibid., 272–273; Andrews Norton to Samuel Norton, Dec. 19, 1804

8. On the stories about David Tappan's appointment, see William Bentley, *The Diary of William Bentley* (Salem, 1905–1914), 3:38. There are only vague references in Norton's letters to the struggle over the Ware appointment, which, as Samuel Norton sourly pointed out, did not seem to interest Hingham folk in spite of their past association with Ware. On failed scholarship, Samuel Norton to Andrews Norton, Dec. 20, 1804. Thaddeus Mason Harris, "Phi Beta Kappa Poem," *Literary Miscellany* 2:197–198 (1805–1806). On the move to Nova Scotia, Andrews Norton to Samuel Norton, Dec. 6, 1804, Mar.[n.d.] 1805.

9. Andrews Norton, Diary, June 22, May 10, 1804. Andrews Norton to Samuel C. Thacher, n.d., to Samuel Norton, Nov. [n.d.] 1808. Andrews Norton to Samuel Norton, Dec. 19, 1807. See also Samuel Norton to Andrews Norton, Oct. 31, 1803, Oct. 21, 1804. For examples of his depression, see Henry Ware, Sr., to Andrews Norton, Sept. 5, 1804, Samuel Norton to Andrews Norton, June 19, 1809. The quotation is from a letter of John Adams to Charles Francis Adams, Dec. 3, 1825, in Aida di Pace Donald and David Donald, eds., *The Diary of Charles Francis Adams* (Cambridge, Mass., 1964), 1:xxviii.

10. Norton's pieces for the *Anthology* included "Sylva," 2:510–514 (1805); "Translations of Secundus on the origin of kisses," 3:359 (1806); "Moore's Poems," 4:41–45 (1807); "Observations on Allowing the Clergy the Occasional Use of Printed Discourses," 5:2–5 (1808); "Original Correspondence," 5:521–530 (1808); "Poetry," 7:112–113 (1809); "Article 7," 7:130–133. Quote from "Article 7," 7:131; "Smith's Lectures," 9:104–116 (1810). Mark Anthony De Wolfe Howe, ed., *Journal of the Proceedings of the Society Which Conducts the Monthly Anthology and Boston Review* (Boston, 1910), 39, 71, 90, 92, 154, 236–237. See also Andrews Norton, "Smith's Lectures," *Monthly Anthology* 8:393–419(1810).

11. On Norton's ministerial career in Augusta and his problems with preaching, see Andrews Norton to Samuel Norton, July 1, Aug. 2, Aug. 22, 1809; Andrews Norton to Samuel C. Thacher, Jan. 17, 1811, June 4, 1810, Sept. 11, 1809, Dec. 20, 1809; Samuel Norton to Andrews Norton, June 22, 1807, Sept. 1, 22, 1809, Mar. 27, 1819, Oct. 10, 1808. John Ware to Andrews Norton, Oct. 4, 1817, Benjamin Tappan to Andrews Norton, Oct. 13, 1810. When reading Gibbon's seventeenth chapter on the theological doctrine of incarnation, he agreed with "his philosophical contempt for the disputants on the doctrine of incarnation," Diary, Cambridge, May 12, 1807. On his view of the Athanasian creed, see Diary, Augusta, Sept. 29, 1809. On his view of preaching, see *Herald of Gospel Liberty* (New Hampshire, Portsmouth), "Two Isms," Feb. 2, 1809. Norton's quote from Andrews Norton, "Sermon by William Paley," *Monthly Anthology* 7:131 (1809). On the backwoods rebellion, see Stephen A. Marini, *Radical Sects of Revolutionary New England* (Cambridge, Mass., 1982).

12. For the pattern, see Joseph W. Phillips, *Jedidiah Morse and New England Congregationalism* (New Brunswick, N.J., 1983).

13. On Brunswick, Bowdoin, and return to Cambridge, Henry Ware, Sr., to Andrews Norton, Apr. 23, 1809. Andrews Norton to Levi Frisbie, Nov. 9, 1809, Feb. 23, Aug. 1, 1810, in Frisbie Papers, Harvard University Archives. Andrews Norton, Diary, Sept. 29, 1809, Nov. 1809. Andrews Norton to Samuel Norton, Mar. 9, 10, 1810, May 19, 1810. Samuel Norton to Andrews Norton, Apr. 26,

Lilian Handlin

June 4, Aug. 8, 1810. Andrews Norton to Samuel Norton, July 16, Aug. 2, 1810. On his depression during the spring when the question of the reappointment came up, see Samuel Norton to Andrews Norton, Mar. 27, 1810. See also Andrews Norton to Benjamin Tappan, Oct. 3, 1810, Henry Ware, Sr., to Andrews Norton, Sept. 5, 1810. Ashur Ware to Andrews Norton, May 12, 1810 (for dangers to Harvard). On how dull life could be at Bowdoin, see Benjamin Tappan to Andrews Norton, Jan. 8, Oct. 13, Nov. 30, 1810. For the significance of Benjamin Vaughan, see Willard, *Memories of Youth and Manhood*, 1:228–229; Elizabeth M. Geffen, *Philadelphia Unitarianism, 1796–1861* (Philadelphia, 1961).

14. Andrews Norton to Samuel C. Thacher, Jan. 17, 1811. Samuel Thacher to Andrews Norton, n.d. 1811, Jan. 12, 1811; Howe, ed., *Anthology Society*, 245, 246, 247 (the question was settled in January 1811). See also Lewis P. Simpson, ed., *The Federalist Literary Mind* (Baton Rouge, 1962).

15. On Norton's anticipation of widespread support for the publication, see Andrews Norton to unnamed correspondent, Sept. 2, 1811. "Editor's Address," *Monthly Anthology* 10:4 (1811); "Gardiner's Sermon," *Monthly Anthology* 10:177 (1811); Joseph Stevens Buckminster, "Griesbach's New Testament," *Monthly Anthology* 10:110 (1811). Norton, "Smith's Lectures," 113, has offending sections on Jewish scriptures. Samuel C. Thacher, "Editor's Address," *Monthly Anthology* 10:362–363 (1811). On the cautious spirit of the *Anthology*, see also Willard, *Memories of Youth and Manhood*, 2:228–230.

16. James Freeman quoted in "Review of the Unitarian Controversy," *Panoplist and Missionary Magazine* 12:206 (1816).

17. Andrews Norton to Charles Eliot, Nov. 3, 1812, Jan. 26, 1813; Andrews Norton to Jared Sparks, Apr. 30, 1812, Sparks Papers, Houghton Library; Andrews Norton to George Bancroft, Dec. 1, 1818, July 15, Dec. 29, 1820; Eliza Buckminster Lee, *Memoirs*, 2nd edition (Boston, 1851), 394.

18. "An Injurious Sophism," *Panoplist and Missionary Magazine* 6:261 (1810). Elizabeth Palmer Peabody, *Reminiscences of William Ellery Channing* (Boston, 1880), 21. Andrews Norton to George Bancroft, n.d., 1820; [Andrews Norton], "Contrast between Calvinism and Hopkinsianism," *General Repository and Review* 3:355, 376 (1813).

19. [Norton], "Contrast," 3:378. [Andrews Norton], "Defence of Liberal Christianity," *General Repository and Review* 1:11 (1812). "A few remarks on the Want of Ecclesiastical Tribunals," *Panoplist and Missionary Magazine* 5:56 (1812). See also "On the practical tendency of error," *Panoplist and Missionary Magazine* 10:204 (1814).

20. William B. Sprague, *The Life of Jedidiah Morse D.D.* (New York, 1874), 85. "Want of Ecclesiastical Tribunals," 57; on Norton's case for a front in form of consocation of liberals, "Contrast," 368.

21. On checks and balances, see [Norton], "Contrast," 377–378. Samuel C. Thacher, "Pamphlets of Noah and Thomas Worcester," *General Repository and Review* 1:348–349, 352, 359 (1812). Joseph Buckminster to his daughter, Dec. 1811, in Lee, *Memoirs*, 2nd ed., 433. For example, where preachers were told to avoid metaphysics, see James Freeman, *Sermons on Particular Occasions*, 3rd ed. (Boston, 1821), 245.

22. On the orthodox view of religion as an instrument for moving mankind, see, for example, *Christian Spectator* 3:538 (1825). On the Dorchester affair, "Review of the Dorchester Controversy," *Panoplist and Missionary Magazine* 10:262–

263 (1814). Andrews Norton, *Review of Professor Levi Frisbie's Inaugural Address* (Cambridge, 1823), 26. Of course Norton did not know, any more than contemporaries did, how religion and politics mixed, and whether rational Christians were more disposed to make proper electoral choices. For a modern assessment, see Paul Goodman, "The Social Basis of New England Politics in Jacksonian America," *Journal of the Early Republic* 6:23–58 (1986).

23. On the connection between liberalism and right politics, see William Ellery Channing, 1810 sermon in William Henry Channing, *The Life of W. E. Channing* (Boston, 1890); Phillips, *Jedidiah Morse*, 39–72; and Howe, *Unitarian Conscience*. On the relationship between wrong politics and wrong religion, see David Brigham to Willard Phillips, Oct. 16, 1812, Willard Phillips Papers, Massachusetts Historical Society.

24. [Norton], "Contrast," 369. William Ellery Channing, in *Christian Disciple* new ser. 2:11, 73 (1820). On which weapon would be more powerful, see also Turner, *Without God, Without Creed*.

25. [Andrews Norton], ed., *Miscellaneous Writings of Charles Eliot* (Cambridge, Mass., 1814), 184; Francis W. P. Greenwood, ed., *Sermons of the Late Reverend Samuel C. Thacher* (Boston, 1824), 162. On orthodox contempt for the same tactics, see Drury Fairbank to Benjamin Trumbull, July 15, 1812, Abiel Holmes Papers, Massachusetts Historical Society.

26. On Norton's evaluation of Kirkland, see Andrews Norton to Ashur Ware, Aug. 16, 1807. On the magazine contract and its future problems, see Samuel Norton to Andrews Norton, Sept. 24, Nov. 23, 1812, Apr. 21, 1813. See also Andrews Norton to Charles Eliot, n.d., summer of 1811; Norton to Samuel Willard, Sept. 3, 1811; and Norton to John Lowell, May 29, 1812, Harvard University Archives.

27. Andrews Norton, "Abbot's Statement," *General Repository and Review* 1:156, 157, 158 (1812). See also Bernard Whitman, *Two Letters to the Reverend Moses Stuart* (Boston, 1830), 27, 28.

28. Andrews Norton to Samuel Norton, Nov. 19, 1811; Norton, "Defence," 25; Samuel Norton to Andrews Norton, Mar. 11, 1812. For the spirit he hoped to destroy, see "Melancholy Effects of Calvinism, or the Human, Killing Doctrine of Fatality," *Herald of Gospel Liberty*, Sept. 28, 1810, reporting that Samuel Smith hanged himself because when he thought of hanging himself, he next thought that it must be God's will, otherwise he would not have thought so.

29. Term of "right reason" in Norton, ed., *Miscellaneous Writings of Charles Eliot*, 142. Norton, "Defence," 1, 2, 11, 12, 22–23, 24–25. For the cast of mind Norton was attacking, see the satiric account in *The Ordeal* 1:87–90 (1809); see also Norton, "Abbot's Statement," 158, 159–160. For Samuel Hopkins and his movement, see Joseph A. Conforti, *Samuel Hopkins and the New Divinity Movement* (Grand Rapids, 1981).

30. Samuel Norton to Andrews Norton, Jan. 30, Feb. 10, Mar. 12, 1812; Benjamin Tappan to Andrews Norton, Feb. 17, 1812. John T. Kirkland to Willard Phillips, Jan. 7, 1813, reviewing the entire opus up till then, also Edward Strong to Willard Phillips, Mar. 21, 1812, Willard Phillips Papers, Massachusetts Historical Society.

31. Samuel Norton to Andrews Norton, Jan. 30, Mar. 11, 1812; Samuel Norton to Andrews Norton, Feb. 10, 1812; [Norton, ed.], *Miscellaneous Writings of Charles Eliot*, 155.

Lilian Handlin

32. "Review of the Unitarian Controversy," 165, 166, 171. Several undated scraps in the Norton Papers, Houghton Library, from Buckminster clarify Buckminster's role as the unofficial censor. Buckminster's self-perception in Ticknor, "Memoirs of the Buckminsters," 183–189; Lee, Memoirs, 2nd ed., 229.

33. Charles Eliot, "Remarks on Ecclesiastical Tribunals," General Repository and Review 2:295, 305 (1812). Andrews Norton to Charles Eliot, Nov. 3, 1812; Andrews Norton, "Editor's Note," General Repository and Review 2:408 (1812); Thacher, "Pamphlets of Noah and Thomas Worcester," 167–168, 179, 182–183; John Lowell, "Montgaillard's Situation of England," General Repository and Review 2:140 (1812). On financial problems and Norton's illness during these months, see Andrews Norton to Samuel Norton, Feb. 18, May 26, July 18, Sept. 19, 1812. Samuel Norton to Andrews Norton, Sept. 24, 1812. Andrews Norton to Charles Eliot, June 27, July [n.d.] 1812. On the death of Buckminster, Andrews Norton to Charles Eliot, June 13, 1812; Andrews Norton, "Character of Rev. Joseph Stevens Buckminster," General Repository and Review 2:306–312 (1812).

34. Andrews Norton to Samuel Norton, Nov. [n.d.] 1812, Nov. 23, 1812; Andrews Norton to Charles Eliot, Jan. 19, 1813. Andrews Norton, "Editor's Note," General Repository and Review 3:231 (1813). Subscription Letter of Society of Gentlemen, March 1813. Alexander H. Everett to Andrews Norton, Mar. 11, 1813; see also Feb. 26, 1814. Andrews Norton to Samuel Norton, Apr. [n.d.] 1813.

35. [Norton], "Contrast," 330, 334–335, 342, 347, 368, 378. As a student, Andrews Norton already did not like Holmes; see Andrews Norton to Samuel Norton, June 24, 1803.

36. "The Editors to the Public," General Repository and Review 4:403, 404 (1813). On the new version of the Disciple, see Willard, Memories of Youth and Manhood, 2:280. For moderation, see "Occasional Reflections," Christian Disciple 1:225–228 (1813); William Ellery Channing, "Dissertation on the Sinfulness of Infants," Christian Disciple 2:245–250 (1814). On Noah Worcester's better press with the orthodox, see Panoplist and Missionary Magazine 12:163 (1816). William Ellery Channing to Samuel C. Thacher, June 20, 1815, William Ellery Channing to Noah Worcester, Jan. 11, 1813, in Channing, Life of W. E. Channing, 199, 202, 187–188. See also draft of letter, Apr. 1813, William Ellery Channing Papers, Massachusetts Historical Society. Norton's affiliation with the Repository continued via several small articles and occasional editorial advice.

37. Harvard College Corporation Records, vol. V; the orthodox quote is from Abiel Holmes, A Sermon Delivered at the Inauguration of the Rev. Ebenezer Porter, A.M., to the Office of Bartlett Professor of Sacred Rhetoric in the Theological Institution at Andover (Boston, 1812), 30.

38. On Norton's attitude to German higher criticism, see Andrews Norton, Statement of Reasons for Not Believing . . . (Boston, 1819), 43n.; Andrews Norton, Inaugural Discourse Delivered before the University in Cambridge, August 10, 1819 (Cambridge, Mass., 1819), 35; Andrews Norton to Samuel A. Eliot, Mar. 4, 1824; Norton, Review of Professor Levi Frisbie's Inaugural Address, 30; G.T., "Theological Remarks," Panoplist and Missionary Magazine 13:156 (1817). For Buckminster, see Lawrence Buell, "Joseph Stevens Buckminster: The Making of a New England Saint," Canadian Review of American Studies 10:1–30 (1979).

39. For appreciation of Herbert Marsh, see [Andrews Norton], "Marsh's Lec-

tures," *General Repository and Review* 1:216 (1812); Andrews Norton, notes for lectures, 1813, see copies in handwriting of his brother John Norton; "Review of Unitarian Controversy," 169; [Norton], "Contrast," 353. Also see Norton, *Inaugural Discourse*, 46. On wider significance and Norton's place in the newly developing philological theories, see James Turner, "Andrews Norton and the Problem of Language" (unpublished paper); Philip F. Gura, *The Wisdom of Words, Language, Theology and Literature in the New England Renaissance* (Middletown, Conn., 1981).

40. On the machinations around the Eliot chair, see Andrews Norton to Samuel Norton, May 4, June 20, 1814, Feb. 29, 1816. See also Andrews Norton to Samuel Norton, July 28, Feb. 25, 1816. On the origins of the Divinity School, see George H. Williams, ed., *The Harvard Divinity School: Its Place in Harvard University and in American Culture* (Boston, 1954), and Corporation Records, vol. 5, Oct. 24, 1815. On Holmes's teaching, see Jared Sparks's comment July 16, 1817, in Herbert Baxter Adams, *The Life and Writings of Jared Sparks* (Boston, 1893), 1:101.

41. Channing, *Life of W. E. Channing*, 204–205; Greenwood, ed., *Sermons of the Late Reverend Samuel C. Thacher*, 240. See also ibid., "Dedication of the New Church," 279, 287–289, 296–297, 302–305. Even John Adams wrote on top of his famous letter to Jedidiah Morse, "This letter must not be printed." See John Adams to Jedidiah Morse, May 15, 1815, in Norton Papers, Massachusetts Historical Society. John Lowell to Timothy Pickering, Feb. 6, 1816, in Timothy Pickering Papers, vol. 31, Massachusetts Historical Society.

42. On his vision of what the school should be, see [Norton], "Contrast," 363. On the association of the *Repository* types with the college and potential theological school, see "Review of American Unitarianism," 165. See also "Review of Observations on Theological Education," *Panoplist and Missionary Magazine* 12:29 (1816). On the purposes of the new school and fund drive, see *Christian Disciple* 4:23, 25, 26, 30 (1816). On his own feelings of insecurity and occasional success: Andrews Norton to Samuel Norton, Dec. 16, 1816, Mar. 23, Apr. 26, June 24, Nov. 3, 1817; John Ware to Andrews Norton, July 17, 1817; Andrews Norton to John Ware, Mar. 14, 1817.

43. The story surrounding the McKean death, Rhetoric chair, and Dexter options followed in an unaddressed letter, Andrews Norton to ——, Aug. 15, 1818; see also Andrews Norton to Samuel Norton, Mar. 31, Aug. 12, 1818; Andrews Norton to Levi Frisbie, Sept. 10, 1818, Harvard College Archives; Andrews Norton to George Bancroft, Sept. 11, Dec. 1, 1818.

44. "Review of the Unitarian Controversy," 207–208. Andrews Norton to J. G. Palfrey, n.d. 1819, also May 28, 1841, Andrews Norton to Josiah Quincy, Mar. 1, 1842.

45. Andrews Norton to —— Cushing, Sept. 20, 1819; Andrews Norton, *Discourse on Religious Education; Delivered at Hingham, May 20, 1818, before the Trustees of the Derby Academy, Being the Annual Derby Lecture* (Boston, 1818), 5. Quote from Kirkland, in Edward Everett to Jared Sparks, Apr. 13, 1821, Adams, *Life and Writings of Jared Sparks*, 1:181. Matters went so far that in an undated 1819 letter to Palfrey, Norton asked that his authorship of a review of Sabine's sermons and the *Panoplist*, printed in the *Disciple*, be kept secret.

46. Andrews Norton to George Bancroft, May 24, July 15, 1819. On salary, two-thirds of the usual one, see Andrews Norton to James Savage, May 25, 1840.

Lilian Handlin

"Review of Observations on Theological Education," 31. Andrews Norton to George Bancroft, Feb. 25, Apr. 6, 1819, also Dec. [n.d.] 1819.

47. Andrews Norton to Jared Sparks, Aug. 10, 1820, Dec. 21, 1820, Sparks Papers, Houghton Library. On the optimism of these years, see also Andrews Norton to John F. Steele, Nov. 7, 1820; to George Bancroft, Aug. 8, Dec. 1819; May 24, July 15, 1819. On battles in New York, see Andrews Norton, "Notice of Some Attacks upon Liberal Christians at New-York," *Christian Disciple and Theological Review* new ser. 3:70 (1821). See also Henry Sewall to Andrews Norton, April 29, Sept. 20, Dec. 26, 1820; Feb. 12, 1821. [Andrews Norton], "Professor Frisbie's Inaugural Address," *North American Review* 6:240–241 (1817–1818).

48. Norton, *Inaugural Discourse*, 15–16, 38. Andrews Norton, *Statement of Reasons for Not Believing the Doctrines of Trinitarianism Respecting the Nature of God and the Person of Christ, Occasioned by Professor Moses Stuart's Letters to Mr. Channing, First Published in the Christian Disciple* (Boston, 1819), 12, 64; Andrews Norton, *Thoughts on True and False Religion* (Boston, 1820), 28, 39–40. On beginnings of *The Genuineness of the Gospels*, see also Diary note, Dec. 31, 1818, undated scraps, Norton Papers, numerous letters in Houghton MSS over the years, also Samuel Norton to Andrews Norton, Apr. 20, 1825. Eliot was in part responsible for *The Statement of Reasons*. See Andrews Norton to Jared Sparks, Aug. 10, 1820, Sparks Papers, Houghton Library; [Andrews Norton], "Review of James Sabine's Glorying in the Cross," *Christian Disciple* new ser. 1:131, 136, 139 (1819); Andrews Norton, "Thoughts on True and False Religion," *Christian Disciple* new ser. 2:353 (1820).

49. "Miscellany," *Boston Kaleidoscope and Literary Rambler*, Aug. 7, 1819; also "Notice of an Article in the Universalist Magazine of July 17, 1818," ibid., July 24, 1819, showing Hosea Ballou's enthusiastic endorsement of Channing. "Extract" (on hostility to colleges), ibid., Aug. 21, 1819. On the reception of Channing's sermon, see also Samuel A. Eliot to Andrews Norton, May 6, 1819; Andrews Norton to George Bancroft, Apr. 29, 1820; Henry Dwight Sedgwick to William Ellery Channing, May 9, 1819, in William Ellery Channing Papers, Massachusetts Historical Society.

50. Samuel A. Eliot to Andrews Norton, Dec. 27, 1819. Later, when Norton proposed to expand and re-publish his answer to Stuart, Channing agreed that the Andover professor was vain, rash, and made unfounded statements. But Channing again cautioned against personalities and was inclined to let Stuart off as lightly as reconcilable with self-respect. "A sense of injury he has done us should be expressed calmly and forcibly," but there was no need to begin another fight (W. E. Channing to Andrews Norton, Sept. 3, 1832). On the Edward Everett debacle, see Levi Frisbie to Andrews Norton, Jan. 27, 1820. Andrews Norton to George Bancroft, Aug. 8, 1819, mentions that he has been chosen to answer Stuart, but another letter, Dec. [n.d.] 1819, says he does not consider his answer to Stuart as important as the articles in the *Disciple*. John Palfrey to Andrews Norton, n.d., 1819, Andrews Norton to Jared Sparks, Jan. 6, 1820, Sparks Papers, Houghton Library, Andrews Norton to John G. Palfrey, Jan. 31, 1820, Palfrey Papers, Houghton Library. John G. Palfrey to Andrews Norton, Dec. 27, 1819, Jan. 11, 1820. Thus, though Palfrey could write to Sparks, Apr. 3, 1820, that the new issue of the *Disciple* had Channing handling Calvinism "without mittens," he also wrote him, Apr. 11, 1821, that at present the *Disciple* de-

clined to review Sparks's answer to Miller, and cautioned him against being too severe and polemical, Sparks Papers, Houghton Library. Norton, *Thoughts on True and False Religion*, 25. On John Gorham Palfrey in these years, see Frank Otto Gatell, *John Gorham Palfrey and the New England Conscience* (Cambridge, Mass., 1963), 29–64. On the way Channing wanted to answer Moses Stuart, see William Ellery Channing to Moses Stuart, Oct. 20, 1819, draft, in William Ellery Channing Papers, Massachusetts Historical Society, where, while not giving an inch on substantive matters, Channing said that he was delighted that he, Channing, gave rise to so able a champion in the defense of orthodoxy, and closed with the hope that God would deliver them both from selfishness, ambition, and prejudice. See also Channing correspondence of the next few years, expressing a similar spirit which included the suggestion that too much attention had been paid to Biblical criticism and theological controversy, cutting off the branch on which men like Norton sat.

51. Francis Parkman to Jared Sparks, Jan. 19, 1820, in Adams, *Life and Writings of Jared Sparks*, 1:167–168. See also Andrews Norton to Jared Sparks, Apr. 30, 1821, Apr. 31[?], 1821. Jared Sparks to Mrs. Storrow, Aug. 3, 1821, in Adams, *Life and Writings of Jared Sparks*, 184–185; John Gorham Palfrey to Jared Sparks, Apr. 11, 1821, Sparks Papers, Houghton Library. Edward Everett to Jared Sparks, May 17, 1821, in Adams, *Life and Writings of Jared Sparks*, 181; Jared Sparks to Andrews Norton, Sept. 12, 1821. William Ellery Channing to Catharine M. Sedgwick, May 20, 1821, in William Ellery Channing Papers, Massachusetts Historical Society. Francis Parkman, undated ordination sermon, in Papers of the Reverend Francis Parkman, Massachusetts Historical Society.

52. Andrews Norton, "Thoughts on True and False Religion," 353–354. On Charles Lowell, see Charles Lowell, *Discourse Delivered before the Society for Promoting Christian Knowledge, Piety, and Charity* (Boston, 1816); Charles Lowell, *Sermon Preached September 12, 1821* (Boston, 1821); Charles Lowell, *Discourse Delivered in the West Church in Boston, December 31, 1820* (Boston, 1820). On the spectre of social anarchy, raised in this instance by the Universalists, see "What are the Grounds of Acceptance with God?" *Christian Disciple* 1:93 (1819). William Ellery Channing to Catharine M. Sedgwick, May 20, 1821, in William Ellery Channing Papers, Massachusetts Historical Society. The term "shadowy orthodoxy" is from an undated letter of William Ellery Channing, filed in the 1820s section in William Ellery Channing Papers, Massachusetts Historical Society.

53. Jared Sparks to Andrews Norton, Oct. 20, 1820, Andrews Norton to Jared Sparks, Aug. 10, 1820, Sparks Papers, Houghton Library. See Andrews Norton to John G. Palfrey, Mar. [n.d.] 1819, to George Bancroft, Dec. 29, 1820. For attacks on the wrong kind of authority, see Andrews Norton to John G. Palfrey, n.d. 1820, also Norton, *Thoughts on True and False Religion*, 19. On crisis of authority, see Barbara Packer, "Origin and Authority: Emerson and Higher Criticism," in Sacvan Berkovitch, *Reconstructing American Literary History* (Cambridge, Mass., 1986), 67–92. Conrad Wright, ed., *A Stream of Light: A Sesquicentennial History of American Unitarianism* (Boston, 1975), 16, traces this crisis to Buckminster.

54. Norton, *Thoughts on True and False Religion*, 23, 28–29.

55. "Review of Pamphlets on the Unitarian Controversy," *Christian Spectator* 3:193, 197 (1821). "Reviews of Views of Calvinism by Professor Norton from the Christian Disciple," ibid., 5:200, 210, 219 (1823); "Reviews," ibid., 6:313

Lilian Handlin

(1824); also "Review of Thoughts on True and False Religion First Published in the Christian Disciple," ibid., 4:311 (1822). For the battle with the *Spectator*, see also Andrews Norton to his brother (John Norton), Sept. 29, 1822, Apr. 8, 1823; to Samuel A. Eliot, May 26, June 18, 1823; to Samuel Norton, July 28, 1823. The substantive points in dispute are examined in Sidney E. Mead, *Nathaniel William Taylor, 1786–1858* (Chicago, 1942).

56. Andrews Norton to George Ticknor, *Christian Examiner* 47:202 (1849); Andrews Norton to John C. Palfrey, n.d. 1822.

Brook Farm. Oil on panel by Josiah Wolcott, of Boston, about 1843. The painting shows the Hive, Shop, Phalanstery, Eyrie, Cottage, and Pilgrim House, and the entrance to the grounds of the community. Gift of Dr. Benjamin H. Codman, 1926. Collection of the Massachusetts Historical Society.

The Cambridge Platonists of Old England and the Cambridge Platonists of New England

DANIEL WALKER HOWE

They [the founders of American Unitarianism] were much more than mere denominationalists. . . . The whole tone of their teaching was profoundly positive in its moral quality. Trained at our American Cambridge, they were really the legitimate heirs of that noble group of men nurtured at the Cambridge of England—the Latitude Men, as they were called,—who blended culture and piety and rational thought in their teaching.

HENRY WILDER FOOTE[1]

This essay, like most, began with a question. How were the Transcendentalists and the Unitarians able to reunite after their great debate in the time of Ralph Waldo Emerson, Andrews Norton, and George Ripley? Although the philosophical issues posed in that classic confrontation of

Daniel Walker Howe is Professor of History, University of California, Los Angeles. He is pleased to acknowledge the help of his research assistant, Rachelle Friedman, as well as the comments and criticisms of his UCLA colleagues Richard Popkin, Amos Funkenstein, Barbara Packer, and Ruth Bloch, and all the participants in the Massachusetts Historical Society's conference on American Unitarianism, 1805–1865, especially Phyllis Cole, C. Conrad Wright, and Conrad E. Wright. An earlier version of this article appeared in *Church History* 57 (1988).

the 1830s were sharp enough, later in the nineteenth century the Transcendentalists proved able to reestablish themselves within the Unitarian denomination, becoming one of the dominant forces within it. There were even a number of leading Transcendentalists who found it possible to remain Unitarian ministers in good standing throughout the whole period of controversy. Perhaps the classical Unitarians and the Transcendentalists held something important in common, which proved a philosophical basis for the resolution of their epistemological differences. I set myself to discover if this were so. In the process I uncovered a complex cultural tradition, reaching back over a long period of time. The inquiry took on a life of its own, going far beyond the question that triggered it.

What the two branches of New England religious liberalism had in common, it turned out, was a form of natural religion that looked inward toward human nature itself rather than outward toward the external world. The study of this "internal" form of natural religion led me to an appreciation for a pietistic, Neoplatonic side of American liberal religion. The origins of this strain may be found in the English Cambridge Platonists.

Introduction

As early as the eighteenth century, there were two strands in New England liberal religion, an empirical rationalism typified by Charles Chauncy and a softer, more pietistic kind of religion typified by Benjamin Colman. The former is better known, particularly because of the prominence of Chauncy's opposition to the Great Awakening. We are less likely to remember that Jonathan Edwards addressed his *Narrative of Surprising Conversions* to a more sympathetic liberal, Benjamin Colman.[2] The intellectual origins of both these strains can be traced back to England: Chauncy's to Locke and the Latitudinarians of the Tillotson school; Colman's to the so-called Platonists who flourished at Cambridge in the mid-seventeenth century.

Close inspection reveals the two strains intertwine. Both the Latitudinarians and the Cambridge Platonists were actually rationalists, but they defined the use of reason differently. The former were empiricists and utilitarians; the latter, while not unsympathetic to science, were more interested in constructing a rational morality. Both were tolerant and humane, undogmatically Arminian in theology, remaining within the established church while seeking to render it comprehensive. The word

"latitude-men" or "latitudinarian" was originally used to apply to the Cambridge Platonists; like most religious labels it was of course at first a slur. Not until John Tulloch's great history of rational theology, written in the 1870s, were the Cambridge Platonists identified as a group separate from the Lockean empiricists.[3]

Throughout the eighteenth century, the rationalist and the pietist strains in Anglican thought continued their coexistence. John Locke, while lacking the mysticism and belief in innate ideas typical of the Cambridge Platonists, concurred in their respect for both natural and revealed religion, their identification of reason with virtue, their impatience with theological quibblings, and their willingness to refer things that Scripture left indifferent to the decision of the secular authorities.[4] The appreciation for the mystery and beauty of the universe that Locke and Tillotson tended to leave out of the heritage of the Cambridge Latitude-Men was supplied by some of the eighteenth century's writers on natural religion: the Earl of Shaftesbury, Edmund Law, and Joseph Butler. The rational-intuitionist ethical system characteristic of the Cambridge Platonists was followed up by a series of prominent thinkers including Samuel Clarke, William Wollaston, Richard Price, and Thomas Reid. Philip Doddridge's influential Dissenting academy displayed (as the name "academy" suggested) Platonic interests. And even Lord Herbert of Cherbury, notorious deist that he was, manifested a Platonic pietism.

Such was the tradition of Latitudinarian reason, morality, and piety, including within its rich variety a powerful Platonic component, available to the religious liberals of New England. As we shall see, both Unitarians and Transcendentalists made use of this Platonic heritage. Indeed, it may well be possible to demonstrate that a strain of Neoplatonic pietism is one of the distinguising characteristics of all the religious heirs of the New England Puritans, whether Hopkinsian, Bushnellian, Unitarian, or Transcendentalist, right through the nineteenth century. That would be more than can be undertaken here. But it is important to recognize that these various schools of New England thought are distinguished from each other on the basis of their intellectual propositions, not necessarily on the basis of the warmth of their piety.

The Cambridge Platonists of Old England

The group of seventeenth-century intellectuals we call the Cambridge Platonists were centered at Emmanuel and, later, Christ's colleges of

Cambridge University. They included Benjamin Whichcote (1609–1683), their founder; Ralph Cudworth (1617–1688); Henry More (1614–1687); Nathaniel Culverwell (1618?–1651?); John Smith (1618–1652); and John Norris (1657–1711), the last true member of the school, who adapted their teachings to the philosophy of Nicholas Malebranche. All came out of Puritan backgrounds which they to some extent rejected. The Cambridge Platonists occupied a difficult position, resisting most of the trends of their time. They were moderates in an age of polarization; sympathizers with the Dutch Remonstrants, or Arminians, after these had been repudiated by the Reformed community at the Synod of Dort; and advocates of toleration in an age of religious warfare. In short, they defended the Renaissance values of reason and humanism against what has been called the "Counter-Renaissance," that is, the exaltation of will and passion.[5]

The writers whom the Cambridge Platonists particularly disputed were Calvin and Hobbes, both of whom made moral values dependent upon will—the will of God, in the case of Calvin, that of the Sovereign, in the case of Hobbes. Either seemed unacceptable to the Cambridge humanists, who invoked Platonic and Stoic conceptions to defend the objective and immutable nature of moral standards. Even God was controlled by these principles, which formed part of His nature and were not subject to His will. True human freedom consisted in the rational pursuit of virtue, not in subjugation to the will of God or the State.[6]

The favorite biblical text of the Cambridge Platonists was Proverbs 20:27: "The spirit of man *is* the candle of the LORD." The Hebrew "spirit" here mentioned they interpreted to mean *psyche* in the Greek sense, usually translated in English as "soul" or "mind," but typically called by them "reason." The mind or reason was the "candle of the LORD" because it was the divine light vouchsafed to guide humanity through the pitfalls of this life. "A man has as much right to use his own understanding in judging of truth as he has a right to use his own eyes to see his way," declared Benjamin Whichcote in one of his famous *Aphorisms*.[7] Reason is what most distinguishes men from animals; religion is a man's most important concern; "hence it follows that the principal use he ought to make of his rational faculty is in religion." So reasoned John Norris.[8] The good life was the rational life, a quest for wisdom and virtue, freely undertaken. The Cambridge Platonists were humanists in both senses of that word: they practiced Renaissance classical scholarship, and they believed that man's destiny could be defined in terms of the full develop-

Daniel Walker Howe

ment of his powers. "In the use of reason and the exercise of virtue we enjoy God."[9] Thus were Christianity and the Greek philosophic ideal synthesized by these engaging Christian Platonists.

Within the writings of Plato, the most important for the purposes of the Cambridge group was the doctrine of Ideas presented in *Phaedrus*. According to this, the objects our senses encounter are but shadows of the eternal Ideas existing in the Mind of God. True human wisdom consists in understanding not the shadows but the reality behind them. Among such realities are the immutable principles of morality and religion.[10] What gave substance to this quest was the recognition that the human mind/reason partook of the same nature as the Divine Mind/Reason.

Although the term "Cambridge Platonists" has become standard, the group made use of many classical thinkers in addition to Plato, including Plutarch, Cicero, and Seneca. In particular, they borrowed from Plotinus (205–270 A.D.), the founder of Neoplatonism. Six hundred years after Plato, the Alexandrian Plotinus elaborated his predecessor's philosophy into a system for seeking God within one's own *psyche*, working through the essential identity between the spirit or reason within and the great Spirit or Reason, the *Nous*, that controlled the Universe.[11] From Plotinus derived the mystical side of Cambridge Platonism and the natural religion of the soul. Through the exercise of reason, the Cambridge thinkers pursued Perfection; through knowledge, they sought communion with the Unknowable.

Platonism in Colonial New England

There was considerable mutual interaction and even influence between the Cambridge Platonists and their Puritan contemporaries, notwithstanding their differences. The Ramist version of Platonism was shared by participants on both sides of the Remonstrant–Counter Remonstrant controversy, and this seems to have laid the groundwork for intellectual borrowings from the Cambridge school by their Calvinist adversaries.[12] During the Interregnum the Latitude-Men kept their university posts and had many ties, personal and professional, with the Puritan regime. (Cudworth, for example, participated in the deliberations leading to Cromwell's readmission of the Jews to England.)[13] The Puritans in the New World had their own network of personal ties with Cambridge Platonism, which grew up in the Emmanuel College of John Harvard,

John Cotton, and Thomas Hooker. Ralph Cudworth's brother, James, lived in Scituate, Massachusetts.

The gradual replacement of Aristotelian by Platonic philosophy at seventeenth-century Harvard has been well documented.[14] Puritan divines found reassurance in the theory, which dated back to the middle ages, that Plato was really Jewish or at least was conversant with the Law of Moses.[15] The pietism of the Cambridge writers resonated with the devotionalism of New England Puritans like Thomas Shepard and Charles Morton, who found enough spiritual nourishment in the Platonists' works to overlook their doctrinal heterodoxy. The adoption of the Cambridge Platonist Henry More's *Enchiridion Ethicum* (1667) as the principal Harvard text in moral philosophy during the 1680s was a landmark in the transition away from Aristotelian scholasticism and toward a reconstruction of moral philosophy in the Neoplatonic tradition. Later, the book was to be assigned at Yale as well.[16] All in all, the Cambridge Platonists seem to have been better received by the American Puritans than they were by their English contemporaries.

The greatest of colonial Puritan philosophers was, of course, Jonathan Edwards. Recently, under the learned guidance of Norman Fiering and Wallace Anderson, we have come to view Edwards as more in the tradition of seventeenth-century rationalism than of eighteenth-century empiricism.[17] The rationalist tradition Fiering and Wallace invoke includes not only the Cambridge Platonists but also Descartes and the Cartesian Oratorian Nicolas Malebranche. Fiering has worked particularly hard to establish a connection between Edwards and Malebranche, an effort reminiscent of those of earlier scholars to connect Edwards with Berkeley.[18] Actually, Edwards had even more in common with the Cambridge Platonists than he did with Descartes and Malebranche.[19]

Reading through works of the Cambridge Platonists, one cannot but be struck by the similarities in style, content, and vocabulary with Edwards. John Smith's "The Excellency and Nobleness of True Religion" (1660) celebrates an inward sense of divine beauty and goodness and declares that the good man "is so overpowered with the love of the universal and infinite goodness, that he would not serve any particular good."[20] Other anticipations of typical Edwardsian themes can be found in the deductive logic of Henry More's *Enchyridion Ethicum* or Ralph Cudworth's argument that "all created beings are themselves in some sense, but the rays of the Deity."[21] And when Edwards encountered Malebranche, it may well first have been through the mediation of the Cam-

Daniel Walker Howe

bridge Platonist John Norris, whose *Essay Towards the Theory of an Ideal and Intelligible World*, published in 1701 and 1704, made Malebranche's ideas well known to the English-speaking world.

An even closer intellectual kinsman for Edwards would be the English Calvinist philosopher Peter Sterry (d. 1672), who tried to reconcile the thinking of the Cambridge school with the decrees of the Synod of Dort. Sterry's *Discourse of the Freedom of the Will* (published posthumously in 1675) anticipated the course of Edwards's later treatise on the subject. Sterry argued that God's will is the only free will in the universe. Like Edwards, Sterry was concerned with the problem of theodicy, and like him as well, he portrayed God as a creative artist and the universe as His work of art. Sterry was more original than Edwards, inasmuch as he argued against the infinite punishment of the wicked.[22]

Not only Edwards but his colonial adversaries as well were aware of and influenced by Platonic rationalism. Jonathan Mayhew, the most outspoken of the New England liberals, made use of ideas from Ralph Cudworth and Samuel Clarke in describing the attributes of God.[23] (More surprisingly, he invoked Plato himself as a theorist of "civil liberty" along with Demosthenes, Cicero, Sidney, Milton, Locke, and Hoadley.)[24] Ebenezer Gay, the liberal patriarch of Hingham, set an important precedent for the liberals of later generations when he delivered his Dudleian Lecture in 1759. Instead of deriving evidence of divine providence from the wonders of external nature, Gay chose to look primarily within the *psyche*. He exalted the "divine Workmanship in human Nature" and argued that human beings were formed "for the Practice of Virtue" because God "hath annexed a secret joy or Complacence of Mind to such Practice."[25] In adopting this line of argument, Gay gave a tacitly Neoplatonic interpretation to the meaning of "natural religion." Later liberals would be more explicit, both in the substance of their theology and in acknowledging its sources.

In the long run, the Platonic tradition in American religious thought was cultivated at least as strongly by religious liberals as by the more orthodox. The Calvinist successors of Edwards were not aware of the full range of his Platonic tendencies because many of his metaphysical idealist speculations remained unpublished. The "New Divinity" theologians of New England did build upon Edwards's Platonic conception of virtue, but the Old School Presbyterian Calvinists of Princeton, although they revered Edwards as a theologian, displayed none of his Platonic philosophy. The liberal heirs of Ebenezer Gay, on the other hand,

elaborated ever more fully on the Platonic tradition, first in the Christian Unitarianism of Channing and his fellows, then in Transcendentalism.

The Cambridge Platonists of Nineteenth-Century New England

There are many analogies between the Platonists of the seventeenth-century English Cambridge and those of nineteenth-century New England Unitarianism. To begin with, they found themselves in similar situations. Both groups were intellectual elites, lacking any substantial popular following. Dependent to some extent on the favor of the powerful, they nevertheless faced up to the duty to criticize power, whether that of Laudian sacerdotalism or Cotton Whiggery. Both conceived of themselves as defending rational Christianity on two fronts: against Calvinism on the one hand and infidelity on the other. Both espoused the virtues of tolerance and irenicism—and, truth to tell, these virtues worked to their advantage, as groups that had little coercive power save that of their arguments.

In describing the relations between the nineteenth-century American Unitarians and the Cambridge Platonists of Renaissance England, it may seem convenient to speak in terms of "influences." But it would be a mistake to invest the term "influence" with a *causal* meaning. We should not for a moment suppose that William Ellery Channing or James Walker or James Freeman Clarke began by making a decision to subscribe to a set of Neoplatonic doctrines and thus was somehow compelled to follow out this logic. A more accurate understanding would be that the Unitarians were aware of this tradition and *made use* of it because it helped them formulate and legitimate what they wanted to say. The many parallels in situations gave rise to analogies in attitudes, so that the earlier Cambridge thinkers provided a ready resource for these later ones.

One reason, and a necessary one, why the nineteenth-century Unitarians were able to make so much use of the Platonic tradition is that they were still trained in classical scholarship. Indeed, the standard curriculum in both secondary and higher education in nineteenth-century America remained dominated by classical studies to an extent historians do not always appreciate.[26] Under the leadership of George Ticknor, Harvard pioneered in the teaching of modern foreign languages, but this does not mean the Harvard Unitarian intelligentsia of his time devalued the ancient languages or their educational role. Even after President Eliot introduced the elective system, Greek and Latin requirements dominated

Daniel Walker Howe

94

the Harvard College admissions procedure until the formation of the College Entrance Examination Board at the end of the century.[27] The traditional classical curriculum and the pedagogical innovations of nineteenth-century Harvard were both defended as providing the proper development of the human faculties, in terms of an educational theory not altogether different from the Renaissance humanism of Ralph Cudworth.[28]

Of course, Neoplatonism was not the only philosophical system employed by the nineteenth-century Unitarians. Classical Unitarians fitted their Platonic heritage into a context of eighteenth-century Scottish realism that provided the basic contours for their thought-world.[29] This Scottish philosophy of common sense lent itself to accommodation with elements of Platonism. The Scottish philosophy had originated in a synthesis of seventeenth-century rationalism with Lockean empiricism. It was intended to respond to Hume's skepticism by providing rational justification for empiricist practices.[30] Like the Platonic tradition, the Scottish philosophy described the faculties of man's complex nature and located *a priori* principles of reasoning in the structure of the human mind itself. The Scottish philosophers taught that the structure of the mind included certain principles (Thomas Reid called them the principles of "common sense") that provided intuitive, yet rational, validation for trusting our five external senses as well as believing in our own free will and our continued existence from moment to moment. In Reid's version, which the New England Unitarians followed, the philosophy also continued the ethical rationalism of Cudworth and More. Since there was so much in the Scottish philosophy that was already compatible with, or even derived from, Platonic rationalism, there was no clear barrier to finding further room within it for the Neoplatonic natural religion of the soul, as this came to be elaborated by New England liberals.[31]

New England Unitarianism, in what may be called its "classic" form, was consistently dualistic in metaphysics, affirming the existence of both mind and matter.[32] In this respect it remained true to Scottish common-sense philosophy. But within this framework, mind was exalted over matter. No one explained the attitude better than Channing:

> From the very dawn of philosophy there have been schools which have held that the material universe has no existence but in the mind that thinks it. I am far from assenting to these speculations. But I recur to them with pleasure, as indicating how readily the soul passes above matter, and as manifesting man's consciousness of the grandeur of his spiritual nature.[33]

The Cambridge Platonists of Old and New England

The Platonic-Neoplatonic philosophical tradition is, of course, accounted as idealist in general; nevertheless there are passages in the writings of the Cambridge Platonists that accord an independent, but inferior, existence to matter.[34] The Cambridge Platonists were actually metaphysical dualists who were initially attracted to Cartesianism until they came to the conclusion that its sharp separation between mind and matter did not lend itself to the kind of Plotinian natural religion that interested them.[35] Centuries later, the shared desire to accept the reality of both mind and matter while according mind priority *over* matter is what drew the New England Unitarians to the Cambridge Platonists. For both groups, mind was the active force in the universe, and matter the passive.

The Unitarians' attitude toward external nature was conditioned by these Platonic, Neoplatonic, and quasi-Platonic presuppositions. Of course, like all Christians of their day, they were practitioners of natural theology, the study of how the order of nature reflected the providence of God. (For example, water expands when it freezes, causing ice to float and preventing the oceans from freezing permanently, as they would if ice sank). More directly relevant to the background of Transcendentalism was the liberals' habit, inherited from the Christian Renaissance, of looking at nature as a set of moral and spiritual symbols, finding (in Shakespeare's wry summary) "tongues in trees, books in the running brooks, / Sermons in stones, and good in everything." The beauties of the world pointed to something beyond themselves, and wise souls aspired to know this, to "penetrate beyond the visible, free ourselves of the finite and mutable, and ascend to the Infinite and the Eternal."[36] Like the Cambridge Platonists, the Unitarian humanists of New England's Renaissance preferred organic and symbolic descriptions of nature to mechanistic ones.

Professor Andrew Preston Peabody of Harvard was a leading spokesman of the official Platonism of classic Unitarianism. His address to the Harvard Phi Beta Kappa chapter, "The Connection Between Science and Religion," applied Platonic principles to Unitarian natural religion. "The attributes of God are the ultimate cause,—his ideas, the archetypes of all things." A just estimate of the attributes of God is therefore conducive to sound inquiry in both science and religion; monotheism encourages science to presume uniform laws of nature, for example. After praising Plato and Pythagoras as examplars of the true spirit of philosophy and

science, Peabody concluded that both science and religion seek, in the last analysis, to read "the thoughts of God."[37]

Among the most important of God's thoughts were the principles of morality. The Cambridge Platonists had taught that these were loved and willed by God because they were right, not the other way around. God then implanted a rational conscience in our nature so that we too might love and fulfill them. This rational faculty, "the candle of the LORD," constituted His first revelation to mankind; Scripture was (in Whichcote's expression) an "after-revelation" elaborating on the first.[38] Peabody built on this tradition of ethical rationalism in another Phi Beta Kappa address, delivered at Brown University in 1858. "Omnipotence cannot make two and two five, or alter the sum of the angles of a triangle," he began. "May not moral laws be equally necessary and immutable?" "God's decrees and acts are not right because they are his, but his because they are right."

> I might, in some important aspects, liken the Bible to Euclid's "Elements of Geometry." Euclid created no truth; but he first codified that portion of eternal truth which appertains to space and dimension. There are spiritual mathematics, necessary and eternal laws of spiritual being, uncreated, co-eval with the divine existence; and these God has codified for us through men specially inspired for that express end. The Bible is the geometry, the mechanics, the astronomy, of the spiritual universe.

Peabody concluded by commending the morally uplifting poetry of Wordsworth and Whittier and condemning an amoral politics of "manifest destiny" that ignored the "higher than human law."[39]

The Unitarians' belief in the intelligible goodness of God played a prominent role in their controversies with the orthodox. The postulated essential identity between the human mind and the Infinite Mind enabled them to make their "moral argument" against Calvinism. If we possessed the "candle of the LORD" to guide us, it was a mistake to consider human nature totally depraved. And since arbitrary predestination was immoral by human standards, God could not be supposed to behave this way. Finally, passages in Scripture that seemed to imply a God of wrath and partiality should be interpreted metaphorically or explained away by critical analysis.[40] Undoubtedly the most telling of these Unitarian polemics was William Ellery Channing's "The Moral Argument Against Calvinism" (1820). But even more interesting as an example of the intellectual, spiritual, and aesthetic richness of this perspective is James Walker's 1858 sermon entitled "Man's Competency to Know God."[41]

The Cambridge Platonists of Old and New England

Walker quotes both Henry More and John Smith of the Cambridge Platonist school in the course of proving that we do possess a measure of reliable understanding of the divine perfections: "When we say that God is wise and just and benevolent, we know what we mean; we mean that he is wise and just and benevolent as men sometimes are, only in an infinitely higher degree." It is essential to both the Christian gospel and any meaningful form of theism that one be able to attribute intelligible moral qualities to God, Walker affirms. But this is not to abandon a sense of mystery and awe and reverence. Precisely because of the commonality between the human and the divine, our natures reach out for His, and religion "addresses itself to our aspirations," Walker declares—"not so much to the curiosity of men and the speculative understanding, as to the sentiments, and especially to that mystical but most characteristic sentiment in human nature, the desire in man to raise himself above himself." Religion "is the instinctive sentiment of the infinite, struggling after an object with which to be satisfied and filled."

> Why then should we be unwilling to admit, as the final and crowning source of our knowledge of God, a practical, a direct, or if you will a mystical, insight into divine things? . . . I speak not now of that false mysticism from which the world and the Church have suffered so much and so long. . . . I mean a true mysticism, which is favorable if not necessary to the life and warmth of a sober and rational piety,—a mysticism which supposes a real communion of the soul with its Maker.[42]

Walker was president of Harvard University when he preached this sermon in the newly built Appleton Chapel. He was certainly no radical, either politically or socially. But his pursuit of a "true mysticism" showed the way Unitarianism would eventually reconcile itself to Transcendentalism.

The Natural Religion of the Soul

Just as they appreciated the wisdom and benevolence of God in the order and beauty of external nature, New England Unitarians saw the same divine qualities manifest in the design of the human mind or soul (words they used synonymously). The human mind was composed of a number of faculties, arranged in hierarchical sequence from conscience at the top to the animal passions underneath with various rational and emotional springs of action in between. Thus, both the macrocosmos without and the microcosmos within displayed the principles of order and hierarchy.[43]

Daniel Walker Howe

"Will the day ever come," demanded Henry W. Bellows rhetorically, "when the sacredness we now superstitiously confine to the Scriptures shall be extended to the soul of man, his reason, his affections, his conscience; and to Nature herself—each of them a book of God, all volumes of one work, truly coherent, equally divine, and not intelligible except in connection and harmony with each other?" Bellows went on to declare that "the faculties of man are divine seeds sown in the soil of his nature and circumstances. . . . Men, no doubt, are arbitrary and capricious, but reason and conscience are never so. It is by acting against reason and conscience that we exhibit our wilfulness and folly."[44]

The Cambridge Platonists of the seventeenth century had commended the practice of religion as helping an individual maintain the proper harmony within his mental faculties, particularly the supremacy of conscience and the subordination of the passions.[45] Surprisingly little had changed for the author of an article in the Unitarian *Monthly Religious Magazine* in 1866, who endorsed the Great Chain of Being, the supremacy of conscience over the other faculties, and the primacy of mind over matter in the course of demonstrating "the personality of God."[46] Even the scientific study of external nature required some attention to the scholar's inward harmony and benefited from "a devout spirit," explained Andrew Preston Peabody. The scientist's mind "must be stable, calm, self-collected, released from the tyranny of the lower appetites and passions."[47]

The process of creating and maintaining the proper order among the faculties of the mind or soul was called "the cultivation of a Christian character." It was the most important purpose of living. In a typical Unitarian statement, "Life is then the education of the soul, the discipline of conscience, virtue, piety." The process was undertaken in a devotional spirit, just as the Cambridge Platonists had enjoined centuries before: "religion is the mind's good health," Benjamin Whichcote had declared.[48] The gradual development of harmony and order in the soul prepared one in this life to enjoy the spiritual blessings of heaven, which would otherwise be meaningless. Thus, Convers Francis explained in 1833, "we are saved when we become capable of salvation." The role of divine grace was to provide mankind with "the means of salvation, or, which is the same thing, the means of spiritual improvement and spiritual happiness."[49] Neither grace nor salvation was treated in supernatural terms by classic Unitarianism.

In the long history of Christian philosophy, several standard argu-

ments have been developed for the existence of God. There are the cosmological argument (from the need for a first cause), the teleological argument (from the apparent order or design in the universe), the ontological argument (an *a priori* argument for the necessary existence of perfection), and the argument from the religious experiences of human beings. The favorite of the Scottish "common sense" philosophers and most other Enlightenment thinkers, whether Christian or deist, was the teleological. Immanuel Kant, by developing a *moral argument* that treated the existence of God as a postulate of the "practical [i.e., moral] reason," opened up a new round of inquiry into the basis for theistic belief, in which nineteenth-century Unitarians participated with enthusiasm. Their Neoplatonic concern with the natural religion of the soul enabled them to develop some variations on the standard themes of theistic argument.

The Unitarian minister Orville Dewey made use of the natural theology of the soul to give an interesting twist to the teleological argument. In a sermon entitled "Human Nature" he pointed out that, when we celebrate the majesty of the external universe, we are *really* paying tribute to the inner powers by which we apprehend and appreciate it:

> We might say that all there is of vastness and grandeur and beauty in the world lies in the conception of man; that the immensity, in other words, is but the image of his own idea; that there is no eternity to him but that which exists in his own unbounded thought; that there is no God to man, but what has been conceived of in his own capacious and unmeasured understanding. [50]

Dewey was, of course, confident that these faculties of understanding had been given to humanity by God; even so, this was a powerful assertion of the dignity of man and his creative mental powers. It brought Dewey to the very verge of Kantianism, if not over that line.

Probably the most remarkable exploration of the grounds for theistic belief within classic Unitarianism was James Walker's essay *The Philosophy of Man's Spiritual Nature in Regard to the Foundations of Faith.*[51] Walker began with the conventional assertions of Scottish philosophy and Cambridge Platonism. People have religious "faculties" in their nature, which include a moral sense, an inclination toward veneration, and an ideal of perfection. A person ought to develop all his faculties if he is to realize his full humanity, and this includes the religious faculties. The philosophical principle of "common sense," which justifies trusting that the faculties of sensation reveal an objectively existing material universe, also

legitimates, Walker claims, trusting that the religious faculties reveal objective spiritual truths. Analysis of Walker's argument shows that it is actually several. Beginning with a teleological argument for God from the design of the human faculties, he constructs an argument that the full development of our nature requires religious expression even for humanistic reasons. He then elaborates Reid's principle of common sense in a way that resembles Kant's postulate of practical reason. And by invoking the idea of the perfect, he brings in the ontological argument.[52] Finally, in his use of the sentiment of veneration, Walker gives us the argument from religious experience. An astonishing range of theistic reflection, from Plotinus to William James, finds resonance in this remarkable essay.[53] Those who heard it in sermon form must have come away feeling overwhelmed; those who paid four cents for it as an A.U.A. tract got good value for their money.

Christian Perfectionism

Classic Unitarianism expressed in its own distinctive way the perennial strivings of Christian perfectionism, in the words of William Ellery Channing, "the desire of an excellence never actually reached by humanity, the aspiration toward that Ideal which we express by the word *perfection*."[54] A carefully chosen selection of Channing's finest sermons on this theme was published after his death by his Transcendentalist nephew William Henry Channing under the title *The Perfect Life*. The discourses typify that aspect of the Unitarian heritage the Transcendentalists most admired:

> Man may entirely trust the revelation of God given in human nature,—in conscience, reason, love, and will,—in reverence for the sublime and joy in the beautiful,—in the desire for blessedness such as the earth cannot appease,—in the ideal of perfection,—and above all in the longing for oneness with the Infinite Being by affinity and fellowship.[55]

In emphasizing this theme in William Ellery Channing's thought, his nephew was not misrepresenting him. The sermons included some of the elder man's favorites, delivered repeatedly under various auspices and in some cases already in preparation for publication before his death.[56]

Taken together, the discourses outline a complete theory of human nature and achievement. They posit a "religious principle" in human nature from which the author derives all artistic and philosophical efforts

The Cambridge Platonists of Old and New England

as well as all efforts at social reform. From our own late twentieth-century perspective, it seems as if Channing has placed religion where Freud placed sex. For Channing, civilization represents the sublimation of the religious impulse. Ultimately, only union with Divine Perfection can satisfy the religious impulse, though its by-products in civilization are not devalued.

Nor was Channing atypical among the Unitarians of his generation for his interest in Christian perfection, as some historians have thought.[57] The aspiration was common to the whole range of classic Unitarian literary and religious production, from the *Monthly Anthology* of Joseph Stevens Buckminster to the *Monthly Religious Magazine* of Edmund H. Sears. Even after the Transcendentalist controversy had divided the denomination, Unitarian conservatives did not renounce this perfectionist tradition.[58]

Of course it was inconceivable that Neoplatonic perfectionism should undergo no transformations across the centuries from Plotinus to the Cambridge school to the New England Unitarians. The major changes, however, were all in the same direction: they all had the effect of making the Neoplatonist tradition more optimistic. The goal remained the establishment of human communion with the Divine Mind. That goal came to seem more attainable when Neoplatonism was synthesized with the Judeo-Christian concept of a God who reaches out to mankind, and was made more attainable still by the Renaissance, the Enlightenment, and nineteenth-century humanitarian liberalism. Thus the two Channings, in the passage just quoted, could think in terms of human "affinity and fellowship" with the Infinite Being.

An apt illustration of how Neoplatonism was reinterpreted in typical nineteenth-century dress is provided in *Union with God and Man*, by the Unitarian biblical scholar Abiel Abbot Livermore. Livermore begins with a conventional statement of Christian Neoplationism: "*To be made perfect in one*—one with God and one with each other—is the perfection and happiness of mankind." In Newtonian fashion, he applies this to the physical universe, where "seemingly lawless" phenomena arc "but more dazzling demonstrations of [God's] eternal truth."[59] To this harmonious but essentially static vision of divine order Livermore adds a nineteenth-century faith in progress. It reinforces his optimistic worldview, to be sure; any seeming disharmonies can be interpreted as "only a temporary transition to a new and better union." If there be a contradiction in that which is perfect becoming continually more perfect, Livermore takes no

Daniel Walker Howe

notice of it. (Very likely he would argue that perfection is the law of spirit and progress the law of matter.)

> The whole creation, physical, mental, and spiritual, has in truth been constructed to bring us into contact with God at every point, to impart to the mind the light, and to pour into the heart the life, of this blessed union.

Mystic or not, Livermore is no medieval ascetic: "St. Simon Stylites dwelt thirty-seven years on the tops of pillars in the open air . . . that he might crucify the body by this lingering martyrdom and be perfectly joined to the Divine Being." But Simon isolated himself from humanity, and "however faithful his struggle and his self-sacrifice to be one with God, he lost the other blessedness of being one with mankind."[60]

The year was 1848, and slavery was still entrenched in the American Union. Yet Livermore denounced all slavery and racial oppression as incompatible with his spiritual vision. "The human soul is the greatest thing on earth. It transcends all cultures, or races, or colors. Mankind are one." The true historic role of the Gospel, he declared, is to introduce a unified state of human civilization that will bring the world of affairs into correspondence with this spiritual unity and grandeur.[61] Livermore's postmillennialism synthesized an ancient philosophy with Renaissance humanism and nineteenth-century humanitarianism.

Just how creative Unitarian Christian Platonism could be is demonstrated by Orville Dewey's "The Appeal of Religion to Human Nature" (first published in 1846), a sermon on Proverbs 8:4: "Unto you, O men, I call; and my voice is to the sons of men." Dewey asks what it is in human nature that God's voice addresses, and answers, our moral nature. "The voice of religion, then, must be as the voice of goodness." God must be good because if he were not, he would not deserve our worship. So far, the seventeenth-century Cambridge Platonists could go. But now Dewey begins to sound like a nineteenth-century religious liberal: "Whatever of the holy and beautiful speaks to you, and through what medium soever it comes, it is the voice of religion. All excellence, in other words, is religion."[62] He then takes a series of logical steps that virtually synthesize Cambridge Platonism with Kant:

> Whatever your conscience dictates, whatever your mind clothes with moral beauty, that, to you, is right; be that, to you, religion. Nothing else can be, if you think rationally. . . . Nay, if I knew a man whose ideas of excellence were ever so low, I should still say to him, "Revere those ideas; they are all that you can revere." . . . All that you can worship, then, is the most perfect

excellence you can conceive of. Be that, therefore, the object of your reverence.

Dewey would seem to be saying that we cannot be sure whether the voice within is really the Divine Reason or only our image of it; we cannot therefore tell whether we are truly in contact with God Himself or only with our notion of Him. But in the last analysis this does not make any difference; we are still obliged to worship as best we can. If I interpret him correctly, Dewey has abandoned the principle of Scottish Common Sense philosophy that things must be what they seem, the principle that James Walker had maintained was the foundation of faith. But Dewey's ontological agnosticism did not weaken in the slightest his commitment to religion as an activity. Like Kant, he based religion on a moral imperative. Dewey's reputation as a conservative is based on his politics and his respect for liturgical forms; as a philosopher of religion, he was a radical.

Transcendentalism and the Neoplatonic Tradition

The prominence of Cambridge Platonist and other Neoplatonic themes in classic Unitarian thought helped lay the groundwork for the reception of the philosophy of Kant by the Transcendentalist Unitarians. Indeed, it might be possible to tell the story of the emergence of Transcendentalism with surprisingly little reference to Kant, simply in terms of the reactivation by the Transcendentalists of idealist themes going back through Unitarianism to Platonism. Almost eighty years ago, Arthur O. Lovejoy protested that Kant had been given credit for too much originality: "It would perhaps be too much to call these [seventeenth-century] English Platonist Kantians," he wrote; "but it is quite accurate to call Kant the continuer of the modern Platonic tradition of which these English philosophers were the Early Fathers."[63] The real point, of course, is not to allocate credit or diminish Kant's genius but to explain why his ideas found a receptive audience among New Englanders.

The continuity between Unitarian Platonism and Transcendental Platonism is most readily traced in the writings of Emerson. The late Sydney Ahlstrom, with his accustomed perspicuity, observed that "the Emersonian message was first of all a Hellenic revival," a revival of Neoplatonism. Earlier, F. O. Matthiessen, in his classic interpretation of the golden age of our literature as an "American Renaissance," called atten-

tion to Emerson's familiarity with the Cambridge Platonists as well as with other seventeenth-century metaphysical writers.[64] Emerson's journals and notebooks, both before and after his break with institutional Unitarianism, amply confirm the great extent to which he drew upon the tradition of Plato, Pythagoras, Plotinus, and Cudworth as he searched for what he called "a vocabulary for my ideas." "I want a spermatic book," he confided in 1841; "Plato, Plotinus, and Plutarch are such."[65] While an undergraduate in Harvard College, Emerson won the Bowdoin Prize for his essay "The Present State of Ethical Philosophy," praising Cudworth and his successors in the school of ethical intuitionism.[66] It was a conventional point of view at a college where Cudworth was a standard authority on both ethics and natural theology. In his youth as a classical Unitarian, Emerson echoed the Cambridge Platonist interpretation of human reason as "a prior revelation."[67] Later, of course, he would carry this a step further and decide that reason was sufficient revelation.

What the Transcendentalists took from the Anglo-American Platonic tradition was twofold: a way of looking at nature, and a way of looking at human nature. Like the Cambridge men and such successors of theirs as Butler and Herbert of Cherbury, the New England Transcendentalists regarded external nature as a gigantic system of analogy. The cosmos taught moral and spiritual principles in the guise of physical ones. The Transcendental artist interpreted the ideal realities behind these physical superficialities. He or she was a combination of poet and priest, the inheritor of the role of the New England clergy and as much a conduit of divine revelation as any ancient prophet.[68] But the continuity between Transcendentalism and the Platonic tradition was even stronger in "internal" natural religion than in "external." As others had done for centuries, the Transcendentalists looked on human nature as a microcosm, a world within. This microcosmos was an even more trustworthy source of revelation than the macrocosmos. Of Kant's two objects of wonder, the Transcendentalists found "the moral law within" even more wonderful than "the starry heavens above." John Smith of seventeenth-century Cambridge had discovered "God's own breath within him."[69] So did the Unitarian of the nineteenth-century American Cambridge and the Transcendentalist of nineteenth-century Concord. Frederic Henry Hedge, the Unitarian minister who was the prime mover of the Transcendental Club (or "Hedge Club") that helped give the new school impetus and definition in the 1830s, put it this way: "The first monotheist was one who

withdrew his gaze from the starry heaven and the creaturely earth, and found in the secret of his own thought the divine 'I am.'"[70]

Emerson's brief sermon "Self-Culture," preached while he was still minister to the Second Church in Boston, illustrates the tradition he inherited. The text, Romans 12:1, reads: "I beseech you therefore, brethren, by the mercies of God, that ye present your bodies a living sacrifice, holy, acceptable unto God, which is your reasonable service." Emerson unhesitatingly declares that "the duty to which we are called is nothing less [than] an unceasing effort at self-culture," interpreting self-sacrifice as self-improvement.[71] Of course this is a triumph of nineteenth-century Arminianism over Pauline theology. But the sermon is also a late example of a tradition of Platonic Christian humanism going back at least as far as the Renaissance. God's service is perfect freedom, perfect rationality, and the perfect development of the human faculties.[72]

An awareness of the Neoplatonic tradition behind Transcendentalism helps illuminate not only the continuities but also the distinctions between Transcendentalism and classical Unitarianism. Renouncing the dualistic compromises made by the New England liberal Christians and their seventeenth-century predecessors at the English Cambridge, the Transcendentalists returned to an idealist monism closer to that of the ancient world, of Plotinus and Plato.[73] Emerson's journal records his observations that Cudworth is more valuable as a vehicle for Plato's thought than for his own sake; that the Platonists represent a decline from Plato.[74] Thoreau seems to have used Cudworth in much the same way.[75]

Classical Unitarianism, like the Scottish philosophy on which it was based, had embraced both empiricism and idealism. The Transcendentalists rejected the empiricist half of classical Unitarianism. Not nature itself, but the human emotional and moral response to nature, interested them. Where the Unitarians had been wont to respect both Cudworth and Locke, both Butler and Paley, both Plotinus and Thomas Reid, the Transcendentalists admired only the former in each of those pairs. Along with other Protestants, the Unitarians had long been accustomed to employing Locke's empiric methodology to legitimate scripture. They had applied a technique called "supernatural rationalism" to develop "evidences" for the truth of scripture.[76] This technique, pioneered by Locke himself, authenticated purported revelations by means of miracles and fulfillments of prophecy. (If the messenger could tangibly demonstrate his power, then his message must be credible.) When the Transcenden-

Daniel Walker Howe

talists lost faith in the relevance of such empirical proofs, the supernatural-rationalist demonstration of biblical authority ceased to convey conviction. In his great debate with Andrews Norton, the Transcendentalist George Ripley did not deny that the miracles had occurred; he denied that empirical evidence was relevant to deciding a religious issue.[77]

What was new about Transcendentalism was not its pietism or its spiritual interpretation of experience, but its rejection of all authority outside the individual. Neither empiricism nor scripture, nothing, in fact, that was publicly verifiable, was accepted as a religious authority by the Transcendentalists. Theodore Parker's distinction between the "transient" and the "permanent" in religion reserved nothing save the conscience of the individual to the category of the "permanent" in religion. Jesus, like Plato, had taught the supremacy of the conscience, though his followers had perverted the purity of the message. "The difference between the Christianity of some sects, and that of Christ himself, is deeper and more vital than that between Jesus and Plato."[78]

The Transcendentalists' enthusiasm for Kant would not have been controversial if it had confined itself to affirming that "practical reason" testified to the existence of God. It was Kant's negative, or critical, assertions, his rejection of the teleological argument and supernatural rationalism, which made his philosophy and that of his Transcendentalist followers shocking to New England's Christians, liberal and orthodox alike. The more controversial aspect of Kant's thought was, in philosophical terms, the more important. But it was his moral side that dovetailed most readily with the Anglo-American Platonic tradition.[79] This side of Kant would not have been repugnant to many Unitarian Christians, as we have seen. Emerson and the Transcendentalists co-opted Kant into the service of an intellectual tradition that included Cudworth and Coleridge, as well as James Marsh, the Transcendentalists' Calvinist contemporary who mediated Coleridge to Americans.[80] And it was the Anglo-America Platonic tradition that would eventually provide the basis for the rapprochement between Unitarianism and Transcendentalism.

Cambridge Platonists and Concord Platonists

Although the Transcendentalists, I would argue, espoused a philosophy closer to that of Plotinus than to that of Cudworth, they were neither unaware nor unappreciative of the Cambridge Platonists as precursors. The fullest and most explicit expression of their attitude toward Cam-

bridge Platonism is given in a review essay Theodore Parker wrote of a new edition of Cudworth's works.[81] Parker devoted most of his attention to Cudworth's *True Intellectual System of the Universe*, a work well known to Harvard students of Parker's generation.[82]

Parker describes the "Latitude Men," Cudworth's circle, as "foes to fanaticism, to irreligion, and to superstition." They stood in opposition to the "profligacy" of Charles II's court and to the atheism of Hobbes, which Parker feels was the inevitable consequence of that profligacy. Cudworth's *True Intellectual System* is organized as a refutation of Hobbes's false one. In his presentation, Cudworth sets forth the atheist's arguments (with a fullness and candor that Parker and most other commentators have found commendable), then rebuts them. Parker summarizes Cudworth's own position as follows: "1. There is a self-conscious God, ruling over all things. 2. God is good, and there is an eternal distinction between Good and Evil. 3. Men are free agents, and therefore accountable Beings." This is, of course, also the position of classic Unitarianism. Whether Parker himself conceived of God as self-conscious is doubtful, but he chose not to raise the issue here.[83]

Yet Parker did not shrink from criticizing Cudworth, and his criticisms are revealing of the Transcendentalist position. He believes that "Cudworth would have been more convincing" in his defense of theism if he had placed more stress on Parker's own two favorite arguments: (a) the existence of necessary truths, such as those of logic and morality, which "supposes the existence of an eternal mind, from whence they come, and in which they reside"; and (b) the argument from personal religious experience. Parker also rejects Cudworth's conception of "plastic nature," the unconscious power of nature itself, which, created by God, blindly carries out His purposes. Parker finds this concession to the autonomous functioning of nature an unnecessary hypothesis; it creates a dualism where monism will suffice. To the New England Transcendentalist, the workings of the universe display the mind of God directly, not indirectly through a mediating power.[84]

For the most part, the Transcendentalists valued the writings of Cudworth and his Cambridge school as introductions to the Platonic and Neoplatonic tradition rather than as authorities in their own right. Emerson's essay "The Over-Soul" (1841) illustrates the point. It begins with an epigraph from Cudworth's friend Henry More:

> But souls that of his own good life partake,
> He loves as his own self; dear as his eye

Daniel Walker Howe

They are to Him: He'll never them forsake:
When they shall die, then God himself shall die:
They live, they live in blest eternity.

Once Emerson begins to discuss his theme, however, it becomes apparent that his conception of the Oversoul is closer to that of Plotinus than to that of the Christian More, whose lines he quoted, it would seem, to ease the reader into an unfamiliar frame of reference. Here is Plotinus, sixteen centuries before, speaking in the name of the cosmos itself:

> It is God who made me [the world], and from Him I came perfect. I include all living beings, and I am self-sufficient, for I contain all creatures, plants, animals, and everything that may be born. I have within myself many gods, hosts of dæmons, lofty souls, and men who find happiness in virtue. . . . All that is within me desires the Good, and each attains it according to its ability. From that good all the heavens depend, as do my whole soul, the gods within me, and all the beings I contain, both animate and seemingly inanimate.[85]

This is a vision of a divine wholeness, a perfect plenitude. And here is Emerson, addressing the subject from the human point of view:

> Man is a stream whose source is hidden. Our being is descending into us from we know not whence . . . that Unity, the Over-Soul, within which every man's particular being is contained and made one with all other. . . . We live in succession, in division, in parts, in particles. Meantime within man is the soul of the whole; the wise silence; the universal beauty, to which every part and particle is equally related; the eternal ONE. . . . We see the world piece by piece, as the sun, the moon, the animal, the tree; but the whole, of which these are the shining parts, is the soul.[86]

Strikingly similar as these conceptions are, the intellectual history of 1,600 years has wrought its effect on them. Plotinus had taught that only by long discipline could one travel up the mystical ladder to attain a vision of the wholeness. Emerson, as a post-Christian, post-Enlightenment Romantic, believes the process is one of opening up the self to an inborn genius. In his poem "The Snow-Storm," written the same year as "The Over-Soul," Emerson displays—with greater artistic success than the essay achieves—his belief that the highest human genius lies in receptivity to the impulses of nature. The snowstorm serves him as the perfect symbol for a wild, ecstatic artistry that is our model and yet beyond our reach. (Plato, too, said we should imitate an ideal beauty, but how different is Emerson's snowstorm from Plato's geometry!)[87]

In *Representative Men* (1850), Emerson directly confronted the ultimate

The Cambridge Platonists of Old and New England

fountain of Platonism, Plato himself. On the one hand, Plato was *The Philosopher*. "It [is] impossible to think on certain levels, except through him. He stands between the truth and every man's mind." On the other hand, Plato was "a great average man" who simply realized the potential in all of us. He was the personification (the "representative man") of the maturity of Greek civilization. Yet, because of his travels abroad, he also synthesized the European (scientific) and Asian (mystical) approaches to knowledge, the Understanding and the Reason. "No man ever more fully acknowledged the Ineffable," Emerson noted, but "he cries, *Yet things are knowable!*" Out of these seeming contradictions, Emerson constructed a portrait of Plato, not as a man of paradoxes, but as a "balanced soul."[88] What interests Emerson in the essay is not philosophy as such but the nature of genius and its relationship to its context and posterity. As a result there is practically nothing to distinguish his treatment of Plato's philosophy from one that a Unitarian of the classical school might have written.

Conclusion

In 1876 Octavius B. Frothingham published *Transcendentalism in New England*. Frothingham was still close enough to the issues involved that he wrote as something of a partisan. He accused the classical Unitarians of having neglected an important aspect of their heritage. "The [prewar] Unitarian divine was more familiar with Tillotson than with Cudworth, and more in love with William Paley than with Joseph Butler," he complained. It had been left to the Transcendentalists to reinvigorate the tradition of the Cambridge Platonists, Frothingham declared.[89]

In 1940 Perry Miller published his essay "From Edwards to Emerson," now a classic of American literary studies, which adopted a similar interpretation. "In Unitarianism one half of the New England tradition—that which inculcated caution and sobriety—definitely cast off all allegiance to the other," the mystical half. When Emerson embraced idealism, Miller believed, he was reaching back over the heads of his classical Unitarian parents' generation to recover a lost Edwardsian mysticism.[90] Miller was quite correct in recognizing a strain of mysticism within the New England tradition. (In this essay he was not interested in its Neoplatonic origins.) But he erred in believing that this strain had gone into some sort of cultural hibernation during a cold winter of rationalism.

Emerson and the Transcendentalists received their idealist inspiration

Daniel Walker Howe

from liberal precursors, principally the Cambridge Platonists and classical New England Unitarians like Buckminster, the Channing brothers, and Everett. Of course the Transcendentalists also encountered New Light pietism—for example, we know now that the young Ralph Waldo Emerson was exposed to this through his intellectually eclectic aunt, Mary Moody Emerson.[91] But the Transcendentalists then turned to reading Plotinus and Plato themselves, without making any significant philosophical detour through Edwards—or, for that matter, through Malebranche and the other seventeenth-century continental Christian rationalists. The New England Transcendentalists found Coleridge and Kant congenial insofar as they interpreted them as contemporary restatements of an enduring idealist tradition.

The study of the Cambridge Platonists and their relation to New England religious thought illuminates the Transcendentalist controversy by showing what was, and what was not, at stake. Both sides in the controversy were convinced of certain principles they had each inherited from Cambridge Platonism. They agreed that morality was objective, immutable, and not created by fiat; that humanity could know spiritual and moral principles through natural faculties of mind and spirit; and that there was a necessary place in religion and morality for the sentiments. Neither doubted the power of the "candle of the LORD" within the individual to illuminate divinity. The issue in the controversy concerned whether there was any authority *external* to the individual to which one could look for guidance in religion. Classical Unitarianism affirmed that both scripture and empirically known nature constituted such authorities. Transcendental Unitarians, for all they delighted in the poetic inspiration external nature could provide, denied that either it or scripture constituted a religious authority binding on the individual.

This essay has provided a long and discursive answer to a short original question, but we have at last reached the point where we know enough to understand the rapprochement between Transcendentalism and mainstream Unitarianism. During the years after the Civil War, Platonism continued to occupy a central place in the intellectual history of Unitarianism. Benjamin Jowett's translation of Plato reached the United States in 1871, providing a more accessible English version than ever before. In the complex interweaving of Transcendental and Christian elements that occurred in the work of thinkers like Frederic Henry Hedge, William Rounseville Alger, and A. A. Livermore, Platonism played a central part. It provided an intellectual basis for the eventual reconciliation between

The Cambridge Platonists of Old and New England

Transcendentalism and the Unitarian establishment. James Freeman Clarke's *Self-Culture*, synthesizing Transcendental and classical Unitarian "internal" natural religion, is a monument to this reconciliation. Bridging what would later be thought of as "high" and "popular" culture, this masterpiece of inspirational Arminianism reached a broad public in its time.[92]

As the nineteenth century went on, other strands of thought entered the philosophical dialogue in which Unitarians participated: free religion, higher criticism, scientific theism, comparative religion, the religion of humanism. But the old strand of Platonic idealism and pietism remained as well, stronger than ever, in fact, for having been reinvigorated by Transcendentalism and its eventual synthesis with Unitarianism. Postwar Platonism manifested itself not only in Harvard philosophy from Francis Bowen to Josiah Royce but also in the writings of the Unitarian clergy. Edmund H. Sears made use of Cudworth and Plato to transcend the Ripley–Norton debate over scripture and restate Johannine theology for his own generation of religious liberals.[93] And in *Foregleams and Foreshadows of Immortality*, Sears produced perhaps the greatest of all Unitarian works of Plotinian natural religion of the soul.[94]

In 1891 the aged Andrew Preston Peabody published an article, "The Life and Times of Plato." In it he declared that "'Christian Platonist' has been almost the only title in which the word *Christian* has not lost dignity and worth by association." He paid special tribute to the Platonists of seventeenth-century Cambridge, calling Cudworth's *Eternal and Immutable Morality* "still the feeding-ground for ethical philosophy worthy of the name." Peabody even defended Plato's distrust of poets.[95] Although Unitarians like Clarke and Sears had by this time gone far beyond him in their use of Platonic principles, Peabody's article appropriately indicates the durability of Unitarian Platonism.

The Platonic idealist tradition proved both a strength and a weakness for New England Unitarian culture. The Unitarians of the pre–Civil War period, one must admit, lacked appreciation for carnality. Their forms of expression, spoken and written, dealt in spirituality. Even when Transcendentalists like Thoreau took note of concrete reality, they did so to capture its symbolic and ideal meaning. The whole thrust of Unitarian, including Transcendentalist Unitarian, intellectual and artistic activity was to escape from the material and embrace the ideal. Art forms that emphasize carnality, like drama, dance, and sculpture, remained alien to them. Conversely, the strength of the tradition lay in its invocation of

moral and spiritual values through oratory, poetry, and prose. Of course the operative cause here was Puritan religious culture. But behind and within the Puritan tradition was a Platonic component that continued to influence the cultural daughters and granddaughters of Puritanism: New England Unitarianism and Transcendentalism. Understanding this Platonic component is essential to an understanding of New England intellectual history and the American culture of which it forms so important a part.

Notes

1. Henry Wilder Foote, *Sermon at the Death of James Walker* (Boston, 1875), 13–14.

2. On the pietistic side of New England liberal religion, see Daniel Walker Howe, *The Unitarian Conscience: Harvard Moral Philosophy, 1805–1861* (Middletown, 1988; first published 1970), 152–173; and Teresa Toulouse, *The Art of Prophesying: New England Sermons and the Shaping of Belief* (Athens, Ga., 1987).

3. John Tulloch, *Rational Theology and Christian Philosophy in England in the Seventeenth Century* (Edinburgh, 1872), vol. 2; see also Marjorie Nicolson, "Christ's College and the Latitude Men," *Modern Philology* 22:35–53 (1929–1930).

4. Frederick J. Powicke, *The Cambridge Platonists* (Cambridge, Mass., 1926); Herbert McLachlan, *The Religious Opinions of Milton, Locke, and Newton* (Manchester, 1941), 110–111; Sterling Lamprecht, *The Moral and Political Philosophy of John Locke* (New York, 1962), 9–10.

5. Caroline Robbins includes David Cumberland (1631–1718) among the Cambridge Platonists, but that is unusual; see *The Eighteenth Century Commonwealthmen* (Cambridge, Mass., 1959), 76. I borrow here from Hiram Hayden, *The Counter-Renaissance* (New York, 1950), though the book does not discuss the Cambridge Platonists.

6. There are many books treating the Cambridge Platonists; among the most useful are Rosalie Colie, *Light and Enlightenment: A Study of the Cambridge Platonists and the Dutch Arminians* (Cambridge, 1957); James D. Roberts, *From Puritanism to Platonism in Seventeenth Century England* (The Hague, 1968); Gerald R. Cragg, *From Puritanism to the Age of Reason* (Cambridge, 1950, reprinted 1966); and Powicke, *Cambridge Platonists*. Ernst Cassirer, *The Platonic Renaissance in England* (Austin, Texas, 1953; first pub. in German in 1932) must be used with caution.

7. Benjamin Whichcote, *Aphorism* no. 40, quoted in Powicke, *Cambridge Platonists*, 23.

8. John Norris, *An Account of Reason and Faith*, 13th ed. (London, 1728), reprinted in Gerald R. Cragg, ed., *The Cambridge Platonists* (New York, 1968), 153.

9. Benjamin Whichcote, *Aphorism* number 121, quoted in Cragg, *From Puritanism to the Age of Reason*, 42.

10. J. A. Stewart and G. R. Levy, eds., *The Myths of Plato* (Carbondale, Ill., 1960), 442–443, makes the connection between *Phaedrus* and the Cambridge Platonists.

11. The best general introductions to Plotinus are William Ralph Inge, *The Philosophy of Plotinus*, 2 vols. (New York, 1918), and Emile Brehier, *The Philosophy of Plotinus* (Chicago, 1958). Inge translates *Nous* as "Spirit," Brehier as "Intelligence."

12. On the Ramism of Jacobus Arminius, see Colie, *Light and Enlightenment*, 51.

13. See the *Dictionary of National Biography*, s.v. Cudworth.

14. Most recently and fully by Norman Fiering, *Moral Philosophy at Seventeenth-Century Harvard: A Discipline in Transition* (Chapel Hill, 1981); see also Clarence Gohdes, "Aspects of Idealism in Early New England," *Philosophical Review* 39:537–555 (1930); and Samuel Eliot Morison, *Harvard College in the Seventeenth Century* (Cambridge, Mass., 1936), 1:260–261. Benjamin Rand, "Philosophical Instruction in Harvard University from 1636 to 1900," *Harvard Graduate's Magazine* 37:29–37 (1928), is not altogether reliable.

15. The widespread theory that Plato borrowed from Mosaic sources invoked a hypothetical document called the "Prisca Theologica."

16. Fiering, *Moral Philosophy*, 64, 240. On Yale, see Edmund S. Morgan, *The Gentle Puritan: A Life of Ezra Stiles* (New Haven, 1962), 65.

17. Norman Fiering, *Jonathan Edwards's Moral Thought and Its British Context* (Chapel Hill, 1981); Wallace E. Anderson, ed., *The Works of Jonathan Edwards: Scientific and Philosophical Writings* (New Haven, 1980).

18. Fiering, *Jonathan Edwards*, 40–45, 51–52, 341–345, et passim. The argument is underscored in Norman Fiering, "Rationalist Foundations of Jonathan Edwards's Metaphysics," in Nathan Hatch and Harry Stout, eds., *Jonathan Edwards and the American Experience* (New York, 1986). See also Charles McCracken, *Malebranche and British Philosophy* (Oxford, 1983), 329–340.

19. On Edwards's debt to the Cambridge Platonists, see Paul Conkin, *Puritans and Pragmatists* (New York, 1968), 40, 44–45; Gohdes, "Aspects of Idealism in Early New England," 552–554; Emily Stipes Watts, "Jonathan Edwards and the Cambridge Platonists" (Ph.D. diss., Univ. of Illinois, 1963), and idem, "The Neoplatonic Basis of Jonathan Edwards's 'True Virtue,'" *Early American Literature* 10:178–189 (1975).

20. John Smith, "The Excellency and Nobleness of True Religion," reprinted in Cragg, *Cambridge Platonists*, 91–140; quotation from p. 132.

21. Henry More, *A Brief Discourse of the True Grounds of the Certainty of Faith in Points of Religion* (translated from the Latin of the *Enchyridion*), in Cragg, *Cambridge Platonists*, 140–150; Ralph Cudworth, "On Providence and God's Direction of Human Destiny," in Cragg, *Cambridge Platonists*, 213.

22. Fiering mentions Sterry in this context; see *Jonathan Edwards*, 235.

23. Jonathan Mayhew, *Two Sermons on the Nature, Extent and Perfection of the Divine Goodness* (Boston, 1763); see also McMurry S. Richey, "Jonathan Mayhew: American Christian Rationalist," in Stuart C. Henry, ed., *A Miscellany of American Christianity: Essays in Honor of H. Shelton Smith* (Durham, N.C., 1963), 292–327.

24. Jonathan Mayhew, *The Snare Broken* (Boston, 1766), 35.

25. Ebenezer Gay, *Natural Religion, as Distinguish'd from Revealed* (Boston, 1759), 12.

26. Some of the evidence for this is surveyed in Daniel W. Howe, "Classical

Education and Political Culture in Nineteenth-Century America" *Intellectual History Newsletter* 5:9–14 (1983).

27. See David B. Tyack, *George Ticknor and the Boston Brahmins* (Cambridge, Mass., 1967); and Hugh Hawkins, *Between Harvard and America: The Educational Leadership of Charles W. Eliot* (New York, 1972).

28. For example, see Andrew Preston Peabody, "A Liberal Education," *The New Englander and Yale Review* 9:193–207 (1886). For a statement on the relationship between classical studies and the new elective system, see Peabody, *The Elective System in Colleges. A Paper Read Before the National Education Association* (Worcester, 1874). Cudworth's most famous statement on the education of the faculties is in his courageous defense of rational religion before the House of Commons, March 31, 1647, reprinted in Cragg, *Cambridge Platonists*, 369–406.

29. I have discussed this overarching scheme in *Unitarian Conscience*, cited in n. 2.

30. Thomas Reid, the founder of the Scottish school, explains his purposes in the introduction to his *Inquiry into the Human Mind* (1764), reprinted in his *Works*, ed. Sir William Hamilton (Edinburgh, 1863), 1:97–104.

31. Reid, *Works*, 1:438; cf. Cragg, *Cambridge Platonists*, 295 (Cudworth), 300 (More), 330–331 (Smith), 410 (Whichcote).

32. I am using the term "classic" Unitarianism to refer to those (often called "Channing Unitarians") who remained faithful to Scottish philosophy and revealed Christianity, in contrast with the Transcendental Unitarians.

33. William Ellery Channing, *The Perfect Life*, ed. William Henry Channing (Boston, 1901), 981.

34. Cragg, *Cambridge Platonists*, 189 (More), 245–249 (Cudworth), 334 (Smith). In my opinion, Bruce Kuklick errs in characterizing the Cambridge Platonists as "anti-dualistic" (*Churchmen and Philosophers From Jonathan Edwards to John Dewey* [New Haven, 1985], 18); they believed in a dualism of mind and matter parallel to a dualism of activity and passivity. Contrary to the Cartesian dualists, however, they believed that mind and matter can readily interact.

35. See Eugene Austin, *The Ethics of the Cambridge Platonists* (Philadelphia, 1935), 12–13; J. A. Passmore, *Ralph Cudworth* (Cambridge, 1951), 9–12, 19–28; John De Boer, *The Theory of Knowledge of the Cambridge Platonists* (Madras, India, 1931), esp. 140–141, 148–149.

36. *As You Like It*, act II, scene 1. William Ellery Channing, "Christian Worship" (1836), *Works* (Boston, 1848), 4:306. Cf. the Boston *Monthly Anthology* 1:61 (1803).

37. Andrew Preston Peabody, *The Connection Between Science and Religion* (Boston, 1845), 6, 14, 16, 29.

38. Cragg, *Cambridge Platonists*, 96 (Smith), 266 (More), 384 (Cudworth), 413 (Whichcote).

39. Andrew Preston Peabody, *The Immutable Right* (Boston, 1858), 3, 4, 5, 11, 20, 21, 24. For an interesting example of the pastoral use of this doctrine, see Henry W. Bellows, *Essential Goodness the Reality of Religion* (Concord, N.H., 1873), a funeral sermon.

40. These and related arguments are surveyed in George E. Ellis, *A Half-Century of the Unitarian Controversy* (Boston, 1857); and H. Shelton Smith, *Changing Con-*

ceptions of Original Sin (New York, 1955). An interesting new study of the use of conscience as a tool of biblical criticism is Richard A. Grusin, "The Hermeneutics of the Heart: Interpretive Transcendentalism," which I read in manuscript.

41. William Ellery Channing, "The Moral Argument Against Calvinism" (1820), *Works*, 1:236ff.; James Walker, "Man's Competency to Know God" (1858), *Reason, Faith, and Duty: Sermons Preached Chiefly in the College Chapel* (Boston, 1877), 18–36.

42. Ibid., 28, 34–36.

43. See Howe, *Unitarian Conscience*, 93–96.

44. Henry W. Bellows, *Restatements of Christian Doctrine: In Twenty-Five Sermons* (New York, 1860), 93–94.

45. E.g., Cragg, *Cambridge Platonists*, 102–117 (Smith), 263–268 (More).

46. C. P. [Cazneau Palfrey?], "The Personality of God," *Monthly Religious Magazine* 36:26–42 (1866).

47. Peabody, *Science and Religion*, 12.

48. Orville Dewey, *Works, with a Biographical Sketch* (Boston, 1893), 176; Whichcote, Sermon on Philippians 4:8, in Cragg, *Cambridge Platonists*, 68.

49. Convers Francis, *Grace, as Connected with Salvation: A Sermon Preached at the Installation of Rev. Rufus A. Johnson, in Grafton* (Boston, 1833), 20–21.

50. Dewey, *Works*, 3.

51. Delivered as a sermon in 1834 and printed that year as a tract by the American Unitarian Association, it may also be found in the *Christian Examiner* 17: 1–15 (1835), and in a collection of his writings entitled *Reason, Faith, and Duty*, 37–61.

52. The Cambridge Platonists themselves were capable of mixing a teleological argument from the human faculties with an ontological argument from the idea of perfection in a similar way. See Henry More, *An Antidote Against Atheism* (1652), reprinted in Cragg, *Cambridge Platonists*, 163–193; and Ralph Cudworth, "The Demonstration of the Existence of a God from the Nature of Knowledge and Understanding," from his *True Intellectual System of the Universe* (1678), reprinted in Cragg, *Cambridge Platonists*, 194–203.

53. On the connection with James, see Gerald E. Myers, *William James: His Life and Thought* (New Haven, 1986), 461–462, 473. The Unitarian religious philosopher Frederic Henry Hedge attributed the argument to the Cambridge Platonist John Norris; see Hedge, *Ways of the Spirit, and Other Essays* (Boston, 1877), 187.

54. William Ellery Channing, *The Perfect Life. In Twelve Discourses*, ed. William Henry Channing (first published 1872), in *The Works of William Ellery Channing* (Boston, 1890), 931.

55. William Henry Channing, "Title and Character of This Book," in *The Works of William Ellery Channing*, 928–929.

56. Ibid., 929.

57. E.g., Robert L. Patterson in *The Philosophy of William Ellery Channing* (New York, 1952), 63–65.

58. See, e.g., Henry W. Bellows, *Religious Education, from Within and from Above* (Boston, 1857).

59. Abiel Abbot Livermore, *Union with God and Man* (Boston, 1848), 3, 5.

Daniel Walker Howe

60. Ibid., 4, 8, 11.

61. Ibid., 12, 13–16.

62. Dewey, *Works*, 28–35; quotation from p. 29. Elsewhere, Dewey declared that "all true moral beauty is a part of religion." "On the Identity of Religion with Goodness and with the Good Life," *Works*, 151.

63. Arthur O. Lovejoy, "Kant and the English Platonists," in *Essays Philosophical and Religious in Honor of William James. By His Colleagues at Columbia University* (New York, 1908), 301–302.

64. "Introduction," in Sydney E. Ahlstrom and Jonathan S. Carey, eds., *An American Reformation: A Documentary History of Unitarian Christianity* (Middletown, Conn., 1985), 28. F. O. Matthiessen, *American Renaissance: Art and Expression in the Age of Emerson and Whitman* (New York, 1941), 103–107.

65. *The Journals and Miscellaneous Notebooks of Ralph Waldo Emerson*, William H. Gilman et al., eds. (Cambridge, Mass., 1960–1982); quotations from 5:343 (1837) and 7:547 (1841). For his interest in Pythagorean idealism, see 3:366–367 (1830).

66. Ralph Waldo Emerson, *Two Unpublished Essays*, ed. Edward Everett Hale (Boston, 1896), 57. Emerson owned at least two editions of Cudworth. Surviving records of his library use confirm his obvious interest in Platonism. See Kenneth Walter Cameron, *Emerson and Thoreau as Readers* (Hartford, 1972), passim.

67. Ralph Waldo Emerson, "A Letter to Plato" (unpublished), Emerson, *Journals and Notebooks*, 2:250.

68. See Lawrence Buell, *Literary Transcendentalism: Style and Vision in the American Renaissance* (Ithaca, 1973), 23–54.

69. John Smith, "The True Way or Method of Attaining Divine Knowledge" (1660), in Cragg, *Cambridge Platonists*, 90.

70. Hedge, *Ways of the Spirit*, 140.

71. *Young Emerson Speaks: Unpublished Discourses on Many Subjects by Ralph Waldo Emerson*, ed. Arthur Cushman McGiffert, Jr. (Boston, 1938), 99–104; quotation from p. 101.

72. A beautiful example of the self-conscious perpetuation of this tradition by a Christian Unitarian strongly influenced by Transcendentalism is William R. Alger, *The Divine Life and Its Way* (Boston, 1866).

73. For Emerson's strong attraction to Plotinus, see especially Stanley Brodwin, "Emerson's Version of Plotinus: The Flight to Beauty," *Journal of the History of Ideas*, 35:465–483 (1974).

74. "Journal Y" (1845), Emerson, *Journals and Notebooks*, 9:265. On Emerson's use of Cudworth, including the reservations he held about him, see also Vivian C. Hopkins, "Emerson and Cudworth: Plastic Nature and Transcendental Art," *American Literature* 23:80–98 (1951).

75. See Robert D. Richardson, Jr., *Henry Thoreau: A Life of the Mind* (Berkeley, 1986), 78.

76. See Conrad Wright, *The Beginnings of Unitarianism in America* (Boston, 1955), 3–4, 135–138.

77. The debate was triggered by Emerson's "Divinity School Address" (1838). For two different interpretations of the issues, see Perry Miller, ed., *The Transcendentalists: An Anthology* (Cambridge, Mass., 1950), 157–246; and William R.

Hutchison, *The Transcendentalist Minister: Church Reform in the New England Renaissance* (New Haven, 1959) 52–97. Two major documents of the miracles controversy, Henry Ware, Jr., "The Personality of the Deity" (1839), and Andrews Norton, "The Latest Form of Infidelity" (1839), have recently been reprinted in Ahlstrom and Carey, eds., *An American Reformation*, 432–440 and 445–461.

78. Theodore Parker's "The Transient and Permanent in Christianity" (1841) has been reprinted in Conrad Wright, ed., *Three Prophets of Religious Liberalism: Channing, Emerson, Parker* (Boston, 1961), 113–149; quotation from p. 117.

79. W. R. Inge, *The Platonic Tradition in English Religious Thought* (New York, 1926), and John H. Muirhead, *The Platonic Tradition in Anglo-Saxon Philosophy* (New York, 1931), are still very helpful.

80. The best work on Marsh is Peter Carafiol, *Transcendent Reason: James Marsh and the Forms of Romantic Thought* (Tallahassee, 1982). The reaction of New England Transcendentalists to Coleridge was mixed, since, despite their admiration for his poetry and his Neoplatonism, they found his turn toward political and theological conservatism distasteful. Particularly galling, of course, was his repudiation of earlier Unitarian views. See [Frederic Henry Hedge], "Coleridge's Literary Character," *Christian Examiner* 14:108–129 (1833).

81. Theodore Parker, "Cudworth's *Intellectual System*," *Christian Examiner* 27:289–319 (1840).

82. See, e.g., George Moore, "Exercises with Dr. [Henry] Ware in Natural and Revealed Religion," an undergraduate notebook for the academic year 1836–1837, ms. in Harvard University Archives.

83. Parker, "Cudworth," 293–294, 297.

84. Ibid., 310, 314–316.

85. Plotinus, *Enneads*, iii.2.3.

86. "The Over-Soul," in *Essays: First Series* (1841); reprinted in *The Collected Works of Ralph Waldo Emerson* (Cambridge, Mass., 1979) 2:159–160.

87. "Naught cares he for number or proportion," says the poet of the snowstorm.

88. Ralph Waldo Emerson, "Plato; or, The Philosopher" in *Representative Men* (1850); reprinted in *Collected Works*, 4:26, 34, 35, 31.

89. Octavius B. Frothingham, *Transcendentalism in New England*, intro. by Sydney Ahlstrom (New York, 1959; first published 1876), 110.

90. Perry Miller, "From Edwards to Emerson" (first published 1940), in *Errand into the Wilderness* (Cambridge, Mass., 1956), 184–203; quotation from p. 196.

91. The most concrete evidence of links between Emerson and the New Lights is supplied by Phyllis Blum Cole in "From the Edwardses to the Emersons: Four Generations of Evangelical Family Culture," which I read in manuscript (forthcoming in *College English Association Critic*). Mary Moody Emerson transmitted the family's ancestral New Light piety to her young nephew. However—as Dr. Cole shows—Mary Moody Emerson also participated in the intellectual tradition of liberal pietism: see, e.g., her writings in the *Monthly Anthology* (under the pen-name Cornelia) during 1804–1805. She was, therefore, a conduit through which New England pietism in *both* its Calvinist and liberal forms reached Ralph Waldo Emerson.

92. James Freeman Clarke, *Self-Culture: Physical, Intellectual, Moral, and Spiritual*

Daniel Walker Howe

(Boston, 1880), went through at least twenty-one editions down to the end of the century. Harvard's award of an honorary doctorate of divinity to Clarke in 1863 was a symbolic landmark in the process of reconciliation between Transcendentalism and the Unitarian establishment.

93. Edmund H. Sears, *The Fourth Gospel the Heart of Christ* (Boston, 1872). Sears accepted the position Ripley had maintained, that religion must commend itself to the human heart, but he argued that the Gospels satisfied this criterion.

94. I used the 11th edition, "revised and enlarged." Edmund H. Sears, *Foregleams and Foreshadows of Immortality* (Philadelphia, 1873).

95. Andrew Preston Peabody, "The Life and Times of Plato," *Andover Review* 15:353–357 (1891); quotations from pp. 355 and 356.

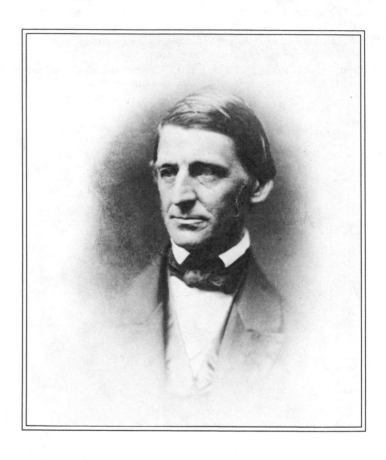

Ralph Waldo Emerson (1803–1882). Photograph by an un-
identified artist, n.d. Forbes Papers, Massachusetts Historical
Society.

Grace and Works:
Emerson's Essays in Theological Perspective

DAVID M. ROBINSON

The Transcendental Confessional

In an 1841 journal entry, Ralph Waldo Emerson, then the clear public leader of the Transcendentalist movement, measured himself and his contemporaries against their New England past:

> Our forefathers walked in the world and went to their graves tormented with the fear of sin and the terror of the Day of Judgment. We are happily rid of those terrors, and our torment is the utter uncertainty and perplexity of what we ought to do; the distrust of the value of what we do; and the distrust that the Necessity which we all at last believe in, is Fair.[1]

Literary and religious historians might consider 1841 a high tide for Emerson and his movement. He began the year by sending his *Essays: First Series* to the press; he would end it in the midst of his important lecture series in Boston, "The Times." He was helping Margaret Fuller to edit the *Dial*, which was giving their "new views" a wider circulation

David M. Robinson is Professor of English, Oregon State University. He would like to acknowledge the support of the Center for the Humanities, Oregon State University, the American Philosophical Society, and the American Council of Learned Societies in the completion of this essay.

and public attention. But as the journal entry and many more like it suggest, the apparent public successes of Transcendentalism were undercut by private struggles. Emerson's journals and essays from this period show a significant ambivalence, particularly as he tried to define the role of the will in the culture of the soul. The concept of an active or developing soul was central to Transcendentalist thinking, so the problem could not be regarded lightly.[2] Emerson could, at times, view this tension dialectically, seeing that moments of insight gave way necessarily to willed acts of morality, thus preparing the way for new insight. But the balance of such a dialectic was always precarious, and his journal suggests his tenuous settlements with doubt. He entitled one entry in January 1841 "The Confessional," a wry allusion to the secret sin of the optimistic Transcendentalist: skepticism. "Does Nature, my friend, never show you the wrong side of the tapestry? never come to look dingy and shabby?" Given the celebration of nature in his early work, this confession of doubt is significant. But note how the passage goes on to explain the sudden evaporation of that doubt, an event in which the individual will has no part:

> You have quite exhausted [Nature's] power to please and today you come into a new thought and lo! in an instant there stands the entire world converted suddenly into the cipher or exponent of that very thought and chanting it in full chorus from every leaf and drop of water. It has been singing that song ever since the creation in your deaf ears.[3]

What transpires here is an experience of unity, or, as Emerson would come to call it, "ecstasy." The thought of the individual, divorced and alienated from nature, is suddenly shown to be one with it. Nature is the "cipher or exponent," that is to say, the living symbol, of human thought, and reflects that thought back to us in its every part. As he explained earlier in *Nature*, "Nature is the symbol of spirit."[4] This is a moment in which that "correspondence" is fully realized. Moreover, the achievement of that unity is due to a transformation of the individual's perception. Nature has always sung this song of harmony—we have been deaf. But strikingly, no cause for this radical change of perception is intimated here. It remains mysterious except insofar as we can say that no individual exertion seems to have caused it. Emerson's linguistic construction confirms the essentially passive nature of the experience. We do not produce or create a new idea; we "come into a new thought." It is not our product; we are its captives.

David M. Robinson

While the passage moves from doubt to faith, though faith of mysterious origin, Emerson is also capable of moving from faith to doubt. A journal entry a few months earlier portrays the confessing Transcendentalist somewhat differently. It is entitled "the excess of direction," and this "excess" denotes the habit of the soul to generate new wants, belittling the achievements it has been driven to make. Thus, after one's discovery of a "first friend," achievement fades: the individual "finds that it was only a quasi-fulfilment, that the total inexhaustible longing is there at his heart still." From here, it is only a short step to one of the most caustic indictments of the nature of things that one is likely to find in Emerson's work:

> How contradictory and unreasonable, you say. Little careth God; he drives me forth out of my cabin as before, to love and to love. He tells me not what that is I seek,—whether choirs of beatific power, and virtue; or the value of nature shut up in a private form; or the total harmony of the Universe. From the beginning this is promised us as the crisis and consummation of life, but no final information is ever afforded us.[5]

Even though the passage concerns love, it is one of the loneliest of the journals. Even though it depicts an active, questing, powerful soul, its ultimate conclusion is pessimism.

Bound on one side by the bafflements of the sources of spiritual power and insight, and on the other by the chilling suspicion that even the possession of such power might not be fulfilling ("Circles" is eloquent testimony to this), Emerson faced an acute spiritual crisis.[6] Just as his model of self-culture seemed to be taking shape, refined through his annual lectures of the late 1830s, its foundations of insight, will, and progress were threatened. In the early 1840s, Emerson would try that model ever more directly.

Grace and Works

In *Essays: First Series*, a guidebook for the culture of the soul, will and acceptance form the poles of what emerged as one of the book's most troubling dilemmas. Most memorably, the book is a hymn to strenuous and persistent effort, as the general popularity of "Self-Reliance" and the critical stature of "Circles" suggest.[7] In both these essays, willed effort is at the center of the spiritual life, and Emerson's rhetorical purpose is to teach his readers to circumvent the various obstacles to that effort. Thus

"conformity" and "consistency" are attacked as the chief hindrances to self-trust in "Self-Reliance," and the many "forms of old age"—"rest, conservatism, appropriation, inertia"—are exposed as the enemies of the energetic pursuit of the new in "Circles."[8] The attractiveness of this stance has been great; it has by and large defined Emerson's place in intellectual history. Yet within that same book is the other Emerson who quietly affirmed in "Spiritual Laws" that "our moral nature is vitiated by any interference of our will," and reduced the wisdom of "Compensation" to the maxim, "I learn to be content."[9]

The sources of this conflict in Emerson's thinking are not difficult to find. In the 1837 "Human Culture" lectures he posited "a divine impulse at the core of our being" which "impels" us to unfold our true nature. This was the basis of his faith in self-culture. This vision affirmed human nature, finding divinity at its very core. But it also held that divinity manifests itself as energy or "metamorphosis," and that growth or expansion was its evidence.[10] Even within that vision of growth or culture, a dichotomy existed between willed effort and passive willessness. Is the "unfolding" of the soul the product of strenuous moral effort, or is it better conceived as a coming to oneself in a quietist acceptance?

We might put this dilemma differently by noting that at times in *Essays: First Series* a sense of spiritual conflict predominates. At other moments a mood of realized spiritual achievement predominates. Such tension, though it is here expressed in different terms, is not new to the student of New England thought. In it, we see the theological division over the question of salvation's source in works or grace. The Calvinist denial of the freedom of the will, and the Arminian reaction to it, is the most notable historical manifestation of this profound dichotomy in the New England mind. While that division did manifest itself in the liberal and orthodox parties, it also continued to exist as a tension in New England thinkers of both camps. Calvinists, committed historically and theologically to deterministic assumptions, remained uneasy about the implied loss of human freedom in their outlook. Arminians, repulsed by that loss of freedom, continued to worry over the logic of determinism.[11] New England's spiritual history continued to speak through Emerson, therefore, and in him we hear alternately the deflected voices of Puritan moral exhortation, eager to add the demands of visible sainthood to the uneasy covenant of grace, and that of antinomian mysticism, insisting on the direct access to the spirit which renders the work of the world a distinctly secondary concern.

David M. Robinson

Emerson received this Puritan inheritance after it had been filtered through the Arminian tradition in New England, which had flowered into the Unitarianism of his father's generation. William Ellery Channing had been its most effective exponent. But his Aunt Mary Moody Emerson also kept a family legacy of orthodox Calvinism alive for him.[12] The liberal movement was prone to stress human capacity, a view that ultimately stressed works as fundamental to religion. The centerpiece of Unitarian theology thus became the doctrine of probation, which, in the words of Emerson's ministerial predecessor at Boston's Second Church, Henry Ware, Jr., stressed that life was a "state of preparatory discipline." For Ware and his Unitarian associates, life was a testing ground for the cultivation of character. "In this world [the human being] is placed in a state of trial and probation," Ware wrote, "for the purpose of forming and bringing out his character."[13] Emerson's sermons are permeated with this vision of life as a probationary state, a concept that allowed the Unitarians to reject what they perceived as the fatalism of Orthodox doctrine, while allowing them to retain the acute sense of sin and limitation that spoke to the human condition. It was, essentially, a theology oriented toward action.

But the Unitarians, too, were offspring of the Puritans, even if rebellious ones. Within their stress on right action was a strand of pietism, almost quietist or mystical in some moments or manifestations. Daniel Walker Howe pointed out this aspect of the "Unitarian conscience" in 1970, and thus gave scholars not only a new perspective on Unitarianism but a new clue to the native sources of Transcendentalism.[14] In Channing's "Likeness to God," Ware's *The Formation of the Christian Character*, some of Emerson's early sermons, and emphatically in his first book, *Nature*, we find this pietist or devotionalist sensibility, whose stress is not on the outer world but on the spirit within.

One anecdote regarding Emerson's double inheritance from Unitarianism might be instructive. In December 1838, Emerson's newly discovered "saint," the mystical poet Jones Very, paid a call on William Ellery Channing. Very was then preaching a doctrine of "will-less existence" which had impressed many in the Transcendental circle, including Emerson, with its spiritual intensity and depth. Very preached an absolute surrender of the private will to God, transforming every act into a gesture of obedience. Channing, whom many young Unitarian ministers regarded as a kind of moral touchstone, listened attentively and sympathetically to Very's doctrine that the Spirit dictated every action, and then

gently asked two direct questions. Had he come to see him that day "in obedience to the Spirit" or simply because Channing had offered him an invitation? Even more specifically, had he walked to the mantle and put his hand on it in obedience to the Spirit as well? Very answered yes to both questions, apparently preferring the possibility of ridicule to the endless chore of discriminating between will and spirit.[15] Ridicule was of course not Channing's object. But his questions, firmly grounded in common sense and a respect for individual action, reveal his coolness about a sense of spiritual enlightenment that takes itself too seriously. Emerson's devotion to both these men is a matter of record. Such conflicting loyalties mirror his own inner conflicts.

Emerson felt an even deeper conflict when these two models of the spiritual life were paired not against each other, but against their own absence. A quietism illuminated by the inner light was sustainable, even at the cost of action. Willed, determined self-culture was fulfilling, even in the absence of visionary forgetfulness. But a quietism that courted only darkness, or a culture frustrated by the prison of constitutional restrictions, or a soul that could not be satisfied with any spiritual achievement—these possibilities were haunting. In the conflict he felt over the means of the culture of the soul, and in the further conflict over the possibility of that culture, we find those aspects of Emerson's thinking that have remained vital to a modern audience. To the age that has felt the heavy weight of creating and sustaining a self, and the heavier weight of seeing this creation as in some senses a fiction, Emerson's conflicts seem familiar.

The tensions in Emerson's thinking are apparent when one attempts to describe his intellectual position at a given moment. But "conflict" becomes less appropriate when the reader surrenders to the intellectual flow of one of the essays. It should be remembered that Emerson's style arose in good measure from the sermon form and its near relative (in his case) the lyceum lecture, a form whose highest purpose was to take the hearer up in an exemplary act of thinking. "Man Thinking" was not only the model of the scholar, but of the orator as well, and therefore of the essayist. For the reader of the essays, this means that the experience of "working through" a problem or issue is more important than isolating Emerson's opinion on that problem. The more the voice of the essays becomes internalized, the fuller this experience becomes. To analyze Emerson's philosophical position is thus to falsify somewhat the intent of the essays themselves, to violate a code of unity and process in the

David M. Robinson

attempt to gain analytic distance from the workings of the essays. Only in retrospect, an inevitable retrospect perhaps, of the reading of an essay in its entirety does the question of its internal conflict become important.

To illustrate the problem, let us look in some detail at "Self-Reliance." Emerson brings that essay to a ringing and effective conclusion with parallel closing sentences. "Nothing can bring you peace but yourself. Nothing can bring you peace but the triumph of principles." [16] This parallelism establishes the identity of the self with principles, giving a final emphasis to one of the essay's chief propositions, the asserted unity of the individual self with a universal or abstract Self underlying it. Possession of the self is thus a universal rather than a private act, a confirmation of principle rather than an assertion of mere selfishness. But while this parallelism establishes the unity that is the essay's goal, it also suggests a duality woven into its entire texture. To say that "nothing can bring you peace but yourself" is to evoke quiet self-possession. To call peace a "triumph of principles" is to suggest a struggle.

Much the same dichotomy exists throughout the essay. The best-known images are those of recklessness, defiance, and irresponsibility, in which Emerson portrays the process of self-culture as a process of self-liberation. Barriers, obstacles, entanglements—these are in the nature of the world, especially the social world, and the individual must respond to them in terms of opposition, will, and action. Perhaps it is the drama of this struggle that makes these images memorable and explains the air of refreshing defiance that lingers over the whole essay.

> Your goodness must have some edge to it—else it is none. The doctrine of hatred must be preached as the counteraction of the doctrine of love when that pules and whines. I shun father and mother and wife and brother, when my genius calls me. I would write on the lintels of the door-post, *Whim*. [17]

Such energetic self-assertion, flirting as it does with irresponsibility (and thus raising and engaging the reader, either pro or con), is the answer to the debilitating demand for social conformity. More broadly, it is the antidote for the basic dilemma of self-consciousness. Youth, even infancy, is praised for its nonconforming nonchalance. This is essential because, as Emerson puts it, "the man is, as it were, clapped into jail by his consciousness." [18] The act of will, necessarily self-directed, is thus celebrated as an act of liberation as well, especially if its basis is in spontaneity. "What I must do, is all that concerns me, not what the people think." [19]

This hymn to the resilient will is best incarnated in the sturdy New England provincial, an evocation of an American cultural icon worthy of Franklin. In contrast to the fine "genius" who feels ruined for not having found an office in Boston or New York immediately after his studies, "the sturdy lad from New Hampshire or Vermont . . . in turn tries all the professions, . . . *teams it, farms it, peddles*, keeps a school, preaches, edits a newspaper, goes to Congress, buys a township, and so forth, in successive years." He perfectly embodies the American rags-to-riches myth. Such a man "does not postpone his life, but lives already." He "is worth a hundred of these city dolls." [20] As Emerson's example suggests, thought paralyzes, while action liberates.

What is easily forgotten, however, is that these images of will, strength, and defiance are built upon a foundation of trust and acceptance. Beneath the sturdy lad who seems to be creating his own identity by a vigorous attack on the world is something of a mystic who has, in the terms of the essay's second paragraph, realized that "he must take himself for better, for worse, as his portion" and decided to toil "on that plot of ground which is given him to till." [21] In fact, it is not the call to struggle and action that we first meet in the essay, but something quite different: "Accept the place the divine Providence has found for you; the society of your contemporaries, the connexion of events." [22] Although the essay rises to a position of defiance, it arrives there by way of acceptance. Even the exuberant, youthful defiance celebrated early in the essay, "the nonchalance of boys who are sure of a dinner," is first introduced into the essay through the praise of a different quality of youth, a simplicity of mind that is manifested in a trusting wholeness. Children lack "that divided and rebel mind," the self-conscious doubting of the adult. [23] Only because of this fuller possession of themselves, a self-possession that even precedes conscious self-acceptance, can the child act from nature. If the essay calls on us to act with decisiveness, it does so in order that we can regain in measure this lost spontaneity, and the lost wholeness it implies. "Self-Reliance" thus addresses the fall of humanity as a growing self-consciousness, which must be repaired by a stricter attention to "that gleam of light which flashes across [the] mind from within." [24] As he would later put it in "Experience," "It is very unhappy, but too late to be helped, the discovery we have made, that we exist. That discovery is called the Fall of Man." [25]

This self-consciousness is a falling away from a true self, a universal Self, which stands at the basis of Emerson's philosophy. When Emerson

David M. Robinson

asks, "What is the aboriginal Self on which a universal reliance may be grounded?" he answers by pointing to spontaneity and instinct, forms of a "primary wisdom" called "Intuition."[26] Spontaneity and instinct are words suggesting action; thus when Emerson traces his way back to the aboriginal Self by this route, he emphasizes self-recovery through action. But the intuition underlying spontaneity is a form of knowledge, a natural intellectual possession. One's intuitions are given. Again, as this issue shows us, works and grace weave a complicated pattern through the essay. If in the dramatization of action the essay reaches its most climactic moments, it is constantly true that those dramatizations of will rest on a foundation of secured knowledge.

It is when we seek the origin of that knowledge that we feel the friction of the outer edges of Emerson's inquiry. "The relations of the soul to the divine spirit are so pure that it is profane to seek to interpose helps."[27] Such an attitude protects the sanctity of intuitive knowledge by denigrating the role of the will in helping to recover such knowledge. Very little, Emerson avers, can be said about intuition. At best we have "the far off remembering of the intuition."[28] All Emerson can do is to recommend the new and the strange, and leave these as a test for the genuine.

> When good is near you, when you have life in yourself, it is not by any known or accustomed way; you shall not discern the foot-prints of any other; you shall not see the face of man; you shall not hear any name;—the way, the thought, the good shall be wholly strange and new.[29]

Newness, the very antithesis of custom and conformity, can only be explained as the product of self-reliance. But Emerson's metaphor of finding the new way differs from a Whitmanian bravado that calls upon us to stride confidently down the open road. Part of the appeal of the metaphor, in fact, is that it communicates a certain sense of wandering, even groping, as part of the process of finding the new. "To talk of reliance," he notes, "is a poor external way of speaking. Speak rather of that which relies, because it works and is."[30] The key to culture, then, is paradoxical, a reliance through work and being. Reliance suggests a borrowed or secondary existence, while working and being seem primary. As Emerson would explain, we work or exist through our act of reliance or surrender to a transcendent self. "This is the ultimate fact which we so quickly reach on this as on every topic, the resolution of all into the ever blessed ONE."[31] Self-reliance is finally a stance of humility.

Grace and Works: Emerson's Essays

If we have followed Emerson from his sermon of acceptance through his praise of youthful disdain for restraint, this return to a quietist acceptance might seem to be the logical rounding out of the essay. But in fact this apparent synthesis comes near the middle of the essay, and it is only after the hymn to the "ever blessed ONE" that we find Emerson's most self-assertive images—the "sturdy lad from New Hampshire or Vermont" (discussed earlier), and the protesting family member whose complaint is dramatized in these terms: "O father, O mother, O wife, O brother, O friend [the modern reader will note the absence of 'O husband' from Emerson's litany], I have lived with you after appearances hitherto. Henceforward I am the truth's." [32] This voice of direct address, suggesting a fragment of buried dialogue, gives this passage a certain power. One can see why the essay has always been regarded by university instructors as so "teachable" among Emerson's essays, tapping, as it does, reserves of adolescent rebelliousness. But the dramatic voice here also helps to underline the "newness" necessary to the stance of self-reliance. By tainting the closest, most sacred of social relationships with the possibility of debilitating conformity, Emerson warns against a facile identification of the genuine with the familiar. What is ready-to-hand in our familial ties or close friendships is not always what is spontaneous or intuitive. Always, we must absolve our actions to ourselves alone, and thus "dispense with the popular code." So the vigil never ends, nor the effort it entails. "If any one imagines that this law is lax, let him keep its commandment one day." [33]

Read with attention to the interplay of its voices of will and acceptance, "Self-Reliance" shows the parameters of Emerson's spiritual world in the early 1840s. In it, he evokes both the hunger for mystical spiritual enlightenment which must be accepted as the free work of grace, and the aggressive determination of one whose spiritual culture is wholly self-generated. The success of the essay arises from Emerson's ability to make these rhetorical stances play persuasively against each other, admitting the primacy of an inner enlightenment when willfulness begins to ring hollow, and turning to determined action when a stale mysticism requires reinvigoration.

These same forces play against each other in the essay "Spiritual Laws," although here the case is instructively different, because in contrast to "Self-Reliance" the fundamental thrust of this essay is quietistic. While the prominence of willed action in "Self-Reliance" gradually fades into an identity with quietist surrender of self, something of the reverse

occurs in "Spiritual Laws." Its most prominent emphasis is on an accept-ance of ever-present, self-transcending laws of the spirit, which com-pletely overshadow the working of the will. Emerson notes with disdain the way that "people represent virtue as a struggle, and take to them-selves great airs upon their attainments." The facts of the case are much simpler: "Either God is there, or he is not there."[34] Because the presence of divinity is beyond the call of will, the moral life calls for a stance of receptive openness rather than aroused aggressiveness.

Such is the lesson, Emerson argues, of the truly great individuals in human history.[35] "We impute deep-laid, far-sighted plans to Caesar and Napoleon; but the best of their power was in nature, not in them."[36] Nature, like God, Spirit, or Self, exists in a category opposed to the individual, the will, or the self. Greatness was achieved through these great men, not by them. They succeeded by becoming "an unobstructed channel" through which "the course of thought" could flow. Although great individuals appear to operate by willed actions, the appearance is deceptive. "That which externally seemed will and immovableness, was willingness and self-annihilation."[37] For Emerson, the definition of the moral life came to rest on the difficult distinction between "will" and "willingness."

In Emerson's praise of will-less self-growth, the metaphor of "falling" vividly illustrates the paradoxical notion of progress through surrender:

Let us draw a lesson from nature, which always works by short ways. When the fruit is ripe, it falls. When the fruit is despatched, the leaf falls. The circuit of the waters is mere falling. The walking of man and all animals is a falling forward. All our manual labor and works of strength, as prying, splitting, digging, rowing, and so forth, are done by dint of continual falling, and the globe, earth, moon, comet, sun, star, fall forever and ever.[38]

The irresistible pull of gravity is shown to be the physical equivalent for the spiritual law of falling forward.[39] Through this letting go of self, we are swept along a more universal course. Even more telling is the meta-phor of ripening. The image of an unconscious natural urge to fullness also carries with it the secondary sense of the giving of the self for the sustenance of others. Thus the moral life is characterized as one of a quietistic faith which finds expression in service.

Certainly the mood, if not the ultimate argument, is widely different from that of "Self-Reliance." But just as self-reliance comes quietly to rest on the Universal Soul, spiritual laws come finally to manifest them-

selves through human actions. This turn in the essay is accomplished in part through Emerson's return to the concept of spontaneity as an adequate criterion for discriminating among actions. Because "a higher law than that of our will regulates events, . . . our painful labors are unnecessary and fruitless." In contrast to laborious or willed action is the action made possible by the surrender of the will: "only in our easy, simple, spontaneous action are we strong, and by contenting ourselves with obedience we become divine." [40] While this action is carefully described as essentially will-less, it is nevertheless action. The means may be those of surrender, but the ends are those of assertion, strength, and pragmatic result.

This emphasis on pragmatic action is enlarged when Emerson turns to the concept of choice, for choice would surely seem to signify the presence of will. "*Do not choose*," he says, explaining that choice is commonly "a partial act." But if made whole, choice becomes the foundation for moral action. "But that which I call right or goodness, is the choice of my constitution." Such choosing is a kind of affirmation of the innate and Universal Self, a realization of it, and such a realization is signified not so much by visionary insight as by appropriate action. "That which I call heaven, and inwardly aspire after, is the state or circumstance desirable to my constitution; and the action which I in all my years tend to do, is the work for my faculties." [41] Herein, of course, lies Emerson's modernized concept of the vocational calling: "Each man has his own vocation. The talent is the call." [42] But in larger terms, this is a confirmation of the fact that the full possession of the universal soul within demands action or expression of some sort. Thus a thoroughly pragmatic axiom comes to summarize the lesson of the will-less acceptance of transcendent laws: "What a man does, that he has." [43]

But the essay is not merely a hymn to doing as an end in itself. Even though Emerson can assert that "'What has he done?' is the divine question which searches men," he is careful to insist that action must be grounded in a mental reality best understood through the metaphor of inner depth. [44] Action is judged by its basis in thought, by the idea or motive that lies behind it, "by the depth of the sentiment from which it proceeds." [45] Action, in the longer view, alters our lives much less profoundly than thought.

The epochs of our life are not in the visible facts of our choice of a calling, our marriage, our acquisition of an office, and the like, but in a silent thought

David M. Robinson

by the way-side as we walk; in a thought which revises our entire manner of life, and says,—"Thus hast thou done, but it were better thus."[46]

The superficial results of the action of the self must be distinguished from the less visible but more profound thoughts of the Self. But if real life is measured by the "silent thought," it is also true that such thoughts take on their significance through their ability to "revise" life. Just as thought has bounded and answered action, action renders thought fruitful.

Transcendentalism and the Double Consciousness

In his lectures "The Times" (1841–1842), Emerson pushed this tension between acceptance and action into the social sphere. His lecture "The Conservative" was in some respects a testing ground for the later "Montaigne; Or, The Skeptic" in *Representative Men*. In "The Transcendentalist" we see a portrait even closer to self-description. Emerson assumes ironic distance from the Transcendentalist he describes, but it is finally self-directed irony.

The figure of the Transcendentalist is distilled from the conflict between action and the ideal, sharing the political reformer's incapacity to accept the state of things, but adding to it the idealist's distrust of solutions that are material. In a tone that borders on the petulant, Emerson gives voice to the Transcendentalist's resistant posture: "I can sit in a corner and *perish*, (as you call it,) but I will not move until I have the highest command."[47] Withered by the contempt and impatience of conservative and reformer alike, his refusal to act is a paralysis, but as Emerson passionately argues, a paralysis that is the best hope of the human spirit. "Will you not tolerate one or two solitary voices in the land, speaking for thoughts or principles not marketable or perishable?"[48] The difficulties of the Transcendentalist suggest the precarious situation of Emerson's idealism. The searching portrait of this rebellious but paralyzed figure is veiled autobiography.[49]

This Transcendentalist was worrisome not only to the conservative establishment, but to the political activists of the day as well. Whatever the spiritual implications of "waiting," the political ones were troubling, and Emerson remained an aloof and difficult ally for the reformers. Much of the conflict lay in the dichotomy between "materialist" and "idealist" that Emerson developed in the lecture. He argued that the

Grace and Works: Emerson's Essays

Transcendentalist was only the contemporary version of the idealist, living out doctrines by no means new. "What is popularly called Transcendentalism among us, is Idealism; Idealism as it appears in 1842."[50] He thereby claimed universal status for the Transcendentalist, linking him or her to a tradition that can be traced to classical times and beyond, a tradition so persistent because it expresses a fundamental impulse of human nature.

> His experience inclines him to behold the procession of facts you call the world, as flowing perpetually outward from an invisible, unsounded centre in himself, centre alike of him and of them, and necessitating him to regard all things as having a subjective or relative existence, relative to that aforesaid Unknown Centre of him.[51]

Such a description sets the idealist apart from the materialist, who "takes his departure from the external world, and esteems a man as one product of that."[52] This linking of the Transcendentalist with the ultimate source of creation, an "Unknown Centre" in himself or herself, confirms his or her identity as one version of the "Universal Man" of Emerson's philosophy. Connected to the universal mind, or moral sentiment, or now "Unknown Centre" of life and consciousness, the idealist is depicted as the figure in whom the fullest development of human capacity has been reached. "The Transcendentalist . . . believes in miracle, in the perpetual openness of the human mind to new influx of light and power; he believes in inspiration, and in ecstasy."[53] Certainly this is the projection of an ideal, the embodiment of much for which Emerson had struggled in the 1830s. But even in this ideal portrait we can sense a shadow if we consider the resonances of the word "ecstasy." Ecstasy captures on the one hand a complete fullness, a moment's realization of unity with the larger Self of the universe. On the other hand it suggests a dangerously unstable and fleeting mystical charge.[54]

Emerson understood the inherent tension between history and the universal and confessed "that there is no pure Transcendentalist." As he expands on this ungraspable ideal, he reveals the radical nature of the Transcendental consciousness:

> We have had many harbingers and forerunnners; but of a purely spiritual life, history has yet afforded no example. I mean, we have yet no man who has leaned entirely on his character, and eaten angels' food; who, trusting to his sentiments, found life made of miracles; who, working for universal aims,

David M. Robinson

found himself fed, he knew not how; clothed, sheltered, and weaponed, he knew not how, and yet it was done by his own hands.[55]

The Biblical resonance of the passage is important ("Consider the lilies of the field . . ."), and the allusion to a "life made of miracles" echoes his declaration in the Divinity School Address that Jesus "felt that man's life was a miracle."[56] But the suggestion of Jesus only emphasized the fact that Emerson actually denies him any special reverence or elevation. Controversial as the Divinity School Address was, and radical as Emerson's views may have seemed to many, he was careful there to afford Jesus a privileged place in the spiritual history of mankind.

> Jesus Christ belonged to the true race of prophets. He saw with open eye the mystery of the soul. Drawn by its severe harmony, ravished with its beauty, he lived in it, and had his being there. *Alone in all history,* he estimated the greatness of man. *One man* was true to what is in you and me.[57]

Now, in 1841, he tells us that "history has yet afforded no example" of an idealist. He had offered one signpost of this movement in an 1840 journal entry that declared that "The history of Jesus is only the history of every man written large. The names he bestows on Jesus, belong to himself,—Mediator, Redeemer, Saviour."[58] This democratizing of Jesus extends the argument of the Divinity School Address that Jesus's importance was his recognition of the potential of the individual. In "The Transcendentalist," Emerson put that potential beyond the reach even of Jesus in an attempt to emphasize its freedom from history.

The significant absence of Jesus from "The Transcendentalist" is the first of a number of polemical shadows that the Transcendentalist controversy cast over the address. That controversy, and Emerson's role in it, forms the first layer of autobiographical suggestion in the lecture. No emphasis on the abstract and universal figures that are the topics of this lecture series can remove the essay very far from the confessional context of Emerson's journal. Much of the lecture's rhetorical power results from Emerson's manipulation of the distance between his speaking voice and the image of the Transcendentalist that he paints. In the objective spirit of the photographer or portraitist which set his initial tone in the series, he offers much dispassionate description of Transcendentalism, including a brief technical discussion of the origin of the term "transcendental" in Kantian philosophy. These seem, however, like the formal preliminaries, which are only preparatory to the core of the argument. When Emerson

discusses the Transcendentalist as most nearly in touch with that sense of the Ideal or the Better, which is the source of spiritual culture, he portrays him or her as a universal but somehow lifeless figure. It is only when he observes the social impact of the imperfect but real versions of the universal man that his portrait comes to life.

That birth occurs rhetorically when Emerson observes that the Transcendentalists "prolong their privilege of childhood" by their withdrawal from the world of action and responsibility in dedication to the ideal.[59] If the wise child has in the past served Emerson (and the entire Romantic movement) as an image of perfected human nature, here it serves rather to emphasize the distance between youthful aspiration and adult reality. The Transcendentalists "make us feel the strange disappointment which overcasts every human youth. So many promising youths, and never a finished man!"[60] The disappointment signals the presence of the world-weary voice that dominates an important segment of the lecture. How far we seem to be from the voice of "Circles," assuring us that "Nature abhors the old, and old age seems the only disease."[61] The dangers of a life at sea metaphorically suggest the spiritual dangers faced by the idealist; the philosophical equivalent to the question "Where are the old sailors?" is "Where are the old idealists?"[62] It is in this admission of an inevitable defeat that Emerson sounds the funereal note for the movement only now capable of being described.

The mature distance that Emerson establishes from the Transcendentalist is thus an important sign of his changing perspective. It signals his recognition that hope of any substantial part is a complex reaction to stark limits, limits the more clearly understood with age. Even so, this voice is not final, but part of an emerging, metamorphic voice within the essay.[63] This voice of skeptical, or disappointed, or at times bemused age is an important one, but it too has its limits.

The tone of self-accusation and the conviction of inadequacy suggest those limits to mature skepticism. If he can see in the promise of youth a source of eventual disappointment, he can also feel the disdain of youth for its failed elders. "These exacting children advertise us of our wants," he notes, and he finds most admirable their undisguised discontent. "There is no compliment, no smooth speech with them; they pay you only this one compliment, of insatiable expectation."[64] Emerson draws the principal resonance of the essay from this confrontation of world-weary skepticism with "insatiable expectation." This forms its autobiographical core. The mature voice functions as the principle of reality in

David M. Robinson

the essay, the expectant look of youth as the principle of idealism. Crucially, each sees in the other something that is oddly self-completing. After all, reality has force and finality not solely of itself but in its resistance to the unrelenting pressure of the ideal. And how else can the value of the ideal be understood apart from the fact of the real? So Emerson dramatizes his intellectual dilemma: to accommodate his increasing skepticism to an idealism that he could never wholly abandon.

That he could never wholly abandon it is suggested by the dialogue between "the world" and the stubbornly balking Transcendentalist youth who complains that he is "miserable with inaction." Emerson ought to be recognized for his understanding of one phenomenon of the modern world—that spiritual crises often manifest themselves as vocational crises. The youth is not fretting about sin and salvation here but about work. He finds none of it satisfying, and that very attitude is telling social criticism. The Transcendentalist has instead adopted the honest but unfulfilling attitude of "waiting." The response of the world is simple and cold: if you do not like the work of the world, "'what will you do then?'" In waiting, "'you grow old and useless.'" The youth, stung by the response, stiffens his willful refusal to work.

> Be it so: I can sit in a corner and *perish,* (as you call it,) but I will not move until I have the highest command. If no call should come for years, for centuries, then I know that the want of the universe is the attestation of faith by this my abstinence. Your virtuous projects, so called, do not cheer me. I know that which shall come will cheer me. If I cannot work, at least I need not lie.[65]

This dramatized defiance is the tensest moment of the lecture, the intensity itself a measure of the threat the world's inescapable common sense poses to idealism. The passion of this moment is rhetorically similar to the well-known passage in "Circles" in which a speaker threatened by a skeptical though undeniably shrewd objector defiantly proclaims himself irresponsible to reason, and instead "an endless seeker, with no Past at my back."[66] In "Circles" the defiance is expressed as experimentation, but in "The Transcendentalist," as waiting. That in itself is a revealing contrast. But in both cases, the extremity of the rhetoric suggests a whistling in the dark.[67] The "virtuous projects" that Emerson's Transcendentalist here so scornfully rejects were the very avenues of action that were a possible alternative for Emerson now. If through the figure of the Transcendentalist he enacts his rejection of action, through the shrillness of that objection he undercuts it.

Grace and Works: Emerson's Essays

As the conflict continues, the autobiographical focus of the lecture sharpens. "When I asked them concerning their private experience," the controlling voice of the lecture reports, "they answered somewhat in this wise: It is not to be denied that there must be some wide difference between my faith and other faith." And so he slides into the voice of the Transcendentalist, a transition all the easier because those words are drawn directly from private struggles that he had recorded in an 1841 journal entry. The faith described is "a certain brief experience," which comes by surprise and reveals the foolishness of daily life. But it passes, and in its passing leaves an emptiness. "My life is superficial, takes no root in the deep world; I ask, When shall I die, and be relieved of the responsibility of seeing an Universe which I do not use? I wish to exchange this flash-of-lightning faith for continuous daylight, this fever-glow for a benign climate."[68]

This rueful admission of failure opens the theme of the "double consciousness," significant both in this lecture and in the later "Experience." It is a consciousness born when the brief experience of faith casts its disparaging shadow over the course of ordinary life. "To him who looks at his life from these moments of illumination" (to the Transcendentalist, in other words), his skill, his labor, the work he is given to do is stripped of value.[69] The faith of the mystic has its cost—the experience of living itself.

Emerson had expressed this concept of the double consciousness in the summer of 1841, when he confessed that a vague sense of disappointment was "the true experience of my late years." Feeling inadequate to do the things needing to be done or to say the things needing to be said, he confessed that "I lie by, or occupy my hands with something which is only an apology for idleness until my hour comes again." If honest in refraining from false work, and humble in refusing to find in a single self the cure for the world, the price of this waiting was a chasm between his conception of life and his experience of it.

> The worst feature of our biography is that it is a sort of double consciousness, that the two lives of the Understanding and of the Soul which we lead, really show very little relation to each other, that they never meet and criticize each other, but one prevails now, all buzz and din, and the other prevails then, all infinitude and paradise, and with the progress of life the two discover no greater disposition to reconcile themselves.[70]

David M. Robinson

Life then does not force us to surrender our faith—it forces us to bracket that faith as an ideal while it continues to demonstrate that reality proceeds as it will. That "Experience" was an attempt to answer this dilemma is suggested by the preliminary remarks in an early journal outline of it: "It is greatest to believe and to hope well of the world, because he who does so, quits the world of experience, and makes the world he lives in."[71] What is most poignant here is the split between hope and experience, and the hint of escapism contained in the very attitude of hope. Here the double consciousness is stretched to its limits.

The attitude of "waiting" is therefore one that acknowledges the facts of experience without surrendering to them. It is the last gesture of faith in a world stripped of possibility. We have already noted the Transcendentalist's defense of waiting. That dialogue is drawn from a journal entry which is preceded by a list of the new "trials of this age . . . early old age, pyrrhonism and apathy."[72] The defiant dismissal of the accusation of Pyrrhonism in "Circles" was apparently short-lived. Patience, and not defiance, has now become the cardinal virtue. "Patience, then, is for us, is it not? Patience and still patience."[73] The capacity to wait, to hold with dignity this double consciousness, was the only resource remaining for the Transcendentalist. "Experience" was the spiritual autobiography which fulfilled the confessional promise of "The Transcendentalist," and even there, Emerson could recommend no further: "Patience and patience, we shall win at the last."[74]

Notes

1. *The Journals and Miscellaneous Notebooks of Ralph Waldo Emerson*, ed. William H. Gilman et al. (Cambridge, Mass., 1960–1982), 8:36. [Hereinafter Emerson, *Journals and Notebooks*.]

2. This essay reflects my continuing interest in the concept of self-culture in Transcendentalist thinking. For related earlier studies, see David Robinson, "The Legacy of Channing: Culture as a Religious Category in New England Thought," *Harvard Theological Review* 74:221–239 (1981); and *Apostle of Culture: Emerson as Preacher and Lecturer* (Philadelphia, 1982).

3. Emerson, *Journals and Notebooks*, 7:487.

4. *The Collected Works of Ralph Waldo Emerson*, ed. Robert E. Spiller et al. (Cambridge, Mass., 1971–), 1:17. [Hereinafter Emerson, *Collected Works*.]

5. Emerson, *Journals and Notebooks*, 7:523.

6. See Robert E. Spiller's discussion of the early 1840s in Emerson's career as a period of crisis in "The Four Faces of Emerson," *Four Makers of the American*

Mind, ed. Thomas Edward Crawley (Durham, 1976), 14–19. I have also commented on this point in "*The Method of Nature* and Emerson's Period of Crisis," in *Emerson Centenary Essays*, ed. Joel Myerson (Carbondale, Ill., 1982). For the most influential version of the overall contour of Emerson's intellectual development, see Stephen E. Whicher, *Freedom and Fate: An Inner Life of Ralph Waldo Emerson* (Philadelphia, 1953).

7. "Circles" has taken on enormous importance in the Emerson canon in recent years. For assessments of it see Jonathan Bishop, *Emerson on the Soul* (Cambridge, Mass., 1964), 142; Harold Bloom, *Figures of Capable Imagination* (New York, 1976), 53–64; David M. Wyatt, "Spelling Time: The Reader in Emerson's 'Circles,'" *American Literature* 48:140–151 (1976); James M. Cox, "R. W. Emerson: The Circles of the Eye," in *Emerson: Prophecy, Metamorphosis, and Influence*, ed. David Levin (New York, 1975), 57–81; David Robinson, "Emerson and the Challenge of the Future: The Paradox of the Unachieved in 'Circles,'" *Philological Quarterly* 57:243–253 (1978), and the related discussion in *Apostle of Culture*; Barbara Packer, *Emerson's Fall* (New York, 1982), 14–19; and Leonard N. Neufeldt and Christopher Barr, "'I Shall Write Like a Latin Father': Emerson's 'Circles,'" *New England Quarterly* 59:92–108 (1986).

8. Emerson, *Collected Works*, 2:189.

9. Ibid., 2:78, 70.

10. For helpful discussions of the concept of metamorphosis in Emerson's thought, see Daniel B. Shea, "Emerson and the American Metamorphosis," in *Emerson: Prophecy, Metamorphosis, and Influence*, ed. Levin, 29–56; and Leonard Neufeldt, *The House of Emerson* (Lincoln, Neb., 1982), 47–71.

11. See Conrad Wright, *The Beginnings of Unitarianism in America* (Boston, 1955), 91–114.

12. See Phyllis Cole, "The Advantage of Loneliness: Mary Moody Emerson's Almanacks, 1802–1855," in *Emerson: Prospect and Retrospect*, ed. Joel Porte (Cambridge, Mass., 1982), 1–32; and Cole, "From the Edwardses to the Emersons: Four Generations of Evangelical Family Culture," forthcoming in *College English Association Critic*.

13. Henry Ware, Jr., "The Faith Once Delivered to the Saints," in *The Works of Henry Ware, Jr., D.D.* (Boston, 1846), 2:230. A fuller treatment of this doctrine and its relation to Emerson's preaching is forthcoming in my introduction to the complete edition of Emerson's sermons, now being edited under the direction of Albert J. von Frank.

14. Daniel Walker Howe, *The Unitarian Conscience: Harvard Moral Philosophy, 1805–1861* (Cambridge, Mass., 1970).

15. Edwin Gittleman, *Jones Very: The Effective Years, 1833–1840* (New York, 1967), 268–269.

16. Emerson, *Collected Works*, 2:51.

17. Ibid., 2:30.

18. Ibid., 2:29.

19. Ibid., 2:31.

20. Ibid., 2:43.

21. Ibid., 2:28.

22. Ibid.

David M. Robinson

23. Ibid., 2:29, 28.

24. Ibid., 2:27.

25. Ibid., 3:43. See the analysis of the various versions of the fall in Emerson's thinking in Packer, *Emerson's Fall*.

26. Emerson, *Collected Works*, 2:37.

27. Ibid., 2:38.

28. Ibid., 2:39.

29. Ibid.

30. Ibid., 2:40.

31. Ibid.

32. Ibid., 2:41–42.

33. Ibid., 2:42.

34. Ibid., 2:78.

35. This complex of ideas about the role of the great individual in human history can be traced back to Emerson's sermons, early journal entries, and the early lecture series "Biography." The same ideas later formed the basis for his *Representative Men* (1850).

36. Emerson, *Collected Works*, 2:78–79.

37. Ibid., 2:79.

38. Ibid., 2:80.

39. "The axioms of physics translate the laws of ethics," he had written in *Nature* (Emerson, *Collected Works*, 1:21).

40. Emerson, *Collected Works*, 2:81.

41. Ibid., 2:82.

42. Ibid.

43. Ibid., 2:83.

44. Ibid., 2:91.

45. Ibid., 2:90.

46. Ibid., 2:93.

47. Ibid., 1:212.

48. Ibid., 1:216.

49. Whicher has argued that the lecture represents only a "second choice" or lesser substitute for Emerson's ideal, and he notes some disaffection that Emerson seemed to hold for the Transcendentalist's lack of spontaneity. I think it more revealing to see how closely the Transcendentalist captured Emerson's own dilemma, and how little choice he had in the portrait, ideal or not. See Whicher, *Freedom and Fate*, 80.

50. Emerson, *Collected Works*, 1:201.

51. Ibid., 1:203.

52. Ibid.

53. Ibid., 1:204.

54. The term ecstasy and its implications for Emerson's philosophy are discussed in more detail in my "*The Method of Nature* and Emerson's Period of Crisis."

55. Emerson, *Collected Works*, 1:205–206.

56. Ibid., 1:81.

57. Ibid., italics added.

58. Emerson, *Journals and Notebooks*, 7:519.

59. Emerson, *Collected Works*, 1:209.

60. Ibid.

61. Ibid., 2:188.

62. Ibid., 1:209.

63. Commenting on two other essays on Emerson, "The Method of Nature" and "Experience," Leonard Neufeldt has identified the fundamental dynamic through which meaning emerges in the best of the essays: "In each the vision is created by the unfolding of the persona, by his variety of tones, changing perceptions, and shifts in opinion, and by the continual dialectic in which he is caught." See Neufeldt, *The House of Emerson*, 206.

64. Emerson, *Collected Works*, 1:210.

65. Ibid., 1:212.

66. Ibid., 2:188.

67. My tendency to see the Pyrrhonist objector in "Circles" as a profound worry to Emerson should be compared with the somewhat different view of Barbara Packer, who finds Emerson's reply expressive of "powerful contempt" for the objection (p. 15). See Packer, *Emerson's Fall*, 14–19.

68. Emerson, *Collected Works*, 1:213; see also Emerson, *Journals and Notebooks*, 8:98–99.

69. Emerson, *Collected Works*, 1:213.

70. Emerson, *Journals and Notebooks*, 8:10–11; see also Emerson, *Collected Works*, 1:213.

71. Emerson, *Journals and Notebooks*, 8:411.

72. Ibid., 8:86.

73. Emerson, *Collected Works*, 1:214.

74. Ibid., 3:48–49.

David M. Robinson

Margaret Fuller Ossoli (1810–1850). Engraving by F. T.
Stuart, n.d., in Thomas Wentworth Higginson, *Margaret
Fuller Ossoli* (Boston, 1895), frontispiece. Collection of the
Massachusetts Historical Society.

"A Higher Standard in Thought and Action": Margaret Fuller and the Idea of Criticism

ROBERT N. HUDSPETH

Margaret Fuller's career as a literary critic grew out of a vocational crisis that was as real as, if less dramatic than, those of Emerson, Ripley, and John Dwight, to name only a few of her Unitarian minister friends. Raised in a perfectly middle-class Unitarian home, Fuller grew up in daily contact with many leading Unitarians: she played with Andrews Norton's children; she was intimate with Joseph Tuckerman's niece; she danced with a succession of Parsons, Lunts, Emersons, and Clarkes; and she came and went from Edward Tyrell Channing's home. Fuller had every reason to develop perfectly conventional, liberal, and genteel habits of mind and literary taste. Heaven knows, the Cambridge and Boston Unitarians wrote enough, and some of her fellow Cambridge citizens made names for themselves that we still recognize—Dana, Holmes, Longfellow, and Lowell.

But Margaret Fuller did not fit this mold; she had little talent for belles-lettres, though like teenagers then and now she tried her hand at versifying. As a woman she was excluded from Harvard and the world it opened to her male friends. She did not assume the role of priest/

Robert Hudspeth is Dean of the College of Arts and Sciences, University of Redlands, and editor of *The Letters of Margaret Fuller* (Ithaca, 1983–).

lawyer/doctor/scholar only to find that she lacked the faith or the talent or the stomach for that vocation. Fuller had no parish to whom she wrote a letter of resignation nor a law practice to give over to become a sculptor. Her congressman-father and her uncles were lawyers; her grandfather Fuller was a minister, but all this made no context for her. If her brothers had difficulties imitating their father, Margaret was freed from that particular guilt.

Of course it became ironic that this specific freedom became Fuller's crisis because there was no institutional or sanctioned alternative for her. She had to measure up to her father's standard without a clear way of doing so. She acquired the equivalent of a Harvard education, but she had no direct use for it. By the time Fuller assumed the leadership of the family in 1835 she was intellectually poised—but for what? Almost by default she became a literary critic, which was not at all a recognized vocation. Even for men, who did not face the obstacles confronting Fuller, the question why be a critic was hard enough to answer. There was no money in writing for the quarterlies or the press; most of the work was anonymous, so there was not even satisfaction for one's ego; the major journals (that is, the *North American Review* and the *Christian Examiner*) did not give assignments to young women; and, most of all, critics were thought to be an intellectually disreputable lot (at least among people of genuine "taste"). Fuller herself said that they were apt to produce "regular articles, got up to order by the literary hack writer, for the literary mart." [1] Despite these handicaps, Fuller persisted because criticism was intellectual freedom for her; she redefined the work that she undertook, for she came to see that it was a potent means of self-culture. Literary criticism offered an opportunity to grapple with what was most important in intellectual life, and it was, she thought, the way to improve the national dialogue between readers and writers.

Fortunately, Fuller never lacked a forum. From the first number of the *Western Messenger* in 1835 to her death in 1850, she could publish whatever she wrote. In all the extensive record of her life we find not a single hint that she had trouble placing an essay or book notice. In fact, if anything, she was pressed to contribute more than she did. Even her daring book on women, with its bold discussion of sexuality, was immediately published. The existence of James Clarke's *Western Messenger*, George Ripley's *Specimens of Foreign Standard Literature*, the *Dial*, and Horace Greeley's *New-York Daily Tribune* (each, one should note, superintended by a Unitarian) assured Fuller that her voice would be heard. Whatever

Robert N. Hudspeth

else she faced, she had her opportunities to speak out. At this point, we should also remember that Fuller had a surprisingly short career as a critic. It began in 1835 and ended in July 1846, when she left New York City for Europe—a career that spanned little more than a decade. In spite of its brevity, that career left a mark on American letters, for Fuller created a vision of what criticism itself might offer the reader.

Briefly put, we may say that Fuller did not want to judge a work to be good or bad; rather, she wanted to show her readers how they could read more profitably. This attitude came from her assumption that self-culture was an end that writers, critics, and readers could attain. This, in turn, led her finally to value psychology over art and to find her natural subject in biography in spite of the fact that she never wrote one. These conclusions emerge from a close reading of her major critical essays written between 1836 and 1844, the period in which Fuller established herself as a writer. Her later work took new directions as she continued to evolve as a writer and thinker, but it is in the years of the 1830s and early 1840s that she arrived at her most complete understanding of her craft.

The first problem Fuller faced was the distance between her ideas and the expectations of her readers. From the early 1830s, she knew she was an outsider: "I cannot well judge," she said in a letter to James Clarke, "what effect any-thing is like to produce on a New-England publick with which I have nothing in common."[2] At the risk of oversimplifying, let us say that that "publick" as Fuller experienced it was the one dominated by the "Harvard Unitarians" described by Daniel Walker Howe. It was an audience that assumed "the artist ought to be a moral and religious teacher."[3] For them, art was sentimental; it taught a clear, praiseworthy moral, and it should reflect that national experience. It was, in short, the most important means to create a high culture in a young country that had none. Furthermore, it was the means of creating a Whiggish hegemony over potentially troublesome democracy, and it guaranteed emotional satisfaction without unleashing irrational and destructive passions. The tenor of such criticism may be caught in Dr. William Ellery Channing, who, in his "Remarks on National Literature," said that "To literature we then look, as the chief means of forming a better race of human beings. To superior minds, which may act through this, we look for the impulse by which their country is to be carried forward."[4] In his much-admired essay on Milton, Channing says that poetry "lifts the mind above ordinary life, gives it a respite from depressing cares, and awakens

the consciousness of its affinity with what is pure and noble. In its legitimate and highest efforts, it has the same tendency and aim with Christianity; that is, to spiritualize our nature."[5] Finally, to use Channing one more time, he asked rhetorically in "The Present Age": "Are not works of genius and the fine arts soothing influences? Is not a shelf of books in a poor man's house some pledge of his keeping the peace?"[6] Neither this relation between literature and the soul nor its relation with society was satisfactory to Margaret Fuller.

She was further alienated by the fact that she was a woman without status in a man's world. William Charvat's apt observation that, previous to 1835, criticism was dominated by lawyers and clergymen suggests how far Fuller was from her audience. According to Charvat, "religion and law together . . . served to create a social pattern of thought in criticism which brooked no assaults upon the political and moral order of the day."[7] Before she died in 1850, Fuller had come to challenge both.

As are most events in literary history, the story of Fuller's intellectual life is an evolution. She certainly shared with the Unitarians a concern for religion and for a moral life (while not at all concerning herself with a national literature), but she was interested in neither historical religion nor a code of conduct. The most significant quality in Fuller's evolution from the Unitarians was her ability to subordinate religion and morals to art, psychology, and self-culture. Fuller did not quarrel with the Unitarians so much as she defined different goals for herself.

Her contemporaries, she thought, were quick to apply reductive principles that insulted the artist. A passage from the *American Quarterly Review* in 1830 that Charvat quotes may stand for a whole attitude. Popular novels

> ought to have their defects as compositions, whether they consist in insipidity
> or feebleness, in inaccuracy or inelegance, in exhibitions of ignorance or of-
> fenses against good taste, pointed out with an unsparing hand, so as to coun-
> teract, as far as possible, the evils which their extensive circulation may enable
> them to effect.[8]

The tone sneers at the author: the critic's aim is to reform bad work and protect the audience. As a corrective to this critical dogmatism, Fuller sought (to paraphrase her) a way to judge gently and excuse generously.[9] She self-consciously allied herself with the writer and took the position that the work must be judged by its own standards, that the critic should assess the effect of the whole, and that, even if the writer failed, the critic

Robert N. Hudspeth

must recognize the work's merits. Because she refused to legislate, Fuller created a different kind of critical persona from that of her contemporaries. No longer did she assume that the critic's knowledge, taste, and values were absolutes against which a work was to be judged.

Fuller's first important discovery was the need to address her criticism to the reader, not to the writer; she had to school her readers in ways of better reading. To this end, she offered her persona as a typical reader, one who makes an effort to respond at the level set by the original author. She thus became a mediator and advocate. The act of reading itself took on an added meaning. As she said in 1844, "The word descended and became flesh for two purposes, to organize itself, and to take cognizance of its organization." [10] This play on the fourth gospel unites the artist's function (to organize) and the critic's (to take cognizance). Both writer and reader experience the word but in different, yet complimentary, ways. If creativity is divine—as her language implies—then so is criticism. "The word" comes to life in readers as well as in writers. From this point of view, the critic becomes the representative or best reader. Fuller asks the reader, not the writer, to rise to her standard. As a result, she implies, all readers are critics.

Fuller was aware of how critical conventions had blighted readers, who were, she says, "accustomed to measure the free movements of art by the conventions that hedge the path of daily life, who, in great original creations, seek only intimations of the moral character borne by the author in his private circle," who were "those whom Byron sneers at as 'the garrison people.'" [11] These readers were the ones whom Fuller sought to educate. Early in her career she clearly saw the need to focus on the work of art itself, not on the author, to proclaim the importance of the work's own goals, and to judge whether or not the work achieved them. The best critics would "enter into the nature of another being and judge his work by its own law. But having done so, having ascertained his design and the degree of his success in fulfilling it, thus measuring his judgment, his energy, and skill, they do also know how to put that aim in its place, and how to estimate its relations." [12] This process demands sympathy and patience with the author. The critic must evaluate the success as measured against the work itself; she must then put her evaluation into relationship with other readings and experiences. The goal is to expand our understanding of the work, not to judge it. Rather than reduce criticism to a catalogue of faults, Fuller wants to extend the rewards the reader might get from the work. She explicitly rejects the question of absolute

worth (is this a great book?) in favor of the relative question (what can I learn from it?).

Fuller knew that any aesthetic experience was a meeting of two minds, but she emphasizes the degree to which the reader is necessary: "What tongue could speak," she says, "but to an intelligent ear?"[13] This implies a freedom for both writer and reader: the writer needs to be heard to be complete, just as the reader needs the author's voice. In an essay on Philip Bailey's *Festus*, Fuller vigorously defends the importance of the reader/critic: "The man who hears occupies a place as legitimate in the unfolding of the race, as he who speaks."[14] This transaction is a fulfillment, not a limitation. Such an ideal critic, the one with the intelligent ear, "will be free and make [others] free from the mechanical and distorting influences we hear complained of on every side."[15] The critic who plays the role of the ideal reader earns her freedom by being an adequate audience; she in turn helps other readers earn their freedom. At every step, Fuller aims to expand, not contract, the effect that a work of art creates.

In many ways "freedom" is Fuller's goal. She wants writers to be free to choose topics and to develop ideas in spite of the public prejudices; she wants readers to be free to respond. The former must be freed from prescriptive critical standards; the latter must be free to evaluate a work for herself. Fuller represents this need best in an imagined address of a reader to a writer: "Better to me is a narrow life of my own, than passive reception of your vast life. You may have all; but you must not be all to me. Let me find your limits; let me draw a line from you to the centre; you indicate it, but are not it. I must be freed from you, if I would know you."[16] Here the act of critical reading creates a space for the reader to recover a balance because domination—even by genius—is destructive.

The freedom Fuller describes here directly relates to her more significant assumption that literary criticism is itself a form of self-culture. This ideal of growth was dear to the New England Unitarians, as David Robinson has shown in his *Apostle of Culture*. It was, in his words, "the progressive realization of the potential perfection of the soul."[17] This realization could be—and often was—mirrored in Romantic literature, first in England and on the continent, and then in the work of Emerson and Thoreau. Fuller recognized this internal power in her own life when she wrote in her journal for 1842:

There is one only guide, the voice in the heart that asks—Was thy wish sincere? If so thou canst not stray from nature, nor be so perverted but she will make thee true again. I must take my own path, and learn from them all,

Robert N. Hudspeth

without being paralyzed for to day. We need great energy, and self-reliance to endure to day. My age may not be the best, my position may be bad, my character ill formed, but thou, Oh Spirit, hast no regard to aught but the seeking heart.[18]

The standard she sets here for herself is the same she set for her criticism. When she confronted a Goethe on his own ground or an Emerson on his, she tested herself against a high mark in order that her "seeking heart" might find growth. It takes energy and self-reliance to discover the coherence of a literary work. The result is not to elevate the writer but to make herself grow. If, as in fact he did, Goethe championed self-culture, Fuller can demonstrate that fact to her readers and urge them to their own self-growth. As a result, both she and they benefited. Her praise of *Faust* illuminates her conception of the relationship between art and life: "Faust contains the great idea of his life, as indeed there is but one great poetic idea possible to man, the progress of a soul through the various forms of existence."[19]

Central to both criticism and self-culture is the place of thought, for to Fuller, the mind has an unusually large significance. In an early essay, she says of Wordsworth that "Talent, or the facility in making use of thought, is dependent, in great measure, on education and circumstance; while thought itself is immortal as the soul from which it radiates."[20] Fuller unites the "soul" and "mind" so that heightened mental life becomes self-culture. To her, the mind is an agent of the soul. While Fuller's overt topic is Wordsworth's mental power, her unstated topic is the power of the mind embodied in criticism. To read well is to think well; a critic's response is largely, though not exclusively, an act of the mind. What she says of Wordsworth exactly expresses her own craft:

> There is a suggestive and stimulating power in original thought which cannot be gauged by the first sensation or temporary effect it produces. . . . Yet when the mind is roused to penetrate the secret meaning of each human effort, a higher pleasure and a greater benefit may be derived from the rude but masterly sketch, than from the elaborately finished miniature.[21]

At its best, criticism does "penetrate the secret meaning" of a human effort. She clearly and bluntly confessed her love of thought when she wrote to James Clarke: "a Shelley *stirs* my mind more than a Milton and I'd rather be excited to think than to have my tastes gratified."[22] Thought, not taste, becomes the end. Such a comment from Fuller

clearly represents her commitment to self-growth rather than to a superficial "high culture." It is not the learned response nor the ability to measure up to aesthetic standards that animates the reader. As a result, criticism became important in its own right. Without being presumptuous or vain, Fuller could assume that what she says of Goethe she means also to stand for the ideal critic: "To be capable of all duties, limited by none, with an open eye, a skillful and ready hand, an assured step, a mind deep, calm, foreseeing without anxiety, hopeful without the aid of illusion, such is the ripe state of manhood." [23] To Fuller, this passage represents an ideal possibility of self-culture through literature. It is this for which every reader might strive.

This focus on the mind and self-culture was part of Fuller's move toward a new freedom for the critic. When, however, she threw over the conventional language of judgment, she was forced to trust a critical language that was poorly defined and vague. For example, she repeatedly praises works for their sincerity and truth, but we sometimes miss exactly what she means. For her, "sincere" means something like its archaic sense of "undiluted," and "true" means faithful to the original. Of letters from Bettine Bretano to Gunderode, Fuller says: "So very few printed books are in any wise a faithful transcript of life, that the possession of one really sincere made an era in many minds." [24] She assumes that, because a "sincere" work is faithful to its antecedent, the reader is connected to the hidden prior life. Sincerity is seriousness, purity, fidelity, and a triumph over time. When Fuller calls a work sincere, she means that the reader recaptures the author's otherwise lost world.

"Truth" is equally troublesome. On one level she simply means fidelity to fact, but, more important, she means a harmony of faculties and an ability to see what we otherwise could not. It is not so much a question of factual accuracy as it is an ability of the work to illuminate something that has been hidden. For this reason, Fuller could praise fantasy, as she does in reference to Goethe: "It is the highest attainment of man to be able to tell the truth, and more hardly achieved by the chronicler than the Phantast." [25] Fantasy may be more "true" than history, an idea common enough for many romantics. Fuller, however, praises the discoveries that the reader makes when a work is "true" or "sincere." In such books, the past becomes the present; the hidden life comes to light.

Thus far we have seen Fuller emphasize the literary work itself, a position that broke away from traditional moralizing criticism. Yet, in spite of the

Robert N. Hudspeth

new emphasis Fuller put on literature and on aesthetic creativity, she was finally interested in moral philosophy, not art. Repeatedly, her essays discuss the psychological reality of either the characters or the author (or, more often, both) and then immediately turn to generalizations about all life. Consider her comments on Apollo in the essay on Goethe:

> What the ancients meant to express by Apollo's continual disappointment in his loves, is felt in the youth of genius. The sympathy he seeks flies his touch, the objects of his affection jeer at his sublime credulity, his self-reliance is arrogance, his far sight infatuation, and his ready detection of fallacy fickleness and inconsistency. Such is the youth of genius, before the soul has given that sign of itself which an unbelieving generation cannot controvert. Even then he is little benefited by the transformation of the mockers into Dalai-Lama worshippers. For the soul seeks not adorers but peers, not blind worship but intelligent sympathy.[26]

The pattern in this passage could be reproduced endlessly from her work: she interprets Apollo as a symbolic psychological process; she finds that psychology in Goethe and then generalizes into "the soul." From art to author to every soul: Fuller aims to make the final connection, for in it lies sincerity (the pure life) and truth (that which has been illuminated). She is less concerned to describe how Goethe's art works than to show what nineteenth-century individuals need. While she does not want to subordinate art, she does see in it the inner principles that made self-culture possible.

One psychological principle may stand for us for the whole, especially because it applies both to art and to criticism. Like Emerson, Fuller assumes a principle of compensatory balance. Repeatedly, her works talk of two souls, of a balance between mind and emotion, of a struggle to reconcile inevitable contradictions:

> we are so admirably constituted, that excess anywhere must lead to poverty somewhere; and though he is mean and cold, who is incapable of free abandonment to a beautiful object, yet if there be not in the mind a counterpoising force, which draws us back to the centre in proportion as we have flown from it, we learn nothing from our experiment, and are not vivified but weakened by our love.[27]

Here, in a discussion of Bettine Brentano, Fuller emphasizes the psychological process that she finds dramatized in the work. The mind itself acts to balance our psyches and in so doing we grow. As she often does, Fuller here implies that criticism has the same psychic conservation of

energy as art. The critic may go too far in one direction, but the mind draws us back.

In her essays on Goethe, Fuller emphasizes this psychological power by contrasting him with Dante. Where Goethe was content to offer Faust a "loophole redemption," Dante was

> a *man*, of vehement passions, many prejudices, bitter as much as sweet. His knowledge was scanty, his sphere of observation narrow, the objects of his active life petty, compared with those of Goethe. But constantly retiring on his deepest self, clearsighted to the limitations of man, but no less so to the illimitable energy of the soul, the sharpest details in his work convey a largest sense.[28]

This is an example of Fuller's habit of contrasting one writer with another. Her aim is not to censure Goethe but to clarify what she thinks is a better psychological process in Dante, to illuminate growth within the boundaries of limitations. For all her belief in self-culture, progress, and human potential, Margaret Fuller was unblinkingly aware of the limitations inherent in human nature. The trick, she saw, was to use them as sources of psychic energy. In rebellion lay possibility: this is, of course, a common enough romantic idea, one taken directly from Goethe, whose words she quotes as a motto for the essay: "He who would do great things must quickly draw together his forces. The master can only show himself such through limitation, and the law alone can give us freedom."[29] Following his lead, Fuller looks for the opposition of forces in the self and for ways in which we can engage in a creative struggle.

The pattern takes several forms in Fuller's writing: she often wrote "dialogues" in which two opposing views balance each other; she used George and Edward Herbert in one essay as two kinds of mind; she put opposing mottos at the head of *Woman in the Nineteenth Century*. Friendship became a natural dualism in which two different personalities balanced each other. Bettine and Gunderode offer a clear example: "The advantage in years, the higher culture, and greater harmony of Gunderode's nature is counterbalanced, by the ready springing impulse, richness, and melody of the other."[30] Fuller's point as a critic is to present the duality in its completeness without choosing one side or the other. She assumes that such an act of synthesis is the means of growth, that the paradox that "law alone can give us freedom" is creative.

The challenge for Fuller is not law but knowledge. Without an ability to know where we stand, we are eternal victims of forces over which we

Robert N. Hudspeth

have no control, for command always implies insight. She spells out this fact in the essay on Bettine and Gunderode. Here she works out an idea of a buried, hidden life that underlay her intellectual career. Of these letters she says that they make a "meteor playing in our sky," that they "diffused there an electricity and a light, which revealed unknown attractions in seemingly sluggish substances, and lured many secrets from the dim recesses in which they had been cowering for years, unproductive, cold, and silent."[31] This passage is central to our understanding of Fuller and her place in our history, for it reveals her assumptions about where nineteenth-century readers found themselves. Life, she says, lies hidden from consciousness, without power and without effect on others. The frustrations Fuller often voices originate here in the cold darkness of the self. With meteor-like swiftness, a work of art brings bright light and electricity and raises the self to new being. This Prometheanism is common enough to European Romantics but infrequent in the American imagination before Melville. Fuller's idea focuses on the effect of art on the self. A life buried in an ineffectual torpor can come into light and life. Once again, Fuller turns to the reader, not to the literary work. Her praise is psychological, not aesthetic. Her "good" has meaning only as a pragmatic ability to foster self-culture.

The energy Fuller describes originates in the author, but Bettine only symbolizes a process that exists in many forms, especially in Fuller's own criticism. Though she seldom says so overtly, she repeatedly implies that the sympathetic act of criticism works on the reader exactly as does the imaginative work: it brings life to light; it is an agent of self-culture. For this reason, Fuller knew that conventional criticism in the quarterlies was pointless. In place of the arrogance of judgment, she wanted to create a way to affect the dormant possibilities of the individual.

It was inevitable that Fuller was drawn to biography, for lives were symbolic structures that endlessly fascinated her. In part her inability to pursue biography is to be regretted, for it was her natural subject. To be sure, she often had biographies to review, especially early in her career— those of George Crabbe, James MacKintosh, and several composers. More important was her long preparation to write Goethe's biography. From the early 1830s, Fuller was struggling to write a biography of the German poet, though the problem of source material was formidable, as was the question of Goethe's sexual adventures. The former rather than the latter finally ended her plans, but the work she invested in the project led her to translate Eckermann's conversations with Goethe and to pub-

lish a long essay on the poet in the *Dial*. Finally, her essay on the lives of musicians and the one on Bettine, both written for the *Dial*, are biographical criticisms. Thus, though she wrote no original biography, much of her best early work was rooted in her interest in the lives of the great.

None of this can be too surprising from a writer who drew sustenance from the Romantic concern for genius, heroes, and great men. More writers than Carlyle and Emerson centered their work on what Fuller called the "pilot-minds" of their generation. For herself, Fuller routinely assumed that some symbolic person, "whether in life or literature, [stands] at the gate of heaven, and represent[s] all the possible glories of nature and art." [32] For Fuller, it was significant that biography can challenge us. "We need," she says, "the assaults of other minds to quicken our powers." [33] While that assault comes from many sources, it comes immediately from our encounters with another human being in biography. As she does so often, Fuller here assumes an active response from the reader of biography: "A sense of the depths of love and pity in our obscure and private breasts bids us demand to see their sources burst up somewhere through the lava of circumstance, and Peter Bell has no sooner felt his first throb of penitence and piety, than he prepares to read the lives of the saints." [34] The relationship here is dynamic. Our hidden lives, when stirred, break out into redemptive reading. Nowhere else is the connection between biography and self-culture so evident: biography is a record of that which did grow and which frees us for further growth; we connect ourselves to the life of another and so end our own isolation.

Once again the Germans provide Fuller with a paradigm. In Bettine and Gunderode Fuller observed the power of biography at work. The young women, she says, had been animated by and transformed through the lives of Goethe, Kant, and Schelling. This process "is a creation not less worthy our admiration, than the forms which the muse has given them to bestow." [35] This is a clear statement that "life" is but another term for the effect of art, that art and life for Fuller were not oppositions, but twin sources of self-culture.

The lives of artists do, however, convey a special opportunity, for in them Fuller finds creations that are more accessible than those of statesmen:

> Of all those forms of life which in their greater achievement shadow forth what the accomplishment of our life in the ages must be, the artist's life is the fairest in this, that it weaves its web most soft and full, because of the material

Robert N. Hudspeth

156

most at command. Like the hero, the statesman, the martyr, the artist differs from other men only in this, that the voice of the demon within the breast speaks louder, or is more early and steadily obeyed than by men in general.[36]

This claim lies at the center of Fuller's idea of what she was attempting as a critic. The work of art leads back to a personal life; that life illuminates the hidden depths of psychology: it provides the necessary "assault" on the reader's mind. This is of special importance to Fuller's portrait of Goethe, for the German was so widely thought to be immoral. Quite clearly Goethe was Fuller's test case, the foundation point for her work. First she shows the need to see all the facts of his life and their relation to each other. It was about the author as well as about the work that she says that we require "a knowledge of the circumstances and character from which they arose, to ascertain their scope and tendency."[37] Fuller implies that there is no absolute moral to either a life or a work of art. The critic's question is not one of moral definition but of sympathetic synthesis. The critic/reader must bring her own mind to bear on Goethe. What emerges is the need for interpretation, not definition. Her "garrison" readers wanted clear facts. Fuller counters this expectation by observing that "Those who cannot draw their moral for themselves had best leave his books alone; they require the power as life does."[38]

Once again Fuller has drawn the parallel between art and life, this time to invoke the necessity of interpretation, a central critical activity. To her, interpretation is the inevitable use of the mind; it is the power of thought to act with sympathy, to uncover the buried life, to be sincere and true. In biography as perhaps nowhere else, the critic can observe self-culture at work and turn that observation into power for the reader. The critic encounters in a Goethe the full range of possibilities.

From 1835 on, Fuller assumed that in order to educate her audience and to champion the psychological values she cherished, she had to discuss British and German literature. Surely one of her best and best-known achievements was her ability to make contemporary foreign literature accessible to an insular American audience. Almost the last piece of literary criticism she wrote confronted this fact: "It has been one great object of my life," she wrote in July 1846, "to introduce here the works of those great geniuses, the flower and fruit of a higher state of development, which might give the young who are soon to constitute the state, a higher standard in thought and action than would be demanded of them by their own time."[39] This is a clear statement of Fuller's goal. Hers

was a need to create new standards at a time when the very idea of criticism was destructively limited; hers was the need to create power in an American audience whose own literature was powerless. "I have hoped," she went on to say, "that, by being thus raised above their native sphere, they would become its instructors and the faithful stewards of its best riches, not its tools or slaves."[40] Once more, Fuller looks to her audience. If the Harvard Unitarians aimed to reform errant writers, Fuller aimed to empower willing readers. She had found no national literature, so she had sought intellectual freedom abroad. She had learned how to be free, but she knew that it was only a partial victory, for she was not, finally, part of her own culture. Margaret Fuller was an outsider in spite of, or because of, her long tutoring in New England. Emerson sought freedom in renunciation of the forms of the church and in the subsequent definition of a secular vocation. Fuller sought her freedom in the creation of a critical vision. Her own price was isolation and alienation, for Jacksonian America lacked the "moral and intellectual dignity to prize moral and intellectual, no less highly than political freedom."[41] Unlike the Harvard Unitarians who looked for a conserving American national literature, Fuller looked abroad to come to terms with literature in the modern world. Fuller was prophetically a John the Baptist when she said "we are sad that we cannot be present at the gathering in of this harvest. And yet we are joyous, too, when we think that though our name may not be writ on the pillar of our country's fame, we can really do far more towards rearing it, than those who came at a later period and to a seemingly fairer task."[42]

Sadly enough, she was right—at least partially, for she died four years later without returning to the America from which she was estranged. She did, however, open possibilities for the life of the mind. By the time she turned her writing to questions of the state of women in the century, to questions of social justice, and to the Italian revolution, Fuller had developed a coherent critical vision. She was, ironically, thought to be imperious and even haughty in person, but in her literary criticism she created a generous and sympathetic persona. Hers was a more productive critical performance than that of Andrews Norton or of Francis Bowen. We have even gotten around to writing her name on our pillar of fame.

Robert N. Hudspeth

Notes

1. "A Short Essay on Critics," *Dial* 1:5 (1840).
2. Fuller to James F. Clarke, ca. April 1833, Massachusetts Historical Society.
3. Daniel Walker Howe, *The Unitarian Conscience: Harvard Moral Philosophy, 1805–1861* (Cambridge, Mass., 1970), 189.
4. *The Works of William Ellery Channing, D.D.* (Boston, 1887), 126.
5. Ibid., 498.
6. Ibid., 167.
7. William Charvat, *The Origins of American Critical Thought* (New York, 1961 [1936]), 6.
8. Ibid., 8.
9. "Modern British Poets," *American Monthly Magazine* 2:249 (1836).
10. "A Dialogue: Poet. Critic," *Dial* 1:495 (1841).
11. "Bettine Brentano and her friend Gunderode," *Dial* 2:313 (1842).
12. "A Short Essay on Critics," 6–7.
13. Ibid., 7.
14. "Festus," *Dial* 2:232 (1841).
15. "A Short Essay on Critics," 11.
16. "Festus," 232. My emphasis.
17. David Robinson, *Apostle of Culture: Emerson as Preacher and Lecturer* (Philadelphia, 1982), 21.
18. Joel Myerson, ed., "Margaret Fuller's 1842 Journal: At Concord with the Emersons," *Harvard Library Bulletin*, 21:329 (1973).
19. "Goethe," *Dial* 2:21 (1841).
20. "Modern British Poets," 327.
21. Ibid., 327–328.
22. Fuller to James Clarke, June 17[?], 1833, Massachusetts Historical Society.
23. "Goethe," 24.
24. "Bettine Brentano," 313.
25. Ibid., 352.
26. "Goethe," 5–6.
27. "Bettine Brentano," 315.
28. "Goethe," 21.
29. Ibid., 29.
30. "Bettine Brentano," 320.
31. Ibid., 314.
32. Ibid.
33. "The Two Herberts," *Present* 1:306 (1844).
34. "Lives of the Great Composers, Haydn, Mozart, Handel, Bach, Beethoven," *Dial* 2:149 (1841).
35. "Bettine Brentano," 320.
36. "Lives of the Great Composers," 149.

37. *Conversations with Goethe in the Last Years of his Life*, trans. S. M. Fuller (Boston, 1839), xi.

38. Ibid., xiv.

39. S. Margaret Fuller, *Papers on Literature and Art* (New York, 1846), 1:vii.

40. Ibid., vii.

41. Ibid., 2:124.

42. Ibid., 125.

Robert N. Hudspeth

Henry Wadsworth Longfellow's popularity revealed itself in many ways, including this *Longfellow Calendar* for 1883, the year after his death. Collection of the Massachusetts Historical Society.

The Literary Significance of the Unitarian Movement

✿

LAWRENCE BUELL

That there is an intimate connection between the American Unitarian movement and the so-called American literary renaissance has been long known and loudly proclaimed. One of the first full-dress national literary histories, Barrett Wendell's turn-of-the-century *Literary History of America*, went so far as to insist that "almost everybody who attained literary distinction in New England during the nineteenth century was either a Unitarian or closely associated with Unitarian influences."[1] George Willis Cooke's contemporaneous *Unitarianism in America* cites chapter and verse:

> Ralph Waldo Emerson was the son of William Emerson, the minister of the First Church in Boston. . . . George Bancroft was the son of Aaron Bancroft, the first Unitarian minister in Worcester, and the first president of the American Unitarian Association. To Charles Lowell, of the West Church in Boston, were born James Russell Lowell and Robert T. S. Lowell.[2]

Triumph by genealogy—a familiar Brahmin tactic. Cooke goes on to claim Unitarian prominence in virtually every genre, fictive and nonfictional—except, significantly, drama, which in proper traditional New

Lawrence Buell is Professor of English, Oberlin College.

England fashion he silently omits. As reinforcement, he quotes the remark from Wendell that I quoted before. But "more even than that may be said," adds Cooke, "for it is the Unitarian writers who have most truly interpreted American institutions and American ideals."[3]

The extravagance of these claims must immediately be discounted in view of their status as artifacts of late-century Brahmin ethnocentrism and collegiality. Still, Wendell if not Cooke was more right than wrong. In New England if not in America at large, Unitarianism clearly did exert a literary influence far out of proportion to its denominational size. My recent research on the careers of New England authors during the renaissance or middle period (from the War of 1812 to the Civil War) indicates that something like one-quarter of all creative writers of any significance were at some time in their lives Unitarians, including fully half of the region's writers who might arguably be called "major."[4] The region's first substantial intellectual quarterly, the *North American Review*; its first important denominational periodical of literary cast, the *Christian Disciple* (which evolved into the still more ambitious *Christian Examiner*); its most prestigious literary magazine, the *Atlantic Monthly*; and its most prestigious publishing house, Ticknor & Fields, were overwhelmingly (although not exclusively) sponsored and dominated by groups of Unitarians who together formed a kind of interlocking directorship whose fraternal networking became publicly concretized for the region's literati most conspicuously by the inauguration of Boston's Saturday Club at mid-century.[5]

So far I have merely been reciting the ABC's of the Unitarian preeminence in the region's antebellum literary culture. Almost equally familiar are the explanations of the rise of that hegemony. As numerous scholars have shown, the Unitarians were well positioned to play a leading role within the region as writers and tastemakers because of their status as the liberal wing of its best educated and most socially prestigious denomination, a denomination which at the beginning of the nineteenth century still enjoyed a sizeable majority in number of churches throughout the region. In New England's intellectual capital, Boston, the liberal presence was especially strong and conspicuous. The Unitarians and their Arminian precursors were far less inclined than were Orthodox Congregationalists to draw a sharp distinction between sanctified and unsanctified pursuits, between sacred and profane letters, between piety and conduct. For the Unitarians, the path to salvation was the growth and maintenance of Christian character, rather than a special conversion ex-

Lawrence Buell

perience that marked the individual off from the rest of the world as the recipient of grace. To this end of character formation, the Unitarians welcomed art and literature as potential aids, all the more readily so given that the transmission of doctrine as such mattered less to their theologically liberal perspective than the raising of ethical consciousness.[6] Even in the pulpit, Unitarian ministers did not hesitate to make sweeping claims like the following about the spiritual value of "secular art":

> books, to be of religious tendency, to be ministers to the general piety and virtue, need not be books of sermons. . . . *Whatever* inculcates pure sentiment, whatever touches the heart with the beauty of virtue and the blessedness of piety, is in accordance with religion; and this is the Gospel of literature and art."[7]

Thus Unitarian reviewers turned to the serious examination of Walter Scott's fiction while the Orthodox continued to debate the propriety of novel reading; and in the hands of the Unitarian preachers, as Cooke put it, the sermon became "a literary product," as ministers "ceased to quote texts, abandoned theological exposition, refrained from the exhortatory method, and addressed men and women in literary language about the actual interests of daily life."[8]

All this by way of a quick review of scholarly consensus as to the link between the development of Unitarianism and of literary culture in America (specifically New England) and the reason for the intimacy of that link. But it is tedious and unnecessary to continue on this level of well-established truths. Rather than give the kind of panoramic survey of the epic of the Unitarian contribution to nineteenth-century arts and letters such as has been given many times before, I want to isolate two special problematic features thereof to analyze in detail. Both points, I confess, have a sort of in-group character to them as being in the nature of admonitions directed especially to my own tribe of literary scholars; but I think they bear stating in mixed company as well.

The first point arises from my sense that literary scholars typically experience as we approach the study of Unitarianism an irresistible temptation to depict it in the image of our own disciplinary interests, to overstate its aesthetic cast as we discuss its place in nineteenth-century culture. Unitarian–Orthodox debates about hermeneutics and doctrine (not to mention church government) do not in themselves concern the

average literary specialist at all; from our point of view American Uni-
tarianism signifies primarily "the transition from religion to aesthetics,"
or, as Perry Miller put it in his seminal essay "From Edwards to Emer-
son," the rolling away of "the heavy stone of dogma that had sealed up
the mystical springs in the New England character."[9] Although Miller is
careful not to claim that the Unitarian–Transcendental continuum is in
itself primarily an aesthetic one (indeed Miller stresses here and else-
where that Transcendentalism was first and essentially a religious move-
ment), it is clear that Unitarianism especially interests Miller, and his
successors in American English departments to an even greater degree,
for the service it performed as a kind of anti-doctrinal solvent to release
the New England imagination from its parochial confines and into con-
fluence with the larger currents of European Romanticism.

What I particularly want to stress about this limited view of Unitari-
anism's character, however, is not its element of disciplinary narcissism,
but its resemblance to the pronouncements of Unitarianism's own early
historians, like Cooke, who seems positively to require us to read his
chapter "Unitarianism and Literature" as the key to his whole book.
"The early Unitarian movement in New England," states Cooke, "was
literary and religious rather than theological." Its early leaders—among
whom Cooke incidentally reckons Emerson the most important—
"made no effort to produce a Unitarian system of theology; and it would
have been quite in opposition to the genius of the movement, had they
entered upon such a task." Likewise, Joseph Henry Allen, another pio-
neer historian of the movement, identifies English Unitarianism with the
Romantic poets, and the classic phase of American Unitarianism with
William Ellery Channing and specifically with the power of Channing's
voice: "its melody and pathos in the reading of a hymn were alone a
charm that might bring men to the listening, like the attraction of sweet
music." Likewise, memoirist O. B. Frothingham, summing up the creed
of his father, Nathaniel Langdon Frothingham—whom he presents as
a representative example of the early Unitarian establishment—calls it
"rather rhetorical than dialectical" ("It would not have contented Abe-
lard, though it might have pleased Emerson"); commends the elder
Frothingham's genteel cultivation while apologizing for his rudimentary
and unphilosophic reasoning; and quotes from among the funereal trib-
utes Frederic Henry Hedge's assessment that although weak as a doctrin-
alist and theologian, Frothingham senior was gifted in hymn writing and
exquisitely polished in speech. "Nothing awkward," insists Hedge, "ever

Lawrence Buell

fell from his lips. His words expressed with unerring fitness the thing most fit to be expressed.[10]

At such moments, it begins to seem that late nineteenth-century Unitarian historiography was engaged in some kind of tacit conspiracy to set the history of Unitarianism up to be read in an aestheticist way. First, there is the tendency to represent William Ellery Channing as the star of the movement's pioneer era and depict Norton, the Wares, Gannett, Tuckerman, and others as minor satellites by comparison, operating at the edges of Channing's penumbra in a not-too-interesting backroom or wheelhorse capacity. Second, and following from this, is the tendency to proclaim (usually with pride) the softness of Unitarianism as a theology and as a sect, and to locate its main source of intellectual energy in its powers of eloquence and cultivation. Third, and again related, is the tendency to cast the Unitarian net as wide as possible and base the prestige of the denomination broadly on the cultural accomplishments of non-mainstream figures like Emerson, and in particular to redefine the Transcendentalist schismatics as the most exciting and central of the second-generation figures.

Up to a point, this approach is very much in the tradition that characterized Unitarianism from the first. Unitarianism took shape in reaction against Orthodox formalism, always resisted movements to form binding creeds, often went to great lengths to preserve the spirit of free inquiry. At the same time, the late-century passages quoted earlier also often represent a skewed rewriting of Unitarianism's classic phase for reasons the totality of which are obscure to me but which certainly include the sense of historical distance that two generations had created on the controversies of the formative period. From the standpoint of 1882, Unitarianism, as Allen put it, "so far as it is destined to survive at all, must understand that it has outgrown its old theological limits; and, as it was once the liberal side of the old Congregational body, so now it must know itself as the Christian side of the broader scientific movement of our time."[11]

It is in light of that retrospective standpoint, I surmise, that we must interpret Allen's earlier, seemingly dithering statement that he finds it hard to say "just what the Unitarian opinion is on any given matter, or what it is that Unitarians believe in general," that indeed "I am a little impatient that they should ever be judged by their theology, which was so small a fraction of either their religion or their life!"[12] While there is *some* truth to this, it greatly understates the importance that not only the

The Literary Significance of the Unitarian Movement

old "moderate" Unitarians but even liberals like Channing and radicals like Theodore Parker attached to the issues of theology and ecclesiastical polity that concerned them. It is a too-conveniently literal reading of early pronouncements like Parker's "Now Arius, and now Athanasius, is lord of the ascendant." [13] In this remark from *The Transient and Permanent in Christianity*, Parker is making a serious theological point, even though his aim is to dismantle theological structures, just as classical Unitarianism had been doing in its arguments against Calvinism. The late nineteenth-century tendency to reduce early Unitarian discourse to aesthetic impressionism reflects at least in part the late nineteenth century's disinterest in the issues that earlier discourse addressed. The readiness to expose theological arguments as a mere rhetoric was indeed a legacy of classical Unitarianism, but only after the fact did it come to seem *the* legacy. [14]

In short, when literary scholars think about the aesthetic cast of the Unitarian sensibility, we need to compensate not only for our own disciplinary ethnocentrism, but also for the effect of insider testimonials like the ones I have cited. Nor would I direct this caveat at literary researchers only, although we are the ones most predisposed to reduce Unitarianism to an aesthetic movement. Scholarship on early Unitarianism as a whole has often shown the same sort of bias in, for example, its intense concentration on Channing relative to Andrews Norton, on whom to this day there is no full-length biography or monograph. Part of this skewing clearly reflects a lingering anti-institutional aestheticist bias in favor of the inspired eloquence of the individual performer as against the laborious ratiocination of the organization man. I suspect that this prince-of-the-pulpit–centered perspective would have been offset to a greater degree than it has so far been had not the anti–institutionalism of Frothingham, Allen, Cooke, and others become paradigmatic.

The second major point I have to make, however, is opposite my first: namely, that even though literary scholarship has probably overstated early Unitarianism's status as an aesthetic movement, in another sense it has not taken that aspect of the Unitarian legacy seriously enough. Even though a great deal of attention—arguably a disproportionate amount of attention—has, during the past decade, been paid to Arminian aesthetics from Buckminster on, even though Daniel Howe has driven home the point that "Harvard Unitarianism probably had its greatest impact on American society through its influence on American letters" and David

Robinson has reinforced it in his recent history of the Unitarians and Universalists,[15] the average student of American literature still tends (taking his or her cue from Emerson's pronouncements in his quotably waspish moments) to look at Unitarianism as a benighted state of cultural privation from which the really important New England writers had to break away in order to accomplish anything interesting. This indeed has remained standard doctrine ever since American literary scholarship began to become a major growth industry in the 1930s. F. O. Matthiessen, in his monumental *American Renaissance*, declared that "the most immediate force behind American transcendentalism was Coleridge."[16] Perry Miller, embroidering on this line of thought, stated a decade later that the function of Unitarianism for the Transcendentalists was to teach them that theology was a dead end.

> Therefore this revival of religion had to find new forms of expression instead of new formulations of doctrine, and it found them in literature. It found them in patterns supplied by Cousin, Wordsworth, Coleridge, and Carlyle.[17]

Here, as in Matthiessen, we have the emphasis on major European literary and intellectual talents as the catalytic agents, with Unitarianism figuring as nothing more than a launching pad.

In taking this position, Matthiessen and Miller were not being solipsistically perverse but were taking their cue from the pronouncements of the Transcendentalists themselves, particularly Emerson, who had called Unitarianism "corpse cold," declared in exasperation that he could never find his "heavenly bread" in Longfellow or Lowell, and said of his contemporaries in general that "Goethe was the cow from which all their milk was drawn."[18] The rhetoric of the Transcendentalist literati easily yields a myth of revolution against, as opposed to evolution from, its Unitarian background.

The tendency to relegate Unitarian literary and intellectual culture to the status of mere background has been reinforced by other factors as well. One is the rise of so-called Puritan legacy scholarship in response to Perry Miller's research: that is, scholarship seeking to define American literary and cultural distinctiveness in terms of America's Puritan antecedence. The newer scholarship has contested Miller in some important respects but on the whole has sustained his contrast between Unitarianism as representing a negative phase of secularization versus Transcendentalism as representing a re-energized expression of Puritan spirit. As today's justly most influential spokesperson for Puritan legacy

studies, Sacvan Bercovitch, puts it in *The American Jeremiad*, "When Unitarianism proved a dead religion, [Emerson] remembered that America was bound to shape the religion of the future," and he expressed this vision by "building upon the old jeremiadic ambiguities."[19]

The ultimately more important reinforcer, though, of the tendency to sideline Unitarian literary culture as a trivial if not positively baleful epiphenomenon in the history of American letters is what might be called "high canonicalism." By "high canonicalism" I mean the practice of defining American literary history quintessentially in terms of a small number of great heroes and mountain-peak literary achievements that count. The history and limiting effects of this mode of literary historicizing, first institutionalized by nineteenth-century Romanticism and revived in America in the 1920s and 1930s, have only recently begun to be documented and analyzed, most particularly by students of minority and women's writing.[20] By now it is a matter of record that until quite recently, American literary anthologies increasingly tended to represent fewer authors in greater depth, and American literary scholarship to focus intensely on a limited number of "classic" texts in proportion to the totality of the field. The full historical explanation for this rise of high canonicalism is complex, but two key factors, clearly, were these. First, in Anglo-American letters generally, the prestige of the so-called new criticism, which valorized the individual complex text, stigmatized contextual research as merely "extrinsic," and tended (following T. S. Eliot) to represent literary history as a series or symposium of the most eminent figures. Second, in the emerging new specialization of American letters particularly, an anxiety to establish its status as an autonomous field, to locate a body of work that would rival without imitating the achievement of European literatures, and with that goal of excellence-with-a-difference in mind to define the great American tradition specifically in terms of its anti-conventionalism, both literary and ideological: for example, in terms of Melville's resistance to nineteenth-century novelistic standards, Whitman's resistance to traditional prosody and Victorian sexual taboos, and so forth.

This anti-conventionalist reading has tangled ideological roots. It can be diagnosed, up to a point, as a form of academic rarefaction (the valorization of the complex for its own sake over the straightforward), but also, again up to a point, as a form of democratic populism (to the extent that "conventionalism" is equated with genteel Anglophile culture). But on the other hand, it is also an anti-populist elitism (to the extent that it

rejects popular culture and ways of thinking for the sake of the few truly original thinkers and doers that rise above the herd); but yet again, this valuation of cantankerous titans could itself conceivably be seen as a mainstream American value. Be that as it may, the bottom line with respect to Unitarian literary culture is that high canonicalism relegates it to the sidelines if not the dustbin and reinforces the myth of the New England renaissance as beginning in earnest with Emerson's dramatic refusal to administer the Lord's Supper rather than with Buckminster and the Anthologists, the North American Reviewers, and all the rest. Notwithstanding the dozens of names smugly listed by Cooke in his chapter "Unitarianism and Literature," in today's normative myth of nineteenth-century American literature there is not only no Unitarian playwright but no bona fide Unitarian novelist (unless we count Hawthorne, whose Unitarian side most readers refuse to see) and indeed not even any noteworthy Unitarian poet apart from Emerson, because from the high canonical standpoint the rest of Transcendentalist poetry boils down into a few decent lyrics and the more conventionally Unitarian schoolroom poets like Bryant, Longfellow, Holmes, and Lowell hardly exist at all.[21]

Precisely at this juncture, however, researches into Unitarianism as a literary and aesthetic movement have a valuable contribution to make, although it has not yet been pressed as vigorously as it might be. So far, such work has mostly been in the nature of foundational studies chronicling various phases of Unitarian literary culture, such as those of Daniel Howe, Joel Myerson, David Robinson, and Lewis Simpson. This work has been indispensible in providing better bibliographical tools, quality editions of inaccessible texts, and biographical and historical study of themes, figures, and episodes within the Unitarian movement—most particularly of course its Transcendental offshoots. But of special note for present purposes, it has also been valuable analytically in demonstrating beyond all possible refutation that the relationship between Unitarian literary culture and the literary texts produced by the major Transcendentalists of "canonical" stature (Emerson, Thoreau, and in recent years Fuller) must be conceived much more in terms of a continuum than in terms of an opposition.

In stating this, I do not mean to erase all difference: to preempt William Ellery Channing as a Transcendentalist aesthete or, on the other hand, to deny any distinction between Emerson's Divinity School Address and Unitarian sermonizing.[22] Transcendentalist discourse surely discomfited middle-of-the-road Unitarians not just because its style seemed self-

indulgently fanciful, elliptically discontinuous, and neologistic compared with their more pellucid prose, but because the fancifulness and neologism arose from a post-Kantian intellectual framework that privileged the individual's creative and intuitive powers to an extent that Unitarian epistemology, based on old-fashioned faculty psychology, did not permit. Still, without the Unitarians' own prior adjustment of the relative priority of reason and revelation, argumentation and intuition, empirical evidence and eloquence, Emerson might not have recognized the significance of the Coleridgean distinction between Reason and Understanding, or if he had, he might not have felt empowered to do anything more creative with it than, say, James Marsh, the moderate Calvinist who introduced the distinction to America.

Literary scholarship of the past several decades has, again, sketched in this picture quite fully. Not that the picture is complete. A great deal more work needs to be done on just about every non-canonical white male literary figure on Cooke's list of Unitarian writers, and the relationships among them. We might start, perhaps, with Longfellow, whose enormous nineteenth-century popularity is today much more often laughed at than understood, and who I am increasingly convinced seems a much more interesting figure than has been realized if looked at as an exemplar of the Unitarian imagination. For example, Longfellow's most popular poem, "A Psalm of Life," which posterity (with some justice) has tended to see as the quintessence of facile banality, seems culturally if not aesthetically more resonant when we read it as a direct response to a "Calvinistic" ethos of determinism in the name of an "Arminian" ethos of effort. A more pervasive sign of Longfellow's Unitarian sensibility is his characteristic fondness for drawing loaded contrasts between religious ideologues and people of intuitive sensitivity (as in his portrayal of Puritanism in *The New England Tragedies*), or between dogged utilitarians like Miles Standish and artist- or scholar-figures like John Alden. Also symptomatic is the amazing catholicity of Longfellow's grasp of diverse literary and mythological bodies of knowledge, in which we find a counterpart to the syncretism that made the Unitarian-Transcendentalist movement the cradle for the study of comparative religion in America, from the "ethnical scriptures" Thoreau edited for the *Dial* to James Freeman Clarke's *Ten Great Religions*. There is a more than fortuitous relationship between the globe-circling plot of Longfellow's "Kéramos," which finds the biblical image of the artist/god as potter in every culture, and Whitman's globe-circling "Salut au Monde," where the persona de

clares solidarity with the world's population at large. The Transcendentalist assumption of the identity of human nature that Whitman extracted from Emerson is the child of the liberal ecumenicism expressed in Longfellow.

In recent years, feminist revisionary scholarship has demonstrated how a literary culture long believed shallow can be seen to have great resonance; and its rediscoveries include, among others, important literary Unitarians like novelist Catharine Maria Sedgwick.[23] But as the example of feminist revisionism also indicates, an even more fundamental priority than fleshing out further the record of literary careers and relationships, or rediscovering the virtues of this or that forgotten author, is to show that a mountainpeaks approach to charting literary history is an impoverished approach: that we need a more capacious theory to explain whatever literary achievement we consider significant, whether it be a *Walden* or an *Evangeline*. We need, to be specific, a theory that will not merely or even mainly seek to explain literary history as a dialogue between strong poets, or an intertextual web in which the only nodal points are marked by names like Dante, Shakespeare, and Wordsworth. A truer and more useful theory of literary achievement will try not to explain that achievement simply in terms of other supposedly great masterpieces or simply as a maverick deviation from the supposed conventionalism of its day, but to show in addition the masterpiece's affinities with and dependence upon the typical literary culture of its milieu, and the extent to which the individual artist was nurtured as well as nettled by a cohort of mostly forgotten contemporaries who at the time, however, crossfertilized each other through their more or less mutual interests.

In the historical phenomenon of literary Transcendentalism arising from the seedbed of Unitarian literary culture, we have an already well-researched exemplary case of the symbiosis of conventional achievement and more radically innovative genius. We see from this case that the works of the latter—the masterpieces of Emerson and Thoreau—took shape both in differentiation *from* the norms of the former and in dependence *upon* them. One sharp limitation of classical Unitarian aesthetics, for example, is its commitment to ethical idealism. This limited the reading matter it could comfortably endorse and limited the range of its literary practice, steering it toward nonfictional prose and toward a certain kind of poetry, placing its practice of fiction within rather prim boundaries, and steering it away from drama. Emerson and Thoreau take their energy to a considerable extent from quarreling with these constraints,

but they also stay within them; their strengths and weaknesses as writers are distributed over the different genres in *precisely* the same way as the Unitarian literati as a whole.

The symbiosis of genius and convention is a two-way street; on the one hand it links the classic with the residuum of conventional achievement, while on the other hand it resists conceiving of the latter as merely formulaic. In the average literary history, the lesser figures assume the status of flat comic characters in a Dickens novel. In the model I am proposing, one would be careful to differentiate, say, the sermon styles of Nathaniel Frothingham and Orville Dewey and F. W. P. Greenwood— all of whom were noted as pulpit stylists in the early years of the Unitarian movement, but for very different effects—and also to recognize the inherent complexity of the Unitarian's "formulaic" literary gestures as such.

Once more to cite the analogue of feminist criticism, it has shown very clearly that the so-called storybook ending device to the Cinderella plot of the typical nineteenth-century domestic novel was a complex ideological artifact, involving a problematic balance between the heroine's aspirations to self-realization versus submission to constraints of patriarchy. A good example of this kind of thing in Unitarian writing is what might be called the discourse of miracles.[24] On the surface this topic might seem out of place in a discussion of the *literary* aspects of Unitarianism, yet I do not think so, because the doctrinal controversy over miracles in the early days of Unitarianism and its struggles with the heresy of Transcendentalism almost immediately bled over into the realm of the literary.

Most Unitarian theologues assumed uneasily and self-consciously the role of apologists for gospel miracles as seals of the divine authority of Jesus's mission. They realized that miracles were a sticking point for the majority of their flocks, and often they themselves were disposed either to doubt or to evade the position that the authenticity of the gospel miracles is the empirical test that validates Christianity's claims to special authority. Consequently, defenses of miracles by Unitarian spokespersons tend to take one of two forms, both of which have the effect of trying to lessen the alterity of the miraculous: either the argument that suspension of the normal laws of the universe is reasonable given God's all-powerfulness, or the argument that miraculous events are (if we look at them closely) conceptualizable as part of the natural order itself, or at least might be if our knowledge were perfect.[25] This second argument is

the more interesting one for our purposes because it tends to lean so heavily on metaphor. As one preacher explained the meaning of the miracle at Cana (turning water into wine), "we do not know anything about the conflict or concord between the chemical laws and the spiritual laws. . . . But we do know that there are presences, there are influences in the world, possessing a mysterious, and, if you will, a miraculous power, to transform things common and homely into things rare and beautiful." And he goes on to give a string of analogies.[26]

Analogy here compensates for and disguises the evaporation of the distinction between the natural and the supernatural which is the original reason for making an issue of miracles to start with, and constitutes a direct link between this moderate Unitarian discourse and the Transcendental menace of Emerson, who notoriously proclaimed in his Divinity School Address that miracle was "Monster."

Or did he? If we look at that Emerson passage very closely, we see that it too belongs to this same type B of miracle discourse, for never does Emerson flatly deny that the gospel miracles happened (he only says that in the way our churches talk about them they give "a false impression," meaning that they sound unnatural: they are "not one with the blowing clover and the falling rain"). In fact Emerson uses much the same ploy used in the sermon just quoted and used also, indeed, in some of the very sturdiest Unitarian defenses, such as Orville Dewey's 1836 Dudleian lecture, which Emerson may partially have been writing against. Dewey begins with a hard-nosed argument that like it or not miracles are the foundation of faith, but he sweetens the pill as he goes on by the device of naturalization through analogy and metaphor, calling the character of Jesus a moral miracle, asserting that "the act of creation is but the grandest of miracles." Emerson makes much the same move in opposition to miracles that Dewey makes for the sake of pill-coating rhetoric in favor of miracles. "He spoke of miracles," says Emerson of Jesus, "for he felt that man's life was a miracle, and all that man doth, and he knew that this daily miracle shines as the man is diviner."[27] Emerson, like the Unitarian apologists for miracles (and specifically apologists of type B), redeems miracle from the realm of monstrosity via metaphor, which renaturalizes its unnaturalness. Emerson differs from them, of course, in his pugnacity toward the churches and in his implication that miracle can *only* be interpreted figuratively. But it is also significant that Emerson never makes a frontal attack on the historicity of miracles; his strategy is

to redefine the concept in ways that to the practiced eye look familiar enough to keep him as much within as without the boundaries of normative Unitarian discourse on miracles.

If we scrutinize the delicate rhetorical ballet of consensus and dissent in which the Divinity School Address participates, we arrive at a better appreciation both of the dependence—even at Emerson's most "radical" moment—of high-canonical achievement on the terms of "conventional" discourse and of the richness and multilayeredness of that conventional discourse in itself. Just as the conventional discourse on miracles greatly illuminates our understanding of Emerson at this point, so, conversely, the Emersonian deviation brings out the complexity of implication, rhetorical subtlety, and tonal nuance that results from the "mainstream" Unitarian impulse to naturalize miracles while at the same time maintaining their status as a special sort of phenomenon. The elegance and diversity of the intellectual and literary powers called forth in the furtherance of that project is grossly flattened if we see it simply in terms of a model of obtuse dogmatic consensus disturbed by the iconoclastic Emerson.

My conclusion from this chain of remarks is that, although the literary approach to the study of the Unitarianism is in some respects seductive and ought not to be undertaken before purging oneself insofar as possible of historical innocence, nevertheless when warily negotiated it promises not only to yield results of significance for the understanding of Unitarianism and American literary history as discrete bodies of knowledge but also an important—and in our time crucial—lesson for literary theory about how canonical and conventional achievements relate to each other and must be read in light of each other. In a way admittedly different from what Cooke and Allen would have understood, we need to claim Emerson and even Thoreau (for example) as legatees of Unitarianism and place them in the company of the more moderate and timid denominational poetasters whom Transcendentalist radicalism rendered distinctively uncomfortable. In the long run, however embarrassing it might have been for both parties, the memory of both is greatly enriched by the juxtaposition.

We will probably not thereby be led to anything like a consensus as to the precise extent to which mainstream Unitarianism anticipated Transcendentalism or the precise extent to which Emerson and Thoreau remained tied to their Unitarian roots. My own experience, at any rate, is

that the more one contemplates, say, the Emerson–Unitarianism relation the more tolerant one becomes of the existence of competing arguments over the question of how far Unitarianism anticipated and encompassed Emersonian discourse. But that type of unresolvability should not concern us. On the contrary, our aim should be precisely to expose the untenability of clear-cut distinctions between genius and convention: to recognize, for example, that "conventional" frames of reference can in fact positively stimulate as well as negatively inhibit the most "individualistic" gestures, as James Duban has recently shown in Thoreau's case by pointing to the basis in Unitarian moral thought of his theory of civil disobedience.[28]

That sort of discovery is not altogether pleasant. It may, indeed, be more likely to distress than to gratify many literary scholars, pointing as it does toward the necessity of mastering dozens of "minor" writers (many of them "nonliterary") at a moment in history when the minimum bibliographical requirements for respectable literary scholarship seem to be expanding with unprecedented rapidity in another direction owing to the advances of literary theory. Here I have no consolation to offer; if historical understanding is to be achieved, the work must be done. Literary scholars must be prepared, as social historians during the last two decades have learned to be, to commit themselves to a more truly vertical mode of research that takes into account the plains as well as the peaks, if only to the extent of learning the flimsiness of all such metaphors of stratification.

Notes

1. Barrett Wendell, *A Literary History of America* (New York, 1901), 289.
2. George Willis Cooke, *Unitarianism in America* (Boston, 1902), 413.
3. Ibid., 435.
4. Lawrence Buell, *New England Literary Culture: From Revolution Through Renaissance* (Cambridge, 1986), esp. 388 and n.
5. For a brief narrative survey of this network, see ibid., 37–49.
6. Recent scholarship that develops this argument in detail includes Daniel Howe, *The Unitarian Conscience: Harvard Moral Philosophy, 1805–1861* (Cambridge, Mass., 1970); Lawrence Buell, *Literary Transcendentalism: Style and Vision in the American Renaissance* (Ithaca and London, 1973); Philip Gura, *The Wisdom of Words: Language, Theology, and Literature in the New England Renaissance* (Middletown, Conn., 1981) and David Robinson, *Apostle of Culture: Emerson as Preacher and Lecturer* (Philadelphia, 1982).
7. Orville Dewey, "The Religion of Life," in *The Works of Orville Dewey, D.D.*, new ed. (Boston, 1883), 125.

8. Cooke, *Unitarianism in America*, 416.

9. Perry Miller, "From Edwards to Emerson" (1940), reprinted in *Errand into the Wilderness* (New York, 1956), 197.

10. Cooke, *Unitarianism in America*, 415; Joseph Henry Allen, *Our Liberal Movement in Theology* (Boston, 1882), 13, 49; Octavius Brooks Frothingham, *Boston Unitarianism 1820–1850: A Study of the Life and Work of Nathaniel Langdon Frothingham* (New York, 1890), 41, 235–236.

11. Allen, *Our Liberal Movement*, 116.

12. Ibid., 30.

13. Theodore Parker, *A Discourse of the Transient and Permanent in Christianity* (1841), reprinted in Perry Miller, ed., *The Transcendentalists: An Anthology* (Cambridge, Mass., 1950), 266.

14. The most ambitious history of Unitarian thinking produced within the classic period itself shows this difference very clearly: George E. Ellis, *A Half-Century of the Unitarian Controversy* (Boston, 1857).

15. Howe, *Unitarian Conscience*, 174; David Robinson, *The Unitarians and Universalists* (Westport, Conn., 1985), 25.

16. F. O. Matthiessen, *American Renaissance: Art and Expression in the Age of Emerson and Whitman* (London, Toronto, New York, 1941), 6.

17. Miller, ed., *The Transcendentalists*, 9.

18. *The Journals and Miscellaneous Notebooks of Ralph Waldo Emerson*, ed. William H. Gilman et al. (Cambridge, Mass., 1960–1982), 9:381, 376; 11:382.

19. Sacvan Bercovitch, *The American Jeremiad* (Madison, Wisc., 1978), 182–183.

20. See for example Nina Baym, "Melodramas of Beset Manhood: How Theories of American Fiction Exclude Women Authors," *American Quarterly* 33:123–139 (1981); and Paul Lauter, "Race and Gender in the Shaping of the American Literary Canon," *Feminist Studies* 9:435–463 (1983).

21. One striking sign of the shift I have described is the increasingly peremptory treatment given the schoolroom poets in our "monumental" literary histories from *The Cambridge History of American Literature* (1917–1921) to the *Literary History of the United States* (1948) to the *Columbia Literary History of the United States* (1988).

22. Conrad Wright comments on the fallacy of conflating Channing with Transcendentalism in "The Rediscovery of Channing," *The Liberal Christians: Essays on American Unitarian History* (Boston, 1970), 34–40. For the argument that the difference between the Divinity School Address and liberal Unitarianism was rhetorical rather than substantive, see Mary W. Edrich, "The Rhetoric of Apostasy," *Texas Studies in Literature and Language* 8:547–560 (1967); for my own partial demur and modification, see *Literary Transcendentalism*, 29–41.

23. See especially Nina Baym, *Woman's Fiction* (Ithaca and London, 1978); Sandra Gilbert and Susan Gubar, *The Madwoman in the Attic* (New Haven and London, 1971); Mary Kelley, *Private Woman, Public Stage: Literary Domesticity in Nineteenth-Century America* (New York, 1984); Jane Tompkins, *Sensational Designs: The Cultural Work of American Fiction 1790–1860* (New York, 1985); and Judith Fetterley's editorial introduction to *Provisions* (Bloomington, Ind., 1985).

24. William R. Hutchison provides an authoritative historical account of the miracles controversy in *The Transcendentalist Ministers: Church Reform in the New En-

Lawrence Buell

gland Renaissance (New Haven, 1959), 52–97. For selections from many of the key documents, see Miller, ed., *The Transcendentalists*, 157–246.

25. The difference between the two types of Unitarian insider explication of miracles, as well as the frequent porousness of the boundary, is pretty well indicated by comparing W. H. Furness, *Remarks on the Four Gospels* (Philadelphia, 1836), esp. 146–158, which undertakes a "naturalistic" response to W. E. Channing's more supernaturalist position in "The Evidences of Revealed Religion: Discourse Before the University in Cambridge," (Channing, *The Works of William E. Channing, D.D.*, 11th ed. [Boston, 1849], vol. 3), with Channing's own argument in full. Channing hurries through his direct defense, referring his audience to Paley (3:131) and lingers on arguments that would minimize the non-naturalness of what he fundamentally feels constrained to admit are departures from the natural order.

26. George Putnam, *Sermons* (Boston, 1879), 323.

27. Dewey, "On Miracles, Preliminary to the Argument for a Revelation," *Works*, 449; Emerson, *Nature Addresses and Lectures*, ed. Robert E. Spiller and Alfred H. Ferguson (Cambridge, Mass., 1971), 81.

28. James Duban, "Conscience and Consciousness: The Liberal Christian Context of Thoreau's Political Ethics," *New England Quarterly* 60:208–222 (1987).

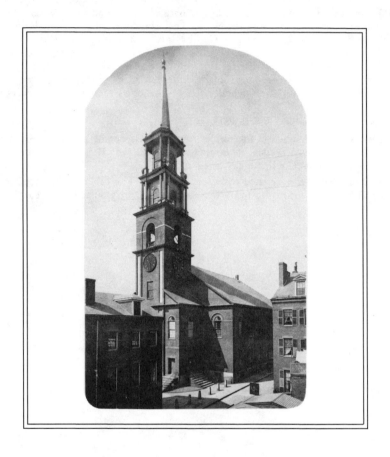

Hollis Street Church, Boston. Photograph by Baldwin
Coolidge, c. 1887. Collection of the Massachusetts Historical
Society.

Whose Right Hand of Fellowship?
Pew and Pulpit in Shaping Church Practice

JANE H. PEASE *and* WILLIAM H. PEASE

Like most institutional history, the early chronicles of Unitarianism were filiopietistic. At the same time, they share with more recent studies the belief that Unitarianism was liberal, not only in matters theological but in literature, politics, and social action as well. Eighty years ago, for example, George Willis Cooke trotted out whole stables of "Eminent Statesmen"—from Ben Franklin and John Marshall to Abraham Lincoln—who ought to have been Unitarians. And among innovators in the arts Walt Whitman and Henry David Thoreau were drafted to join those who, like Charles Bulfinch and Henry Wadsworth Longfellow, had at least been known to attend Unitarian churches. More to our purposes here, Cooke also compiled an imposing array of social reformers, marshaling Quaker Angelina Grimké and Finneyite evangelical Theodore Weld with bona fide Unitarian abolitionists like Charles Follen and Theodore Parker.[1]

Modern scholarly studies, by contrast, rest solidly on archival research and avoid the "ought-to-have-beens." Nonetheless, they reflect a similar understanding of liberal religion. Conrad Wright and David Robinson in

Jane H. Pease and William H. Pease are Bird and Bird Professors of History, University of Maine, retired.

their denominational assessments reinforce the portrayals of Unitarianism that Merle Curti developed in his general survey of American social and intellectual history and that, more recently, William McLoughlin sketched in his *New England Dissent*. To paraphrase Charles Lyttle, freedom moved with Unitarianism. Yet, if we consult Ronald Story's exploration of Unitarians' role in nineteenth-century cultural institutions—whether the Athenæum, Harvard, or the Lowell Institute—we lay bare a rumbling refutation. His Middle-Period Unitarians were rich and powerful men who dominated Boston's intellectual and philanthropic organizations and shaped them not to melioristic liberalism but to their own exclusive, conservative, and business-oriented values.[2]

To understand such contradictions, we must examine the Unitarian churches themselves. While we may reject the old chestnut that defined Unitarianism as the fatherhood of God, the brotherhood of man, and the neighborhood of Boston, we can nevertheless very profitably examine Boston's churches, for the City on a Hill was Unitarianism's demographic as well as geographic center. And we must also look beyond its eminent spokesmen—preachers and laymen alike—for their singular fame has too long obscured the broader human dynamics played out within individual congregations.[3]

In 1833 Amos Lawrence wrote his son that "as your new aunt is *pretty presbeterian*, in Baltimore, she will make I trust a most exemplary and very loveable episcopalian in Boston; the idea of her becoming a Unitarian, would frighten her mother more than a Dunker or Methodist would."[4] Significantly Lawrence did not mention Congregationalism—although from a theological perspective it was a displaced Presbyterian's most logical choice. Indeed, his cryptic observation tells us much about the social structure of denominational affiliation in the Massachusetts capital. While orthodox and evangelical Protestantism still counted many more followers, a Unitarian or Episcopal affiliation was preferred by those who enjoyed economic power, social prestige, or visible wealth. In the decade when Mrs. Samuel Lawrence made her choice, a third of those with any claim to elite standing and more than half of those with very great wealth or power or high social position in Boston were Unitarians, while a quarter of the former and a third of the latter were Episcopalians. (See Table I.) So, despite Calvinism's persistence among half the city's humbler Protestants who were Congregationalists or Baptists, Mrs. Lawrence's future clearly lay elsewhere. And, though she chose an

Jane H. Pease and William H. Pease

Table I. Bostonians of known denominational affiliations

Denomination[1]	Percentage of non-elite petitioners[2] (N = 34)	Percentage of non-elite jurors[3] (N = 85)	Percentage of all elite[4] (N = 1540)	Percentage of super-elite[5] (N = 258)
Baptist	24%	12%	10%	2.0%
Catholic	12%	0%	6%	0.3%
Congregational	21%	40%	19%	7.0%
Episcopal	15%	7%	23%	32.0%
Methodist	9%	4%	3%	0.3%
Unitarian	21%	29%	35%	56.0%
Universalist	0%	4%	2%	0.3%
Swedenborgian	0%	1%	2%	0.7%

1. Denominational affiliation was compiled from surviving lists of church members, communicants, pewholders, and officers—often overlapping categories. Doubtless Catholics and Methodists were undercounted because we found only sketchy records for these denominations. In the tally here presented, Lutherans, Presbyterians, Restorationists, and Free Enquirers were omitted because of their relative invisibility in the city.
2. A statistically valid random sample of 792 names was drawn from one pro-Bank of the United States petition to Congress in 1834 and from one anti-Bank of the United States petition to Congress in 1834. Of these, 490 were non-elite.
3. A statistically valid random sample of 708 names was drawn from lists of jurors who served Boston's Municipal Court, 1829–1840. Of these, 428 were non-elite.
4. The universe of 4,403 elite candidates comprises all Bostonians, 1828–1843, who left any record of having exercised any power or influence in the city or of having taxable property worth $20,000 or more.
5. The universe of the rich, powerful, and/or distinctly upper-class members of the elite comprised 424 Bostonians. See Pease and Pease, *Web of Progress*, 230–233, for selection criteria.

Episcopal church, she joined a congregation whose social and economic profile differed little from that of a Unitarian alternative.[5]

Was there then some general socioeconomic link between liturgical Episcopalianism and liberal Unitarianism? Probably not, as a quick comparison with the denominational structure of Charleston, South Carolina, suggests. In the low country capital Unitarians, regardless of wealth, power, or status, were an uncannily stable four to five percent of known churchgoers, whether among the relatively undistinguished, the elite generally, or the richest and most powerful men in the city. Yet the Episcopalians there showed a class pattern even more accentuated than that in Boston, representing a mere tenth of the non-elite but a third of

Whose Right Hand of Fellowship?

Table II. Charlestonians of known denominational affiliations

Denomination[1]	Percentage of non-elite voters[2] (N = 82)	Percentage of non-elite jurors[3] (N = 104)	Percentage of elite[4] (N = 1041)	Percentage of super-elite[5] (N = 167)
Baptist	1%	2%	2%	3%
Catholic	2%	10%	9%	2%
Congregational	6%	6%	9%	5%
Episcopal	11%	9%	37%	63%
Jewish	13%	5%	7%	1%
Lutheran	38%	49%	12%	7%
Methodist	10%	7%	6%	0%
Presbyterian	15%	10%	15%	13%
Unitarian	4%	4%	4%	5%

1. Denominational affiliation was compiled from surviving lists of church members, communicants, pewholders, and officers—often overlapping categories. Doubtless Catholics were undercounted because we found records for only one of Charleston's three Catholic churches. The predominance of Lutherans among voters and jurors reflects Charleston's large German population.
2. A statistically valid random sample of the 593 Charleston voters among the 1,054 voters who cast their ballots in the October 1830 state election and had no claim to elite status.
3. A statistically valid random sample of the 658 non-elite jurors who served in the Court of General Sessions in Charleston at any time between 1828 and 1841.
4. The universe of 2,308 elite candidates comprises all Charlestonians, 1828–1843, who left any record of having exercised any power or influence in the city or of possessing a significant measure of wealth in land or slaves either within or outside the city.
5. The universe of the rich, powerful, and/or distinctly upper-class members of the elite comprised 215 Charlestonians. See Pease and Pease, *Web of Progress*, 230–233, for selection criteria.

the elite and two-thirds of those who inhabited the peak of economic and social privilege. (See Table II.)

That said, let us return to Boston, where Unitarianism, even more than Episcopalianism, was associated with high rank. (See Table III for the definition of the various categories of elite and the minimal qualifications for being considered a person of high rank or of the upper class.) But how much? Of all those whose wealth, office, or social station gave them influence or power and whose church preference is on record, one-third were Unitarians and a quarter, Episcopalians; only one-fifth were Congregationalists. The rest in the 1830s were scattered among Baptists, Catholics, Methodists, Universalists, and Swedenborgians in that order.

Jane H. Pease and William H. Pease

Table III. The distribution of wealth, power, and status within the ranks of Boston's elite Congregationalists, Episcopalians, and Unitarians

Denomination	Those with economic power chiefly as corporate directors	Those with property assessed over $30,000	Those with modest or high social status[1]	Those with political power as public officials
Congregational (N = 296)	24%	11%	17%	21%
Episcopal (N = 350)	31%	33%	43%	19%
Unitarian (N = 540)	46%	32%	34%	34%

1. Social status represents some combination of higher education, prestigious occupation, social club membership, and service as a church official in the given denomination.

Let us then skim off the top three denominations, which together comprised over three-quarters of all the elite, and examine the characteristics of the men—and the very few women who made it on their own—in that rank. By so doing, we can lay bare the correlation between the specific factors which thrust individuals into elite standing and their particular denominational choices.

Of the three major sects, elite Unitarians were most likely to enjoy political power, economic power, or wealth. (See Table III.) Almost half of them exerted power as corporate directors; a third possessed assessed property valued at over $30,000; a third held city, state, or federal office. On the other hand, only one-third of elite Unitarians, as opposed to two-fifths of elite Episcopalians, enjoyed those educational experiences or club memberships that put them in the upper class. Finally, although elite Congregationalists were about as likely as Episcopalians to hold political office, only one-tenth of them were rich, and only a fifth either served as corporate directors or enjoyed high social status.

In the end, therefore, that Calvinism which Tawney and Weber associated with capitalism no longer powered the Boston economy. Not only did men of economic prowess predominate among all elite members of their churches, but in absolute numbers Unitarians clearly by the 1830s made the decisions that shaped the city's economy.[6] (See Table IV.) More than half of all the city's corporate directors whose denominations we know were Unitarians. More than half of those who directed the rail-

Table IV. Distribution of the wealthy, the powerful, and the prestigious among denominations in Boston

Category of elite	Congregational	Episcopal	Unitarian	Other
Economically powerful (N* = 453)	15%	23%	54%	8%
Wealthy (N* = 349)	9%	33%	49%	9%
Modest or high social status (N* = 412)	12%	36%	45%	7%
Politically powerful (N* = 365)	17%	18%	50%	15%

* The number given is of those whose denominational affiliation is known. All told, there were 1,000 Bostonians who were economically powerful, 763 who were wealthy, 763 of modest or high social status, and 782 who were politically powerful.

roading revolution, half of the bank directors who controlled the credit extended to merchants, and two-thirds of those who charted the course of that giant of investment capital, the Massachusetts Hospital Life Insurance Company, were Unitarians.[7]

If, therefore, Unitarians exerted so much more economic power—both absolutely and proportionately—than did Episcopalians, why were they not also proportionately richer? Part of the answer may lie in the limitations of a skewed data base. Assessed property valuation presumably included investments in Boston corporations as well as in city land. But since there was at the time no mechanism for assessing stocks and bonds, and since by 1830 no more than ten or fifteen Bostonians of any rank voluntarily reported such intangible wealth, assessed property valuation reflected primarily investment in real property. So even though assessed valuation provides a systematic basis for measuring and comparing individual property ownership, it inflates wealth in real estate, a relatively old and stable form of investment, at the expense of alternatives. Moreover, all assessments deliberately excluded any property—real or personal—not located in the city. Thus, if Unitarians more than others invested heavily in new growth areas, their wealth was sure to be disproportionately unrecorded. In fact, when we consult the lists of stockholders in individual Boston-based companies which have survived, in random fashion, from the second quarter of the nineteenth century, we do find Unitarians in the majority. Of all Boston investors thus recorded, Unitarians account for 51 percent of the shareholders of known religion, while Episcopalians account for only 26 percent. And

Jane H. Pease and William H. Pease

Table V. Religious affiliation of Boston stockholders

	Congregational	Episcopal	Unitarian	Other	None
All known stockholders (N = 1267)	6%	12%	22%	4%	56%
All stockholders of known denomination (N = 564)	15%	26%	51%	9%	
Railroad investors of known denomination (N = 80)	10%	28%	58%	4%	
Textile investors of known denomination (N = 105)	3%	51%	46%	0%	
Insurance investors of known denomination (N = 247)	13%	26%	57%	4%	

that pattern is even more accentuated among the shareholders in railroads and insurance companies, which, much more than banks, invested their capital in other corporations. (See Table V.)

In only one area—textiles—did Episcopalians equal Unitarians in innovative investment. Here is an apparent contradiction, for textile manufacturing was surely a major factor in Massachusetts's industrializing future. On the other hand, it was also one of the earliest of the new investment areas to develop and, in its initial pattern, rather deliberately sought old wealth. Thus, original stock in the Waltham and Lowell operations was priced at $1,000 per share—ten times the par value for the shares of most companies. It seems reasonable, therefore, to assume that the exclusive circles of shareholders who launched these bellwether textile companies had sizeable fortunes and were able, like William Appleton, to invest heavily in new enterprises and then enjoy the profits when stocks were split to entice smaller investors. But such an assumption demands better evidence than Appleton's Episcopalianism alone demonstrates. Did Episcopalians in fact more than Unitarians batten on old wealth?

It would seem they did. If high social status is more likely to grace second-generation than first-generation wealth, it is indicative that 43

percent of Episcopalians but only 34 percent of Unitarians enjoyed that rank. Or if, as Peter Dobkin Hall argues,[8] family wealth freed the sons, grandsons, and nephews to choose a professional career rather than to continue in the mercantile pursuits of their predecessors, it is also suggestive that two-thirds of elite Unitarians but only half of elite Episcopalians engaged in commerce, while a third of Episcopalians but only a fifth of Unitarians entered the professions.[9]

If, therefore, Unitarians collectively were more likely to be seeking their fortunes, their investment practices and career choices like their prevalence on boards of corporate directors in antebellum Boston bear testimony to economic liberalism. But was it related to their religious liberalism? Attempting to relate religious belief to any action is hazardous at best. As in all statistical analysis, but especially here, we must heed Edward Pessen's warning that "correlation doth not causation make." Yet a correlation exists and begs for an explanation. Can it be that in Boston of the 1830s Unitarians' pursuit of wealth, power, and prestige predated their religious affiliation? that religious attitudes had nothing to do with determining economic activity but only sanctified it after the fact? A look at the movement from other churches into Unitarian congregations suggests that the reverse is more probable. It is true that almost half of those who, in the 1830s, joined a Unitarian church after having been a member of another congregation had left a trinitarian one. But the collective profile of the Unitarian converts argues that they do not explain the concentration of men of power, wealth, and prestige in their new denomination; for they were, as a group, less likely to display such attributes than the 90 percent of Unitarians who had not changed denominations. One may at least hypothesize that, if secular goals determined religious affiliation, becoming a Unitarian was more likely to be undertaken to enhance future prosperity than to legitimate past worldly accomplishments. (See Table VI.)

Finally, regardless of the secular reasons for which men may have become Unitarian, there does seem to have been a special compatability between Unitarianism and the process of economic modernization. Even though promotion of education was more closely associated statistically with upper-class standing than with economic power, it is not unreasonable to associate Unitarians' active role in it as much with their economic goals as with theories of social reform. They not only molded a new Harvard; they tied it, as Ronald Story argues, to Boston's business and financial power centers.[10] So, too, the Unitarians who, in the 1830s,

Jane H. Pease and William H. Pease

Table VI. A comparison of those leaving a church of any denomination to join a Unitarian church as a second affiliation with Unitarians known to have only one church affiliation

	Economically powerful	Wealthy	Modest or high social status	Politically powerful
Unitarians with one church affiliation only (N = 540)	46%	32%	34%	34%
Those with a Unitarian church as a second affiliation (N = 56*)	27%	24%	36%	27%

*Includes 30 who moved from one Unitarian church to another.

made up 48 percent of Boston School Committee members and nearly as many of all those who left any record of having influenced educational practices in the city, simultaneously created the literate and numerate work force essential to Boston's economic growth. This relation between philanthropy and self-interest does not diminish the importance of active benevolence, but it may help explain both its extent and its limits.

How well, then, does this description of Boston Unitarians fit with traditional historical understanding of their roles in antebellum philanthropy or of their participation in fundamental reform? Certainly individual parishioners as well as the American Unitarian Association backed and lauded Joseph Tuckerman's ministry at large, which began in 1826 when the Chelsea cleric responded to the "will of God, that there should be a permanent ministry for the poor of [the] cities,—a distinct ministry for the special purpose of the poor." [11] During its first four years, Tuckerman made no fewer than 4,500 visits to impoverished homes, where he encountered "virtuous widows" with families to support, "virtuous husbands and wives" unable to maintain their children without assistance, and "virtuous single women" who could not earn the bare minimum for subsistance, as well as the poor who were elderly and the "families which [had] known better days." [12] Tuckerman was also struck by those no less needy although sometimes apparently less virtuous: "families which . . . are never more than a few months in a place . . . [who] are compelled to remove by inability to pay their rent; and, to escape from the little debts which they have contracted in the neighborhood in which, for a short time, they have been located." [13]

Unemployment, bad pay, extended illness, lack of material resources or kin to fall back on, and the alienating experiences of urban life all demanded more than religious consolation. Tuckerman's ministry responded accordingly. He designed his Saturday afternoon "Pleasant Hours," full of fascinating observations about natural history, to show the young the importance of learning. And for children who ought to attend the city's public schools he provided essential clothing and shoes, just as he distributed to indigent adults the physical necessities requisite to tide them over in hard times.[14] So responsive were Unitarian congregations to Tuckerman's example that within the decade they supported at least three other ministers-at-large who organized a special mission chapel in Friend Street, built another in Warren Street, and established a third in Pitt Street—each with attendant social services. Furthermore, some individual churches had, even before Tuckerman, undertaken extensive philanthropy. The Brattle Street Association independently provided clothing to the poor and also donated systematically to other charities. The Federal Street Society for Benevolent Purposes did likewise. Then, in 1834, the Benevolent Fraternity of Churches was formed to coordinate and expand support for the city mission.[15]

Yet the same Boston Unitarians who supported these ventures fretted that the underlying conditions that created ever more demands on their charity were getting out of hand. After many years of experience the Federal Street branch of the new fraternity summarized it bluntly. "All experience shows," it reported in 1849, "that pauperism and vice and crime increase in great cities in a ratio much beyond that of the population; so that institutions like the Ministry at Large become more and more needed." And as complexity grew so, too, did abuses of charity. Thus, almost simultaneously with the Benevolent Fraternity, the Association of Benevolent Societies emerged to coordinate all Unitarian-sponsored charities in the city where "the moral sense of the poor . . . has been deadened by the course which charity has taken." Those poor had learned to milk the system. They no longer showed gratitude for alms but "openly declare[d], that our funds were meant for them and that they have a legal claim to them." Families moved to the city "for the express purpose of being supported by charity; and many husbands and fathers leave their wives and children," returning not to support them but to share the booty accumulated from several charitable organizations each acting without knowledge of the other.[16] Small wonder good folk

Jane H. Pease and William H. Pease

feared that philanthropy was nurturing a growing class of paupers and thereby subverting the requisites for the city's economic well-being.

Similar concerns stimulated the establishment of Sunday schools. Operating eighteen of the city's eighty sabbath schools by 1845, Unitarians perhaps more than the other denominations were conscious of their nonsectarian purposes. In particular, the Hancock and Howard Sunday schools, attached to no one church, were designed less to teach the "evidences of Christianity" than to socialize the young poor to "sound" values, "to instruct the mind in its moral and religious duties" as those duties were defined by adult supporters. Much of their instruction, it is true, was dedicated to teaching the children who did not attend public day schools basic reading and writing. Yet, if minutes of teachers' meetings are any guide, almost as much effort was expended instilling "good manners and sobriety of behaviour" or conquering "rudeness and idleness" as in making the young "wiser, better, and happier" or immersing them in "sound moral and religious . . . principles."[17] Indeed, in a city whose population surged from 61,000 to 85,000 in the 1830s and whose new inhabitants were ever more likely to be drawn from Ireland, Unitarians quickly perceived that if they promulgated their own religious views, they would surely limit their social mission. Orthodox Protestants were predictably appalled when a Unitarian-operated infant school proposed to employ a Catholic teacher to assist the Irish toddlers in its charge. But, as Tuckerman argued, it was better to have the cooperation of Catholics in the elevation of their young than to sacrifice that elevation to religious bigotry. The crucial issue was to ensure that young children not loiter and play in the streets or on the wharves, where there were "evil disposed boys" and "many men as well . . . who stand ready to entice them . . . and lead them into vice." Whatever form of church school, therefore, it was more productive in the long run to "inculcate . . . principles of order, sobriety, truth and goodness" than to insist upon the unity—or even the Protestantism—of the godhead.[18]

Even so, it is evident that in some Sunday school classes the individualism that so shaped the minds of Unitarian intellectuals and opposed social conformity influenced teaching. At West Church instruction in reading and writing skills was linked to nourishing the ability to comprehend, reason, and understand. "It should be less [the teacher's] aim to fill the minds of his pupils with his own treasures, than to excite them to think and feel for themselves. Their tho'ts should be a *reply*, not an

echo, to his own."[19] On the whole, however, there is far more explicit discussion of social control than of intellectual independence in the surviving record of teachers' meetings—and that probably reflects the reality of a constantly changing battery of teachers facing a constantly changing collection of pupils across the age, class, and often ethnic lines that divided them.

If promoting simple benevolence betrayed ambivalence—even internal contradictions—within Unitarianism's social ethic, what of those reform activities that challenged the status quo and often the specific vested interests of church members? Here, even more clearly than with philanthropy, we see how the socioeconomic values of entrepreneurially oriented and powerfully elite congregations generated responses at odds with those of a denomination understood to be socially progressive and theologically innovative.

In 1831 Garrison's *Liberator* sounded the trumpet call for immediate abolition which made Boston a center of antislavery agitation. The Unitarian response to it, however, was mixed. Some radicals leapt forward to assume active roles in the new antislavery societies: Henry and Maria Weston Chapman of the Federal Street Church; Lydia Maria Child, whose brother, Convers Francis, presided over the Watertown church; and Samuel Joseph May, whose Brooklyn, Connecticut, parish never isolated him from Boston. But how typical were they?

As early as 1830, the *Christian Register*, which supported African colonization after most northern opponents of slavery doubted its efficacy, did comment favorably on Garrison's program. Yet even George Willis Cooke, who sorely wished that institutional Unitarianism had been in the forefront of antislavery, had to conclude that "the desire of Unitarians to be just, rational, and openminded, exposed many of them to the criticism of being neither for nor against slavery." It was such equivocation that kept the *Register*, while it announced that opposition to slavery was a moral obligation, teetering between a colonizationalism thoroughly discredited by 1835 and the new immediatism. Twelve years later, after northern Presbyterians and Methodists had already split from their southern brethren over slavery, the American Unitarian Association still was turning down resolutions to "come out" from all slaveholding associations. No wonder William Ellery Channing, who in 1835 had put his opposition to slavery on record—albeit not in a way to suit Garrison—soon after admitted that the sect of which he was preeminent

spokesman ranked worse than any other as far as an interest in the slavery question was concerned.[20]

Indeed, Channing's own church was a case in point. In 1831 it denied the young Unitarian cleric Samuel May, Jr., permission "to preach a sermon [in the church] in behalf of the colored population of the United States." Two years later it rejected as "not expedient" a request by Rhode Island abolitionist Arnold Buffum to conduct there a meeting on behalf of oppressed Africans. Next year the church refused to join other city churches in the monthly concert of prayer for slaves. And in 1835, the year Channing published his famous essay on slavery, his congregation turned down the request of Boston-born Unitarian pastor Samuel J. May to permit the New England Antislavery Convention, of which May was a vice-president, to use its meeting rooms. Even more strikingly, five years later it again refused its auditorium, this time to the Massachusetts Antislavery Society, on the occasion of May's eulogy for his ministerial colleague, Charles Follen, killed in the explosion and sinking of the steamboat *Lexington*.[21]

The Federal Street Church was not, of course, unique. When it had denied its facilities to the New England Antislavery Convention, so too had most other Boston churches. But that was not the issue for some of Channing's most devoted parishioners, who associated their own opposition to slavery with his teachings. Henry G. Chapman, treasurer of the Massachusetts Antislavery Society, his wife, and her sister, Anne Weston, all quit the church in 1840. By then it was clear that Federal Street differed little from the churches Maria Weston Chapman had condemned in her 1837 annual report of the Boston Female Antislavery Society. "We find that at almost every step we have taken towards the slave, our progress has been impeded by the same obstacle. As church members, we have been hindered by the ministry," and as abolitionists by avowedly antislavery clerics who "prevent, as far as in [them] lies, the vigorous prosecution of our efforts." Such public protests had little effect, for as Samuel May, Jr., confided to Mrs. Chapman in 1844, Ezra Stiles Gannett, Channing's successor at Federal Street, was a "millstone about the neck of Unitarianism, so far as its utterance of a true and powerful word on Slavery is concerned."[22]

Why was this so? Available data do not directly link the Federal Street Church more particularly than any other congregation to the lords of the loom and, through them, to the lords of the lash. But such a link, even if it did exist, is unnecessary to explain their action. The mercantile oc-

cupations of so many elite Unitarians surely attuned them to the importance of those national ties which made their commercial ventures predictable and profitable and which would be endangered by sectional friction and animosity. They might condemn the sin of slavery but, as William Goodell observed of Channing, they separated "the sinner from the sin" in a way to preclude ending the sin. Again and again abolitionists returned to the inadequacies of Channing's antislavery stance. Elizur Wright, writing soon after Channing's essay had been published, damned its author along with many other clerical leaders. Their "liberal, enlightened, benevolent minds" adopted "into their creed the fundamental principles of human rights, and *theoretically* recogniz[ed] their bearing upon the evil in question; but when they come to the practical application," he concluded, the ministers "fall into violent fits of 'worldly wisdom.'" It was just this paradox which caused Samuel May, Jr.—abolitionist, Unitarian, and clergyman—to writhe at the inaction of the American Unitarian Association. It was, he observed bitterly, "a lifeless, soulless thing, having but a name to live." [23]

Unique in laying bare how one Unitarian society opposed reform activism was the controversy between the pew proprietors of the Hollis Street Church and their longtime pastor, John Pierpont. In that instance the lines were so clearly drawn that while the battle clarifies the dynamics within a Unitarian congregation it does not typify them. Yet to insist on a single pattern of behavior for churches whose members, however much they had in common, did vary in specific characteristics would produce oversimplification. For instance, the very paucity of established wealth and the prevalence of men-on-the-make in Hollis Street created there an organizational style in all likelihood much different from that of King's Chapel with its unusually high concentration of wealthy and upper-class parishioners. [24] Nonetheless, the secular business of both churches was carried on by their respective corporations, in which those who owned pews were taxed to pay the minister's salary and financially bound by the contractual relations between society and pastor to whose terms they— or their predecessors—had assented.

In 1819 the Hollis Street Society had so contracted with John Pierpont. By the 1830s, however, his notoriety stemmed less from his pastoral work than from his activity as a textbook writer, a poet, a minor Transcendentalist, and a reformer—indeed as an agitator. Yet it was not until proposed legislation to restrict liquor sales to quantities of twenty-eight

gallons or more disrupted Massachusetts politics that Pierpont and the pew owners of Hollis Street met in a head-on clash. This proposed law, the chief issue in the 1838 state elections, was designed to close saloons altogether and to eliminate most grocery sales for off-premises consumption. It was an overt temperance measure designed to keep alcohol from all but those who could afford to buy it in very large quantities.[25] Pierpont not only supported the reform but drafted petitions and participated in other public activities on its behalf. It was therefore not coincidental that only in 1838 did the proprietors' meetings begin to complain of his failures as pastor: that his parish visiting was irregular; that he had engaged in dubious business practices; that he dabbled in phrenology; and, most damaging of all, that he introduced the "exciting issues" of abolitionism and temperance into his sermons.[26] However hot the shot, Pierpont did not surrender. Privately and in published letters he refuted the charges with wit and often with sarcasm. Warming to challenge, he counterattacked. His accusers' motivation was, he alleged, mercenary self-interest. Yet his particular targets, the four adversaries who either were or had been distillers, the eight who dealt in wine or West India goods—that is, in sugar and rum—and the one merchant of glassware, who together composed the core of his opponents, pressed steadily on. Because votes of the corporation were tallied by the number of pews owned rather than by the number of owners, proponents and opponents alike vied to buy up vacant pews. Not surprisingly Pierpont's nineteen antagonists, who were nearly three times as likely to be rich as were his forty-four supporters and who were more than five times as likely to exert economic power, had, by 1839, garnered more than half of the pews. (See Table VII.) Controlling the corporation with this majority, they rammed through resolutions seeking Pierpont's resignation; and, when he refused, they forced the creation of an ecclesiastical council comprising thirteen Unitarian clerics and ten laymen. And even when the council rather backhandedly cleared Pierpont, they withheld his salary until, in 1845, he finally did resign.[27]

Both sides conceded all along that Pierpont had, at least since the early 1830s, openly condemned the makers and purveyors of alcoholic beverages. His 1833 sermon "The Burning of the Ephesian Letters," although it did not once mention temperance, "depicted in glowing colors the mercenary motives which incline the parties interested to oppose it." If temperance would harm the purses of his entrepreneurial hearers, Pierpont advised them to think not that "gain is always godliness" but rather

Table VII. Hollis Street pewholders, 1839–1843

	Elite	Economically powerful	Wealthy	Politically powerful
Pierpont opponents (N = 19)	89%	47%	47%	42%
Pierpont supporters (N = 44)	55%	9%	16%	23%
All known pewholders (N = 63)	65%	21%	25%	29%

that "godliness is great gain." At times his bluntness bordered on the offensive, as did his widely reported 1837 toast at a meeting of the Charitable Irish Society: "Hibernia—Steeped in her own tears, she never can get up;—soaking in whiskey, she must go down; but bathing in *coult wather*, she will get on *swimmingly*." [28] Still more offensive to his own disgruntled parishioners was Pierpont's sermon ironically titled "The Things that Make for Peace." However pleasant his flock might find the ritual of the Lord's Supper, it was, he contended, an insufficient expression of that militant and reforming Christianity which demanded *"righteousness, or right moral feeling and action."* Not surprisingly, "nearly all of the most active and influential members of the society including the deacons and standing committee refused to have any thing to do with" that sermon. Yet Pierpont, deserted even by his supporters, would not budge: it "must be my advocate with the community." [29]

All this bore bitter fruit when the dispute over the twenty-eight-gallon bill—ultimately passed as the fifteen-gallon law—had become sufficiently rancorous to fracture Boston's dominant Whig party along temperance lines and to produce three-way elections that denied all candidates the majorities required by law and, in turn, left Boston for two whole years represented in the State House by a mere half of the delegation to which it was entitled. Within that context one does rather understand the corporation majority, which in September 1838 reported that "many members of this Society have viewed with deep regret the zeal of their reverend Pastor in those exciting topics which divide and disturb the harmony of the community, thereby alienating his friends and diminishing his usefulness as the Christian teacher of this Society." But their more pointed opposition to a "Christian minister" tangling

Jane H. Pease and William H. Pease

with the "established laws of the land," and their insistence that "the alteration of old and the adoption of new laws, belong to the legislators" alone emphatically announced their basic contention that reform, when it touched on politics, had no place in their or any other church.[30] Pierpont supporters were, by this document, forced to shape their defense of their pastor to the opposition's charges. Accordingly, it had to be either a defense of a "free pulpit" (the right of a minister to preach as his conscience directed) or an endorsement of one or more of the specific reforms which Pierpont advocated.

To discover just who it was who came to Pierpont's defense after the corporation's September attack and why they did so requires a further exploration of church membership. In the first place, the secular standing of Pierpont's friends differed markedly from that of his foes. Of the forty-four pew holders—thirty-five men and nine women—counted in his camp in 1840, scarcely over half could in any fashion be called elite, whereas 17 of his 19 pew-owning opponents were clearly so. Not only were fewer of his friends rich, but half of them lacked even $4,500 worth of taxable property. Furthermore, one-third of the men whose occupations were known were mechanics rather than the merchants and storekeepers who predominated on the other side. There was, to be sure, no absolute division between the haves and the have-nots. Perrin May, a staunch Pierpont supporter, for example, paid taxes on property valued at $140,000, which, though not so much as that owned by John D. Williams, wine merchant, with his nearly half-million dollars' worth of real estate, was enough certainly to place May among Bostonians of great wealth. It is thus clear that humbler pewholders were even more likely to support Pierpont than were elite members to oppose him.[31]

Finding the answer to why so many pewholders backed Pierpont is, however, more complicated than simply describing their worldly condition. Francis Jackson, an antislavery man so committed that Garrison named a son after him, contended that the issues splitting the church were "*temperance* and *abolition*" and that "every body" knew it. Yet there is little record of other pewholders' engaging in either reform, albeit we should note that the church moderator throughout the controversy was Samuel May, the father of one and the uncle of another highly visible abolitionist. But beyond those two, Pierpont's opponents were just as likely as his backers to belong to reform organizations like the Prison Discipline Society, and they were twice as likely to be members of philanthropic organizations.[32]

Whose Right Hand of Fellowship?

Although involvement in public benevolence sheds little light on what divided the Hollis Street Society so sharply, active participation in the spiritual and social mission of the church proves to be a critical distinction. Of the fifty-two who became communicants in the fourteen years from 1828 to 1843, eleven men and ten women were either known Pierpont supporters or apparently related to a pewholder in his camp. Only three new communicants—all of them women and none pewholders—bore the same family name as any of his opponents. Or, to use another measure of active church participation, of the twenty-nine teachers in the Hollis Street Sunday school in 1839, only one woman shared a surname with a Pierpont opponent, while six men and nine women, half of the total, were themselves pro-Pierpont pewholders or were either positively or apparently related to one.[33]

Here also may lie the explanation of the solid alignment of all known female pew proprietors—two rich and seven not—with their pastor. Women communicants in Hollis Street outnumbered men, as they did in most antebellum churches regardless of denomination. They were sixteen of the twenty persons admitted to communion in the ten years preceding the controversy and twenty-seven of the forty-one admitted during the following six years. Indeed, the conflict itself seems particularly to have attracted women to church services, for fifty-four of the seventy new worshippers who first attended Hollis Street services in the six months preceding the deliberations of the ecclesiastical council on Pierpont's fate were women. Involved here was no question of sexual attraction; rather the numbers reflect a pattern that prevailed not just in Hollis Street but in most churches, where the governing body was a predominantly male corporation but where women predominated among the faithful. Again, while we dare not confuse correlation with causation, and while it is impossible to establish whether an allegiance to Pierpont and his ministerial style came first and then pressed worshippers to more active church roles or whether the reverse was true, it is plausible to argue that the correlation between the two helps explain his followers' loyalty. Their primary commitment to a "free pulpit" is far more evident than a presumed dedication to reform—be it abolition or temperance.

From all the controversy two overlapping patterns emerge. For Pierpont's supporters, the issue was how their religious commitment should guide their secular lives, whether in service to their church or to a broader community. Among his opponents the nub of the matter was how their secular interests might appropriately shape their actions as

Jane H. Pease and William H. Pease

church proprietors. Not only did the former charge the latter with being more interested in the money value of the pews they owned than in the practical application of Christianity, but the hostile proprietors admitted as much. Pierpont's fanaticism not only had driven them from his ministerial tutelage—four had bought pews in other churches—but, they charged, had reduced the price of the pews in Hollis Street. Thus, as they saw it, the conflict was a commercial one, pitting "those who own[ed] the Meeting House, who are parties to the contract of settlement, and pay the salary" against a minister who, in their eyes, was intent on destroying their investment. No one refuted Francis Jackson's wry observation that there would be no battle at all if Pierpont would act in a way to "raise the price of the pews to par value." [34]

The ecclesiastical council, therefore, was caught between different priorities. On the one hand, those eminent clerics and layman cleared Pierpont of charges that he was morally derelict in his dealings and untrue to his ministerial obligations when he pursed matters of public policy. On the other hand, they faulted the style of this man of God who chose in the midst of the contest to preach from the text "Suppose ye that I am come to give peace on earth? I tell you, nay; but rather division"; and who damned the business of his opponents as a scourge on the land and a "curse . . . making our country a stench in the nostrils of the nations." [35]

In the light of Pierpont's continuing challenge to them, one understands why the proprietors—still a minority in absolute numbers but still holding a majority of the pews—rejected the council's exoneration of their minister and continued their war to unseat him. Pierpont was, as former Unitarian William G. Brooks observed, a "very imprudent man"—and the proprietors were still "very much excited against him." But finally, in 1845, after prolonged haggling over the terms, Pierpont did resign; and the proprietors committed themselves to pay his back salary and to give him the customary one year's additional salary associated with involuntary resignation. But they adamantly refused to pay his lawyers' bills. [36]

However distressing to all concerned, the experience of the Hollis Street Society does illuminate some apparent contradictions in the received wisdom about early nineteenth-century Unitarianism. Within their churches Unitarians were a diverse group both in interest and in actions. There were disjunctions between pastors and laymen. There were conflicting priorities which separated reformers—whether clerical

or lay—from fellow churchmen whose secular conditions both gave them power in church corporations and attached them to the status quo. Sometimes their intersections were symbiotic, as when wealthy churchmen bought up pews in new churches to get them launched—and then sold the pews at or above cost. Occasionally they created dramatic clashes, as they did in Hollis Street. Either way, the ever-present tensions—whether veiled or overt—were surely visible to the ministers whom the churches employed. Accordingly, only two of the ministers who had sat in judgment on Pierpont would thereafter exchange pulpits with him. Ralph Waldo Emerson, who had himself experienced a congregation made hostile by innovation, long afterward lamented that "Things are in the saddle/And ride mankind." And Nathan Appleton rode hard when young Ezra Stiles Gannett presumed to criticize the business ethic. There was, this merchant, banker, and future congressman asserted, "no purer morality . . . than that of the counting house." For him, the very individualism so important to Unitarian thought encompassed the right of "every individual . . . to the benefit of his own acquisitions." [37]

It is useful in trying to understand an institution to examine its constituent parts. When we assess a religious denomination, we must, of course, respect the major documents and associations that enunciated its theology, listen to the prominent lay and clerical leaders who spread its message, and take into account the charges of renegades and backsliders who deserted its cause. Far less exciting is an examination church by church, and almost as distracting is a preoccupation with that congregational conflict which resulted not in dramatic heresy but only in petty bickering.

Yet if we are to understand how Unitarianism actually functioned and what it meant to its followers in antebellum America, we must fashion a mosaic whose individual pieces represent those who worshipped and owned pews in its churches, who taught Sunday school and contributed to its social program. And we need also to shape the mosaic's structure to the economic as well as the intellectual achievement of Unitarians, and to do that in relation to their numbers as well as to the prominence of their achievement. We need further to add the perspective that secular resources, interests, and constraints give to otherwise two-dimensional portrayals of benevolence.

In 1820, Channing addressed the crucial connection between religion

and reform and defined religion as "eminently *a social principle*." Yet David Robinson in seeming assent makes an almost throwaway observation that Unitarian social activism—like Tuckerman's ministry to the poor, for example—"was rarely if ever a threat to the established economic order in America."[38] We do not posit that it should have been so—but rather that until we understand why it was not so we shall have only a partial history of Unitarianism.

Notes

1. George Willis Cooke, *Unitarianism in America* (Boston, 1902), 376–383, 428–435.

2. Conrad Wright, *The Beginnings of Unitarianism in America* (Boston, 1955); David Robinson, *The Unitarians and the Universalists* (Westport, Conn., 1985); Merle E. Curti, *The Growth of American Thought* (New York, 1943); William McLoughlin, *New England Dissent, 1630–1833: The Baptists and the Separation of Church and State* (Cambridge, Mass., 1971); Charles H. Lyttle, *Freedom Moves West: A History of the Western Unitarian Conference, 1852–1952* (Boston, 1952); Ronald Story, "Class Development and Cultural Institutions in Boston, 1800–1870: Harvard, the Athenæum, and the Lowell Institute" (Ph.D. diss., S.U.N.Y. Stony Brook, 1972); Story, "Class and Culture in Boston: The Athenæum, 1817–1860," *American Quarterly* 27:178–199 (1975).

3. In making an argument for more systematic attention to those who in fact made up individual church congregations, we do not mean to imply that historians of Unitarianism, or church historians generally, have been unaware of the importance of congregations in formulating church policies and making organizational decisions. Rather we suggest that their attention to the process has been marginal and that their conclusions have been more inferential than solidly grounded in either quantitative or literary data. Clearly Clifford E. Clark touched on the matter when he linked Henry Bellows's social elitism and theological liberalism to the demands of his New York congregation. William R. Hutchison also observed, without further elaboration, that pewholders defined church power. More systematically, Elizabeth Geffen, in noting the occupational status of Philadelphia's Unitarian congregation during the first half of the nineteenth century, defined its pewholders, trustees, and other church leaders largely in terms of their socioeconomic status. Yet even Geffen's work is minimal in its use of quantification and its application of secular data to church decision making.

One does not fault the essayists who contributed to Conrad Wright's recent sesquicentennial history of American Unitarianism, nor Daniel Howe's study of the Unitarian conscience, nor Andrew Delbanco's dissection of Channing's liberal theology for ignoring the methods used by recent social historians. Their books focused explicitly on philosophy and theology, and by extension, clerical leadership. But it is surprising that at this late date the sort of examination we propose here is so conspicuous by its absence. Richard Sykes's 1966 dissertation about Unitarianism and social change in nineteenth-century Massachusetts, de-

Whose Right Hand of Fellowship?

spite its extensive appendix charting occupational data of church membership, hardly gave a nod to parishioners' class and status. David Moberg, in his study of the church's role within the community, rarely mentioned how the community defines that role. Indeed, he followed his contention that the governing boards of 387 Protestant churches of nine different denominations were dominated by proprietors, managers, and professional men with the tentative generalization that "in the absence of contrary evidence, it may be assumed that this leadership has immediate effects upon sermon references to the profit motive, organized labor, and other class-related topics" (p. 415). In such company, Henry F. May's 35-year-old *Protestant Churches and Industrial America* comes closer than recent church historians and sociologists to examining the interaction of urban congregations composed largely of "the upper social and economic groups" (p. 193) and their less fortunate neighbors. Yet his approach, too, was anecdotal rather than systematic, readier to focus on clergymen like W. S. Rainsford than vestrymen like J. P. Morgan in explaining how New York's St. George's Episcopal Church applied the Social Gospel.

Our concern, therefore, is simply this. As social historians, we can and we should take full advantage of no-longer-so-new techniques and insights to test old assumptions about how Unitarian church policy shaped and was shaped by the communities of which the individual churches were part.

See: Clifford E. Clark, Jr., "Religious Beliefs and Social Reform in the Gilded Age: The Case of Henry W. Bellows," *New England Quarterly* 43:59–78 (1970); Elizabeth M. Geffen, *Philadelphia Unitarianism, 1796–1861* (Philadelphia, 1961); William R. Hutchison, *The Transcendentalist Ministers: Church Reform in the New England Renaissance* (New Haven, 1959); Conrad Wright, ed., *A Stream of Light: A Sesquicentennial History of American Unitarianism* (Boston, 1975); Daniel Walker Howe, *The Unitarian Conscience: Harvard Moral Philosophy, 1805–1861* (Cambridge, Mass., 1970); Andrew Delbanco, *William Ellery Channing: An Essay on the Liberal Spirit in America* (Cambridge, Mass., 1981); Richard Eddy Sykes, "Massachusetts Unitarianism and Social Change: A Religious Social System in Transition, 1780–1870" (Ph.D. diss., Univ. of Minnesota, 1966); David O. Moberg, *The Church as a Social Institution: The Sociology of American Religion* (Englewood Cliffs, N.J., 1962); and Henry F. May, *Protestant Churches and Industrial America* (New York, 1949).

4. Amos Lawrence to A. A. Lawrence, March 24, 1833, A. A. Lawrence Papers, Massachusetts Historical Society (hereinafter MHS).

5. Lemuel Shattuck, *Report to the Committee of the City Council Appointed to Obtain the Census of Boston for the Year 1845* (Boston, 1846), 125, reports 3,833 Baptists and 4,830 Congregational (Orthodox) communicants or 51 percent of the 16,863 Protestant communicants in this city of 114,000 people.

All the statistical data in this essay not otherwise cited are on file with the Interuniversity Consortium for Political and Social Research, Ann Arbor, Michigan. The data have been assembled from a wide variety of sources including church records, private papers, public press, business records, club records, philanthropic and reform organization records, probate records, tax records, and others. For detailed information about the original data collection see the authors' *The Web of Progress: Private Values and Public Styles in Boston and Charleston, 1828–1843* (New York, 1985), Appendix A. All of the relevant statistical data for this essay are contained in the accompanying tables I through VII.

Jane H. Pease and William H. Pease

6. Shattuck, *Census of Boston*, 123, 125, records that while Boston's Unitarian churches could, in 1845, accommodate 15,975 worshippers and thus had the largest capacity of any denomination in the city, only an estimated 18,000 people or 16 percent of the city's population had any Unitarian affiliation and only 2,810 or 2 percent of the population were Unitarian church members.

7. Two hundred forty-six of the 453 corporate directors whose religious affiliation was known were Unitarians. Thirteen of the 23 railroad directors of known denomination were Unitarians as were 189 of the 364 bank directors of known denomination. And Unitarians represented 22 of the 24 directors of the Massachusetts Hospital Life Insurance Company. The total numbers of corporate directors was 1000; of railroad directors, 42; bank directors, 733; and Massachusetts Hospital Life Insurance Company, 47.

8. Peter Dobkin Hall, "Family Structure and Class Consolidation Among the Boston Brahmins" (Ph.D. diss., S.U.N.Y. Stony Brook, 1973).

9. In 1841, 36 percent of elite Episcopalians of known occupation were in the professions and 50 percent followed mercantile pursuits. Only 19 percent of elite Unitarians had professional occupations and 65 percent engaged in commerce.

10. Ronald Story, "Harvard and the Boston Brahmins," *Journal of Social History* 7:99, 100, 105 (1975). For a full study of Harvard's relationship to Boston aristocracy in general (including Unitarians), see his *The Forging of an Aristocracy: Harvard and the Boston Upper Class, 1800–1870* (Middletown, Conn., 1980).

11. American Unitarian Association, *Annual Report* (1828), 33.

12. The compilation is constructed from Joseph Tuckerman, *Semi-Annual Reports of the Ministry at Large* (Boston, 1828–1830); and *Quarterly Reports Addressed to the American Unitarian Association* (Boston, 1828), passim. The quotations are from the *Second Semi-Annual Report* (1828), 17–27.

13. Joseph Tuckerman, *Second Quarterly Report* (1827), 5.

14. See, *inter alia*, American Unitarian Association, *Annual Reports* (1827), 41, 48–49, and (1829), 30; also Joseph Tuckerman, *First Semi-Annual Report* (1829), 15–17.

15. Benevolent Fraternity of Churches, *Annual Report* (1839) (Boston, 1839), 4–13; Brattle Street Church, Special Meeting of the Society, Oct. 26, 1834, Minutes, serial, passim; Brattle Street Association, *Tenth Annual Report* (1834) (no imprint), serial, MHS; *Report on a Union of Churches for Benevolent Purposes, Read and Accepted at a Meeting [in the Berry Street Vestry] Held April 27 1834* (Boston, 1834).

16. Arlington Street (Federal Street) Church Records. Federal Street Branch of the Benevolent Fraternity of Churches, Records (1849), Harvard Divinity School, Cambridge (hereinafter HDS), 3; Benevolent Societies of Boston, *Report of the Committee of Delegates . . .* (Boston, 1834), 20–21.

17. The data and quotations (Q) come, in order, from the following sources: Shattuck, *Census of Boston*, 124; Hollis Street Church, Records of the Meetings of Sunday School Teachers, 1832–1845, Minute of May 20, 1834 (Q), HDS; Howard Sunday School, Records, Minute of Jan. 11, 1832 (Q), in Bulfinch Church Records, HDS; S. H. Winkley, "History of the Howard Sunday School," 66–68, in Bulfinch Church Records, HDS; Howard Sunday School, Records, Minute for July 8, 1833; Winkley, "Howard Sunday School," 21–22

(Q); American Unitarian Association, *Annual Report* (1828), 16 (Q); Winkley, "Howard Sunday School," 21–22 (Q).

18. Boston *Observer*, Jan. 22, 1835; Henry C. Wright, Journal, Feb. 1, 1835, Boston Public Library Collections (hereinafter BPL); Howard Sunday School, Records, July 8, 1833, and June 11, 1838 (Q); Howard Sunday School, revised Constitution, in Winkley, "Howard Sunday School," 59 (Q).

19. West Boston Sunday School, Records of Teachers Meetings, Minute of Oct. 16, 1837, HDS.

20. *Christian Register*, Oct. 23, 1830; Cooke, *Unitarianism in America*, 365–368, 353 (Q); *Christian Register*, Jan. 10, 1835; Samuel May, Jr., to [John B. Estlin?], May 29, 1847, May Papers, BPL; American Unitarian Association, *Annual Report* (1846), 33, quoting a Channing letter reproduced in Joseph Blanco White, *The Life of Rev. Joseph Blanco White, Written by Himself; with Portions of His Correspondence*, ed. John Hamilton Thom (London, 1845) 3:96–97.

21. Arlington Street Church, Records, Standing Committee of Proprietors, Minutes of May 18, 1831, Jan. 7, 1833, Nov. 3, 1834, and May 4, 1835, HDS; John Jay Chapman, *William Lloyd Garrison* (New York, 1913), 29.

22. Wendell Phillips Garrison and Francis Jackson Garrison, *William Lloyd Garrison, 1805–1879: The Story of His Life Told by His Children* (New York, 1885–1889), 2:131; Henry G. Chapman to William Ellery Channing, [1840–1841], Draft, Henry G. Chapman Papers, Cornell University; *Liberator*, June 5, 1840; Boston Female Anti-Slavery Society, *Fourth Annual Report* (Boston, 1837), 71–72; Samuel May, Jr., to Maria W. Chapman, July 23, 1844, May Papers, BPL.

23. William Lloyd Garrison to William Goodell, Feb. 26, 1836, Berea College, Berea, Kentucky; Elizur Wright, "Slavery, and its Ecclesiastical Defenders," *Quarterly Antislavery Magazine* 1:341 (1836); Samuel May, Jr., to Mary Carpenter, July 15, 1851, in Garrison and Garrison, *William Lloyd Garrison*, 3:172n.

24. Fifty-nine of 113 King's Chapel worshippers had assessed property worth $30,000 or more, as opposed to 16 of Hollis Street's 63 pewholders. And only one of the Hollis Street Society enjoyed the high social status that 20 of the King's Chapel worshippers did.

25. For a discussion of the temperance issue in Boston, see Pease and Pease, *Web of Progress*, 158–161.

26. Boston *Morning Post*, Mar. 29 and Apr. 5, 1838. The long and complex story of the Hollis Street controversy is best followed in the various documents published by the principals during its progress. Chief among them are *Documents of the Hollis Street Society 1838* (no imprint), *Proceedings in the Controversy between a Part of the Proprietors and the Pastor of Hollis Street Church, Boston, 1838 and 1839* (Boston, [1839]), *Proceedings of a Meeting of Friends of Rev. John Pierpont, and His Reply to the Charges of the Committee, of Hollis Street Society Oct. 26th, 1839* (Boston, [1839]), *Reply of the Friends of Rev. John Pierpont to a Proposal for Dissolving the Pastoral Connexion Between Him, and Society in Hollis Street* (no imprint), *Special Meeting of the Proprietors of Hollis Street Meeting House, March 9 1840 [and Pierpont's Response, March 23, 1840]* (Boston, 1840), *Correspondence between a Committee and the Pastor of Hollis Street Society, Upon the Subject of a Second Ecclesiastical Council, From Oct. 26 to Nov. 12, 1840* (Boston, 1840), *Mr. Pierpont's Remonstrance Against the Action of the Ex-Parte Council, With His Offer of a Mutual Council; The Committee's Reply to that Offer and His Answer to the Offer of the Council. February*

Jane H. Pease and William H. Pease

15–17th, 1841 (Boston, 1841), *Argument of Hon. Emory Washburn Before an Ecclesiastical Council . . . with the Charges Preferred Against the Rev. John Pierpont, and the Result of Said Council* (Boston, 1841), *Proceedings of the Ecclesiastical Council in the Case of the Proprietors of Hollis Street Meeting House and Reverend John Pierpont . . .* (Boston, 1841), *Report of the Committee of the Proprietors of the Meeting House in Hollis Street upon the Result of the Late Mutual Ecclesiastical Council* (Boston, 1841), *A Letter from the Pastor of Hollis Street Society, to His Parochial Friends, with their Reply to the Same, October and November, 1841* (Boston, 1841), and *Correspondence Between the Committee of the Proprietors of the Meeting House, in Hollis Street, and the Rev. John Pierpont, Which Terminated in His Resignation, May 10, 1845* (Boston, [1845]).

27. In addition to those connected with liquor interests, there were several other proprietors who actively opposed Pierpont, making nineteen all together. A list of the Ecclesiastical Council members was published in the *Morning Post*, Feb. 16, 1841.

28. John Pierce, Memoirs, 25 May 1803 to 19 August 1849, MHS, VII:389–401; John Pierpont, *The Burning of the Ephesian Letters: A Sermon Preached in Hollis Street Church, Sunday 8th Dec., 1833* ([Boston], 1834), 15; *Morning Post*, Mar. 24, 1837.

29. John Pierpont, *"The Things that Make for Peace." A Sermon Preached . . . 3d December 1837* (Boston, 1837), 5; Francis Jackson to John Pierpont, Feb. 5, 1838, and John Pierpont to Francis Jackson, Feb. 5, 1838, both in the manuscript collections, BPL.

30. *Documents of the Hollis Street Society, 1838, No. 1* (n.p., n.d.), 1.

31. City of Boston, *List of Persons, Copartnerships, and Corporations Who Were Taxed Twenty-Five Dollars and Upwards in the Year 1840 . . .* City Document No. 8 (Boston, 1841).

32. *Proceedings of the Controversy . . . 1838 and 1839*, 16. Nine Pierpont opponents (47 percent) and only ten Pierpont supporters (23 percent) left records of visible participation in one or more of thirty-nine philanthropic organizations. Five Pierpont opponents (26 percent) and eight of his supporters (18 percent) participated visibly in one or more of twenty-six reform organizations.

33. For the data in this and the following paragraph, see Hollis Street Church, Records, 1732–1849, microfilm copies, Genealogical Society of Utah, containing records of admission to communion, marriage, and baptism; Hollis Street Church, Records, 1787–1879, HDS, containing, *inter alia*, financial and church school records; and Washburn, *Argument*, 96, for the sudden increase in female worshippers. Fifty-two persons—sixteen men and thirty-six women—became communicants from 1828 through 1842. Nine more—seven women and two men—were added in 1843. Three of Pierpont's daughters, including the mother of J. Pierpont Morgan, joined in this year. John Pierpont, Jr., was not counted among his father's supporters because of his more direct interest in the matter. He became a communicant in 1841.

34. *Report of the Committee of Proprietors*, 16; *Proceedings of the Controversy . . . 1838 and 1839*, 19–20.

35. *Proceedings of the Ecclesiastical Council*, 375–384; *Morning Post*, Aug. 13, 1841, summarized the findings of the council; Daniel F. and Mary Child, Diary, Aug. 2, 1840, MHS; *Special Meeting of the Proprietors . . . 1840*, 14.

36. William G. Brooks, Diary, July 14, 1841, MHS; *Correspondence . . . 1845.*

37. Ralph Waldo Emerson, "Ode to William E. Channing" (1847); Nathan Appleton to Ezra Stiles Gannett, Jan. 24, 1828, Appleton Family Papers, MHS.

38. William Ellery Channing, *Religion a Social Principle: A Sermon Delivered in the Church in Federal Street . . . December 10, 1820* (Boston, 1820), 6; Robinson, *Unitarians and Universalists,* 46.

Jane H. Pease and William H. Pease

Divinity Hall, Harvard University, Cambridge. Engraving in
Josiah Quincy, *The History of Harvard University*, 2nd ed.
(Boston, 1860), 2:361. Collection of the Massachusetts
Historical Society.

"A True Toleration":
Harvard Divinity School Students and
Unitarianism, 1830–1859

✿

GARY L. COLLISON

In the summer of 1838, Unitarians found themselves deep in a long-simmering collective identity crisis. Ralph Waldo Emerson had just shaken the denominational foundations with his powerful Divinity School Address. Emerson's address, and the arguments over it, exposed the profound theological and philosophical differences that afflicted the denomination, differences further exacerbated by division over social and political issues. For a time Unitarianism seemed destined to split into two. War between the conservatives and the radicals never came, however. Instead, over the next forty years, a relatively peaceful evolutionary process of addition, modification, and attrition gradually stripped Unitarianism of much of its elitist social and political philosophy and nearly all of its traditional theology. This evolutionary process has been partially traced in histories of the Transcendentalist revolt of the 1830s and of the Free Religion movement after the Civil War. However, the decades in between have received little attention. As the Unitarian identity evolved

Gary L. Collison is Assistant Professor of English, York Campus, Pennsylvania State University.

during those thirty years, the Harvard Divinity School and its students played a vital but little understood role.[1]

Much of what has been said about the Harvard Divinity School of the antebellum period hardly suggests that it was a powerful force for change. The Transcendentalists' disgust with the school is well known to readers of Ralph Waldo Emerson's journal. Several months before delivering his famous address before the school, Emerson had fumed about the "intense grumbling enunciation of the Cambridge sort," while grumbling himself that "A minister nowadays is . . . a Warming-pan, a Night-chair at sick beds and rheumatic souls."[2] After attending the annual visitation ceremonies in 1835 he had written, "The best performance . . . was founded on nothing and led to nothing and I wondered at the patience of the people."[3] Theodore Parker was equally disparaging and caustic. Looking back to the mid-1830s, Parker epitomized his Harvard Divinity School days in an image of a professor who "milked the wether" (that is, a castrated male sheep) while the students "held the sieve."[4] On another occasion Parker played on the theme of "corpse-cold" Unitarianism by comparing the Divinity School faculty to morticians. "Egyptian embalmers took only seventy days . . . to make a mummy out of a dead man," Parker observed, whereas "Unitarian embalmers use three years in making a mummy out of live men."[5]

While Transcendentalists ridiculed and railed at the Harvard Divinity School, conservative and moderate Unitarians were almost equally critical. Some complained that the school produced only dry scholars when live ministers of the Gospel were needed in the Unitarian pulpits.[6] Promising ministerial students like Edward Everett Hale, repelled by what he regarded as a mechanical and arid program, bypassed the school entirely in preference to the old-fashioned method of "reading divinity" with a seasoned clergyman.[7] Others despaired over the "unchristianizing" influences of German higher criticism and Transcendentalism on the young clergy, both in and out of Cambridge.[8] Andrews Norton, a professor at the school during the 1820s and an archenemy of Transcendentalism, thought the situation so bad that by 1840 he was actually advising a young Unitarian who wanted to be a minister to study another profession.[9] Eventually, longstanding dissatisfaction with the Divinity School was to result in the formation, in 1867, of a short-lived rival Unitarian theological school in Boston to "help to introduce into our body those

Gary L. Collison

earnest and practical elements, the lack of which we so constantly feel." [10]

In many minds, Emerson's Divinity School Address of 1838, with its remarks about Christianity dwelling with "noxious exaggeration about the person of Jesus," made matters worse.[11] "A bad blow to our hopes," wrote a discouraged John G. Palfrey, dean of the school. In the public mind, the Divinity School and Harvard College, already suspected of acting in collusion to undermine traditional Christianity, were thereafter known as "an association of infidels, without belief in the awful mystery of Christ's incarnation, placing no reliance on his propitiatory death, . . . [and] denying his divine mission."[12] If "The theological department had its day of favor formerly," as Palfrey wistfully put it in 1839, the Transcendentalist stain added a stamp of finality.[13] Science, which now bore the scepter of Harvard learning, was an expensive proposition; college officials wanted no embarrassing religious controversies driving away conservative and moderate students or dollars. By the end of the 1830s, Palfrey was complaining of a university policy "to ignore the Divinity School as much as possible, and keep it from attracting public notice."[14] A movement led by Edward Everett and Jared Sparks, successive presidents at mid-century, tried to solve the problem by formally separating the Divinity School and the college, an effort ultimately frustrated by a complex tangle of legal issues. Everett hoped to banish the Divinity School into the wilderness—twenty-five miles seemed a minimally safe distance.[15]

Ultimately dissatisfaction was reflected in conditions at the Divinity School, particularly in a shrinking student body and faculty. In the early 1830s, after its first full decade in operation, the Harvard Divinity School commonly had senior classes of a dozen students and a combined sophomore, junior, and senior enrollment exceeding forty. By the end of the 1830s, the combined enrollment was typically half that number. Emerson delivered his famous address of 1838 to a senior class of only seven. At the beginning of the next term, a seemingly blighted Divinity School opened with a new class of only four students, one of them (symbolically) lame, when fifteen had been expected.[16] In the 1830s, the average number of seniors finishing the program was nearly ten per year; in the 1840s, it fell to eight, and then in the 1850s to fewer than seven. Twice in the two decades before the Civil War only three seniors completed the program of study, and another three times only four finished their senior year. Although every few years a larger class would materialize, within a

year or two enrollment would shrink once again. Illnesses and absences during the term must have often left the professors feeling like private tutors.

Even more revealing of the Divinity School's depressed state was the situation of the faculty. Lack of interest on the part of Harvard College and grudging support from the Unitarian community resulted in the faculty decreasing from five professors in 1830–1831 to three by the late 1830s. Then from 1839 until 1857, two professors alone taught the entire three-year curriculum. The two professors faced grueling schedules: as many as nineteen classroom hours a week; hours of grading, conferences, and preparation for a wide range of sophomore, junior, and senior courses; more hours in administrative duties, supervising morning and evening prayers at the college and the school, even delivering a portion of the Sunday sermons in the Harvard College Chapel. "The distractions of mind resulting from the miscellaneous character of my occupations," an exasperated Henry Ware, Jr., said shortly before retiring (or retreating) in 1842, "renders it impossible for me to do anything thoroughly and well, and is a perpetual cause to me of mortification and dissatisfaction." [17] Year after year the professors pleaded for one of the vacant professorships to be filled, and year after year their pleas went unheeded. Not until 1857 would the Harvard Corporation, the governing body, finally relent, allowing two non-resident professorships to be created. [18] With these additions the Harvard Corporation made the first tentative steps towards rejuvenating the Divinity School. It would be more than a decade, however, before the school was finally restored to something like a flourishing condition with the establishment of two Bussey professorships, one in theology and the other in New Testament criticism. [19]

Enfeebled as the Harvard Divinity School had become in the tumultuous decades of Unitarian–Transcendentalist conflict, it can easily be seen as a victim of its times. Yet the loudest voices in an era of bitter controversy, as the Transcendentalist era clearly was, are often misleading. And declining numbers of faculty and students did not necessarily translate into declining energy. In fact, evidence suggests that the Harvard Divinity School maintained a tenuous dynamism, often invigorated by the same intradenominational conflicts that threatened the existence of the school.

Two circumstances in particular helped infuse vitality into the Divinity School. The first was the electric intellectual atmosphere of Boston that crackled with new ideas, ideas which the growth of the lyceum and press

Gary L. Collison

helped make accessible to the students. Living on the outskirts of Boston, Divinity School students got firsthand exposure to the ideas and debates that made Boston the greatest intellectual center in antebellum America. Outside Divinity Hall, Boston of those days was a great, thriving emporium of goods and ideas, offering spiritualism, Swedenborgianism, Fourierism, and a whole host of other enticing *isms*. The fact that Unitarian ministers like William Ellery Channing and Ralph Waldo Emerson welcomed and stimulated this intellectual ferment set the stage for the young ministerial candidates. For the divinity students, the most enticing of all the swirling movements and currents was Transcendentalism. Emerson's example, and the examples of the other Unitarian liberals associated with the Transcendental movement, had a powerful impact. From the time Emerson began lecturing in the 1830s, his words echoed through Divinity Hall. Divinity School students trooped to his lectures and even camped on his Concord doorstep. In their rooms they debated the merits of his ideas—on more than one occasion with Emerson himself present—until the early hours of the morning. Some of them sat in on the Transcendental Club meetings of the late 1830s. When Theodore Parker's Twenty-Eighth Congregational Society was formed in Boston in 1845, the divinity students were given easy access to another radical example. What is more, young men already under the influence of an Emerson or a Parker began entering the Divinity School. As these students were often among the brightest and most articulate members of their classes, they could be powerful influences among their fellows. Students with radical tendencies, like Theodore Parker in the 1830s or Thomas Wentworth Higginson and Samuel Johnson in the 1840s, could influence five separate classes directly: their own, the juniors and seniors ahead of them when they entered, and the sophomores and juniors behind them when they finished after three years. A few such students could turn Divinity Hall into a breeding ground for radicalism.

The second circumstance, equally important though less dramatic, was the result of faculty turnover beginning in the late 1820s. The original faculty of Henry Ware, Sr., Sidney Willard, and Andrews Norton had given the school an old-fashioned elitist tone during the 1820s, the school's first full decade of operation. Although Norton inaugurated a new era in modern biblical scholarship, his social and political impulses were largely conservative and elitist. By 1831, only mild, old-fashioned Henry Ware, Sr., remained from the original three faculty members. The 1830 appointment of J. G. Palfrey as Norton's successor inaugurated an

era of toleration and sympathy at the Harvard Divinity School. Andrew Peabody, a student in this transitional period, later remembered the change from Norton to Palfrey as a complete revolution in the intellectual atmosphere. "Norton's utterances in the class-room," Peabody was to remember later, ". . . crushed out for the time all possibility of dissent." But Palfrey, "with hardly less fixedness of opinion . . . invited discussion, welcomed the expression of non-agreement, and even asked his students to prepare in writing, and read to the class, their reasons for differing from him."[20] Editor of the *North American Review* during part of his tenure at the school, Palfrey gave divinity students of the 1830s a model of intellectual range and sympathies equaled by few, if any, in a denomination known for intellectual achievement.

An appointment in the pastoral department had an equally profound effect on the school's atmosphere. From assuming the professorship in pastoral care in 1829 to his retirement in 1842, Henry Ware, Jr., provided the divinity students with a model of toleration and progressive sympathies. Ware took an interest, sometimes an active one, in many of the reforms of the day. And because Ware was widely admired as *the* model pastor throughout the denominaton, his presence at the school gave added weight to his independent liberal example. Two incidents from 1839 illustrate just how open Ware could be. The Divinity School was suffering from the effects of the uproar over Emerson's address. In the popular mind the school was stained with infidelity. Yet Ware invited Charles Follen to repeat for the students a series of evenhanded but sympathetic lectures on pantheism, and he even allowed a senior divinity student to deliver an Emersonian piece during Visitation Day, the school's version of graduation.[21] In the charged atmosphere of 1839, Ware's actions required courage.

Faculty turnover early in the 1840s continued the atmosphere of intellectual openness at the school and in some ways furthered it. George R. Noyes replaced Palfrey in 1840 as professor of critical studies and for the next twenty-eight years would teach divinity students how to be impartial intellectual explorers. Temperamentally "a conservative by nature," as a scholar and teacher he was willing to "submit whatever he most wanted to believe to the crucial test of research."[22] In the classroom he was coolly analytical, presenting the most advanced critical views without apology, and expecting from the students the same unflinching pursuit of truth that he expected from himself. Naive literalistic readers of the Bible found themselves deeply shaken in Noyes's classes. After a lec-

ture on a familiar story from Genesis, one student wrote in anguish, "It seems like tearing away something dear, to start doubts, and compel us to throw away what from our childhood we have been accustomed to reverence."[23] Then in 1842, Convers Francis succeeded Henry Ware, Jr., as professor of pastoral care, bringing sympathies with new ideas and movements perhaps even more wide-ranging than Ware's. Francis had even been a member of the Transcendental Club. From 1842 until his death in 1860, Francis nudged the school in the direction of new ideas. Known for his all-sided sympathy, he encouraged the students to decide all kinds of religious and social questions for themselves. Noyes and Francis together made it the policy of the school to allow any line of questioning so long as it was undertaken in the proper pious spirit.[24]

Developments in the Boston intellectual world and changes in the Divinity School faculty helped open the school to the swirling currents of the age. Outside in the larger denomination, old habits of thought and feeling often dictated otherwise. New ideas and attitudes had a much more difficult time gaining acceptance or even a hearing among the older generation. Congregational principles kept the denomination from ever enforcing a standard set of beliefs, but Unitarianism still came as close as it could to excommunicating Theodore Parker. In place of the Inquisition Unitarianism had public scorn to keep its members in line. Young ministerial candidates were sometimes warned to keep their opinions on the disturbing subjects of the day to themselves or else rule out some of the best pulpits.[25] A virtual taboo banned the subject of slavery from many Boston pulpits. It was not that Unitarians loved slavery; most abhorred it. But many loved order and stability more, a not-so-surprising position for a denomination in which the best pews were filled with political leaders and merchant princes. Even after William Ellery Channing, the most revered minister of his generation, published several antislavery pamphlets, slavery remained a forbidden topic in many churches, particularly in Boston.[26] Similarly, too much flavor of "infidelity" branded as outcasts those who openly sympathized with radical views of the Bible, again particularly in Boston. But at the Divinity School, abolitionism, Transcendentalism, and other controversial topics would find a more receptive audience than the denomination as a whole provided.

Reconstructing the intellectual world of Divinity Hall would provide insight into Unitarian evolution in the middle decades of the nineteenth century. However, recovering that world is not easy. Sydney Ahlstrom

and Conrad Wright have traced many of the important antebellum changes in the Divinity School curriculum, administration, and faculty. Yet these topics represent only the formal portion of the students' educational experience and provide, at best, limited insights into their minds and experiences. To enter their mental world requires other materials.

The students themselves provided little direct help. Although they kept a manuscript history of the school, it yields relatively few insights. When it is not merely a dry recitation of dates and events, it tends to reflect the idiosyncrasies of whoever happened to be secretary. Diaries and letters written by Divinity School students (or faculty) are scarce and mostly unrevealing.[27] Important correspondences tended to start after graduation, when letters became a vital way for the young ministers to continue their intellectual life amidst the cycle of mundane parish duties. Surviving lecture notes of a few students provide few clues about what the notetakers were thinking. Student sermons and exercises, which might provide important evidence, have mostly disappeared, and the few that survive tend to be mechanical, labored imitations. For all these reasons, the students' own deepest intellectual tendencies and struggles have remained obscure.[28]

Fortunately, however, two valuable records of divinity students' discussions and opinions during the crucial period from the mid-1830s to 1859 have survived. These are the manuscript minute books of the Philanthropic Society (1831–1851) and Debating Society (1853–1859), both held in the Harvard University Archives. The following discussion draws heavily upon these records, particularly on the Philanthropic Society minutes, to create a portrait of the thoughts and attitudes of the Harvard Divinity School students in the Transcendentalist era.[29]

The Philanthropic Society had a very conventional origin. Early in the spring of 1831, several students who had been conducting Sunday school classes at the Charlestown state prison expressed a desire to ensure a permanent ministry for the prisoners. On the advice of Henry Ware, Jr., their fatherly professor of pastoral care, they formed the Philanthropic Society of the Harvard Divinity School. Members were to provide the prisoners with religious instruction and to help them find employment when they were released. The first year the society was in existence, from three to six divinity students conducted religion classes each Sunday at the state prison and others performed the same service for prisoners at the county jail.[30] Nothing, however, seems to have come of the plan to assist prisoners in finding jobs.

Gary L. Collison

Although divinity students continued to conduct Sunday school classes at local prisons at least through the mid-1830s, the Philanthropic Society apparently never gave the prison efforts more than informal support.[31] In fact, the prison Sunday schools were not even mentioned in the constitution, which declared that the purpose of the organization was to "obtain and communicate . . . information with respect to the moral and religious wants of our community, and the various benevolent projects of the day."[32]

During the twenty-one-year life of the Philanthropic Society, members met in Divinity Hall on the average of once a month, although meetings were more frequent in the first decade. Between the founding of the Philanthropic Society in 1831 and its final meeting in 1851, the records show that the society held 244 meetings, two-thirds of these in the first ten years. Each meeting began with prayer, often delivered by a professor or by one of the numerous guests or honorary members of the early years. The reading of a report on the topic assigned for the week followed. Then the students debated the resolutions attached to each report and, usually, ended the meeting by voting on the resolutions. Sometimes reading the report and debating the resolutions occupied several meetings (once as many as eight), but ordinarily the society took up a separate topic at each session.

Three controversial topics—antislavery, religious radicalism, and social reform—provide convenient measures of Divinity School student opinions. These issues severely challenged the uneasy marriage between progressive views and elitist class interests that characterized Unitarianism, especially in Boston and Cambridge.

Antislavery and other controversial issues only gradually became a staple of Philanthropic Society meetings, however. In the first year, topics fell mostly within the narrow range of established church-related charities and missions, the kind of do-gooder crusades that Thoreau said he would run from. The constitution suggested as appropriate topics "Missionary, Bible, Tract, Prison Discipline, Temperance, and Peace Societies," together with "Sunday Schools, Education generally, the prevention of Crime, Poverty, &c."(3). Early Philanthropic Society agendas followed the original list of popular and acceptable topics fairly closely. Of the seventeen meetings the first year, more than half were devoted to discussing missionary work among distant heathens and local sailors. At one of these meetings, when the famous Father Taylor of the Boston seamen's bethel was invited to speak, so many visitors attended that the

gathering had to be moved from Divinity Hall to the college chapel. A few of the early topics, notably peace, temperance, and African colonization of American slaves (in 1831 still widely accepted as a reasonable solution to the slavery problem), might have generated controversy, but none represented direct challenges to the established social order. Many early Philanthropic Society meetings, in fact, focused on the efforts by which the established order attempted to control social disruption in an increasingly diverse democratic society.

The "established" character of early Philanthropic Society topics reflects the conscious direction of the junior Henry Ware and other Unitarian ministers who saw in it an ideal training ground for ongoing Unitarian benevolent efforts. To Ware, the Philanthropic Society provided an opportunity to supplement the school's often dry intellectual content. "They are training up to be active and benevolent, as well as learned, ministers of Christ," he had boasted to a friend shortly after the Philanthropic Society had been founded.[33] Early minutes show Ware in control—offering the opening prayer, proposing topics, contributing to and guiding discussions, and closing meetings with remarks that the student secretaries often took down in the records. Dean John G. Palfrey also attended, though less frequently than Ware, and invited guests and semiofficial honorary members added their distinguished and sometimes intimidating presences to many gatherings. Minutes of more than one meeting reveal that occasionally the faculty found the temptation to lecture too strong or that the ministers and faculty in attendance, impatient with plodding, poorly informed student contributions, simply took over discussions. Following an 1834 lecture by peace advocate William Ladd, the minutes note that "remarks were made by Profs. Willard and Follen, and Rev. Mr Ware, Jr."(44). The students, it appears, listened in respectful silence. The weighty influence of faculty and honorary members, including Andrews Norton, even threatened to become a formal mechanism of control when, in 1836, someone proposed that the Philanthropic Society choose its president from among honorary (read "responsible") members. (It may be no mere coincidence that this measure was proposed just after Theodore Parker had graduated.) The members, however, rejected the measure.

In the early 1830s when the Philanthropic Society did take up controversial subjects like slavery, it usually echoed the common wisdom. When slavery was first discussed, in 1831, the radical abolitionist movement was just developing. William Lloyd Garrison himself had only re-

Gary L. Collison

cently turned against African colonization as a solution to the slavery issue. Thus it is hardly surprising to find the Philanthropic Society strongly behind African colonization. A report by William Henry Channing, later a staunch abolitionist, apparently voiced entire approval for colonization, calling it a plan "for ameliorating the condition of the Blacks in this country"(14). Channing's journal further reveals that at the time he believed extending equal rights to freed slaves "certainly not desirable" (at some later date he added the penciled notations "alas" and "shame").[34] James Freeman Clarke's report the following week embodied the pervasive racist assumptions of the period more directly. The Colonization Society "deserves the warm support of Christians," Clarke wrote, "on account of the direct tendency of its operations to relieve our Country from the evils of a free black population"(14).[35] In 1833, Clarke and more than thirty other divinity students, or nearly the entire Divinity Hall population, signed a resolution commending the efforts of the Colonization Society.[36]

Early Philanthropic Society discussions of other social issues also resonated with the moralistic social philosophy of most middle-class Christian philanthropists.[37] In an age when the root cause of poverty was believed to be sinfulness, social programs aimed at relieving mere physical distress were thought to weaken individual character and the social fabric. Accordingly, Unitarian moralists like Joseph Tuckerman, the first of many Unitarian "ministers-at-large" to the urban poor, supported only those philanthropies that aimed at strengthening social bonds and moral fiber. So committed was Tuckerman to this extreme voluntarism that he actually supported the repeal of the long-standing Massachusetts law requiring each township to provide for its indigents. By and large divinity students of the early 1830s echoed Tuckerman's assumptions. When they talked about ameliorating the condition of the poor, they insisted on tying aid to moral improvement and dismissed out of hand any social reforms aimed purely at material aid or at attempts to eliminate the social inequalities in general. In 1833, for example, they passed a resolution opposing "every law which could make permanent provision for the poor"(38). They did not go quite so far as Tuckerman in advocating extreme voluntarism, however, for they agreed to exempt workhouses, almshouses, and hospitals.

Although early Philanthropic Society discussions were narrowly focused and imitative, there were soon hints that the Divinity School students

would not be content with standard topics or timeworn responses to social or religious questions. The year after an 1833 report bewailing the effects of popular literature, Philanthropic Society members dismissed the topic impatiently and in its place substituted a discussion of antislavery. In 1834 they drew up a schedule that included "Magdalen Reform" (the nineteenth-century euphemism for social work among prostitutes), a topic of questionable propriety for proper Bostonians. Taken by surprise, Henry Ware, Jr., tried to rein them in by insisting that a special committee reconsider whether the topic should be discussed at all(40). The students obediently formed the committee, which soon declared the topic safe for divinity students as long as they were protected from "all offensive particulars"(42). The students may not have informed plain-spoken Father Taylor of this requirement when they invited him to their discussion, however, for he gave the sheltered, mostly middle-class ministerial students an earful. Wrote one student visitor after the meeting, "It is appalling to hear of the arts practiced by deceivers and abandoned men."[38] At the end of the meeting, the students expressed sympathy with the Magdalen reform work going on in New York City, but they could not bring themselves to agree that the topic came "within the range of pulpit discussion"(47–48). Nevertheless, their discussions showed them determined to confront social problems arising in an increasingly urbanized, industrialized America, problems that would overwhelm the social remedies of the earlier agrarian society.

By the mid-1830s, as the Magdalen reform discussion shows, the Philanthropic Society had greatly expanded its range of interests. Like the Transcendental Club that would be founded in 1836 by Ralph Waldo Emerson and other liberal Unitarian ministers, the Philanthropic Society provided a forum for issues and ideas that did not fit comfortably within the narrow range allowed by existing Unitarian organizations. Suicide, women's wages, botanic medicine, Swedenborgianism, physical education, and much more were to come under Philanthropic Society scrutiny within a few years. Interest in such topics did not mean that the students abandoned conventional subjects or that they were all Transcendentalists and social reformers. Sunday schools and missions remained perennial topics. Most students, at least initially, voiced the conventional religious and social views they had learned at home or in church. But the overall pattern among the members was decidedly toward a broad toleration of new points of view. This trend was most dramatic in the mid- to late 1830s, and again in the mid-1840s and mid-1850s when new religious

Gary L. Collison

220

and social ideas were not merely entertained but embraced by the majority of divinity students in Cambridge.

Social activism had begun to appear in segments of the denomination in the mid-1830s and was quickly reflected among the students. This rapid assimilation at Divinity Hall is relatively easy to explain. Charles Follen, Samuel J. May, and a few other similarly liberal Unitarian clergy were particularly close to the school. Follen and May, both early Garrisonian abolitionists, had been made honorary members of the Philanthropic Society and so provided the students with firsthand models of Unitarian antislavery activism. Follen had been an instructor in the Divinity School and the college for a brief period in the 1820s, but he had lost his position, so the rumor ran, for refusing to be silent about slavery.[39] May was more closely associated with Garrison than was any other Unitarian minister.

While May and Follen undoubtedly stimulated the development of abolitionist sentiments among the divinity students, the example of their own professor, Henry Ware, Jr., was probably even more influential in promoting antislavery views among them. From the early days of the antislavery movement, Ware sympathized strongly with its aims, though like many other Unitarians he deplored the abolitionists' strident methods. In 1834 Ware even formed his own antislavery group, the Cambridge Antislavery Society, to provide a restrained alternative for antislavery sympathizers repelled by the "unchristian language" and "unreasonable violence" of the Garrisonians.[40] Although the peace-loving Ware quickly abandoned the organization when it drew loud objections from within the denomination, his work nevertheless sent the message to his students that activism on behalf of "disturbing" causes was a legitimate function of the ministry.

Philanthropic Society minutes of the mid-1830s show that the examples of Ware, Follen, and May were not lost on the divinity students at Cambridge. After three nights of discussion in 1835, the Philanthropic Society passed resolutions condemning northern black laws and declaring slavery an "outrage against the dearest rights of man" and "a sin against God"(69). While still recommending African colonization as "best adapted to promoting the safety and happiness of both master and slave," the students expressed serious reservations about the feasibility of this solution. If colonization plans proved to be impractical, the students declared, slaves should simply be emancipated. Support for emancipation was not wholehearted, however, for the resolution passed only after

the words "here immediately"(71) were removed. Nevertheless, the vote showed the students edging toward the Garrisonian camp.

One particularly revealing example of the changing attitudes toward social issues at Divinity Hall in the mid-1830s is furnished by John Hopkins Morison, a student in the class of 1835. In 1833, Morison had voted with the majority against all attempts to ameliorate the condition of the poor through legislation.[41] But by the following February, when Morison delivered a report entitled "The Influence of Manufacturing Over Pauperism," his position had altered sharply. In the new report Morison argued that large manufacturing industries were "unfavorable to the cultivation of man's Moral and Intellectual Nature, and therefore lead to the worst evils of Poverty"(44). This much was not surprising, for industrialization aroused widespread suspicion along the whole intellectual spectrum. But now Morison concluded that preventing the worst effects of industrialization on the lower classes required laws to regulate large industries. He recommended a law prohibiting hiring children under the age of thirteen, another requiring all children under twenty to receive schooling for a portion of each workday, and a third, more radical yet, guaranteeing older workers a part of each day for "mental and moral improvement." The resolutions all passed.

Discussions of other topics showed many Divinity School students of the mid-1830s ready to face the consequences of free inquiry in an increasingly pluralistic world. In the spring of 1834 they took up the question of atheist Abner Kneeland's "obscene and blasphemous libels," an issue that sorely tested the Unitarian commitment to free inquiry.[42] Indicted in 1834 under an ancient Massachusetts statute, the iconoclastic Kneeland and his paper, the *Boston Investigator*, symbolized for many an unbridled, irresponsible freedom that threatened not just religion but society itself. A few Unitarians, including William Ellery Channing, swallowed hard and lined up in support of Kneeland's right to free speech, but others sided with the prosecuting attorney, James T. Austin, himself a Unitarian and attorney general of Massachusetts. Philanthropic Society discussions reflected the division among older Unitarians over Kneeland. Kneeland and his followers threatened "the complete destruction of all Religion," read one student resolution. Several members submitted a proposal endorsing Kneeland's prosecution. However, Cyrus Bartol (later identified with the Transcendental Club) countered with resolutions supporting Kneeland's right to express views obnoxious to the Christian population. Kneeland's atheistic essays were not the cause of

infidelity, Bartol argued in explanation of his position; religious dog-
matism was: by requiring believers to swallow every indigestible lump
of outmoded theology, the Christian churches were driving people to-
ward unbelief. The only way to combat infidelity, Bartol argued, would
be to scrap archaic theology. Unbelievers themselves should be treated
with Christian kindness to encourage them to come back into the fold.
For several nights after Bartol introduced his resolutions, the Philan-
thropic Society meetings were the scene of lively debate. In the end,
Bartol's resolutions prevailed. Within a few years after the Kneeland de-
bate, Divinity School sympathy for wide toleration of "infidelity" had
apparently strengthened. At Philanthropic Society meetings in 1836,
Theodore Parker was rudely dismissing conservative fears about the anti-
Christian tendencies of German higher criticism. "We are told, indeed,
by the astute critics of American closets that the Germans are mainly
atheists," Parker wrote in the preamble to his report on developments in
German theology, adding, "nothing could be further from the truth."[43]

In some of their other debates, however, students of the mid-1830s
continued to echo the Unitarian moral elitists' deep fears about declining
social controls in—and their declining control over—American mass so-
ciety. An 1835 discussion of "pauperism" showed the students sympa-
thizing with elitist justifications of economic and class stratification. "It
is particularly incumbent upon the clergymen to have the poor always
with them" and to improve their condition, they agreed. Nevertheless,
they warned against any tendency to "arm the poor and ignorant with
jealousy towards the rich and educated"(61). A little over a year later
a report on popular reading led to an attack on "the recklessness of
the age" with its "extravagant multiplication of books"(97). In these
two reports divinity students were expressing the conservative, anti-
democratic side of Unitarianism that longed for the clear social bounda-
ries and moral control of an earlier age.

Toward the end of the 1830s, all hints of social or religious conserva-
tism disappeared among the students as Transcendentalism swept Divin-
ity Hall. The invitation to Emerson to give his address before the grad-
uating class of 1838 is the familiar example of this revolutionary spirit
(although all the attention has focused on Emerson's rather than the stu-
dents' motivations), but there were others. In the spring of 1838, months
before Emerson's address, the Philanthropic Society demonstrated its de-
fiant spirit in a dramatic controversy growing out of its discussions of
slavery. For four nights, Philanthropic Society members listened with

rapt attention to a thoroughly abolitionist report. After the fourth meeting, junior George Moore wrote excitedly in his journal, "The report ended with a thrilling appeal to us all to come forward and help in the good work, and stirred us all up."[44] But before the students could take up the resolutions attached to the report, the faculty, citing "some apprehensions of disturbance"(116), asked them to postpone voting on the resolutions indefinitely. At a special meeting, members decided that the faculty request was merely "advisory" and observed bluntly that to comply with the faculty request "would be to give up our right of free discussion." At the next meeting, it became clear that to some extent the faculty's "apprehensions" had to do with a "general invitation" to abolitionists to attend one of the meetings. One student proposed banning invitations altogether out of "courtesy and expediency." In the discussion that followed, the members split over the question. But before the issue could be finally settled, President Quincy stepped in, and the whole debate shifted direction.

President Quincy, himself sympathetic with antislavery arguments, had no wish to see Harvard further weakened by becoming embroiled in the abolitionist controversy. Accordingly, he sent a message informing Divinity School faculty and students that he was recommending to the corporation a law "prohibiting members of any Society in the University from inviting strangers to attend and speak at their meetings"(118).[45] Quincy's move only strengthened the students' resolve. Without a single dissenting vote they declared themselves "strongly opposed to any measures which shall tend to any abolishment of our customs, restraint of our privileges, or infraction of our Constitution." Another resolution explicitly condemning the proposed university law also passed, by a vote of eight to four.[46]

A few nights after their rebellious declarations, the Philanthropic Society members convened to vote on the thirteen antislavery resolutions attached to the report. For two nights, they debated and voted on the propositions one by one. Several resolutions, including one endorsing immediate emancipation, passed unanimously. Even radical "higher law" resolutions passed, some by a single vote. One of these resolutions declared all civil laws recognizing slavery "are null and void before God, and ought to be broken"(119). Of the students' thirteen abolitionist resolutions, the only one to fail, by a vote of seven to four, was a recommendation to join forces with William Lloyd Garrison. Harvard Divinity

Gary L. Collison

students could defy the faculty, the college, and the federal government, but they were too deeply saturated with Unitarian elitism to allow themselves to be led by an uncouth outsider like Garrison.

The attitudes that led to these abolitionist resolutions and defiant proclamations appeared in the religious and social views of the students as well. A May 1838 report by William Dexter Wilson, one of three signers of the invitation to Emerson, declared religion and philosophy nearly in harmony. If everyone were permitted "to believe what his Reason, Nature and the Bible seem to him to teach concerning God and Religion," Wilson declared sanguinely, ". . . a great cause of infidelity will be removed among us"(113–114). Though one of Wilson's classmates complained that the resolutions were vague, unintelligible, and even ungrammatical, most students apparently shared Wilson's enthusiasm for the new currents of transcendentalized Christianity.[47] The Harvard witticism of that year was that Wilson's Divinity School class consisted entirely of mystics, skeptics, and dyspeptics.[48]

Discussions of other social questions in the late 1830s were less revealing, in part because abolition monopolized so much of the Philanthropic Society's attention that there was little room for other issues. In a debate on the peace question, however, the students of 1839 showed further radical tendencies by opposing all war, offensive and defensive, and nearly approving absolute nonresistance.[49]

By 1840 Henry Wadsworth Longfellow, then a professor of romance languages at Harvard, was defending the university against a fresh allegation of "pantheism" at Cambridge. "This is too gross," Longfellow protested. "Why, there is in all Cambridge only one Transcendentalist,— and he a tutor! In the Theological School there is none of it; the infected class is gone."[50] In this assertion of Longfellow's there is much truth. Never again did an entire graduating class fall victim to an epidemic of mysticism, skepticism, and indigestion. But in suggesting that the Harvard Divinity School of 1840 was entirely free of transcendental and other radical *isms* Longfellow could not have been more wrong. Divinity Hall had been thoroughly contaminated. Every class after 1838 had its victims, and what is more, the 1840s and 1850s brought renewed epidemics. Already at least two Emerson disciples (Rufus Ellis and George Lippett of the class of 1841) were carriers of the disease at the school.[51] The tutor that Longfellow dismissed so easily was the brilliant young

scholar Charles Stearns Wheeler, Emerson's valuable assistant in preparing the American editions of Carlyle. Wheeler visited his close friends in Divinity Hall, and for three or four years he was an important Cambridge source of Transcendentalist infection until he left for Germany in 1842.[52] Conservatism did reappear among the student body in the next two decades, but the record suggests that various strains of liberalism and radicalism had a continuous influence among the students and that the strong social and religious conservatism of the early 1830s rarely held sway again at Divinity Hall.

Philanthropic Society minutes through the 1840s show that abolitionism had taken up permanent residence at Divinity Hall. Students in 1842 passed strong abolitionist resolutions, and in 1844 Professor Francis, who himself advised each student to "go forth into the ministry prepared to set his face as a flint against this terrible iniquity," testified that "almost all the School thought and felt strongly as antislavery men."[53] In 1847 a strongly abolitionist report declared that "the duty of every slaveholding community [was] to renounce at once the whole system of bondage, and to endeavour to elevate the condition of its slaves, after, and not before, it has restored them to their rights as freeman"(208). At the end of the decade members of the Philanthropic Society voted to invite controversial English abolitionist George Thompson to their meeting. Thompson's first visit to America in the 1830s had provoked the famous anti-abolitionist riot of Boston's "gentlemen of property and standing" that had nearly resulted in William Lloyd Garrison's lynching. On Thompson's return in 1850, demonstrations and riots erupted in Boston and Springfield. Fearing a further backlash against the much weakened Divinity School, the faculty refused to sanction the invitation. This time the students bowed to the faculty (who now had university policy on their side), but not without getting in the last word. A resolution was offered stating that "the labors of George Thompson . . . are entitled to our respect and gratitude." Just in case the faculty missed the point, the students added: "and we condemn the persecution to which he has been subjected on account of his opinions"(225). The resolution passed by a vote of eight to two. As if symbolizing the revolution taking place within Unitarianism, many family names that once stood for social and religious conservatism appear among the eight defiant "yeas": a Young (Edward James), a Pierce (James), a Ware (Loammi Goodenow), and a Frothingham (Octavius Brooks).

Gary L. Collison

The 1840s saw a continued presence of the liberal theological views of the late 1830s, although the majority sometimes fell with the conservatives, sometimes with the liberals and radicals. After an 1843 address to the senior class by conservative minister Nathaniel L. Frothingham (the invitation itself hints that several seniors leaned to the conservative side), student historian Ephraim Nute recorded that Frothingham ably defended "what at this time is called 'the conservative principle,'" adding condescendingly that "many in our denomination" preferred "more movement, more knowledge and more fellowship and sympathy—the reform movements of the day."[54] Two years later, in the fall of 1845, a resolution to bar the word "infidel" from being applied to anyone (such as Parker or Emerson) who was "faithful to his *own highest light*"(186) was narrowly defeated. However, if Samuel Johnson, liberal author of the resolution, had not been absent, it might have passed.[55] The next year members narrowly defeated Thomas Wentworth Higginson's proposal in favor of defining as Christian anyone who accepted the phrase, "love to God and love to man." This phrase was practically Theodore Parker's motto, and a majority of the divinity students, as a majority of their elders, balked at the abandonment of Christ and the Bible implied in the wording. One student even countered Higginson's resolution with a proposal to limit the name "Christian" to those who accepted Jesus "as an infallible teacher in matters of religious faith and practice"(199). How many agreed with this conservative resolution is impossible to determine, for in the middle of the debate members approved a measure to forbid voting on resolutions "unless by special order of the Society"(198).

Social reforms continued to attract adherents among the divinity students of the 1840s, despite O. B. Frothingham's recollection that Brook Farm and other such movements went unheeded while he was there (Frothingham may have meant only that they went unheeded in the classroom).[56] A report of 1843 greeted social experimentation enthusiastically as "part of God's plan to remove evils of existing society"(142). While debate revealed that not all of the students saw the divine stamp of approval on Bronson Alcott's Fruitlands and similarly eccentric experiments, the resolution passed. In 1845, the social utopian platform of Fourierism, which had just replaced Transcendentalism as the guiding philosophy at Brook Farm, proved too rigidly prescriptive for the students' tastes, as it had even for Unitarian radicals like Theodore Parker.

In criticizing the Fourierist prescriptions, the students revealingly fell back on old arguments against social change. "The source of sin being in ourselves," their resolution read, social experimentation gave "no reason to suppose that any essential diminution of social evils would result"(185).

In 1847, barely two years after the condemnation of Fourierism, the Philanthropic Society was considering anti-capitalist resolutions in almost every way as radical as Fourierism. Every "member of the human family," the report proclaimed, had certain "positive" social rights not recognized by existing governments, which recognized only political, or "negative," rights. The true Christian nation, according to the report, would guarantee four "positive" rights. First, it would assure each person a "minimum supply" of food, clothing, and shelter. Second, it would fulfill the right of education by providing each child and adult the means necessary for full intellectual development. Third, the Christian nation would recognize a "Right to Labor," whereby everyone would be guaranteed employment fitted to his or her individual abilities, and, moreover, this employment would be designed to avoid the "too prevalent character of monotony, slavish drudgery, and physical exhaustion." Fourth, this utopian Christian society would recognize the right of workers to "a just share of the proceeds of industry." Moreover, every person in this ideal society would be entitled to a fair share of the society's wealth in the form of land or an equivalent value of money or goods. Again in 1849, a report argued for "a thorough reform . . . [in which] the social distinctions which now exist between man and man be greatly modified, or entirely removed," and urged ministers to "take a leading part in this Reform."[57] Resolutions justifying social stratification were substituted during debate, however. "Distinctions in society are necessary from the nature of man," the substitute resolutions proclaimed, "and ought to be sanctified by . . . Christian sympathy"(223). As only the substitute resolutions are recorded in the official minutes, it appears that conservative impulses had prevailed.

In the 1848–1849 school year, Harvard Divinity School enrollment again dipped dramatically, and the Philanthropic Society teetered on the verge of collapse. Only one meeting was held, and it was a business meeting. During the next two years interest in the society seemed to be reviving. Five meetings were held in the 1849–1850 sessions, and eight the next year. But when the Philanthropic Society adjourned its meeting of March 14, 1851, it proved to be for the last time.

Gary L. Collison

Two years after the demise of the Philanthropic Society, a new organization, now called simply a Debating Society, arose to take its place. Minutes of this new organization, however, are neither as thorough nor as revealing as those of the Philanthropic Society.[58] Debates are no longer summarized and resolutions are no longer recorded. The minutes merely give the week's question and, rarely, the final vote. Even where, occasionally, the minutes report who spoke for or against a proposition, we cannot know whether students adopted their positions merely for the sake of argument. Nevertheless, the Debating Society minutes of seventy-seven meetings between 1853 and 1859 contain hints that students continued to be strongly interested in social and religious reforms. In fact, the issue was not whether there should be reforms, but, as the topic for the eleventh meeting put it, "What is the best method of advocating reforms?" At the first discussion, September 16, 1853, members took up the controversial question of women's rights: "Should woman be admitted to equal civil and religious privileges with man?" At a meeting on March 23, 1854, all agreed that the Nebraska bill justified dissolving the Union with the slaveholding states. But records of few other meetings provide such clear indications of student interest in reforms. More typical than women's rights or the Nebraska bill were topics such as "Does man originate sin?" (October 7, 1853) and "Is the Puritan influence on the New England character good?" (November 23, 1854).

Evidence from other sources helps to show that divinity students of the 1850s continued to entertain new points of view and to insist on the broadest possible freedom and toleration. In 1854, when the faculty rejected a topic proposed for Visitation Day exercises by one member of the senior class, three other seniors protested by requesting permission to choose subjects on their own. When the faculty denied their request, the three joined the first student in boycotting that year's ceremonies, leaving only two seniors to perform.[59] A similar incident occurred in 1857, when the seniors voted to invite Theodore Parker to deliver the "customary address" to their class. Probably remembering the uproar over Emerson's uncustomary address before the seniors almost twenty years before, the faculty refused to sanction the students' choice. Although the seniors obediently withdrew their invitation, they protested the decision by publishing their correspondence with the faculty and refusing to name a substitute for Parker.[60]

Of all the possible examples of independence and toleration among the Harvard Divinity School students in the thirty years before the Civil

War, perhaps one that does not involve any confrontation or rebellion captures most fully the spirit of the Divinity School students. In 1847 the issue of religious radicalism appeared indirectly when the seniors discussed whom to invite to deliver the customary address before the senior class. One group argued for Samuel J. May, the Garrisonian Unitarian minister and friend of Theodore Parker. May shortly received a letter informing him (in what must be one of the most candid speaking invitations on record), "You have been elected on the 11th ballot by a vote of 7 to 6." The invitation went on to reassure May that the divided vote was not important: "the division was entirely on theological grounds, no opposition being made to you personally. You were chosen to represent the theological movement known as transcendentalism, and the six who in every instance supported the opposition movement voted for a candidate conservative so far as regards his theological views."[61] The invitation reveals that the students accepted their wide differences over theology with tolerant good humor and expected May to do the same. Apparently he did, for he delivered that year's address.

The Harvard Divinity School faculty deserves much credit for encouraging the atmosphere of openness and toleration. It is true that it refused to allow unrestricted freedom in choosing exhibition topics or to permit several controversial figures including Theodore Parker and George Thompson to appear before the students.[62] But in the Parker and Thompson incidents as well as in the matter of the student dissertation, a public reaction was at stake, and there was a danger (perhaps exaggerated, but still a danger) that the Divinity School and Harvard College would be further damaged by an uproar like the one that followed Emerson's address. Except in those rare instances, the faculty apparently encouraged the students to explore unconventional topics freely. In 1853, without "prohibition or dissenting voice," Amos Bronson Alcott delivered a series of lectures at the Divinity School that he considered "an entering wedge quite successful and triumphant," and in 1854 James Freeman Clarke gave lectures on comparative religion.[63] The faculty defended the school against persistent pressures from certain parts of the denomination for a more conservative theology. "I remember very well," one Unitarian liberal recalled fondly, "what splendid indignation Dr. Noyes rained upon the suggestion of Dr. George B. Emerson, that students receiving beneficiary funds should agree to preach a supernatural theology or none at all."[64]

While the faculty of the three decades before the Civil War helped cre-

Gary L. Collison

ate a tolerant, progressive atmosphere, the students were the ones who continually used the opportunity to enlarge Unitarian boundaries. At Divinity Hall they mingled supernaturalist theology with Transcendentalism and Parkerism, social and economic elitism with democratic sympathies and social utopianism. As a result of this often vigorous dialogue, antebellum divinity students inevitably developed a conception of Unitarianism at once more flexible and more open than was possible for many of the ministers of Andrews Norton's generation to entertain. Experiences of Harvard Divinity School students thus paved the way for the broad church pluralism of post–Civil War Unitarianism.[65]

Stating exactly what impact the Harvard Divinity School experience had on the denomination is impossible, partly because the direction of the divinity students after they entered the ministry was unpredictable. For some like Rufus Ellis, who while a student was one of the most Emersonian, pastoral life produced a dramatic about-face. After assuming, in 1850, the ministry of the conservative, wealthy First Church of Boston, Ellis rapidly became one of Unitarianism's conservative spokesmen. Others like George Ripley and Thomas Wentworth Higginson grew increasingly radical once in the pulpit and found themselves increasingly in conflict with conservative factions in their congregations. Some, like Theodore Parker, grew more and more radical without apparently encountering any opposition from their congregations. If it is difficult to generalize about even the group of best-known students, it is virtually impossible even to make guesses about the careers of the nearly two hundred new ministers about whom almost nothing is known. To generalize at all would require studying the careers of a substantial sample of the two hundred Harvard Divinity School students who entered the ministry between the Transcendentalist revolt in the 1830s and the Free Religion movement in the 1860s.

Yet no matter what the later social, political, or theological transformations of the ministers educated at the Harvard Divinity School were, clearly the group of two hundred new ministers helped infuse the denomination with both radicalism and toleration for radicalism.[66] By 1860, Moncure Conway counted twenty-five "left wing" Unitarian pulpits (by "left" Conway apparently meant both theologically and politically left), as against one, Theodore Parker's, in 1845.[67] Although Conway observed that Harvard Divinity School seniors with conventional religious and social ideas had their pick of vacant pulpits while the radical

students were left hanging around the American Unitarian Association rooms waiting for a single invitation, he noted that the twenty-five established radicals "are nearly all settled over large and worthy congregations." Where was the cry against these twenty-five men that had risen against Emerson or Parker? What sermons on "The Personality of the Deity" were directed against these new voices, as the sermon of Professor Ware, Jr., had answered Emerson's pantheistical 1838 address?

The answer is that opposing voices—often the same voices that had opposed Emerson and Parker—were still heard in the 1850s, but they were growing weaker. Even well after the Civil War, advocates of an exclusive Unitarianism of supernatural theology continued to be heard. When the National Conference of Unitarian Churches was formed in the mid-1860s, conservatives had their way in the battle over naming the organization and including references to Christ in the preamble, leaving the radical minority to withdraw into their own "spiritual antislavery society," as founder William James Potter, Divinity School class of 1857, called the Free Religious Association.[68] However, the conservative victory at the National Conference was merely temporary, the result of a conciliatory gesture by the *moderate* majority.[69] Although two decades would be needed before the Free Religionists finally felt welcome in the National Conference, their eventual reconciliation was already foregone in 1867. Even in 1855, when Frederick Henry Hedge wrote of "our mission . . . to maintain a true toleration . . . by a generous abandonment, on our part, of all doctrinal defenses and theological ramparts,"[70] he was writing of a largely accomplished fact.

The vitality, independence, and "true toleration" of Harvard Divinity School students helped extend Unitarian boundaries and guarantee the "generous abandonment" called for by Hedge. Emerson himself appears to have acknowledged this when, visiting Divinity Hall in the spring of 1838, he found an enlightened spirit among the residents. Having gone "rather heavy-hearted" to meet a band of them in Robert Cassie Waterston's room, Emerson returned to Concord cheered by their views and enthusiasm. Two weeks later a visit from a divinity student of the class of 1839 left him even more sanguine. After the student had gone, Emerson wrote happily in his journal of "aspiring and heroical young men," and added enthusiastically, "*I begin to conceive hopes of the Republic.*"[71] The Divinity School Students of the 1830s through the 1850s hardly saved the republic. But, as Emerson seemed to recognize in his stirring 1838

Gary L. Collison

address, their vitality, their diversity, and their spirit of broad toleration were already forging the new, inclusive Unitarianism.

Notes

1. Two essays, Conrad Wright's "The Early Period (1811–40)" and Sydney Ahlstrom's "The Middle Period (1840–80)," in George Huntston Williams, ed., *The Harvard Divinity School: Its Place in Harvard University and in American Culture* (Boston, 1954), 21–147, provide thorough coverage of many aspects of the Divinity School. However, neither essayist focuses directly on the experiences of the students in this period. Moreover, the choice of 1840 as a dividing line tends to dilute the analysis. Ahlstrom pays much less attention to the 1840s and most of the 1850s than to the post–Civil War period. Willard L. Sperry's brief essay, "'A Beautiful Enmity': The Student History in the Nineteenth Century," in the same volume, 148–164, is based largely on the two-volume manuscript "Records of the Theological School" in the Harvard University Archives. Despite the official-sounding title, the work is entirely a student production and hence is commonly called the "Student History." By ignoring other sources and attempting to cover the entire nineteenth century, Sperry inadvertently fragmented and trivialized the experiences of the divinity students.

2. *Journals and Miscellaneous Notebooks of Ralph Waldo Emerson*, ed. William H. Gilman et al. (Cambridge, Mass., 1960–1982), 5:471 [hereinafter cited as Emerson, *Journals and Notebooks*]. Bliss Perry's selection, *The Heart of Emerson's Journals* (Boston, 1926), made nearly all of Emerson's bitterest remarks about the Harvard Divinity School available for generations of readers. For a recent example of the persistent influence of Emerson's negative characterization, see Roger C. Mueller's remarks on the Divinity School in his "Samuel Johnson, American Transcendentalist: A Short Biography," *Essex Institute Historical Collections* 115:17, 21 (1979).

3. Emerson, *Journals and Notebooks*, 5:58.

4. Parker to Edmund Senkler, May 6, 1858, in John Weiss, *The Life and Correspondence of Theodore Parker* (New York, 1864), 1:369.

5. Theodore Parker to Samuel J. May, Oct. 24, 1853, in Weiss, *Theodore Parker*, 1:322.

6. The "hard speeches" against students and professors at one alumni meeting (John Langdon Sibley, entry for July 16, 1849, ms. journal for 1846–1865, p. 214, Harvard University Archives) suggest widespread dissatisfaction toward the end of the 1840s.

7. Edward Everett Hale, Jr., *The Life and Letters of Edward Everett Hale* (Boston, 1917), 1:125–126.

8. J. G. Palfrey, quoted in Frank Otto Gatell, *John Gorham Palfrey and the New England Conscience* (Cambridge, Mass., 1963), 77.

9. Andrews Norton to H. J. Huidekoper, Aug. 27, 1840, Harvard University Archives.

10. *Catalogue of the Officers and Students of the Boston School for the Ministry (Unitarian) for the Year 1868–9* (n.p., n.d.), [3].

11. "The Divinity School Address," in *Three Prophets of Religious Liberalism: Channing, Emerson, Parker*, ed. Conrad Wright (Boston, 1961), 90.

12. The quotation is from Josiah Quincy's summary (ca. 1845) of the "systematic calumnies" against the university, quoted in Samuel Eliot Morison, *Three Centuries of Harvard, 1636–1936* (Cambridge, Mass., 1936), 258.

13. Quoted in Gatell, *John Gorham Palfrey*, 77.

14. Palfrey, quoted in Gatell, *John Gorham Palfrey*, 68.

15. There is a brief summary of the separation debate in Ahlstrom, "Middle Period," 100–101, and a more extensive discussion in Ronald Story, *The Forging of an Aristocracy: Harvard and the Boston Upper Class, 1800–1870* (Middletown, Conn., 1980), 136ff.

16. Arthur B. Ellis, *Memoir of Rufus Ellis, Including Selections from his Letters and Journals* (Boston, 1891), 31.

17. Convers Francis, "Report to Visiting Committee," Oct. 25, 1845, May 4, 1847, Overseers Reports 7:196–197, 368–369, Harvard University Archives; Ahlstrom, "Middle Period," 91, 104–108.

18. Henry Ware, Jr., to Josiah Quincy, Feb.[?] 1842, Harvard University Archives.

19. Ahlstrom, "Middle Period," 109–112.

20. Andrew P. Peabody, *Harvard Reminiscences* (Boston, 1888), 109.

21. Theodore Parker, Journal, 1838–1841, Andover-Harvard Theological Library, Harvard Divinity School, 180; Elizabeth Lee Follen, *Life of Charles Follen*, vol. 1 of *The Works of Charles Follen* (Boston, 1841–1842), 1:504.

22. Peabody, *Harvard Reminiscences*, 130, 131.

23. Charles Lowe, diary entry for Nov. 7, 1849, quoted in Martha Perry Lowe, *Memoir of Charles Lowe* (Boston, 1884), 63.

24. Samuel Johnson was rebuked in 1843, for example, when he seemed to be arguing that selfishness was sometimes justified (Mueller, "Samuel Johnson," 20–21) ; Ahlstrom, "Middle Period," 105–109.

25. For example, when Rufus Ellis was a candidate for the prestigious First Church ministry, the former minister, N. L. Frothingham, wrote to him: "I acknowledge that this [antislavery] would be an unwelcome theme to my old Society, and that the *agitation* of it would be dangerous to our harmony. But I am of the opinion that you would not feel called upon to stir discussion upon subjects of this nature, with the whole field of Christian truth inviting your planting and pruning hand" (N.L.F. to R.E., Jan. 25, 1853, in Ellis, *Memoir of Rufus Ellis*, 112–113.) Ellis took the pulpit and obeyed the warning.

26. The evolution of Channing's antislavery stand is conveniently traced in Douglas Stange, *Patterns of Antislavery among American Unitarians, 1831–1860* (Rutherford, N.J., 1977), 147–149.

27. A scattering of letters along with one diary or notebook of T. W. Higginson (1847) and Charles Dall (1840) are held by the Harvard University Archives; the Andover-Harvard Theological Library holds some additional letters and notes.

28. For example, Theodore Parker, who was much influenced by higher criticism while still a student at the Divinity School, waited several years before feeling confident enough to present his critical views of the Bible to his congregation (Weiss, *Theodore Parker*, 1:102).

Gary L. Collison

29. As all but a few divinity students belonged to the Philanthropic Society (and those few students may have participated nonetheless, despite not signing the constitution), I have used the terms *students* and *members* interchangeably throughout the discussion.

30. Henry Ware, Jr., to Lant Carpenter, Nov. 12, 1831, quoted in John Ware, *Memoir of the Life of Henry Ware, Jr.* (Boston, 1846), 325.

31. *The Diary of George Moore, Friend of Emerson*, publ. as vol. 1 of Kenneth Walter Cameron, ed., *Transcendental Epilogue: Primary Materials for Research in Emerson, Thoreau, Literary New England, the Influence of German Theology, and Higher Biblical Criticism* (Hartford, 1965), 1:194.

32. "Records of the Philanthropic Society in The Theological School of Harvard University," Harvard University Archives, 1. Hereinafter, page numbers to this manuscript are given parenthetically in the text.

33. Ware to Carpenter, Nov. 12, 1831, Ware, *Life of Henry Ware*, 325.

34. Quoted in Octavius Brooks Frothingham, *Memoir of William Henry Channing* (Boston, 1886), 85.

35. Later Clarke forgot, or blotted out, the memory of his early Philanthropic Society report (James Freeman Clarke, *Autobiography, Diary, and Correspondence*, ed. E. E. Hale [Boston, 1891], 213–214). He eventually became one of the most outspoken advocates of equal rights for blacks. His "Condition of the Free Colored People of the United States," *Christian Examiner*, 5th. ser., 66 (1859), 246–265, pleads eloquently against racial prejudice in the North.

36. Conrad Wright, "The Minister as Reformer: Profiles of Unitarian Ministers in the Antislavery Reform," in his *Liberal Christians: Essays on American Unitarian History* (Boston, 1970), 65, 132n.

37. Daniel Walker Howe, *The Unitarian Conscience: Harvard Moral Philosophy, 1805–1861* (Cambridge, Mass., 1970), 239. Howe's illuminating discussion of Unitarian philanthropy, especially his chapter, "Problems of Moral Leadership" (236–269), has provided much of the background for this and the following paragraphs on the philanthropic aims of the divinity students.

38. *Diary of George Moore*, 138.

39. Stange, *Patterns of Antislavery*, 47–48, 51–53.

40. Ibid., 84–87.

41. In later life Morison argued—I think unconvincingly—that he had only *seemed* conservative to his classmates because he had not been "satisfied with the superficial measures that were suggested by the most zealous reformers" (quoted in [Mary Morison, George S. Morison, and Robert S. Morison,] *John Hopkins Morison: A Memoir* [Boston, 1897], 64).

42. For the Kneeland case, see Leonard W. Levy, ed., *Blasphemy in Massachusetts, Freedom of Conscience, and the Abner Kneeland Case: A Documentary Record* (New York, 1973); Roderick S. French, "Liberation from Man and God in Boston: Abner Kneeland's Free-Thought Campaign 1830–1839," *American Quarterly* 32:202–221 (1980); and Robert E. Burkholder, "Emerson, Kneeland, and the Divinity School Address," *American Literature* 58:1–14 (1986).

43. "Report on German Theology . . . ," in Cameron, ed., *Transcendental Epilogue*, 2:706. Although two students had been assigned with Parker to report on the topic, the manuscript (Harvard University Archives) is in Parker's hand and seems to have been entirely his work.

44. *Diary of George Moore*, 221.

45. At a meeting on July 21, the Harvard Corporation passed the following: "Resolved, that no person, not a member of the University, shall be permitted to teach, lecture, or preach, or deliver any oration or discourse in any of the schools belonging to the University, or in any Society connected with either of them, without a previous vote of the Faculty of such school" (quoted in the "Minutes of the Divinity Faculty," Dec. 25, 1850, Harvard University Archives).

46. The conflict is discussed briefly in Richard D. Hathaway, *Sylvester Judd's New England* (University Park, Pa., 1981), 257–258. See also "Student History," entry for May 25, 1838, Harvard University Archives. Stange, *Patterns of Antislavery*, 91, suggests that Emerson was part of the cause of the new restrictions. Although Emerson had been invited in a letter of Mar. 21, it must be remembered that he was still very much in favor at Harvard until sometime after the Divinity School Address, having acquitted himself handsomely in his Phi Beta Kappa address of the previous year. The Divinity School controversy certainly may have had a role in the corporation's vote, but it appears likely that they would have passed the measure even if Emerson had never uttered a word.

47. No vote was recorded, but George Simmons's insistence on having his objections stated in the minutes suggests that he stood alone or nearly alone in opposition to Wilson's report.

48. The seven members of the class of 1838 were Benjamin Barrett, Harrison Gray Otis Blake, Theodore Haskell Dorr, Crawford Nightingale, George Frederick Simmons, Frederick Augustus Whitney, and William Dexter Wilson. Of these, Barrett, an incipient Swedenborgian, and Blake, later a close friend of Thoreau, probably were the mystics of the remark.

49. Judd to A.H., June 29, 1839, in [Arethusa Hall], *The Life and Character of the Rev. Sylvester Judd* (Boston, 1854), 155.

50. Longfellow to Samuel Ward, Dec. 1, 1840, *The Letters of Henry Wadsworth Longfellow*, ed. Andrew Hilen (Cambridge, Mass., 1966), 2:268.

51. Ellis, *Memoir of Rufus Ellis*, 285.

52. John Olin Eidson, *Charles Stearns Wheeler: Friend of Emerson* (Athens, Ga., 1951), 24–46; Joel Myerson, "Charles Stearns Wheeler," in his *New England Transcendentalists and the Dial: A History of the Magazine and its Contributors* (Rutherford, N.J., 1980), 219–223.

53. Guy Woodall, ed., "The Journals of Convers Francis," *Studies in the American Renaissance, 1982* (Boston, 1982), 258.

54. "Student History," 1:138.

55. Joseph May, *Samuel Longfellow: Memoir and Letters* (Boston, 1894), 58.

56. Octavius Brooks Frothingham, *Recollections and Impressions, 1822–1890* (New York, 1891), 30.

57. Philanthropic Society minutes, [Nov. 1850], loose sheets, Harvard University Archives.

58. "Records of the Divinity School Debating Society," Harvard University Archives. Interest in the organization fell off dramatically after the first two years, though it somehow managed to survive until Nov. 4, 1859, when the final meeting was held. In the fall of 1863 an attempt was made to revive the Debating Society, but apparently only two meetings were held.

Gary L. Collison

59. "Minutes of the Divinity School Faculty," June 14, July 9, 1854, where the decision appears signed by George Noyes, Convers Francis, and James Walker. At the former meeting the faculty, including Walker, passed a resolution stating that any dissertation could be rejected "in whole or in part, if deemed inappropriate to the occasion and on any account unsuitable to be delivered in the Chapel of our Institution." A note dated July 20 reports that the annual meeting of the Harvard Divinity School alumni discussed the faculty's actions and gave their approval. One puzzling aspect of the whole affair is that the faculty would seem to have rejected J. H. Fowler's "Use of Liturgies in Public Worship," which from its title sounds entirely harmless. By comparison, one of the protestors, Richard Metcalf, had planned to give "Interests of Faith as Affected by Historical Criticism and Scientific Research" ("Student History," 1:232).

60. "Student History," 1:252ff.

61. Ibid., 1:158.

62. In addition to the Thompson and Parker denials, the faculty refused to grant an 1845 student request to hear Polish-born linguist and revolutionary Charles Kraitsir ("Student History," 1:142).

63. Abby Alcott to "Dear Brother" [S. J. May], Mar. 18, 1853, Houghton Library, Harvard University; Ahlstrom, "Middle Period," 113.

64. "The Harvard Divinity School," unsigned article ca. 1864, Harvard University Archives.

65. One explanation for the readiness of antebellum divinity students to reach out to the new reforms, aside from the obvious fact of their youth, may be their increasingly diverse backgrounds. Originally, almost all the students at the Divinity School had held undergraduate degrees from Harvard, but by the 1830s, as Conrad Wright has noted, fewer and fewer of them simply moved from Harvard Yard to Divinity Hall. In the 1820s, 85% of students who completed the program held Harvard undergraduate degrees. In the 1830s the figure was just 60%. Then in the 1840s the percentage of Harvard graduates fell to 51%, and then to 42% in the 1850s. Undoubtedly this influx of non–Harvard-educated men into the Divinity School and Unitarian pulpits helped to erode elitist tendencies within Unitarianism.

66. All together 243 students completed the Divinity School program from 1830 to 1859, but not all of them entered the ministry.

67. Moncure Conway, "The Nemesis of Unitarianism," *The Dial* (Cinn.) 1:363 (1860).

68. Quoted in Stow Persons, *Free Religion: An American Faith* (Boston, 1963), 42.

69. Conrad Wright, "Henry W. Bellows and the Organization of the National Conference," in his *Liberal Christians*, 102–103.

70. "The Unitarian Denomination,—its Advantages and Mission," *Quarterly Journal of the American Unitarian Association* 3:2 (1855).

71. Emerson, *Journals and Notebooks*, 5:475 (emphasis added).

Appendices

Illustrations by Christopher P. Cranch of passages from
Ralph Waldo Emerson's *Nature*. Christopher Pearse Cranch
Papers, Massachusetts Historical Society.

Materials at the Massachusetts Historical Society for the Study of Unitarian History

PETER DRUMMEY

The library of the Massachusetts Historical Society is primarily a manuscript repository. The Society's 3,500 collections of personal papers and manuscript records of organizations are supported by a range of published and pictorial historical material. It is not possible to list here all of the Society's manuscript collections that pertain to Unitarian history. Moreover, a simple enumeration of the collections of Unitarian figures would be misleading because for many individuals surviving manuscripts are to be found within several holdings. Nevertheless, brief mention of some of the larger, more important collections of papers of Unitarians, both clergy and laity, and notice of the Society's holdings of institutional records will indicate the extent of its resources for the history of the denomination.

For the Arminian period, the correspondence of Jeremy Belknap, the principal founder of the Historical Society, and the historical manuscripts* he gathered form the largest collection. Belknap, originally orthodox in his theology, held the pulpit of the Church in Long Lane (later

Peter Drummey is Stephen T. Riley Librarian, Massachusetts Historical Society.

the Federal Street Church and now the Arlington Street Church) from 1787 until his death in 1798.[1]

Also for the Arminian period there are sermons of Amos Adams of Roxbury in the Baxter-Adams Papers; seventy-five sermons by David Barnes of Norwell; scattered correspondence of William Bentley of Salem; correspondence of Charles Chauncy of the First Church in Boston in several collections; letters of John Clarke, Chauncy's colleague at the First Church, in the Timothy Pickering Papers*; and letters in the Benjamin Colman Papers* from many liberal ministers. The Andrews-Eliot Collection contains the writings of Andrew Eliot of the New North Church of Boston and his son and successor John, another founder of the Historical Society.[2] Correspondence of William Emerson of the First Church in Boston, father of Ralph Waldo Emerson and an active member of the Historical Society, is in various locations.

Ebenezer Gay is represented by a volume of Hingham First Church Records* covering the years of his pastorate. There is material concerning Timothy Hilliard's settlement as minister of the First Church in Cambridge in the Wendell Papers; scattered correspondence of Simeon Howard of West Church in Boston is in a number of collections; and many of the surviving letters of Jonathan Mayhew, Howard's predecessor at West Church, are in the Thomas Hollis Papers.[3] "Memoirs and Memorabilia" by John Pierce of Brookline records Harvard commencements from 1803 through 1849, 1,800 Thursday Lectures in Boston, and 141 ordinations or installations that Pierce attended. There are also documents in the Nathan Stone Papers concerning the dismissals of Samuel Osborne of Eastham and other early Arminian ministers. A collection of notes by Joseph Thaxter of Edgartown on the religious history of Martha's Vineyard recounts the course of a revival on that island in 1809–1810.

No member of the first generation of avowed Unitarian ministers was held in greater respect by his contemporaries than William Ellery Channing of the Federal Street Church in Boston, nor did any member of this generation do more to shape Unitarian thought than he did. Fire consumed most of Channing's manuscripts, but surviving correspondence of his in several collections at the Society forms the largest holding of his papers in any repository.*

The first generation of Unitarian ministers is also represented by a collection of letters written to Joseph Allen of Northborough by his Har-

Peter Drummey

vard classmates, many of whom were fellow clergymen; a biographical memoir that Convers Francis of Watertown and Harvard Divinity School wrote of his father-in-law, John Allyn of Duxbury; a notebook that John Andrew of Newburyport kept regarding the Unitarian controversy in Newbury and his own preaching; and, in the Pemberton Collection, a list of sermons by Joseph Stevens Buckminster of Brattle Street Church in Boston.

Other collections include a small amount of material in the Perry-Clarke Collection on James Freeman of King's Chapel in Boston; a box of papers of Thaddeus Mason Harris of Dorchester; and sermons by Samuel Kendall of Weston. There are sermons, accounts, and commonplace books of John Lathrop of the Second Church in Boston; a diary of preaching that Thomas Prentiss of Charlestown kept; sermons preached by Thomas Thacher of Dedham both in the Thacher Papers and in the Frederick L. Gay Transcripts; and diaries, letters, sermons, and miscellaneous manuscripts by Joseph Tuckerman of Chelsea and Boston, the founder of the ministry-at-large to the poor of Boston, in three small collections bearing his name. The Allen-Ware Family Papers contain manuscripts of Henry Ware of Hingham, whose appointment as Hollis Professor of Divinity at Harvard was the occasion of the first open hostilities of the Unitarian controversy. There is also a manuscript "Course of Reading for a Student of Divinity" by Ware as well as his records as minister in the Hingham First Church collection.* Interleaved almanacs contain diaries kept by Samuel West of Boston.

Manuscripts of orthodox ministers also illuminate the history of Unitarianism for this period. For example, the papers of Jedidiah Morse of Charlestown reveal him trying to goad liberal ministers into making clear statements of their beliefs. More famous is Morse's correspondence with John Adams on the early history of Unitarianism in Massachusetts. On the other hand, the papers of Abiel Holmes, who served as minister of the First Church in Cambridge for thirty-seven years and as corresponding secretary of the Historical Society for twenty, do not reflect the bitter controversy that led him, a conservative, to withdraw from that congregation and later accept a call to serve as the first minister of the Shepard Congregational Society.

Two very large holdings, the Perry-Clarke Collection and the papers of Henry W. Bellows, are particularly important for the study of Unitarianism in the mid-nineteenth century. While the Perry-Clarke Collection

includes some papers of James Freeman, it is, for the most part, made up of a substantial number of the personal and professional papers of James Freeman Clarke, the reformer, editor of the Transcendentalist periodical the *Western Messenger*, and minister in Louisville and Boston. In recent years the Society has received important additions to the Perry-Clarke Collection, including Clarke's correspondence with Margaret Fuller and manuscript poetry and writings by Fuller. The papers of Henry W. Bellows,* 104 boxes and volumes, recount the life of the minister of the First Unitarian Church in New York City, best known for his administrative contributions both during the Civil War as originator, founder, and president of the United States Sanitary Commission and after the war as the moving force behind the establishment of the National Conference of Unitarian Churches.

The Society also holds the journal and correspondence of Joseph Henry Allen of Jamaica Plain, Washington, and Bangor before he left the active ministry in 1857; five volumes of sermon records and memorandum books by Cyrus Bartol of West Church in Boston; papers of Charles Brooks of Hingham in the Jonathan Brooks Family Papers; and letters in the Bulfinch Family Papers of Stephen Greenleaf Bulfinch of Washington, D.C., and other churches. Records of marriages that Henry Colman of Dedham and Salem performed are in the Andrew Family Papers. The career of Charles H. A. Dall, missionary to India for thirty-one years, is documented in the extensive papers of his wife, Caroline Healey Dall,* the social reformer and critic.

Also, there are manuscript ministerial records kept by David Damon for his church in West Cambridge (now Arlington); extensive scattered correspondence of Orville Dewey of Boston, New Bedford, and New York City; and two small collections of manuscripts relating to Charles T. C. Follen of Harvard University and East Lexington. There are Henry Wilder Foote papers in the records of King's Chapel (on deposit) and in the Foote family correspondence, which is part of the Merriam Family Papers. There is Convers Francis correspondence in the Theodore Parker Papers.* There are also miscellaneous manuscripts pertaining to Octavius Brooks Frothingham of Salem, Jersey City, and New York City. The Ezra Stiles Gannett Papers* provide very important insight into the activities of this Boston minister, who was Channing's colleague at the Federal Street Church and the first secretary of the American Unitarian Association. The Society also has scattered correspondence of Samuel

Peter Drummey

Gilman of Charleston, South Carolina; a small collection of the papers of Edward Everett Hale of Worcester and Boston; correspondence of Frederic Henry Hedge of West Cambridge, Bangor, Providence, and Brookline; letters of Thomas Starr King of Charlestown, Boston, and San Francisco in the Henry W. Bellows Papers*; manuscript records concerning the Civil War service on the United States Sanitary Commission of Frederick N. Knapp of the First Parish Church in Plymouth; and a collection (on deposit) of manuscripts of President John T. Kirkland of Harvard and Samuel K. Lothrop of the Fourth (Brattle Street) Church in Boston.

In addition, the Society has diaries by George Leonard of Marshfield; a small collection of the papers of Charles Lowell of West Church in Boston; papers of William P. Lunt of Quincy; two boxes of sermons by William H. Lyon of Brookline; and manuscripts of the two Samuel Mays—Samuel May (1810–1899) of Leicester, the secretary of the Massachusetts Anti-Slavery Society, and his more famous cousin, Samuel J. May of Brooklyn, Connecticut, South Scituate, and Syracuse, who was also active in the antislavery movement—along with the papers of Theodore Parker of West Roxbury and Boston,* eighteen volumes of diaries, commonplace books, transcribed letterbooks, and original correspondence.

Other collections include manuscripts of Francis Parkman of New North Church in Boston and correspondence with his son, the historian; Ephraim Peabody's writings in the Derby-Peabody Papers as well as his papers in the King's Chapel Records; and manuscript material relating to the twin brothers Oliver William Bourn Peabody of Burlington, Vermont, and William Bourn Oliver Peabody of Springfield in the Everett-Peabody Papers. For John Pierpont of the Hollis Street Church in Boston, Troy, New York, and West Medford the Society holds correspondence and an anti-tobacco poem. There are Chandler Robbins manuscripts in the Second Church in Boston Records as well as scattered letters in other collections, much of it relating to Historical Society matters. The Society also holds some correspondence of Horatio Stebbins of Fitchburg, Portland, and San Francisco; material on James Walker of Charlestown and Harvard University in the records of the *Christian Examiner* and in other collections; Henry Ware, Jr., manuscripts in the records of the Second Church of Boston; and correspondence of William Ware of New York City, Waltham, and West Cambridge in the Ware

Family Papers. The diaries and correspondence of John Weiss of Watertown and New Bedford are located in the Belcher, Jennison, and Weiss papers. Three boxes of manuscripts, relating for the most part to the Massachusetts Peace Society, contain the papers of Noah Worcester of Brighton. And the Society also holds a collection of the sermons of Alexander Young of New South Church in Boston, one of several ministers to serve as its corresponding secretary.

For the modern period there are extensive unprocessed papers of Edward Cummings of the South Congregational Society of Boston and the First Church in Boston, the father of the poet e. e. cummings; a small collection of papers of Samuel A. Eliot of the Arlington Street Church relating to his early career as a commissioner of Indian affairs; and twenty-three boxes of sermons by Paul Revere Frothingham of New Bedford and Arlington Street Church.

A number of collections exist for men who were ministers only briefly; other collections pertain to the nonclerical activities of men who served in the ministry for many years. The former include two boxes of papers of Christopher Cranch, who supplied pulpits between 1835 and 1842, and an enormous collection of the papers of Edward Everett,* who served the Brattle Street Church for a year. Of the latter, the papers of Henry H. Edes of Charlestown and those of George E. Ellis, also of Charlestown, are concerned primarily with antiquarian research, although some of this involves Unitarian history. George Ripley of Purchase Street Church in Boston and the Brook Farm Community and William Henry Channing, who served churches in New England, the midwest, New York, England, and Washington, had extended careers as ministers, but the small collection of Ripley Papers and the William H. Channing correspondence in the Channing Family Papers and elsewhere are concerned with other matters. Ralph Waldo Emerson's brief career as minister of the Second Church in Boston is described in the records of the church. There is much scattered correspondence for his later activities as a Transcendentalist lecturer and author. Thomas Wentworth Higginson of Newburyport and Worcester was an active minister for many years, but his scattered manuscripts pertain to his other careers—as a Transcendentalist writer, an abolitionist, and a social reformer. John G. Palfrey, minister, then dean of Harvard Divinity School, editor, and historian, appears in the papers of his son, John C. Palfrey. Scattered cor-

Peter Drummey

respondence of Charles W. Upham of Salem is concerned with his writings on history and social reform rather than Unitarianism. The papers of Jared Sparks are also in this category. The Society holds materials concerning Sparks's ordination as minister in Baltimore, the occasion for William Ellery Channing's sermon "Unitarian Christianity," but his own manuscripts include his historical writings and papers relating thereto. The Robert Cassie Waterston Library, collected by one of Joseph Tuckerman's successors as minister-at-large to the poor of Boston, is devoted largely to literature and history.

In addition to the personal papers of ministers, the Society owns or has on deposit the records of a number of Unitarian churches and organizations. Many institutional records antedate open adherence to Unitarian beliefs. The Archives of King's Chapel, 1686–1899, for example, deposited at the Society, document not only the first Unitarian church in America, but also, for the early period, the first Anglican church in New England.

The Society has a variety of records for the First Church in Boston and the Second Church in Boston, which merged in 1968. The Society owns copies of the early records of the First Church, and on deposit there are eighty-nine boxes and volumes, together with uncatalogued additions, of the records of the Second ("Old North") Church and Society. The archives of the Second Church include the only extant book of early records of the Federal Street Church and scattered records of two defunct churches that merged with the Second Church, the Seventh ("New Brick") Church and the Church of the Savior.

The Society also holds transcripts in the Lamb Papers of Federal Street Church records and sermons; copies of early records of the Eighth (Hollis Street) Church; two small collections of the records of the West Boston Society (Ninth Church); a volume of records of Theodore Parker's Twenty-Eighth Congregational Society; and, in the George E. Ellis Papers, records of the Ministry-at-Large of Charlestown, kept by Henry H. Edes.

The Society has a record book of the Religious Union of Associationists. Formed under the leadership of William Henry Channing, the Union included many members of the Brook Farm Community as well as Boston-area religious liberals and free thinkers. There is related manuscript material in the James T. Fisher Papers.

For churches outside Boston there are records of the Cambridgeport

Parish, 1814–1830, kept by Thomas B. Gannett; a historical discourse on the First Congregational Unitarian Church in Harvard, Massachusetts, in the Seth Chandler Papers; deposited records of the First Parish ("The Old Ship Church") of Hingham*; and photocopies of both early and modern records of the First Parish in Plymouth, on deposit.

The Society holds other collections of organizational records relating to Unitarianism: a volume of the records, 1804–1819, of the Kappa Delta Society, an association of college students at Harvard who planned to become ministers; the records of the "Examiner Club," 1829–1863, the publishers of the *Christian Examiner*, the preeminent Unitarian journal; and the records of the Isles of Shoals Association, Unitarian Universalist.

The papers of James Freeman Clarke document the role of his father-in-law, Harm Jan Huidekoper, in the founding of Meadville Theological School. The Horace Mann Papers and the Henry W. Bellows Papers* contain much material on Antioch College following the death of President Mann, when the survival of the school was in doubt. Harvard Divinity School appears in a large number of collections, including the John Pierce "Memorabilia" listed above.

Many politicians and reformers who were animated by Unitarian beliefs are represented in the manuscript collections. The John A. Andrew Papers* document the career of the Civil War governor of Massachusetts, a member of James Freeman Clarke's Church of the Disciples and an ardent abolitionist. Scattered correspondence of Lydia Maria Child, author, abolitionist, and historian of religion, is in the Robie-Sewall Collection and elsewhere. The Society also holds a small collection of the papers of Samuel Gridley Howe, active in medical and educational reform, as well as scattered correspondence of his wife, Julia Ward Howe, the abolitionist, woman suffrage advocate, and author of the lyrics of the "Battle Hymn of the Republic."

The Society has a very large collection of the papers of Horace Mann. Mann, a legislator and educational reformer, was married to Mary Tyler Peabody Mann, an influential educational and social reformer in her own right. The collection also includes correspondence with Mary Tyler Peabody Mann's sister Elizabeth Palmer Peabody, the Transcendentalist and reformer.

There are also three small collections of the records of the Boston Society for the Diffusion of Useful Knowledge. A number of Unitarian ministers and reformers were active in that society.

Peter Drummey

The papers of Unitarian ministers involved in the Transcendentalist movement include previously cited materials by or about Cyrus A. Bartol, William Henry Channing, James Freeman Clarke, Christopher P. Cranch, Ralph Waldo Emerson, Convers Francis, Octavius Brooks Frothingham, Frederic Henry Hedge, Thomas Wentworth Higginson, Theodore Parker, George Ripley, and John Weiss. As indicated above, some of these men were active ministers only briefly.

For the major figures in the Transcendentalist movement who were not ministers, the Society has a small collection of Amos Bronson Alcott manuscripts and memorabilia; Ellery Channing letters in the Channing Family Papers; scattered Elizabeth Palmer Peabody correspondence; and manuscripts of Benjamin Franklin Sanborn, together with manuscripts by other Transcendentalists that he collected and gave to the Society. In addition, as noted above, the Perry-Clarke Collection includes a substantial number of letters to and from Margaret Fuller.* Her 1844 journal is on deposit at the Society.*

The Society owns an important collection of Brook Farm manuscripts* and much correspondence by and about the participants. Of published Transcendentalist material, there are copies of the movement's major journals, several of which—the *Dial*, the *Massachusetts Quarterly Review*, and the *Western Messenger*—were edited by Unitarians whose papers the Society holds.

The Society has always been active in collecting publications relating to religious activities; it purchased pamphlets by "Silver-Tongued Sam" Cooper, the orthodox minister of the Church in Brattle Square, 1746–1783, in 1791 at its second meeting. As a result, the Society's holdings of printed Arminian and Unitarian materials, particularly pamphlet literature, are very large. The Society systematically collects Massachusetts imprints through 1820. It also has a large collection of Boston-area newspapers extending through the Civil War era. In addition to extensive collections of published local historical and biographical materials, including church histories, and the sermons of individual ministers gathered for biographical information, there are the serial publications of many Unitarian religious and philanthropic organizations. Other Unitarian material is to be found in the Society's collection of more than 15,000 broadsides and posters.

Liberal ministers were well represented among the founders of the Historical Society, and it holds portraits of a number of them. There are

three likenesses of Jeremy Belknap (two oil portraits and a portrait miniature), portraits of Charles Chauncy and John Clarke (both on loan to the First and Second Church in Boston), and a portrait of James Freeman (on deposit at the Society from King's Chapel). Likenesses of Unitarian ministers from later generations who were active in the affairs of the Society include George E. Ellis, Edward Everett, Charles Lowell, Andrew P. Peabody, and Robert Cassie Waterston. There are also a portrait of Edward Cummings and a bust of John Pierce. Portraits of early opponents of Arminianism and Unitarianism include likenesses of Samuel Hopkins and Abiel Holmes.

Notable Unitarian laymen represented in the Society's portrait collection include John Adams and John Quincy Adams, John A. Andrew, William Hickling Prescott, Lemuel Shaw, Caleb Strong, and Charles Sumner. In addition to the Society's large collection of full-size oil portraits, there are related collections of miniature portraits, silhouettes, and early cased photographs—daguerreotypes and ambrotypes. Among the silhouettes at the Society are likenesses of William Ellery Channing and Andrew Eliot; among the daguerreotypes and ambrotypes are portraits of Samuel K. Lothrop, Horace Mann, and Theodore Parker.

The Society's extensive collection of engravings, lithographs, and photographs on paper (approximately 20,000 images) contains likenesses of almost all the men and women listed in this guide, along with views of early Boston-area Unitarian churches and other historic buildings. Many Unitarians appear in the Society's special collection of engravings and photographs of abolitionists. For the Transcendentalist movement, in addition to the collections listed above, there is a crayon portrait of Benjamin Franklin Sanborn and a painting of Brook Farm in 1843, one of very few contemporary views of the Transcendentalist community.

This brief list is only a sampling of the Unitarian research materials at the Massachusetts Historical Society. For more complete information on manuscript holdings, see the seven-volume Catalog of Manuscripts of the Massachusetts Historical Society (Boston, 1969), and the two-volume First Supplement (Boston, 1980). In addition, there are unpublished inventories of more than 450 collections at the Society. While only a small portion of the Society's 3,500 manuscript collections is recorded in the National Union Catalog of Manuscript Collections, the Society is now systematically recataloguing them all through the OCLC shared cataloguing system, which is now in use in more than 5,000 American libraries. Since 1978

Peter Drummey

the Society has also used the OCLC system to catalogue or recatalogue printed materials. Andrew Oliver, Ann Millspaugh Huff, and Edward W. Hanson provide a comprehensive survey of the Society's collection of full-size portraits in *Portraits in the Massachusetts Historical Society* (Boston, 1988).

Notes

*Materials available on microfilm.

1. Portions of the Belknap Papers are published in *Collections of the Massachusetts Historical Society*, ser. 5, vols. 2–3 (1877), and ser. 6, vol. 4 (1891).

2. Some letters in the Hollis Papers from Andrew Eliot to Thomas Hollis are published in *Collections of the Massachusetts Historical Society*, ser. 4, vol. 4 (1858). John Eliot's "Ecclesiastical History of Massachusetts" is published in *Collections*, ser. 1, vols. 7, 9, 10 (1801, 1804, 1809), and ser. 2, vol. 1 (1814).

3. The correspondence of Jonathan Mayhew and Thomas Hollis is published in *Proceedings of the Massachusetts Historical Society*, 69 (1947–1950).

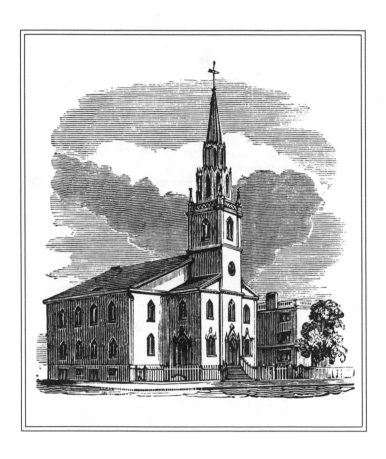

Federal Street Church, Boston. Many of the records of
the Federal Street Church, including this engraving from
the church's letterhead, are deposited at Andover-Harvard
Theological Library in the Arlington Street Church
Collection. Courtesy of Andover-Harvard
Theological Library, Harvard Divinity
School.

Unitarian Resources at Harvard University

※

ALAN SEABURG

In the early years of the nineteenth century, as Unitarianism took hold of the minds and hearts of a number of leading clergymen and lay persons in Massachusetts and up and down the eastern coast of the United States, Unitarian ideas were also taking hold at the university in Cambridge. The controversy surrounding the Hollis Professorship of Divinity in 1805, which ended in a "Unitarian" appointment, was a part of the beginnings of this new intellectual and religious movement in America. The bookshelves of the Harvard College Library soon reflected this new interest of learned ministers. Now, especially in the collections of the Divinity School Library (the Andover-Harvard Theological Library), the Houghton Library, the University Archives in Pusey Library, and the Schlesinger Library on the History of Women, there are rewarding resources for scholars studying Unitarian thought, history, and contributions to the social and cultural life of America between 1805 and 1865. A significant related resource to be found at Andover-Harvard is the outstanding collection of books and pamphlets on the Socinian, the Nonconformist, and other radical Protestant movements. A study of this broader tradition, from which Unitarianism developed, makes possible

Alan Seaburg is Curator of Manuscripts, Andover-Harvard Theological Library.

comparisons between American Unitarianism and other radical post-Reformation sects.

The Divinity School Library is the official repository for the archives of the American Unitarian Association (AUA) and its successor organization, the Unitarian Universalist Association (UUA). The AUA archives for the nineteenth century are contained, for the most part, in a set of bound volumes, the AUA Letterbooks.[1] This set consists of letters that the various secretaries of the AUA received between 1825 and 1902. In the 1850s the AUA decided to bind the letters each year in chronological order. For decades the resulting 229 volumes were kept in the back of the vault at Unitarian headquarters in Boston, and as a result many scholars were unaware of their existence. In 1971 the UUA presented them to Harvard. Andover-Harvard has since indexed the collection by date, by name of the writer or writers, and by the place where each item was written.

These letters document the workings of the AUA in its early years. They also provide information on the establishment of local churches and on the problems, disputes, and controversies between churches and their ministers (and between the ministers themselves) which the Association had to mediate. The collection has sixteen volumes of copies of letters written by the secretaries in response to the correspondence they received. Much of the correspondence is with individuals prominent in the intellectual and religious life of America—for example, Samuel J. May, James Freeman Clarke, Henry Whitney Bellows, and William Henry Furness.[2] Related archival collections include the records of the Anonymous Association (1822–1843), an informal group of persons who helped to form the AUA, the records of the annual meetings of the AUA from 1845, microfilms of the original records of its Executive Committee and Board of Directors beginning in 1825,[3] and numerous other records such as reports of the AUA's treasurer and lists of the tracts it published during its first decade.

A corollary resource with potential for Unitarian scholarship is a recently established special collection of pamphlets, sermons, addresses, reports, church histories, and similar publications. Written and published by Unitarian and Universalist ministers, lay persons, and their various church organizations, these works recount local, regional, and national developments in America, as well as in other countries where Unitarians have been active. This collection also includes the publications of other liberal religious organizations. It was constructed from several large gifts

Alan Seaburg

254

to Harvard and includes the pamphlet collection of the former Historical Library of the AUA, the hundreds of pamphlets in the library of the Universalist Historical Society which came to Harvard in 1976, and pieces from the private libraries of several Unitarian Universalist ministers. In 1988 the collection consisted of approximately 16,000 items, but it continues to grow as new material is added.[4] The collection exists in the original and on microfilm. A full index of authors, additional names, and subject entries, computer generated from the on-line database, is available on fiche. A briefer index, limited to authors, is available in paper copy.

In addition to these two important resources, and the bibliographic tools that help scholars make use of them, the Divinity School Library has microfilmed its entire collection of Unitarian (and Universalist) serials, probably the most complete such collection in the United States. The library has also filmed hundreds of Unitarian books in fragile condition due to the poor paper on which they were printed. A guide to some of these microfilmed titles is available.[5]

Even more significant for scholarship is the fact that all the processed manuscript and archival collections in the Andover-Harvard Library, along with those in the Houghton and Schlesinger libraries and forty-four other repositories at Harvard with manuscript and archival holdings—some 4,000 data entries—have been described in the Archives and Manuscript Control (AMC) format and entered into the Research Libraries Information Network (RLIN) database. Similarly, access is available to the catalog records of some of the printed materials—books, serials, pamphlets—in the Harvard University Library that are already part of the database of the Online Computer Library Center (OCLC). Both types of records are also available in HOLLIS, the on-line library system at Harvard. In the future, when RLIN and OCLC are linked, access will be even wider and more convenient.

It was a remarkable and talented group of individuals who populated the early years of the Unitarian movement in America. Foremost, of course, was Dr. William Ellery Channing, the pastor at Federal Street. Unfortunately, only a small portion of his papers have survived. Those at Harvard are to be found in collections at the Divinity School (four boxes), at Houghton (three boxes), and in the University Archives at Pusey (one letter). One of the manuscripts that has survived is the original copy of "Unitarian Christianity," the sermon he delivered in Baltimore in 1819

that provided the theological structure for the denomination. It exists at Andover-Harvard in several drafts, and so far no scholar has compared them with the care and attention they deserve. Beginning in 1978, the present congregation of his church, now called the Arlington Street Church, began to deposit its records at the Divinity School. These have been arranged, cataloged, and registered, and they provide essential data not only for the period when Channing was the minister, but also for the establishment of Unitarianism in Boston and for its early development.[6]

For a long time many library collections have included records from churches that are defunct. Now, more and more active churches are also depositing their records with libraries, or are having their archives microfilmed for library use. Sometimes only a few key volumes are copied; at other times all the extant records are filmed. An example of the former is the record book, in the hand of Theodore Parker, of the Second Parish in Roxbury for 1837–1846, and in which Parker listed the ministers with whom he made exchanges. Examples of the latter are the records (1716–1847) for the Second Parish of Christ in Marblehead and the records (1734–1976) for the First Parish in Sherborn, today both Unitarian churches. Some of the records that have come to the Divinity School are fascinating single items: for example, the account kept by Abigail Phippea West of preachers who filled the pulpit at the North Church in Salem between 1822 and 1826. This journal lists each preacher's text and sometimes gives a summary of the sermon. Another example is a collection of abstracts of the sermons of Thomas Barnard West while he was minister at the same church in the 1840s.

Among the active churches that have placed some of their records at Andover-Harvard are the First Church in Roxbury and the First Parish in Cambridge. The First Parish in Cambridge has long had close associations with Harvard and, at the same time, has had a strong connection to the history of the AUA.[7] Its extensive records document the story of how one of the oldest of the Boston-area churches made the change from the Standing Order to Unitarianism. Inactive churches whose records are at Harvard include the South Congregational Society, the Brattle Street Church, the Church of the Disciples, the Hollis Street Church, the Bulfinch Place Chapel, the Thirteenth Congregational Society, the Twenty-eighth Congregational Society (all of Boston), the Harvard Church in Charlestown, the Third Religious Society in Dorchester, and the Church of Our Father in East Boston. This partial list of Greater Boston church

Alan Seaburg

records at the Harvard Divinity School shows the depth, and the impressive range, of local church archives available for scholarly study and interpretation.

Dr. Channing was not the only Unitarian minister in Boston between 1805 and 1865. He preached, discussed, wrote, and worked with many able and rational colleagues. This goodly company included the Wares, the father who was the first Unitarian Hollis Professor and the pastor son who also taught for thirteen years at Harvard; James Walker, one of the founders of the AUA, a member of its Executive Committee, and from 1853 to 1860 president of Harvard; Andrews Norton, the controversial and reactionary Biblical scholar; John Thornton Kirkland, another Harvard president; and Ezra Stiles Gannett, the sober, somber, scholarly, enthusiastic, and conservative successor to Dr. Channing. And there were others preaching and teaching outside "blest New-England." These individuals, along with many others—Ezra Ripley, for sixty-three years minister in Concord, and Joseph Tuckerman, minister to the poor of Boston and founder of the Benevolent Fraternity of Churches, come readily to mind—were all active in the lively classroom that was the beginnings of American Unitarianism.

At Harvard there are nine boxes of the papers of Henry Ware, Sr., in the University Archives at Pusey. This collection includes some of his sermons between 1793 and 1835, some of his lectures on religion, other teaching materials like assignment books, and correspondence for the period 1795–1805. A number of his lectures are at Andover-Harvard. Five boxes for Henry Ware, Jr., are also at the University Archives. This collection includes sermons and personal correspondence. At Andover-Harvard are some additional letters as well as a handful of miscellaneous manuscripts. For James Walker ten boxes of sermons, addresses, letters, and official outgoing correspondence as the president of Harvard are at the University Archives. More letters are at Andover-Harvard, including two boxes of letters he received in connection with his work for the AUA and the *Christian Examiner* for the period 1815–1859. For Andrews Norton, Houghton Library holds a very large collection of manuscripts and letters, seventeen boxes, beginning with his college diary and covering his work as the first Dexter Professor of Sacred Literature at Harvard. Andover-Harvard holds some of the notes from lectures to his classes on the New Testament, as well as further letters. For John Thornton Kirk-

land the University Archives includes fifteen boxes, mostly dealing with his years as president of Harvard. A few additional letters are at Andover-Harvard. Finally, at Andover-Harvard there are papers relating to Ezra Stiles Gannett's ministry at Federal Street and a large collection of his sermon manuscripts. Supporting these manuscripts are books and pamphlets by these ministers, as well as magazines that also published their essays and articles.

The second generation of Unitarians, if very different in outlook, was as able and attractive as the founding generation. Once again the researcher must check the registers and finding guides at several repositories in order to discover Harvard's holdings for any one of the men and women who were making contributions to the period Daniel Walker Howe has termed "the golden age" of American Unitarianism.

Two of the Unitarians who dominated "the golden age" were Ralph Waldo Emerson and Theodore Parker. The Emerson journals and manuscripts are at Houghton Library and a good part of the Parker corpus is divided between Andover-Harvard and the Massachusetts Historical Society. But there were many other "planets" circling in "the golden age." A listing of their names and Harvard's holdings for each would be tedious, but it is proper to show a sample. Houghton Library has a significant collection of manuscripts by Dorothea Dix and some for Samuel Gridley Howe and Horace Mann, three reformers who exemplified the Unitarian belief in the dignity of each individual. Schlesinger Library has an extensive collection for Caroline Wells Healey Dall—the author, reformer and teacher—and Andover-Harvard has an extensive collection for her husband, Charles Henry Appleton Dall—the Unitarian minister who was a missionary to India for thirty-one years and who influenced the developing Brahmo Samaj movement. Schlesinger Library also has letters written by Lydia Maria Child, abolitionist and one of the country's first women of letters.

It was during this period that "the Hedge Club" held its meetings. Seventeen of its twenty-six members were Unitarian ministers. In 1840 they began to publish the *Dial* with Margaret Fuller as the editor. Houghton Library has the Fuller family papers (1662-1909), and Andover-Harvard has James Freeman Clarke's copy of the *Dial* in which he identified with initials the authors of some of the anonymous articles. Also in both libraries are sizable collections of Clarke papers. Indeed, the

Alan Seaburg

members of "the Hedge Club," more commonly called the "Transcendental Club," are well represented at Harvard.

Additional Unitarian manuscripts continue to be presented to Harvard, as they are to many other fine libraries, and so the possibilities for research continue to be expanded and enriched. In 1983 William F. Dewey, a descendant of Orville Dewey, a protégé of Dr. Channing at Federal Street and later a minister at the Second Church (Unitarian) in New York City, gave Andover-Harvard his private collection of Dewey manuscripts (1828–1882), which includes fifty-five letters to Orville Dewey from such individuals as Channing, Edward Everett Hale, and William Cullen Bryant, as well as two of Dewey's own letters and lectures. About this same time Henry G. Pearson of the Ware family presented to the Divinity School four boxes of letters centering around William Ware, the brother of Henry Ware, Jr. William has been called "the pioneer Unitarian minister" in New York City, and these letters are filled with fascinating gossip and insights as well as a delightful pencil sketch of "Uncle William Ware." Of his brother Henry wrote, "Oh, that William could preach his letters." Frederic Henry Hedge, the minister at Bangor, Maine, for whom the Transcendentalists named their club, is represented at Harvard by several small but significant collections. In 1977 Barbara C. Spalding gave Andover-Harvard twelve of Hedge's letters to his friend Waldo Emerson and photocopies of twenty-seven letters from Hedge to William Rounseville Alger. A few years later, her aunt, Margery L. Chandler, gave twenty-four letters from George Bancroft, Henry W. Bellows, Channing, Emerson, Margaret Fuller, James Russell Lowell, and a note from Emerson's daughter Ellen to Hedge, written the day after her father's death: "Are you willing to speak at Father's funeral at the church tomorrow. . . . We have asked Dr. Clarke if he also will speak; and Mr. Alcott. . . . The illness was pathetic though not severe, and Father's death we regard as a mercy, and we think he did. Affectionately Ellen T. Emerson." Hedge, however, was not able to take part in the service, which proved to be the final meeting of "the Hedge Club."

In 1966 the UUA Board of Trustees appointed a special committee, chaired by Conrad Wright, to consider the future of the historical library it maintained at its headquarters. The library had never been adequately funded or staffed, and it was fairly clear that this situation was not going to improve in the immediate future. The report of this committee, which

the trustees approved, recommended that the historical library collections become the responsibility of appropriate educational institutions rather than continue to be the direct responsibility of the denomination.

> The value of a denominational collection is enormously multiplied when it is supported by the research facilities of a college or university. The materials will be much more readily available to scholars if they are not isolated from the general historical collections and research tools that [the scholar] needs to have close at hand. The history and vision of the denomination in question is much more likely to be drawn within the horizon of the general historian who may not be centrally concerned with it.[8]

This was an important decision, and not only for this denomination's own concern with its past. In ways the committee could not have foreseen, the decision has resulted not only in preserving Unitarian and Universalist resources, but also in making them more readily available to scholars studying American Unitarianism and Universalism, thanks to the bibliographic tools modern technology has made possible. Harvard, which saw much of the UUA library collections come to the library of its Divinity School, is a good example of how a larger research facility can attract the funding, the staff, the space, the related material, and the expertise that permits the work of past generations—their books, sermons, manuscripts, letters—to enter the minds of the present generation and, under the careful guidance of scholars, to influence in helpful ways how ordinary men and women organize the living of their days.

Notes

1. For earlier accounts of the Unitarian (and Universalist) holdings of the Divinity School Library, see Alan Seaburg, "Some Unitarian Manuscripts at Andover-Harvard," *Harvard Library Bulletin* 26:112–120 (1978), and "The Universalist Collection at Andover-Harvard," *Harvard Library Bulletin* 28:443–455 (1980). See also the article on Andover-Harvard in *Guide to Massachusetts History* (Westport, Conn., 1988). For a good overview of the manuscripts and archives in the Harvard University Library, consult *Directory of Archives and Manuscript Repositories at Harvard University and Radcliffe College* (Cambridge, Mass., 1988). For a much earlier survey, which is still useful, see Ernest Kurtz and William R. Hutchison, "Boston Area Resources for the Study of American Religious History," *Religious & Theological Resources* 2:1–13 (1971).

2. Film copies are available through the Interlibrary Loan Department of the Andover-Harvard Theological Library.

Alan Seaburg

3. The original records of the Executive Committee and the Board of Directors remain at the UUA headquarters in Boston.

4. The collection does not exhaust Andover-Harvard's holdings of Unitarian pamphlets. Some previously cataloged materials, for example Unitariana in the Sprague Collection, were not included in this special collection.

5. *Unitarian and Universalist Publications*, microfilmed under grants from the U.S. Department of Education and available in the Andover-Harvard Theological Library (Cambridge, Mass., 1983).

6. The records of a number of national and regional Unitarian organizations founded in this era are available at Andover-Harvard. Among these associations are the Society for Promoting Theological Education (the records of which have been microfilmed), the Unitarian Sunday School Society, the Society for the Promotion of Christianity in India, and the Evangelical Missionary Society in Massachusetts. These collections are discussed in Seaburg, "Unitarian Manuscripts." Since the 1960s, Andover-Harvard has also microfilmed the newsletters and bulletins of more than six hundred Unitarian Universalist churches. The library has filmed earlier extant newsletters when possible.

7. See Conrad Wright, *Harvard and the First Parish: A 350th Anniversary Retrospect* (Cambridge, Mass., 1987.)

8. See "The Library of the Unitarian Universalist Association" and "Unitarian Universalist Historical Scholarship" (the reports of the Wright committee to the Board of Trustees of the UUA, Feb. 15, 1967, and Jan. 1973) published in *The Proceedings of the Unitarian Historical Society* 17:63–77 (1970–1972).

Index

Beecher, Lyman, 42, 44, 45, 46; and Finney, 35, 46; on First Great Awakening, 45–46; on Second Great Awakening, 44
Belknap, Jeremy, 250; papers, 241–242
Bellows, Henry W., 99, 201n3, 259; papers, 244, 245, 248
Belsham, Thomas, 18, 66
Benevolence, disinterested, 40–42
Benevolent Fraternity of Churches, 190
Bentley, William, 14–15; papers, 242
Bercovitch, Sacvan, *American Jeremiad,* 170
Berry Street Conference, 5
Bible News, 62
Biblical criticism. *See* Criticism, higher
Boston, Mass., 189, 196, 242; churches, denominational strength, 202n5, occupational correlations, 188, philanthropy, 190, social composition, 183, socioeconomic structure, 182–189, Unitarian seating capacity, 203n6; intellectual life, 164, 213; Sunday schools, 191
Boston, Mass., First Church, 234n25, 242; records, 247
Boston, Mass., Second Church, 243, 245; records, 247
Boston, Association (clergy), 13; and Codman, 8, 9, 12
Boston Female Antislavery Society, 193
Boston Investigator, 222
Boston School for the Ministry (Unitarian), 210–211
Boston Society for the Diffusion of Useful Knowledge, records, 248
Bowdoin College, 58, 257
Brattle Street Church (Boston), 190, 243, 245, 246, 249; records, 256
Brazer, John, 15
Broadsides, Unitarian, 249
Brook Farm, 86, 227, 246, 249, 250
Brookline, Mass., 242, 245
Brooklyn, Conn., 245
Brooks, Charles, 244
Brooks, William, 199
Buckminster, Joseph Stevens, 7, 54, 66, 67; sermon list, 243
Buell, Lawrence, ix
Buffum, Arnold, 193
Bulfinch, Stephen Greenleaf, papers, 244
Bulfinch Place Chapel, records, 256
Burlington, Vt., 245

Calvinism, and Emerson, 125
Cambridge, Mass., First Church, 242, 243
Cambridge, Mass., First Parish, 17, 22; records, 256
Cambridge Antislavery Society, 221
Cambridge Platform, 20–22
Cambridge Platonists. *See* Platonists, Cambridge
Cambridgeport, Mass., Parish, records, 247–248
Cambridge University: Christ's College, 89–90; Emmanuel College, 89–90, 91–92; and Platonism, 88
Camp meetings, southern, 33, 34, 41
Canonicalism, high, 170–176
Catholics, 191; Boston, 183; Charleston, S.C., 184
Channing, Edward T., 32
Channing, Ellery, papers, 249
Channing, William Ellery, ii, 18–19, 75, 125–126, 166, 168, 250; accommodationism, 70–71; and Codman, 7, 8; as critic, 83–84n50, 147–148; debates S. Worcester, 3, 18–19; discusses controversial topics, 62–63; establishes *Christian Disciple,* 68; and F. H. Hedge, 259; historiographical prominence, 167; on Hopkins and disinterested benevolence, 41–42; on human nature, 101–102; on mind and matter, 95; and A. Norton, 64, 83–84n50; on obscenity, 222; papers, 242, 255–256; on religion and reform, 200–201; on slavery, 192–193, 194, 215; works, 3, 73, 97, 101, 125, 147, 148
Channing, William Henry, 41, 47, 219, 247; papers, 246
Chapman, Henry G., 192, 193
Chapman, Maria Weston, 192, 193
Character, 99, 125, 165. *See also* Self-culture
Charitable Irish Society, 196
Charleston, S.C., 183–184, 245
Charlestown, Mass., 243, 245
Chauncy, Charles, 36, 38–39, 43, 88, 250; Beecher on, 46; on First Great Awakening, 33; papers, 242
Chelsea, Mass., 243
Child, Lydia Maria, 192; papers, 248, 258
Childhood, Emerson on, 136
Choice, Emerson on, 132

Index

264

Christian Disciple, 68, 74, 164; founded, 5; reorganized, 72

Christian Examiner, 36, 40, 41, 44, 164, 257; founded, 5; records, 245, 248

Christianity, definition of, and the Philanthropic Society, 227; relationship of Unitarianism to, 167

Christian Register, 192; founded, 5

Christian Spectator, 76

Church and Parish, 22–26

Churches: processes for resolving disputes, Connecticut and Massachusetts, 20–22; Unitarian, records, 247–248, 256–257

Church in Long Lane (Boston), 241–242

Church of Our Father (East Boston), records, 256

Church of the Disciples (Boston), records, 256

Church of the Savior (Boston), records, 247

Clarke, James Freeman, 230, 258; on colonization, 219; on equal rights for blacks, 235n35; papers, 243–244, 258; *Self-Culture,* 112

Clarke, John, 250; papers, 242

Clarke, Samuel, 93

Clubs, literary, 164

Codman, John, 7–14, 62

Coleridge, Samuel Taylor, 111, 169

Colman, Benjamin, 88

Colman, Henry, papers, 244

Colonization, 192; and Philanthropic Society, 218–219, 221–222

Columbian Centinel (Boston), 9

Common sense, Scottish and Unitarian, 95

Communion, 196

Conformity, Emerson on, 127, 129, 130

Congregationalism, and Unitarianism, ix

Congregationalists: Boston, 183, 185; Charleston, S.C., 184

Congregations, Unitarian, 201n3

Connecticut Evangelical Magazine, 33

Conscience: Cambridge Platonists on, 99; Unitarians on, 98

Consciousness, double, Emerson on, 138, 139

Converts, 188

Conway, Moncure, 231–232

Cooke, George Willis, 163–164, 166–167, 181, 192

Cooper, Samuel, 249

Cooper, William, 7

Councils: ecclesiastical, 10–12, 20–22, 195, 198–199; *ex parte,* 10, 22

Cranch, Christopher P., 240; papers, 246

Critic: as educator, 149; as representative reader, 149

Criticism, 147–148; higher, 4, 61–62, 69, 210, 223; and W. E. Channing, 83–84n50; and A. Norton, 69, 213; and Parker, 223, 234n28

Criticism, literary: and Fuller, xi, 145–158; objectives, 149–150, 153

Cudworth, James, 92

Cudworth, Ralph, 90, 91, 93, 95, 107; Emerson on, 106; Parker on, 108; Thoreau on, 106

Culverwell, Nathaniel, 90

Cummings, Edward, 250; papers, 246

Curti, Merle E., 182

Dall, Caroline Healey, papers, 244, 258

Dall, Charles H. A., papers, 244, 258

Damon, David, papers, 244

Davis, Daniel, 10

Davis, John, 65

Deane, Samuel, 17

Debating Society. *See* Harvard Divinity School

Dedham, Mass., 243, 244

Deerfield, Mass., 21

Demond, Elijah, 17

Dewey, Orville, 44, 100, 103, 175; papers, 244, 259

Dexter, Samuel, 10–11, 64

Dial, 121, 258

Dix, Dorothea, papers, 258

Dorchester, Mass., 10–12, 13, 62, 243

Dorchester, Mass., First Church, 6

Dorchester, Mass., Second Church, 2, 6, 10, 22

Dorchester, Mass., Second Parish: and Codman, 9, 10, 12; controversy, 6–25; controversy resolved, 13

Dorchester, Mass., Third Church, 13

Dorchester, Mass., Third Religious Society, 6, 13; records, 256

Drama, and Unitarians, 163–164

Index

Index

Index

Index

Index